THE ART OF THE JULY MONARCHY

THE ART OF THE JULY MONARCHY
France 1830 to 1848

Museum of Art and Archaeology, University of Missouri–Columbia

University
of Missouri
1839 - 1989

University of Missouri Press
Columbia and London

The exhibition "The Art of the July Monarchy: France 1830–1848" has been made possible by generous grants from the National Endowment for the Humanities and the National Endowment for the Arts, Federal Agencies; Museum Associates, Inc.; and the University of Missouri–Columbia Sesquicentennial Committee. An indemnity was received from the Federal Council on the Arts and the Humanities.

Exhibition dates:

Museum of Art and Archaeology, University of Missouri–Columbia
 October 21 to December 3, 1989
Memorial Art Gallery of the University of Rochester
 January 21 to March 12, 1990
The Santa Barbara Museum of Art
 March 31 to May 20, 1990

Library of Congress Cataloging-in-Publication Data

The Art of the July monarchy : France 1830–1848 / Museum of Art
 and Archaeology, University of Missouri–Columbia.
 p. cm.
 Exhibition dates: Museum of Art and Archaeology, University of Missouri–Columbia, Oct. 21–Dec. 3, 1989;
Memorial Art Gallery of the University of Rochester, Jan. 21–Mar. 12, 1990; Santa Barbara Museum of Art,
Mar. 31–May 20, 1990.
 Bibliography: p.
 ISBN 0–8262–0721–9 (alk. paper).
 1. Art, French—Exhibitions. 2. Art, Modern—19th century—France—Exhibitions. 3. Politics in art—
Exhibitions. 4. Eclecticism in art—France—Exhibitions. 5. Allegories—Exhibitions. 6. France—History—Louis
Philippe, 1830–1848. I. University of Missouri–Columbia, Museum of Art and Archaeology.
N6847.A794 1989
709.44'074'73—dc20 89-4864
 CIP

5 4 3 2 1 94 93 92 91 90

For photo credits, see p. 313

Under the Patronage of
His Excellency Emmanuel de Margerie
Ambassador of France

CONTENTS

Lenders ix
Acknowledgments xi
Note to the Reader xiv

ROBERT J. BEZUCHA
1. An Introduction to the History 17

MICHAEL PAUL DRISKEL
2. An Introduction to the Art 49

PATRICIA CONDON
3. Historical Subjects 80

GABRIEL P. WEISBERG
4. Early Realism 101

PETRA TEN-DOESSCHATE CHU
5. At Home and Abroad: Landscape Representation 116

GABRIEL P. WEISBERG
6. The Cult of Personal Portraiture 131

GABRIEL P. WEISBERG
7. The Coded Image: Agitation in Aspects of Political
and Social Caricature 148

ROBERT J. BEZUCHA
8. The Renaissance of Book Illustration 192

Catalog of the Exhibition 215

Bibliography 299
About the Contributors 305
Index 307
Photo Credits 313

EUROPEAN LENDERS

France

Musée des Beaux-Arts de Bordeaux
Musée des Beaux-Arts, Caen
Musée des Beaux-Arts de Chartres
Musée Municipal, Clermont-Ferrand
Musée Vivenel, Compiègne
Musée de Grenoble
Musée des Beaux-Arts, Lyon
Musée des Beaux-Arts, Marseille
Musée Fabre, Montpellier
Musée des Beaux-Arts, Nantes
Bibliothèque du Protestantisme Français, Paris
Galerie Fischer-Kiener, Paris
Musée Carnavalet, Paris
Musée des Arts Décoratifs, Paris
Musée des Hôpitaux de Paris
Musée du Louvre, Département des Arts Graphiques, Paris
Musée du Louvre, Département des Peintures, Paris
Musée des Beaux-Arts, Pau
Musée des Beaux-Arts, Rouen
Musée du Château de Versailles

Netherlands

Dordrechts Museum

AMERICAN LENDERS

The Baltimore Museum of Art
The Walters Art Gallery, Baltimore
Boston Public Library
Museum of Fine Arts, Boston
The Houghton Library, Harvard University, Cambridge
The Art Institute of Chicago
The Newberry Library
The David and Alfred Smart Gallery of the University of Chicago
Museum of Art and Archaeology, University of Missouri–Columbia
The Detroit Institute of Arts
Northwestern University Library, Evanston
Los Angeles County Museum of Art
The Minneapolis Institute of Arts
Yale University Art Gallery, New Haven
The Beinecke Rare Book Library, New Haven
Faber Donoughe, New York
Michael Hall, Esq., New York
Michael Hall Fine Arts, Inc., New York
Janson Collection, New York
The Metropolitan Museum of Art, New York
The New York Public Library
Private Collection, New York
Private Collection, U.S.A.
Sandorval and Co., Inc., New York
H. Shickman Gallery, New York
The John Hay Library, Brown University, Providence
Anne S. K. Brown Military Collection, Brown University Library, Providence
International Museum of Photography at George Eastman House, Rochester
Santa Barbara Museum of Art
The Library of Congress, Washington, D.C.

ACKNOWLEDGMENTS

Considering the enormous attention French art and culture of the nineteenth century have received, it is hard to believe that no substantial exhibition has focused on two of the century's decades—those of the July Monarchy. Delacroix, Ingres, Daumier, and other of the era's eminent artists have of course been the subject of exhibitions, as have the great movements of romanticism and realism. Our exhibition and catalog examine neither a single artist nor an ism, however, but bring to attention and aim to illuminate the art of an eighteen-year period in all its bewildering—and, we have found, engaging—complexity.

Auguste Jeanron, Dominique Papety, and Prosper Marilhat are as unfamiliar as Delacroix and Daumier are famous. Nevertheless, they and their little-known fellows are by no means unimportant as we consider what the art of the July Monarchy is like and what it is about. Moreover, twentieth-century revisionism has taught us that obscure artists do not necessarily deserve their obscurity.

The July Monarchy exhibition and catalog have been undertaken by our museum to mark the 150th anniversary of the University of Missouri. When planning began in 1984, the intention was to organize an exhibition of European and American art of the university's founding year, 1839. As interesting as this thin but deep slice of art history would have been, we soon learned that such an exhibition would not be feasible. After Dr. Patricia Condon, a specialist in French art of the first half of the nineteenth century, joined the museum staff in 1985, the exhibition was rethought and took its present definition. Dr. Condon attributes her interest in the art of the July Monarchy to a stimulating seminar at Brown University in 1980 conducted by Professor Michael Driskel.

Concentrating on France in the period of the university's establishment is appropriate: the historical links between our state and France are many, and Missouri's was the first public university founded in the former French territories of the Louisiana Purchase. The founders would of course have been quite aware of contemporary events in France: the Revolution of 1830 and the accession of Louis Philippe had gained front-page headlines in the central Missouri newspapers of the day.

A grant from the University Sesquicentennial Committee provided vital seed money for the July Monarchy project. Subsequently, grants from the National Endowment for the Arts and the National Endowment for the Humanities have underwritten the preparation of the exhibition and catalog. We are most grateful to the Endowments for their support and encouragement. Additional funds were generously provided by Museum Associates, our museum's splendid membership organization.

The exhibition's showing at the Memorial Art Gallery of the University of Rochester was made possible in part by grants from Chemical Bank and the National Endowment for the Arts. The Santa Barbara Museum of Art wishes to thank Casino U.S.A., Inc./Smart and Final Iris Co. for local support.

Our sincere thanks are also due many helpful persons in the United States and Europe. Our essayists, professors Petra ten-Doesschate Chu, Robert Bezucha, Michael Driskel, and Gabriel P. Weisberg, must be mentioned first. In addition, Professor Weisberg has served as consulting curator. He participated in the selection of objects and has advised on every phase of the project. Professor Driskel worked closely with us through the exhibition's early

development, and Professor Bezucha was deeply involved in the formulation of the exhibition's humanities themes.

Others who have consulted on various matters, and to whom appreciation is due, include Gerald Bolas, Ann Brubaker, James Cuno, Julius Freedman, June Hargrove, Joseph A. Ketner, Meredith Shedd, and Suzanne Tise. Special thanks go to Patricia Whitesides and Robert Kashey for helpful advice. Additionally, Mr. Kashey verified the insurance value estimates for the indemnification application.

The ambassador of France, His Excellency Emmanuel de Margerie, has kindly extended his patronage to our exhibition. We also appreciate the assistance of Yvon Gousty, the deputy cultural counselor in the French embassy; Daniel Ollivier, cultural attaché at the Services Culturels Français in Chicago; and Stuart Symington, Jr., the honorary French consul in St. Louis.

In France many administrators, scholars, collectors, and dealers have given generously of their time and effort. These include Roger Quillot, mayor of Clermont-Ferrand; Isabelle Julia of the Ministry of Culture and Communication; and Neal Fiertag, Jacques Fischer, Chantal Kiener, and Marianne Roland Michel. Also included are: in Amiens, Dominique Vieville of the Musée Picardie; in Angers, Béatrice de Chancel and Vivianne Huchard of the Musée des Beaux-Arts and Galerie David d'Angers; in Bordeaux, Hélène Lafont and Philippe Le Leyzour of the Musée des Beaux-Arts; in Caen, Caroline Joubert and Alain Tapié of the Musée des Beaux-Arts; in Chartres, Maithé Valles-Bled of the Musée des Beaux-Arts; in Clermont-Ferrand, Gérard Tisserand of the Musée Municipal; in Compiègne, Andrée Durieux and Christian Lapointe of the Musée Vivenel; in Dijon, Marguerite Guillaume and M. Lechanut of the Musée des Beaux-Arts; in Grenoble, Catherine Chevillot and Serge Lemoine of the

Musée de Peinture et de Sculpture; in Lyon, Philippe Durey of the Musée des Beaux-Arts; in Marseille, Elisabeth Mognetti and Marie Paule-Vial; in Montauban, Mme. Viguier of the Musée Ingres; in Montpellier, Thierry Bajou, Valérie Bajou, and Aleth Jourdan of the Musée Fabre; in Nantes, Claude Cosneau, Henry-Claude Cousseau, and Béatrice Sarrazin of the Musée des Beaux-Arts; in Paris, Yvonne Brunhammer and Marie-Noëlle de Grandry of the Musée des Arts Décoratifs, Idelette Beauvais-Teitgen of the Bibliothèque du Protestantisme Français, Frank Folliot, François de Lepiney, and Bernard de Montgolfier of the Musée Carnavalet, Nicolas Sainte Fare Garnot of the Musée des Hôpitaux de Paris Assistance Publique, Jacques Foucart, Pierre Rosenberg, Arlette Sérullaz, and Françoise Viatte of the Musée du Louvre, Geneviève Lacambre of the Musée D'Orsay, Thérèse Burollet and Gilles Chazal of the Musée du Petit Palais; in Pau, Patrick Dupont of the Château Henri IV, Philippe Comte of the Musée des Beaux-Arts; in Rouen, François Bergot and Gilles Grandjean of the Musée des Beaux-Arts; and in Versailles, Yves Bottineau and Claire Constans of the Château de Versailles.

Colleagues at other European museums whose help we gladly acknowledge are Ann Adriaens and André Moerman in Brussels; G. J. Schweitzer in Dordrecht; William Hauptman and Bernard Wyder in Lausanne; and Pierre von Allman in Neuchâtel.

In the United States, special thanks go to our colleagues at the museums sharing the exhibition with us: at the Memorial Art Gallery of the University of Rochester, director Grant Holcomb III, curator Bernard Barryte, and registrar Sandra Markham; at the Santa Barbara Museum of Art, director Richard Vincent West, curators Robert M. Henning, Jr., and Merrily Peebles, and registrar Cherie Summers.

We express our appreciation also to the fol-

lowing personnel of American museums and libraries: in Baltimore, Jay Fisher and Melanie Harwood of the Baltimore Museum of Art, and William Johnson, Cora Sedcheck, and Gary Vikan of the Walters Art Gallery; in Boston, Laura V. Monti of the Boston Public Library and Karen Otis and Barbara Shapiro of the Museum of Fine Arts; in Cambridge, Roger Stoddard of the Houghton Library, Harvard University; in Chicago, Anselmo Carini and Douglas Druick of the Art Institute of Chicago, Richard Born of the David and Alfred Smart Gallery of the University of Chicago, and Paul Gehl and Cynthia Wall of the Newberry Library; in Cincinnati, Millard F. Rogers, Jr., of the Cincinnati Art Museum; in Cleveland, Henry Hawley and Ann Tzeutschler Lurie of the Cleveland Museum of Art; in Detroit, Alan P. Darr, Kathy Irwin, and J. Patrice Marandel of the Detroit Institute of Arts; in Evanston, Russell Maylone of the Northwestern University Library; in Hartford, Jean K. Cadogan of the Wadsworth Atheneum; in Kansas City, Roger Ward of the Nelson-Atkins Museum of Art; in Minneapolis, Richard Campbell, Karen Duncan, and Evan M. Maurer of the Minneapolis Institute of Arts; in New Haven, Vincent Giroud and Richard Hart of the Beinecke Rare Book Library, Yale University, and Richard Field of the Yale University Art Gallery; in New York City, Roberta Waddell of the New York Public Library and James Draper of the Metropolitan Museum of Art; in Providence, Richard Harrington of the A. S. K. Brown Military Collection, Brown University, and Jennifer B. Lee of the John Hay Library, Brown University; in Richmond, Paul Perrot and Richard Woodward of the Virginia Museum of Fine Arts; in Rochester, Janet E. Buerger of the International Museum of Photography at George Eastman House; in Toledo, Roger M. Berkowitz, William Hutton, and Steve Novak of the Toledo Museum of Art; in Washington, D.C., Donna Elliot,

Kathleen Mang, Joyce Nalewajk, Stephen E. Ostrow, Carol Pulin, and Bernard Riley of the Library of Congress.

Others in the United States who have provided much-appreciated advice are David Bancroft, Nancy Pressly, and Alice Martin Whelihan of the National Endowment for the Arts and Marsha Semmel, Sue Traylor, and Thomas H. Wilson of the National Endowment for the Humanities. The following scholars, collectors, dealers, and friends have also been generous and helpful: Stevan Baloga, Janis Bergman-Carton, Kermit Champa, Phillip Dennis Cate, David Daniels, Charles Eldredge, Bea Farwell, Michael Hall, Dora Jane Janson, Elizabeth Kashey, Edward J. Nygren, Addison Franklin Page, Stuart Pivar, Robert Rosenblum, Gert Schiff, Herman Shickman, Gerard J. Stora, Gerald Stiebel, James Symington, Yvonne Weisberg, Kevin Weremeychik, Wheelock Whitney, and David and Constance Yates.

On our own campus many colleagues are owed a debt of gratitude. Chancellor Haskell Monroe, Vice-Chancellor Roger Gafke, Provost Lois De Fleur, and Vice-Provosts Jeffrey B. Chinn and Judson D. Sheridan have provided vital moral support. Other administrators to whom thanks are due include E. Kenneth Bittner, Mary Hartigan, Don Haskell, and Christine Koukola.

The members of the university advisory committee for the July Monarchy project were: Ray Brassieur, Larry D. Clark, Patricia Crown, Noble E. Cunningham, Jr., Haskell Hinnant, Margaret A. Howell, Karen Kleinfelder, Barbara Oliver Korner, Bonnie MacEwan, Howard Wight Marshall, Donald McGlothlin, Osmund Overby, Naomi Ritter, and Vickie Wilson.

The graduate students in a 1986 seminar on nineteenth-century painting taught by Patricia Condon undertook research that helped in the formulation of the exhibition's themes. They were Jeffrey Ball, Pamela Jones, David

Montgomery, Virginia Murphy, and Claudia Einecke-Schuck.

At the University of Missouri Press we are indebted to our friends and colleagues whose hard work and professionalism have been exemplary: Rick Boland, Susan McGregor Denny, Beverly Jarrett, Barbara J. King, Edward D. King (now of the University of North Carolina Press), Jane Lago, and Pipp Letsky.

Needless to say, our fine museum staff has shouldered a great deal of the work to bring the July Monarchy project to fruition. Curator Patricia Condon was responsible for much of the organization of the exhibition and has been involved in nearly all aspects of the complex arrangements. She has been most ably assisted by graduate student Claudia Einecke-Schuck. Assistant director Morteza Sajadian undertook a large part of the preparation and administration of the grants, and effectively carried out many other duties as well. Much painstaking record-keeping, as well as preparation of the indemnity application, fell to registrar Jeffrey B. Wilcox. Other important work was carried out efficiently by Luann Andrews, Jeffrey Ball, Amy Brassieur, Anne Harwell Brooks, Pat Hubbs (now of Columbia College), Sue Stevens, Christine Wallace, and Melissa Wolfe (now of the Art Institute of Chicago). Heartfelt thanks, one and all!

Forrest McGill
Director, Museum of Art and Archaeology

NOTE TO THE READER

Figures are numbered by chapter and order; thus Figure 2–9 is the ninth figure in Chapter 2. For figures that illustrate works included in the exhibition, the captions give only the artist and the title of the work; the catalog number included at the end of the caption indicates where additional information can be found. The captions of the color plates also include the catalog numbers.

The works in the catalog proper are arranged thematically following their order in the exhibition. If a work is not illustrated adjacent to its catalog entry, the figure or plate number indicating where its illustration will be found is included in the catalog entry. Each work is illustrated only once, either in the color plates, the figures, or the catalog proper. The exception to this rule is books: in some instances a single book is represented by illustrations of several of its pages. When a work in the catalog is illustrated or mentioned in one of the chapters, the catalog number is always given to enable the reader to find the complete information easily.

In the catalog proper all measurements are in centimeters. The first number is the height, the second the width. For three-dimensional objects the depth may also be listed.

A list of acknowledgments of permission to reproduce photos is found at the very back of the book.

Works of art are called by the titles supplied by their owners, with English translations of French titles in parentheses.

Unless otherwise indicated, all translations of passages from the French in the essays are the work of the authors.

THE ART OF THE JULY MONARCHY

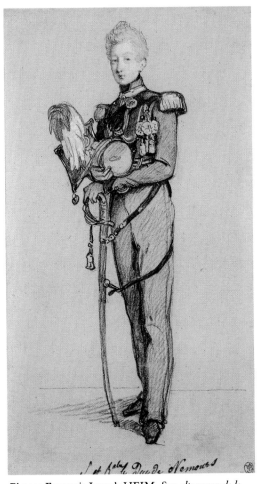

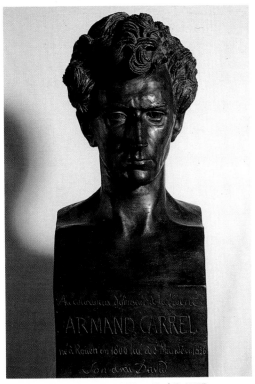

Plate 2. Pierre-Jean DAVID, called DAVID
D'ANGERS, *Armand Carrel*. See cat. no. 16.

Plate 1. François-Joseph HEIM, *Son altesse royale le
duc de Nemours* (His royal highness the duc de
Nemours). See cat. no. 12.

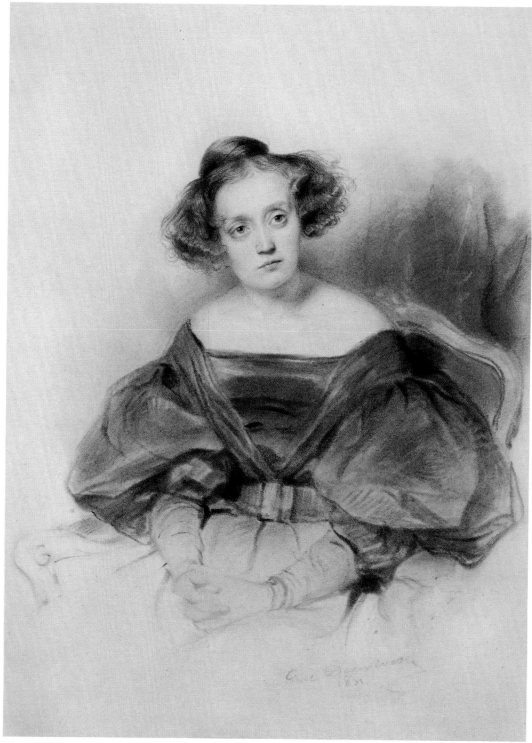

Plate 3. Hippolyte, called Paul DELAROCHE, *Portrait of the Actress Marie Dorval (1798–1849)*. See cat. no. 22.

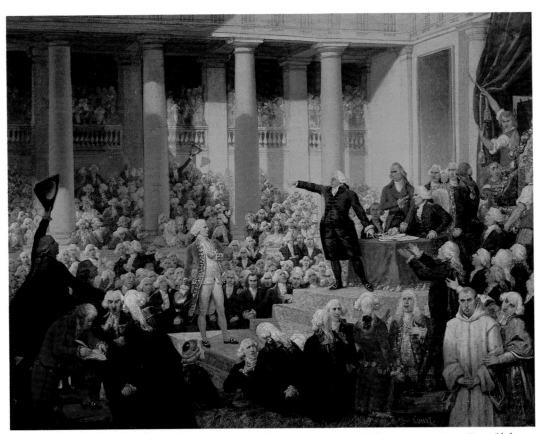

Plate 4. Joseph Désiré COURT, *La Protestation de Mirabeau contre le congé signifié par Louis XVI aux Etats Généraux par la bouche du marquis de Dreux-Brézé* or *Mirabeau devant Dreux-Brézé* (Mirabeau's protest against the dismissal conveyed to the general assembly by Louis XVI through the marquis de Dreux-Brézé, or Mirabeau before Dreux-Brézé). See cat. no. 38

Plate 5. Tony JOHANNOT, *Sophie sauvée du torrent* (Sophie rescued from the torrent) from *The Vicar of Wakefield*. See cat. no. 75A.

Plate 6. Tony JOHANNOT, *Le Coup de fusil* (The gunshot) from *The Vicar of Wakefield*. See cat. no. 75B.

Plate 7. Tony JOHANNOT, *La Diseuse de bonne aventure* (The fortune-teller) from *The Vicar of Wakefield*. See cat. no. 75C.

Plate 8. Tony JOHANNOT, *Départ de Moïse pour le marché* (Moses's departure for the fair) from *The Vicar of Wakefield*. See cat. no. 75D.

5

Plate 9. Tony JOHANNOT, *Vengeance* (Revenge) from *The Vicar of Wakefield*. See cat. no. 75E.

Plate 10. Tony JOAHNNOT, *Olivia retrouvée* (Olivia found) from *The Vicar of Wakefield*. See cat. no. 75F.

Plate 11. Tony JOHANNOT, *L'Incendie* (The conflagration) from *The Vicar of Wakefield*. See cat. no 75G.

Plate 12. Tony JOHANNOT, *Le Départ pour la prison* (The departure for prison) from *The Vicar of Wakefield*. See cat. no. 75H.

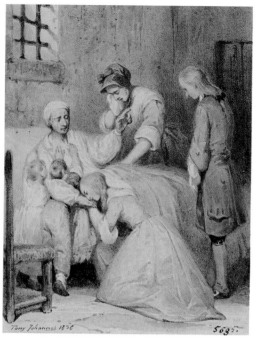

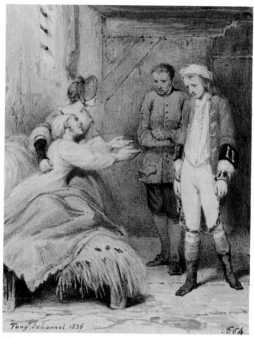

Plate 13. Tony JOHANNOT, *La Visite dans la prison* (The visit in prison) from *The Vicar of Wakefield*. See cat. no. 75I.

Plate 14. Tony JOHANNOT, *Georges prisonnier* (Georges as prisoner) from *The Vicar of Wakefield*. See cat. no. 75J.

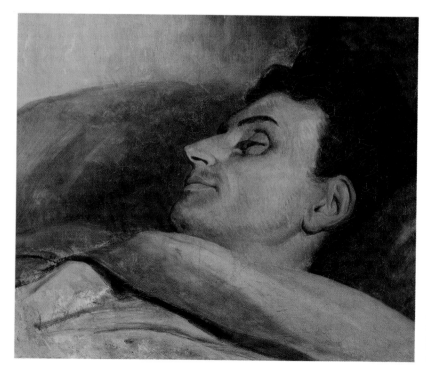

Plate 15. Ary SCHEF-FER, *Armand Carrel sur son lit de mort* (Armand Carrel on his deathbed). See cat. no. 76.

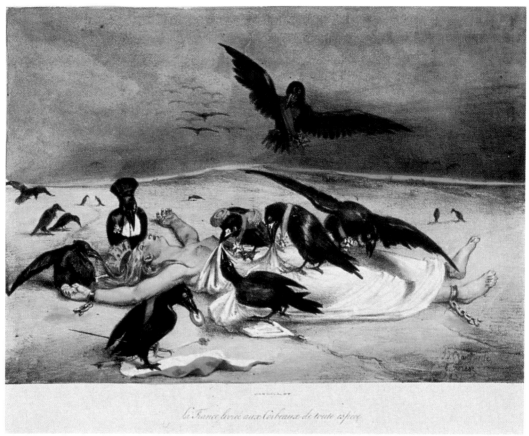

Plate 16. Jean-Ignace-Isidore GRANDVILLE, *La France livrée aux corbeaux de toute espérance* (France, robbed of all hope by the crows). See cat. no. 94.

8

Plate 17. Charles Joseph TRAVIÈS, *M. Mayeux* (Monsieur Mayeux). See cat. no. 105.

Plate 18. Jean-Ignace-Isidore GRANDVILLE, title page from *Les Fables de La Fontaine,* New York, The New York Public Library, Spencer Collection. For additional illustrations from another copy of this book, see cat. no. 74 and Figure 8–7.

Plate 19. Jean-Ignace-Isidore GRANDVILLE, *Scènes de la vie privée et publique des animaux* (Scenes from the private and public lives of animals), New York, The New York Public Library, Spencer Collection. For additional illustrations from another copy of this book, see cat. no. 113 and Figures 8–9 and 8–14.

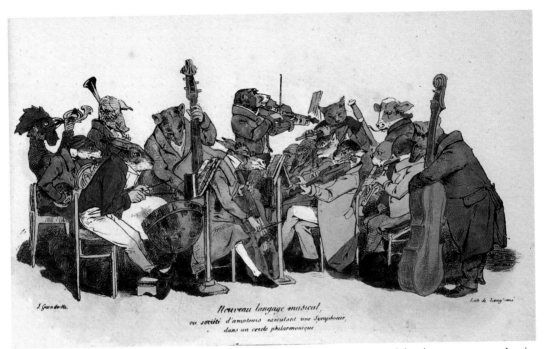

Plate 20. Jean-Ignace-Isidore GRANDVILLE, "Nouveau langage musical ou société exécutant une symphonie dans un cercle philharmonique" (New musical language or society performing a symphony in a philharmonic circle), from *Les Métamorphoses du jour, ou les hommes à têtes de bêtes* (Modern metamorphoses, or men with animal heads). See cat. no. 112.

Plate 22. (facing page, lower left) Merry-Joseph BLONDEL, *Portrait of a Man.* See cat. no. 137.

Plate 23. (facing page, lower right) Théodore CHASSÉRIAU, *Le Souvenir* (The memory). See cat. no. 140.

94 UNE ÉCLIPSE CONJUGALE.

qui n'est, à vrai dire, qu'une représaille de la morale.

C'est grande fête aujourd'hui dans le ciel. Si vous n'avez
pas la vue courte, vous devez certainement voir les Signes

PÉRÉGRINATIONS D'UNE COMÈTE.

Plate 21. Jean-Ignace-Isidore GRANDVILLE, pp. 94–95 from *Un Autre Monde* (Another world). See cat. no. 114.

12

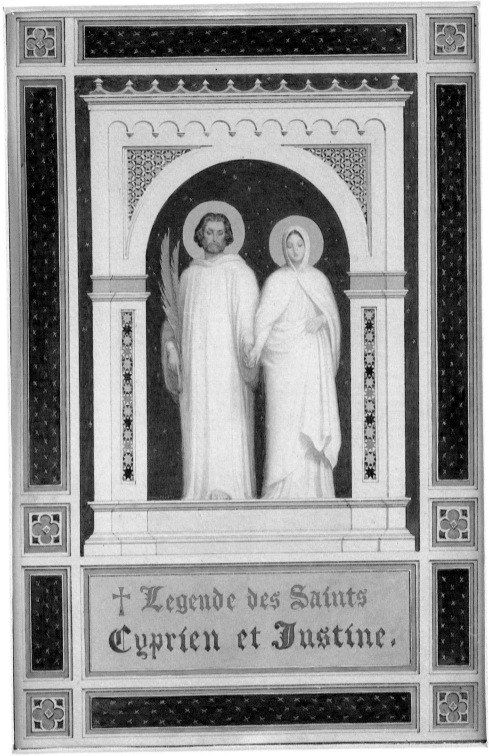

Plate 24. Dominique Louis PAPETY, *Saint Cyprien et Sainte Justine.* See cat. no. 141A.

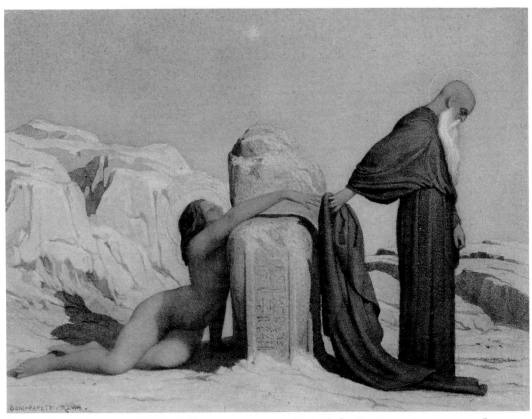

Plate 25. Dominique Louis PAPETY, *The Abbot Zosimas Hands His Cloak to Saint Mary.* See cat. no. 142B.

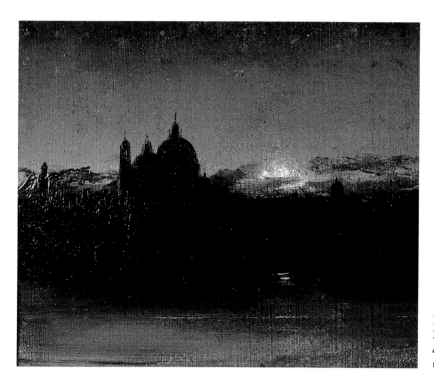

Plate 26. Jules-Claude ZIEGLER, *Venise vue de nuit* (Venice seen by night). See cat. no. 131.

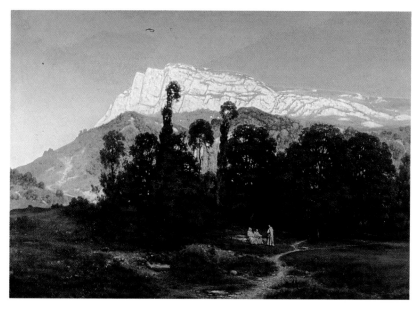

Plate 27. Jean-Alexis ACHARD, *Environs de la Grande-Chartreuse* (The surroundings of the Grande-Chartreuse). See cat. no. 165.

Plate 28. Philippe-Auguste JEANRON, *Les Petits Patriotes* (The little patriots). See cat. no. 144.

Plate 29. Philippe-Auguste JEANRON, *Une Scène de Paris* (A scene of Paris). See cat. no. 146.

1 AN INTRODUCTION TO THE HISTORY

Anyone interested in learning more about the art produced in France during the July Monarchy (1830–1848) would do well to heed the advice once offered by the great historian Jules Michelet: "Before the play begins, observe the theater."[1] It seems appropriate to begin this introduction to the history of the period with a line from Michelet, whose stormy career made him a Parisian celebrity during the same brief era. Because this complex eighteen-year span of nineteenth-century French history is not generally well known, even in France, we will concentrate here on answers to three basic questions: What was the July Monarchy? What was France like then? Why did the July Monarchy fail?[2]

A second level of commentary on these questions is provided in the extended captions for the illustrations that accompany this essay. In each instance I have attempted to connect a specific example of the art of the July Monarchy with the broader history of the time at which it was created.[3] Indeed, as Michelet's remark reminds us, every historical text (whether a play, a painting, or a political oration) comes more fully to life in context.

1. Jules Michelet, *Histoire de France jusqu'au XVIe siècle,* 17:143.
2. The best general work in English is Hugh Collingham, *The July Monarchy: A Political History of France, 1830–1848.* It is available in a paperback edition and has an extensive bibliography. A recent French summary of the period is by André Jardin and André-Jean Tudesq, *Restoration and Reaction, 1815–1848.* Jardin has also written an excellent study of a central figure of the period, *Tocqueville: A Biography.*
3. The best single book on the art of the July Monarchy remains Léon Rosenthal's *Du romantisme au réalisme: Essai sur l'évolution de la peinture en France de 1830 à 1848,* which was first published in 1914. It was republished by Editions Macula in Paris in 1987, with a new introduction (in French) and bibliography by Michael Marrinan. Marrinan is the author of *Painting Politics for Louis-Philippe: Art and Ideology in Orléanist France, 1830–1848.*

Question 1
What Was the July Monarchy?

There are four ways to answer this question, each emphasizing a different aspect of the political regime that governed France from the end of July 1830 until the end of February 1848. Rather than imagining them as roads leading off in separate directions, we might better think of them as members of a string quartet. A single melody—the Orleanist compromise—can be heard at different times from all four instruments.

The July Monarchy was, first of all, the name contemporaries gave to the reign of Louis Philippe I, who holds the distinction of being the only French monarch to come to the throne as the result of a popular uprising against his predecessor. He had been born under the Old Regime in 1773. His father, the duc d'Orléans, was a cousin of the Bourbon King Louis XVI, although this did not prevent him from being elected to the Convention and voting for his former majesty's execution. The Orléans family served the Revolution in its early stages. In the fall of 1792, for example, Louis Philippe (then called the duc de Chartres) fought as an officer in the important French victories at Valmy and Jemapes. He was forced to flee for his own safety when his father was guillotined during the Terror, however. With this bloody event Louis Philippe inherited the title of duc d'Orléans and became head of a branch of the (by then deposed) royal family.

Louis Philippe returned to France after the restoration of the Bourbon monarchy in 1814 and played an appropriately detached role as a member of the court outside the line of succession to the throne. Although he had visited

the United States during his years in exile (a subject on which he was known to speak at boring length), he also dutifully married a Neapolitan princess and participated in the lavish coronation ceremony that Charles X (Louis XVI's youngest and most reactionary brother) staged for himself in the Cathedral of Reims in 1825. Five years later, when a Parisian uprising on 27–29 July 1830 chased the king from the throne, a small band of political leaders (a mixture of peers and deputies opposed to Charles X and aged veterans of the Revolution of 1789 such as Talleyrand and Lafayette) turned to the duc d'Orléans to preserve the monarchy. This was a desperate act, taken because these men believed that the *Trois Glorieuses,* the "Three Glorious Days," as the rebellion was popularly called, presented a truly critical situation that must be controlled lest it lead to civil war. Most of all they feared the establishment of a republic, which they associated with the Terror of 1793–1794. Nevertheless, the "July Revolution," as the rapid switch in ruling families in the summer of 1830 was also described, gave the new and unanticipated Orleanist regime its name: the July Monarchy. (See Figures 1–1 to 1–4.)

"Louis Philippe was accepted, for want of anything better and for fear of something worse."[4] Alexis de Tocqueville's later assessment of the situation in July 1830 is probably accurate, but this does not mean there was no opposition afterward (see Figure 1–16). Early in his reign the new monarch was known to stroll the sidewalks of central Paris virtually unattended, wearing a business suit and carrying an umbrella. In this period he also wore a tricolored cockade in his hat to symbolize his link to the July Revolution. They called him the Citizen King, and he reviewed the National Guard, a patriotic citizen's militia, which cheered him. The mood did not last

long, however. Louis Philippe had commissioned a monument to those who lost their lives in the *Trois Glorieuses* to be built on the site of the Bastille (which had been demolished in 1789). When the July Column was completed, however, he was hesitant to attend the dedication ceremony for fear of being booed by the Paris crowd. By the end of the 1830s, the Citizen King was intent on forgetting his revolutionary origins, and having them forgotten by the public as well. (See Figure 1–3.)

Louis Philippe was not a weak man, and having unexpectedly become "king of the French" in 1830, he set out to rule. In foreign policy he played an active role in the improvement of French relations with the ancient enemy England. There was a much publicized exchange of royal visits with Queen Victoria and her family during the July Monarchy, events that set anglophobes such as Michelet to grinding their teeth with anger. Charles X had invaded Algeria just before the July Revolution, but it was Louis Philippe who sent his sons to fight there (see Figures 1–7, 1–8, and my comments on Plate 1), and it was during his reign that the conquest of North Africa began to send waves of Napoleonic nostalgia through the French body politic. Tocqueville, for example, was an enthusiastic supporter of development there by French colonists. In domestic matters Louis Philippe was principally interested in fulfilling the terms of the Orleanist compromise: he (and his heirs) had been given the right to rule France in return for performing the task of maintaining order. His downfall came when he miscalculated the altered terms of this arrangement in February 1848 (see Question 3).

Louis Philippe ultimately must be judged an unsuccessful king because he failed to found a dynasty, although the Orleanist cause suffered a tragic accident that may have made it impossible for anyone to do so under the circumstances (see Figure 1–8). In any case, he

4. Letter to Gustave de Beaumont (22 April 1838) in Roger Boesche, ed., *Alexis de Tocqueville: Selected Letters on Politics and Society,* 129.

does not deserve to be treated as a comic figure by historians. During his reign Louis Philippe escaped several attempts on his life, including one attack by a device the press called "the infernal machine," a group of rifles linked together to fire like a machine gun, which killed members of the royal party riding on horseback down a boulevard in the middle of Paris. He also survived riots and insurrections in 1831, 1832, and 1834, as well as a failed revolutionary conspiracy—the first in history—in 1839. Early in his reign he was the butt of what are now considered masterpieces of the art of caricature, the lithographs of Honoré Daumier, Jean-Ignace-Isidore Grandville, and other artists who abused and mocked him in commercial prints until censorship was imposed in September 1835. Opposition newspapers (until they, too, were silenced) also accused him of selling out the liberating spirit of the Revolution of 1830 to the forces of political repression. But he survived it all for nearly eighteen years, we should recall, and only fell when he had resisted change too long.

Our second answer is that the July Monarchy can also be described, this time in legal terms, as France's third and last attempt at constitutional monarchy since the Revolution of 1789. The other two had ended violently, moreover. After the Revolution, Louis XVI had accepted the limitations of a constitutional monarchy. Then, in August 1792, a militant crowd stormed the Tuileries Palace, slaughtered the king's Swiss Guard, and toppled Louis XVI at a moment when France was being invaded by foreign troops intent on imposing a counterrevolution. There was plenty of evidence that the king was in correspondence with the enemy; he was tried and executed in January 1793. A Bourbon monarch, Louis XVIII, was restored when Napoleon was defeated by the combined Great Powers of Europe in 1814, but only after agreeing to accept a written constitution called the Charter. In July 1830, it was a widely

perceived violation of the Charter of 1814 by Louis XVIII's successor, Charles X, that provoked a spontaneous rebellion by the people of Paris. This caused the king to flee the capital and eventually to abdicate. In the meantime, Louis Philippe was given temporary ruling power and then invited by the Chamber of Deputies to become "king of the French," the title Louis XVI had accepted in 1791, as opposed to "king of France," as earlier monarchs had been called. Louis Philippe was required, however, to swear an oath to defend a revised constitution called the Charter of 1830. (See Figures 1–1, 1–3, and 1–4.)

The Charter of 1830 was the July Monarchy's founding document and also the regime's claim to having been a classic form of nineteenth-century constitutional "liberalism." For example, the Charter of 1830, in contrast to that of 1814, specified that the king was "without the power ever to suspend the laws or to dispense with their execution." "Legislative power," moreover, was to be "exercised collectively by the king, the Chamber of Peers, and the Chamber of Deputies." The Charter of 1830 guaranteed freedom of religion (the Charter of 1814 held Catholicism to be the official faith), it promised equality before the law to all citizens, and it declared private property to be "inviolable." The Charter of 1830 also stated that censorship could "never be reestablished," but this provision was suspended in September 1835 in order to silence the government's enemies and (according to the official version) to complete the restoration of domestic tranquillity, which had been disturbed by the July Revolution. This ruthless official campaign continued for more than five years after the *Trois Glorieuses*. Hundreds of lives (many of them innocent ones) were lost in the process, if not as many as those who had died bringing about the opportunity to revise the charter in the first place. Opponents of the regime such as Michelet called the open violation of the Charter of 1830 by the very

men who wrote it "the ruin of July."[5] Indeed, during the debate in the Chamber of Deputies on reintroducing censorship, Michelet's fellow historian and political enemy, the cabinet minister François Guizot, supported the special legislation on the grounds that too much freedom of speech was a dangerous thing. The legal spirit of the July Monarchy, he noted, was "hostile to absolute principles, to consequences pushed too far."[6]

There was a difference in mid-nineteenth-century France between being called a "liberal" and being called a "democrat." Among the most revealing portions of the Charter of 1830 are the provisions that cover election to the Chamber of Deputies. The men who wrote the statutes considered themselves reformers because they lowered the age for voting from thirty to twenty-five and that for being a deputy from forty to thirty. The voters and politicians of the July Monarchy are often portrayed as old men (see Figure 1–5), but one of the first things they did in 1830 was to lower the average age of the group. They also sought to increase their numbers by lowering the property-tax qualifications for voting that existed in the Charter of 1814 from 300 to 200 francs, and reducing from 1,000 to 500 francs the amount of taxes it was necessary to have paid to serve as a deputy. The number of French voters rose from under one hundred thousand to nearly two hundred and fifty thousand with the Charter of 1830. At the time, the supporters of the Orleanist compromise congratulated themselves on sharing power within a greatly expanded *pays légal,* which was what a legally separate minority (about 3 percent) of adult males who had a direct voice in French politics during the July Monarchy was called. In retrospect, their fatal error was an unwillingness to consider legisla-

tion further expanding the circle of those eligible to vote in the early 1840s, once the regime had achieved stability and the economy was prosperous. Such action would have broadened support for the Orleanist compromise. Instead, the only way to become a voter remained, in Guizot's immortal phrase, to "Get Rich." By February 1848, as we shall see, the political odds on electoral reform were vastly greater. In fact, the Charter of 1830 did not survive the fall of Louis Philippe, and the constitution of the succeeding Second Republic included a provision for universal male suffrage.

The third answer to our question, which once appeared so simple, is that the government of the July Monarchy was commonly referred to as the *juste milieu* (see Figure 1–2). This is a slippery term whose meaning shifted over time and among its users. It was Louis Philippe himself who coined the phrase when he told a delegation in January 1831 that "with regard to domestic policy, we shall seek to hold to a middle way (*juste milieu*), equally distant from the abuses of royal power and the excesses of popular power."[7] Originally the "middle way" between the absolutism of the Bourbons and the rule of the people was to be the political balancing point on which the Orleanist compromise rested. It was this sense of the term that painters such as Horace Vernet represented in their treatment of Louis Philippe as an artistic subject (see Figures 1–4 and 1–18). The *juste milieu* was never intended to be an evenhanded approach toward the opponents of the government, however. The early years of the July Monarchy, dominated by the rise of Adolphe Thiers, were stormy (see Figures 1–2 and 1–5). After 1835, political and social order brought foreign and domestic investment, and in the early 1840s the economy began to expand rapidly. This, in turn, led to prolonged political success by prime

5. Jules Michelet, *Journal,* 1:657.
6. François Guizot, *Histoire parlementaire de France, recueil complet des discours prononcés dans les Chambres de 1819 à 1848 par M. Guizot,* 2:444.

7. Cited in Collingham, *The July Monarchy,* 108–9.

minister François Guizot (see Figure 1–5), Thiers's rival for leadership, who increased his influence in the Chamber of Deputies with a victory in the general elections of August 1846, the last to be held before the Revolution of 1848. By then the term *juste milieu* had become political shorthand for an entrenched majority, and a coded formula for government by the wealthy.

This leads to our fourth and final answer: both the opponents and the supporters of the July Monarchy called it a "bourgeois monarchy." On this point, at least, they were able to agree. We need to learn more about what they meant, however, for the term can easily lead to a misunderstanding of the character of French society at the time (see Question 2). Let us start at the top. In his *Recollections,* Alexis de Tocqueville described the king as "the accident that made the illness fatal." He continued:

> What was peculiar to Louis-Philippe was the analogy, or rather the consanguinity, between his defects and those of his age; it was this that made him an attractive prince, but one who was dangerous and corrupting for his contemporaries, and particularly for the class that held the power. Placed at the head of an aristocracy, he might have had a happy influence on it. At the head of the bourgeoisie, he pushed it down the slope that by nature it was only too inclined to go.[8]

The July Monarchy was a "bourgeois monarchy" because it rejected privilege as a political principle and replaced it with wealth and reputation. The July Revolution, in fact, ended an attempt by a powerful group of ultraroyalist aristocrats (led by Jules Armand Polignac, the adviser to Charles X) to turn the clock back. During the July Monarchy the old saying (attributed to Napoleon) that the Revolution of 1789 had "opened careers to talent" was once again the order of the day. Under the

Charter of 1830, for example, membership in the Chamber of Peers ceased being hereditary. The elected officials of the July Monarchy represented the most prosperous portion of the nation, aristocrats and notable commoners alike. Some members of the nobility withdrew from political life and went into internal exile, tending their farms and businesses. Others, such as Tocqueville, campaigned for election among the *pays légal* of their provincial districts and represented rural interests in Paris. The percentage of cabinet ministers of aristocratic origin who held office during the July Monarchy was actually higher than the percentage of those who rose to prominence in banking, commerce, or industry. The absence of special privilege was the primary reason that contemporaries called it a "bourgeois monarchy." It was a self-proclaimed plutocracy.

The government of the July Monarchy also deserved the title because it clearly behaved in a manner that benefited the French middle classes, that varied mass of individuals who could be described as belonging to the bourgeoisie. It did so by proclaiming that it stood for economic liberty as it sent the army and the National Guard to shoot down striking workers, declaring their guilds and unions illegal. It did so by filling the Parisian and provincial bureaucracy with "bourgeois" lawyers, bookkeepers, and clerks, the pension-seekers so familiar in the world of Balzac's novels (see Figure 1–10). And it did so by promoting profitable enterprises. As Tocqueville noted, by the 1840s, "the government . . . took on the features of a trading company whose every operation is directed to the benefit that its members may derive therefrom."[9] The "bourgeois monarchy" at its height was also associated with significant economic change and development. It was an era of industrial revolution.

8. Alexis de Tocqueville, *Recollections,* 8.

9. Ibid., 14.

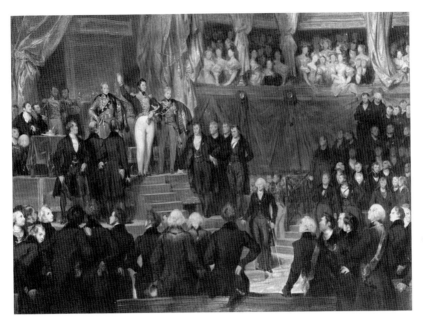

Figure 1–1. Eugène-
François-Marie-
Joseph DEVÉRIA,
*Le Roi Louis-Philippe
prêtant serment . . .*
(King Louis Philippe
taking the oath . . .).
See cat. no. 2.

Charles X abdicated on 2 August 1830, and the reign of his successor formally began with an unprecedented ceremony held a week later. The artist Eugène Devéria captured the climax of the event in this painting, which was purchased by the king after it was exhibited at the Salon of 1831. This oil sketch, which had been unsuccessfully entered in a competition for a painting to redecorate the Chamber of Deputies after the July Revolution, represents the precise moment when Louis Philippe vowed, "In the presence of God, I swear to observe faithfully the Constitutional Charter, with the modifications set forth in the declaration; to govern only by the laws and according to the laws; to have justice done to each according to his rights, and to act in all things uniquely for the interest, happiness, and glory of the French people."

In contrast to a coronation in the Cathedral of Reims, where French kings had been crowned for more than a thousand years, Louis Philippe stood in the Chamber of Deputies, bareheaded, sounding like a man agreeing to uphold a contract. And, in the deepest sense, he was. His oath not only signified the negotiated settlement of a profound political crisis, it was also meant to end the threat of civil war. The "declaration" to which the new monarch alluded was a public statement issued by the deputies two days earlier declaring "the throne vacant in fact and law." This was a clear violation of the constitutional settlement of 1815, however, which returned the royal seat to the Bourbons and guaranteed its passage by heredity through the male line.

In proclaiming the throne empty, the deputies were not only seeking to cut the ground from under those who supported a succession by Charles X's grandson (several of the former king's ministers would be tried and sent to prison), but they were also concerned to find an alternative ruler and head off any attempt to establish a republic, which most politicians in 1830 associated with the Terror that followed the execution of Louis XVI in 1793. In addition, some feared radical attacks on private property, while others believed that France was not ready for democracy. In his *Recollections,* Talleyrand explained his switch of allegiance from the Bourbon monarchy to an Orleanist compromise: "I accepted it, I clung to it as to an anchor sheet, and I served it energetically; for if this government fell, I saw nothing before us but another Republic, and the terrible consequences that would entail—anarchy, a revolutionary war, and all the other evils from which France had been rescued with so much difficulty in 1815."

Thus, one reading of Devéria's canvas is that it depicts a carefully staged legal ceremony designed to cover up the fact that the July Monarchy was not only illegitimate in origin but also the result of an

unplanned and unexpected Parisian uprising. The Orleanists were never very comfortable with these facts, and this helps explain why Louis Philippe later commissioned Devéria to create a large-scale

version of this scene to hang in the Château of Versailles. By focusing on the moment of the king's oath, the artist had created an alternative vision of the birth of the July Monarchy.

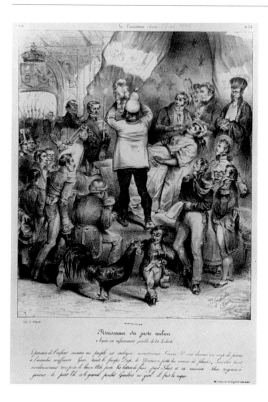

Figure 1–2. Jean-Ignace-Isidore GRANDVILLE, *Naissance du juste milieu* (Birth of the *juste milieu*). See cat. no. 96.

Devéria (see Figure 1–1) specialized in works about the beginning of new royal lines. His first great success came in the Salon of 1827 with a major history painting of *The Birth of Henry IV*. It is this work, well known at the time, to which Grandville alludes in his lithograph. Three elements are particularly worthy of attention for a historical reading of the complex caricature. First, Grandville reverses our perspective on the central scene as it was originally presented in Devéria's painting. Rather than facing the viewer in order to display the genitalia of a new male heir, Louis Philippe (looking very unregal) and the infant *juste milieu* show us their backsides. In the context of its first appearance (in Philipon's famous journal of political satire and commentary, *La Caricature*), this was

likely intended to represent the way ordinary French citizens were being excluded from the Orleanist monarchical compromise from the start.

Grandville's portrayal of Liberty is the second element of historical interest in this coded image (a concept that Gabriel Weisberg explores elsewhere in this book). The caption informs us that she has suffered giving birth to a fat child (who thus resembles his father), and this is confirmed by the look in her eye. But what else is she saying by her pained and exhausted gaze? The caricaturist has placed the answer on the sheet of paper that lies under her hand: "27, 28, 29" refers to the *Trois Glorieuses,* the three-day July Revolution of the people of Paris. Thus, *Naissance du juste milieu* is also (indirectly, at least) a commentary on a second painting, Delacroix's *Le 28 juillet: La Liberté guidant le peuple* (28 July: Liberty leading the people; Figure 1–3), which Grandville probably saw a few months earlier in the Salon of 1831. The strong woman of the July barricades has become a royal prisoner, held captive by the cabinet ministers and army generals who surround her bed. And, from the looks of the medical instruments in some of their hands, they mean to continue violating Liberty.

The third element is the minidrama going on in the foreground, directly in front of the viewer and outside the central action. In Devéria's *Birth of Henry IV* the small male figure was a dwarf dressed as a court jester, accompanied by a parrot and a dog. Only the leather sack remains in Grandville's caricature, and even then he has filled it with the *juste milieu*'s gold and hung it on the shoulder of Adolphe Thiers, an ambitious, young (and very short) politician and journalist considered a turncoat by many of his former friends after he became a cabinet minister of the July Monarchy. A few days before this work appeared in the window of Philipon's print shop on 2 February 1832, Thiers's old newspaper the *National* had come out against him by declaring itself in favor of a republic. In Grandville's commentary, Thiers has been given a large knife and leads the Gallic cock out of the scene. His menacing gesture leaves no doubt about the reason for the bird's evident alarm.

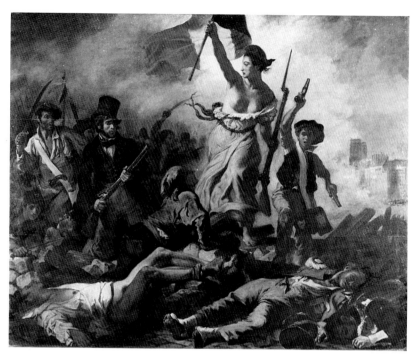

Figure 1–3. Eugène DELACROIX, *Le 28 juillet: La Liberté guidant le peuple* (28 July: Liberty leading the people). Oil on canvas, 1830. Paris, Musée du Louvre.

There were twenty-three paintings inspired by the July Revolution of 1830 in the Salon of 1831, and most of them were more along the lines of Delacroix's famous barricade scene than they were like Devéria's *Le Roi Louis-Philippe prêtant serment . . .* (Figure 1–1). There was also little doubt at the time that *Le 28 juillet: La Liberté guidant le peuple* was the greatest, as well as the most controversial. One critic suggested that the artist had "found his models among the rabble rather than among the true people" and described Liberty as "no more than a soiled and shameless woman of the streets." Another said the painting had "a new poetry" in it "which I might call cruel; a kind of deviltry, if you like, as in Hugo and Paganini." A third called the canvas evidence that Delacroix was one of the great painters of the century. Yet another focused on the artist's evident intention to paint an allegory about the reappearance of Liberty, the female figure who represented the French Revolution of 1789 in popular memory. She had not been seen in public since the restoration of the Bourbons. From 1815 to 1830 the fleur-de-lis had once again been the official symbol of the nation.

The July Revolution unleashed a flood of memories of the Revolution of 1789. In the early mo-ments of the July Monarchy people turned to the revolutionary symbols they remembered and that gave meaning to the 1830 events. Delacroix's allegorical goddess of the people carries a tricolored flag, for example, and another tiny one is visible on the tower of Notre-Dame in the background. A *tricolore* was actually planted on that lofty spot on 28 July 1830; when Charles X's advisers saw the flag of the French Revolution through a telescope, they knew that the fighting in Paris had taken a serious turn. From 1815 to 1830 the flag of France had been the white banner of the Bourbons.

This work was purchased by the minister of the interior (in charge of domestic policy) in 1831 and hung for a time in the Luxembourg Museum before it was removed by orders of the director of fine arts. In 1839, it was returned to the artist, who considered dismantling the huge canvas. The government's embrace and subsequent rejection of this great painting is explained by the fact that in the late 1830s Louis Philippe was openly distancing himself from his revolutionary origins (in part by removing art commemorating the July barricades) and seeking to fan the popularity of the heir to the throne, the duc d'Orléans (see Figure 1–7).

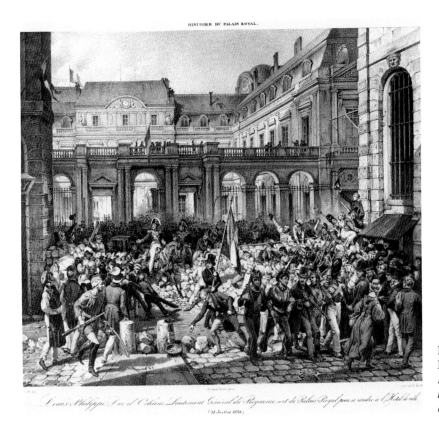

HISTOIRE DU PALAIS ROYAL.

Louis Philippe Duc d'Orléans Lieutenant Général du Royaume sort du Palais Royal pour se rendre à l'Hôtel de ville
(31 Juillet 1830)

Figure 1–4. Bernard Romain JULIEN, *Louis Philippe Leaving the Palais Royal.* See cat. no. 1.

This lithograph is taken from a painting by Horace Vernet, which was shown in the Salon of 1833. It depicts Louis Philippe leaving the Orléans family's ancestral home in Paris after the end of the fighting in 1830 to go to the Hôtel de Ville, the city hall, which had been the site of popular authority during the Revolution of 1789. Once there, he received the acclamation of the crowd, but only after General Lafayette, the aged hero of the American and French revolutions, went out on a balcony and embraced the next ruler of France, while the two of them were draped in a tricolored flag. Indeed, in Vernet's painting Louis Philippe is already being led by the *tricolore*.

Along with the figure of Liberty and the tricolored flag, the third revolutionary symbol to return with the Revolution of 1830 was the "Marseillaise," the forty-year-old song that had been

France's national anthem before the restoration of the Bourbons in 1815. "And the music that was there then," recalled the composer Hector Berlioz in his memoirs about the atmosphere in Paris in the aftermath of the July Days, "the songs, the harsh voices resounding through the streets—nobody who did not hear it can have an idea what it was like." Each night crowds gathered under the windows of the Palais Royal to sing the "Marseillaise," and Louis Philippe would go out on his balcony and beat time for the citizens' chorus. When questioned by Guizot about the wisdom of this behavior (both men's fathers had been guillotined during the Terror), the man who was soon to take the oath as monarch is reported to have replied, "Do not concern yourself, Minister. I stopped saying the words long ago."

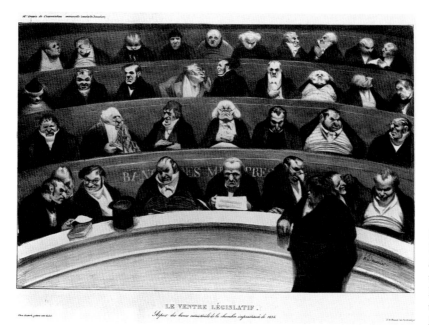

LE VENTRE LÉGISLATIF.
Aspect des bancs ministériels de la chambre improstituée de 1834.

Figure 1–5. Honoré DAUMIER, *Le Ventre législatif* (The legislative paunch). Lithograph, 1834. Baltimore, The Baltimore Museum of Art.

One of Daumier's greatest early works, this famous caricature depicts the members of the Cabinet during a session of the Chamber of Deputies. Among the radical (that is, republican) opposition to which the artist belonged, this scene represented the Heart of Darkness of the *juste milieu*. Indeed, the full caption may be translated as "The legislative paunch: Aspect of the ministerial bench in the prostituted chamber of 1834." It appeared in a series of twenty-four lithographs published by Charles Philipon, whose entrepreneurial talents lay behind the republican satirical journal *Le Charivari*. In this case, the venture was sponsored by the legally separate *Association Mensuelle,* which sold fine prints to subscribers for a franc each as a means of raising money to defend *Le Charivari* in court. Both the journal and its artists were often in trouble with the law in the early years of the July Monarchy. (Daumier had already gone to prison for a particularly outrageous image of the king as a gross Gargantua devouring the taxes of the poor and defecating financial benefits onto his already prosperous supporters.) The men depicted as the "legislative paunch" were all in favor of commerce, but they were not amused by such use of art. In September 1835, they would impose government censorship on the display and sale of images.

Daumier in this period became a student of the faces depicted in this work. He attended sessions of the Chamber of Deputies in the first years after the July Revolution and watched the cabinet members wheel and deal as they sought to impose what they called "Order" on France. He modeled their heads out of clay (these works have now been given a place of honor in the Musée d'Orsay in Paris), and he drew separate portraits of them. Then he produced this remarkable group *portrait chargé.* Evidence of the perspicacity of the artist's political vision can be found by looking closely at the only real "action" going on in the lithograph.

On the left in the front row Guizot is showing a piece of paper to Thiers, whose hat is perched on the rail. Perhaps this paper is a draft of the Law on Associations, a controversial piece of legislation proposing to ban all unauthorized associations with more than twenty members, which the Cabinet would propose to the deputies the next month. In any case, their conversation is being closely watched by a dark, portly figure standing outside the ministerial bench on the right. This is Dr. Prunelle (Daumier called him "Dr. Prune"), who was both a member of the Chamber of Deputies and the mayor of France's second city, Lyon. As minister of the interior, Thiers was in charge of the prefects, the central government's chief administrators throughout France. About this time Thiers wrote: "It is not easy to be prefect in Lyon when M. Prunelle is the mayor." The two men were on a political collision course when Daumier made them the dramatic poles of his scene.

Shortly afterward, the Chamber of Deputies passed the Law on Associations. The result was a violent uprising (three hundred deaths) in Prunelle's Lyon, as well as smaller revolts in Paris and other cities. (Daumier's lithograph *Rue Trans-nonain* [Figure 7–13; cat. no. 101] commemorates the innocent victims of government troops in Paris during the April 1834 troubles.) Mayor Prunelle was busy being Deputy Prunelle when his city

exploded. Angered when the minister of the interior requested that he remain in Paris while the prefect and the army took charge, Prunelle submitted his resignation as mayor, only to have it accepted to his chagrin. Thiers gave him the job back eventually, but Dr. Prune was made to ask for it formally. After that, the mayor of Lyon seldom was seen leaning on the ministerial bench.

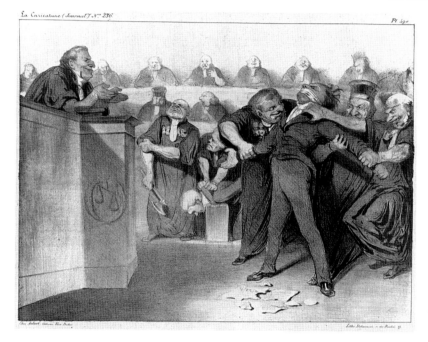

Figure 1–6. Honoré DAUMIER, *Vous avez la parole, expliquez-vous, vous êtes libre!* (You have the floor, explain yourself, you are free!). See cat. no. 98.

Even were we to ignore its caption, Daumier's lithograph of a defense lawyer being restrained and muzzled by the agents of a crooked judge (note the tipped scales) stands by itself as a powerful protest against the *juste-milieu*'s campaign to silence the republican opposition in 1835. This was a central theme of his art at this time. In this case, the context is the so-called *Procès monstre,* the controversial Mass (or Monster) Trial of the leaders of the April 1834 uprisings, which began in Paris on 5 May 1835. The judges were the peers of France sitting as a high court to hear charges of crimes against the state. Specifically, Daumier alludes to the peers' decision to arrest two newspaper publishers who had printed, and a group of republican deputies who had signed, a letter proclaiming that "the infamy of the judge makes the glory of the accused." Press censorship was imposed four

months later with the passage of the September Laws.

The three-phrase caption also deserves our attention, principally because it is so difficult to translate accurately. The second and third phrases ("explain yourself, you are free!") are clear, but the initial ("Vous avez la parole") represents something more than a loose translation such as "Go ahead" or "You have the floor" can fulfill. Literally one would say "You have the word," and that is what the entire work (the image and caption read together) is actually about. For the republicans (and for the *juste milieu*) the dispute over the government's attempt to restrain free speech was a test of the meaning of the July Revolution itself. To have "la parole"—the printed, as well as spoken, word—was to have language itself, and with it the ability to speak directly to the people. That is why

the government used the occasion of an assassination attempt on the king to present legislation controlling the press. In September 1835, the *juste milieu* legally denied its political opponents access to "la parole," even at the cost of violating the Charter of 1830.

The repressive Press Laws also regulated images. Article 20 stated: "No design, no engravings, lithographs, medals and stamps, no emblem of whatever nature and kind may be published, exposed, or put on sale without preliminary authorization of the ministry of the interior." Curiously, this censorship of art was also a matter of "la parole." As the minister of justice proclaimed, "When opinions are converted into actions by the circulation of drawings, it is a question of speaking to the eyes. That is something more than the expression of an opinion; it is an incitement to action." After September 1835, French caricaturists were obliged to avoid direct commentary on political issues.

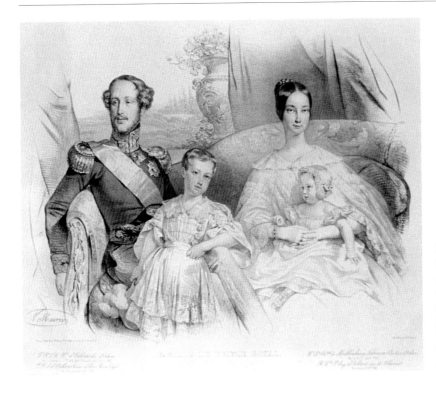

Figure 1–7. Nicolas-Eustache MAURIN, *La Famille du prince royal* (The family of the prince royal). Lithograph, undated. Washington, D.C., The Library of Congress.

Louis Philippe was fifty-six years old when the Orleanist monarchy began in 1830, but the heir to the throne was only twenty. Taking his father's former title as the duc d'Orléans, the prince royal was known for his taste in contemporary art and music (Louis Philippe preferred the style of his own late-eighteenth-century youth) and was thought to be more politically progressive than the king. France had invaded Algeria in 1830, shortly before the fall of Charles X, and one of the first foreign-policy decisions made by Louis Philippe was to continue the military campaign. The duc d'Orléans served as an officer in Algeria in 1835, and he made the improvement of conditions for French troops in North Africa a personal program after his return to Paris. His national popularity was demonstrated on an official tour of France in 1839, when he was even cheered in areas where the legitimist supporters of Bourbons were usually vocal in their opposition to the Orleanist settlement. Charles de Rémusat, one of the most experienced political hands of the July Monarchy, thought that the duc d'Orléans was the most qualified man in France to become king.

"More princely in that he does not want to assume airs," as one person described him, the duc d'Orléans remained unmarried (and with a reputation as something of a rake) until 1837. In that year

he was wed to Princess Hélène de Mecklembourg-Strelitz, whom he never laid eyes on until she arrived in France for the ceremony. In spite of the odds presented by this diplomatically arranged dynastic union, the marriage proved to be a success, and the future queen, now called the duchesse d'Orléans, was accepted by the political establishment. Their first child, a boy who received the title comte de Paris, was born in 1838. This event was an occasion for public celebration. Alfred de Musset called the infant prince "that final offspring of an ancient race, that firstborn of a glorious revolution."

Maurin's lithograph of the duc d'Orléans and his family is an example of one of the ways that art was used to promote public support for the July Monarchy. A domestic icon, this fine multiple was likely meant to be framed and hung in private homes. Its impact, in part, may have been to remind restless members of the bourgeoisie that a bright future lay ahead.

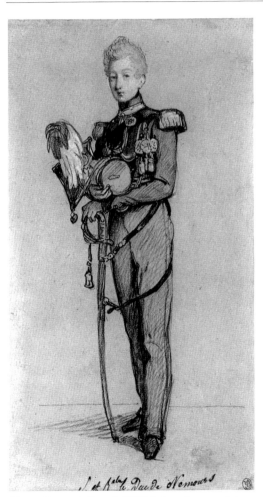

Plate 1. François-Joseph HEIM, *Son altesse royale le duc de Nemours* (His royal highness the duc de Nemours). See cat. no. 12.

Louis Philippe once described his second son, the duc de Nemours, as "a born archduke." Only fourteen when his father became king, Nemours was frequently compared unfavorably to his older brother. "The appearance of the duc d'Orléans was noble, that of the duc de Nemours was nobiliary," commented the exiled German poet Heinrich Heine. In 1836, Nemours followed his brother to Algeria and distinguished himself in the otherwise bungled French expedition to take the city of Constantine. In Heim's drawing from this period young Nemours is presented as a military figure, a member of the royal family who had earned his sword fighting for Orleanist France. Like the duc d'Orléans, Nemours married a German princess, but his was from the more prestigious house of Saxe-Coburg.

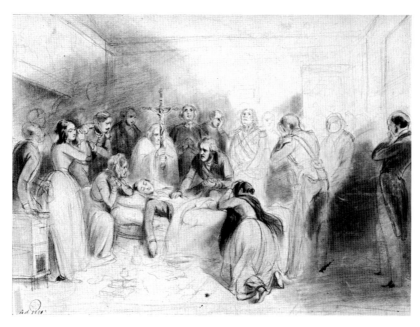

Figure 1–8. A. PROVOST, *Derniers moments du duc d'Orléans après l'accident de Neuilly, le 13 juillet 1842* (The last moments of the duc d'Orléans after the accident at Neuilly, 13 July 1842). See cat. no. 14.

This small drawing records a tragic and largely forgotten turning point in the history of the July Monarchy. On 13 July 1842, the duc d'Orléans died of a fractured skull a few hours after a bizarre traffic accident on the outskirts of Paris. Here Provost depicts the scene in the back room of a grocer's shop, where the prince royal was carried after he had leapt from his carriage and struck his head on a cobblestone. His parents, the then sixty-nine-year-old king and his Neapolitan queen, are at the head of the bed on which the dying man is stretched, while his wife, the duchesse d'Orléans, and brother, the duc de Nemours, are at its foot. The duc d'Orléans was buried after a funeral mass in Notre-Dame, and a funerary chapel was built on the site of the accident. It was decorated with stained-glass windows designed by Ingres and a copy of a statue of an angel made by the prince royal's late sister, Marie d'Orléans.

With the sudden and unexpected death of the duc d'Orléans, his son the comte de Paris became the heir to the French throne. The question then arose over whether his mother should be asked to serve as regent (if, as was likely, the occasion arose) until the five-year-old child reached maturity. Louis Philippe favored Nemours, however, and made an impassioned speech on his behalf to the Chamber of Deputies and the Chamber of Peers, which claimed the constitutional right to decide the matter. Drawing on the reservoir of public pity over his deep and genuine grief, the king prevailed with his preference, the stiff and conservative Nemours, but only after having to listen to deputies such as Tocqueville lament being asked to support "the blind accident of birth" over "the judicious choice of the powers of the State." The majority's case against the duchesse d'Orléans, in addition to the facts that she was foreign born and a woman, was that she was too acceptable to the political opposition.

After July 1842, in the final third of the reign of Louis Philippe, the prospect of a Nemours regency hung over the July Monarchy like a wet blanket. Nemours himself was a renowned pessimist and became convinced well before February 1848 that the Orleanist dynasty was doomed.

Question 2
What Was France Like Then?

The July Monarchy was the start of France's
Steam Age, a period when steam technology,
much of it imported from England, began to
transform perceptions of space and time (the
steamboat and the railroad), material culture
(the powerloom for weaving cloth), and the
circulation of words and images (the mecha-
nized printing press). The number of steam
engines in France rose from six hundred in
1830 to five thousand in 1847,[10] and contem-
poraries were powerfully aware of the changes
they portended.[11] Indeed, the July Monarchy
has never received sufficient acknowledgment
for setting the stage for the major economic
boom of the 1850s and 1860s, for which the
Emperor Napoleon III was happy to take
credit. Nevertheless, in two fundamental
ways, France before 1848 was more like it had
been at the end of the eighteenth century than
like it would be by the beginning of the twen-
tieth.

In 1846, only a quarter of France's 37.5
million population lived in cities of more than
ten thousand people, and 60 percent of all
French citizens still directly depended on agri-
culture for their existence, while many more
persons lived providing services in market
towns and villages. Small plots abounded,
sharecropping was common, and the few
wealthy landowners (the sort of men who were
voters and served as deputies) lamented over
the difficulty of convincing "the peasants," as
they called them, to abandon traditional farm-
ing methods and adopt new technologies in
order to improve production and profits. The
rural population of France was at its height
in the years just before midcentury. In 1846,
there was a potato blight and then a major

failure of the grain harvest. This resulted in
scattered famine and widespread hunger. It
even led to violence against grain merchants,
millers, and bakers who were seeking to profit
from the scarcity of bread by raising prices. In
December 1848, French rural voters took the
opportunity offered by the absence of elec-
toral restrictions to give the old emperor's
nephew, Louis-Napoleon Bonaparte, a land-
slide victory as the first (and only) president of
the Second Republic. During the second half
of the nineteenth century the great exodus
from the countryside to the cities would be-
come a major theme of French social history.

In a still predominantly rural nation,
France's major cities were for the most part
preindustrial places during the July Mon-
archy. Rouen was an exception, with its tex-
tile factories and ironworks (some of them
English-owned), but most French steam-
mechanized industry was concentrated in the
small towns of Alsace or in coal-mining vil-
lages far from Paris. This pattern is like the
one seen earlier in England, where the indus-
trial revolution took place in the north, far
from London, and proceeded to transform
British society from there. In any case, French
towns and cities before 1848 were not dis-
tinctively "bourgeois" in character, at least in
terms of numbers. Historians have estimated
that in Paris, a city of a million persons, only
one hundred and fifty thousand would have
been described by others as being "bour-
geois." Instead, the vast majority was made up
of traditional artisans and shopkeepers (who
lived comfortable lives when their customers
had money, and might even belong to the
National Guard), the working poor (jour-
neyworkers, day laborers, and pieceworkers),
and the indigent. It was widely perceived in
the crime statistics of the period that the last
group was growing faster than the others.
Contemporaries called them *les misérables.*
They fascinated Parisians, who read every-
thing from government reports to novels

10. Philippe Vigier, *La Monarchie de juillet,* 40.
11. On this subject, see David H. Pinkney, *Decisive
Years in France, 1840–1847,* and Christopher H. Johnson,
"The Revolution of 1830 in French Economic History."

about them and still argued about whether the unemployed poor got what they deserved or were victims of society. Similarly, the Chamber of Deputies studied the question of prison reform for years but never was able to agree on legislation.

By 1848, Paris, although not an industrial city, was socially ready to explode. The continued presence of a potentially revolutionary Parisian "crowd"—including (as we shall see in Question 3) those respectable artisans and shopkeepers—is the second way that French society during the July Monarchy resembled the Old Regime more than the Third Republic.

Paris during the July Monarchy began to be the hub of a fledgling national railroad network (see Figure 1–9), but it was already recognized as the cultural center of Europe, the place for international acclaim such as that received by Chopin. Artists, writers, and musicians were drawn from the provinces and abroad to the French capital, which the young composer Richard Wagner called a "world-center, this focal point into which flows the art of every nation, where people everywhere find recognition." In a story he wrote while he lived in Paris between 1839 and 1842, Wagner has the central character exclaim, "Would you have me go to, say, Tunis to make a fortune? No, I've come to Paris! Here I shall find out whether those who said I have talent were deceiving me."[12] It is a familiar modern story, told about a city that had not yet taken on its nineteenth-century "modern" look: the rebuilding of central Paris by Baron Haussmann came in the 1850s and 1860s.

Louis Philippe's Paris was an overgrown medieval city with walls and gates, an inadequate sewer system (the capital's waste went directly into the Seine), and cobblestone streets better suited for building barricades than bearing the load of the new horse-drawn public transportation system. Most of the bridges over the river still had tollbooths on them. The pockets of poverty in the center of the city were heartbreaking, particularly when a cholera epidemic struck in 1832. About nineteen thousand Parisians died in the disaster, which is more persons than the city had eligible voters under the Charter of 1830. One of the victims was the prime minister, a tough banker named Casimir Périer, but most of them lived in the slums, the territory of *les misérables*. The crowding of the Right Bank of central Paris led to urban expansion into new districts, mixed commercial and residential territory for the well-to-do. One of those areas was around the new church of Notre-Dame de Lorette, a neighborhood where shop girls from the women's hat and clothing stores wore smart clothes and walked the streets waiting to be picked up. These *lorettes* remind us that Paris was a terrible place to be a poor young woman during the July Monarchy.

Not all women were poor, however, and increasing numbers of them were the beneficiaries of a consumer revolution that began to stir French society, particularly in the 1840s.[13] "What an immense and powerful consumer the people is when it is engaged," wrote Michelet in *Le Peuple* in 1846.[14] He also saw "a revolution little noticed but a great, great revolution nonetheless." The celebrated historian was pointing out, almost in passing, the fact that France was experiencing the commercialization of significant portions of daily life (see Figures 1–9 to 1–15). Mass consumption still lay in the future, but the July Monarchy saw, for example, the origins of the French

12. Robert L. Jacobs and Geoffrey Skelton, *Wagner Writes from Paris*, 85.

13. For a general introduction, see N. McKendrick, J. Brewer, and J. H. Plumb, eds., *The Birth of a Consumer Society: The Commercialization of Eighteenth-Century England*. For France, see also Valerie Steele, *Paris Fashion: A Cultural History*; Michael B. Miller, *The Bon Marché: Bourgeois Culture and the Department Store, 1869–1920*; and William M. Reddy, *The Rise of Market Culture: The Textile Trade and French Society, 1750–1900*.

14. Jules Michelet, *Le Peuple*, 43–44.

fashion industry (complete with artists like Gavarni), the department store (which specialized in bolts of cloth to be tailored), and the ready-made store (the *boutique*), whose items had been stitched together in sweatshops and embroidered in garrets. This was also the age of Flaubert's Madame Bovary, who dreamed over fashion plates and spent the family savings on clothing and interior decorations such as curtains and spreads. It is seldom remembered, moreover, that Flaubert assigns the Bovary's orphaned daughter to a Rouen textile factory at the end of the novel. France's first Child Labor Act was also passed during the July Monarchy.

A second way that the July Monarchy oversaw the commercialization of daily life was through the development of a print culture.[15] Publishing became an industry, and this, too, was a significant change in the direction of modern society. In a basic sense it was made possible by technological improvements such as the mechanical printing presses that (after 1834) turned some Parisian shops into factories with their ability to raise production from 250 to 3,600 impressions per hour, in part by printing simultaneously on both sides of the page. A majority of the capital's eighty printers still used handpresses by 1848, however. Increased production of printed material (whether an illustrated book, a novel, a newspaper, or a throwaway advertisement) was economically desirable because France was

passing through a cultural revolution in which, for the first time, it became a nation of readers. The July Monarchy is associated with the creation of France's first primary education system (the Guizot Act of 1833), and it was no accident that the country's oldest publishing houses today were founded in this period. The publishers (and editors) commercially separated their functions from their origins as Old Regime printers who sold their work in the front of the shop. New marketing methods were attempted: separate bookstores, newsstand sales, and advertising. Many among those who began to read books regularly were new consumers in the process of shedding the old custom that held that books (if one could afford them) were valuable property. As *juste-milieu* prosperity neared its height, books—or at least cheap booklets—even took on the status of disposable objects. In January 1842 alone fifteen of the tiny works known as *Physiologies* were published in Paris. The *Physiologies* were small, often satirical, illustrated essays on various social types printed in a miniature format. This brief commercial fad is worthy of citation as our final example of what France was like during the July Monarchy for two separate reasons: first, Daumier and Balzac contributed to the fun, and, second, the miniatures sold thousands of copies. France's early Age of Steam—with its fashion plates and *Physiologies*—was also the country's introduction to the Age of the Commodity.

It was in this environment that French art was produced, displayed, bought and sold, and commented upon during the July Monarchy, as more than one unread writer, unseen artist, and unheard musician noted at the time. The hero of Wagner's Paris story died young, poor, and unknown.

15. There is a major new French work on this important subject: Henri-Jean Martin and Roger Chartier, eds., *Histoire de l'édition française,* vol. 3, *Le temps des éditeurs: Du Romantisme à la Belle Epoque.* The transformation of print culture was also evident in the development of a new form of journalism. This subject is discussed in my captions to Figures 1–13, 1–14, 1–15, and Plate 15.

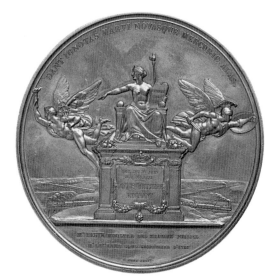

Figure 1–9. J. F. Antoine BOVY, *Medal of Louis Philippe with Allegory of the Establishment of the French Railroad.*
See cat. no. 5.

The law of 11 June 1842 establishing the French railroad system was passed in the same year as a train accident killed forty persons on the short line to Versailles. The controversial new legislation provided government guarantees to private investors, as well as state aid for the construction of a rail network radiating out from Paris. The law of 11 June also sparked a railway boom that attracted investors and was popular with the public. A second railway bill was passed in 1846, promising additional expansion. The father of the teenage artist Gustave Doré, for example, was a state-trained and -paid civil engineer assigned to survey the route of a future line between Lyon and Geneva.

The allegory decorating the back of this official medal minted to commemorate the law of 11 June

1842 (the front has a bas-relief portrait of Louis Philippe in profile wearing a garland in his hair) portrays France not as Liberty but as Juno, a Roman goddess holding a stone tablet carved with a copy of the Charter of 1830. Her scepter is topped with the Gallic cock rather than a revolutionary bonnet as she commands her winged fellow gods with a bold gesture. Mercury, the god of commerce, and Mars, the god of war, fly off to serve her, swift as speeding steam engines. Indeed, during the 1840s writers such as George Sand began to predict that the commercial impact of the railroad would quickly destroy the local customs and traditions that still regulated the culture of most of rural France. Others, such as Tocqueville, were more interested in the railroad's use for a rapid military response in case of an English invasion.

Figure 1–10. Horace VERNET, *Portrait of a Young Woman*. Oil on canvas, 1831. Toledo, The Toledo Museum of Art.

The contribution of women to the art and literature of the July Monarchy (and the social and economic obstacles most of them faced) is a subject that has yet to receive serious and systematic consideration. There are, for example, the novels of George Sand, the essays of the social reformer Flora Tristan, the paintings of the young Rosa Bonheur, and the sculpture of the Princess Marie d'Orléans to be studied. The July Monarchy also saw the origins of a small French feminist movement, or "the emancipation of female thought" as it was then called. An early leader, Claire Demar, warned her sisters away from the romantic idea of "love at first sight." As she observed:

I have the misfortune of not believing in the spon-

taneity of [this] feeling, or in the law of irresistible attraction between two souls. I do not believe that from a first meeting, a single conversation, can result certainty, on all points, and (I believe) it is not until a long and mature self-examination, serious thought, that it is permissible to admit to oneself that at last one has met another soul that complements one's own, that will be able to live its life, think its thoughts, mingle with the other, and give and take strength, power, joy, and happiness.

Demar contended, "It is by the proclamation of the LAW OF INCONSTANCY that women will be freed; it is the only way." Horace Vernet's portrait of a young woman gives only the merest suggestion of whether its subject might have supported this radical proposal for free love. The careful presenta-

tion of proper bourgeois costume, down to the
pretty gloves, renders it unlikely. Her very ano-
nymity makes it just as possible to imagine that she
attended convent school with Flaubert's character

Emma Bovary, who certainly could have benefited
from Demar's advice. Madame Bovary, one may
recall, commits suicide at the end of the novel after
a series of unhappy extramarital affairs.

Figure 1–11. Sulpice-
Guillaume Chevalier,
called Paul GAVARNI,
*Portrait d'Hippolyte
Beauvisage Thomire.*
See cat. no. 135.

In this watercolor Gavarni portrays an individual whose father was an industrialist and whose older brother was a distinguished professor. From the looks of him, Hippolyte Beauvisage Thomire had a keen eye for fashion in casual clothing, however. He represents the new generation of bourgeois consumers that emerged during the July Monarchy. He is the modern young man off the newly invented fashion plates and out of the cast of Balzac's *Human Comedy*.

Charles Baudelaire, the great cultural critic of Louis Philippe's reign in latter years, called the artist Gavarni "the poet of official *dandysme*." *Dandysme,* Baudelaire said (in his famous essay "De l'héroisme de la vie moderne" [The heroism of modern life], which appeared in his review of the Salon of 1846), was "a modern thing." By this he meant that it was a way for bourgeois men to use their clothing as a costume in order to stand out from the respectable, black-coated crowd in an age when aristocratic codes were crumbling and democratic values had not yet fully replaced them.

The dandy was not Baudelaire's "modern hero," however. "The black suit and the frock coat not only have their political beauty as an expression of general equality," he wrote, "but also their poetic beauty as an expression of the public mentality." That is why Baudelaire worshiped ambitious rebels, men who disguised themselves by dressing like everyone else. "For the heroes of the *Iliad* cannot hold a candle to you, Vautrin, Rastignac, Birotteau [all three were major characters in Balzac's novels] . . . who did not dare to confess to the public what you went through under the macabre dress coat that all of us wear, or to you Honoré de Balzac, the strangest, most romantic, and most poetic among all the characters created by your imagination," Baudelaire declared.

Figure 1–12. Jean-Ignace-Isidore GRANDVILLE, "La Mode" (Fashion), from *Un Autre Monde* (Another world). See cat. no. 114.

This full-page wood engraving from Grandville's masterpiece, the illustrated book *Un Autre Monde,* was published in 1844. This was at the peak of the boom years of the July Monarchy, and the commercial revolution in men's and women's clothing was being widely felt, particularly in Paris. The subject here is Fashion, an elegant goddess turning the wheel of time and displaying changing styles in men's and women's hats. On the facing page, in the text accompanying this allegory, the artist's collaborator, Taxile Delord, comments on the crowd of men gathered at Fashion's feet. He calls them by the different names they have had since the end of the Old Regime—"Muscadins, incroyables, dandys, fashionables, lions"—and points out the common quality they share: "They are always the same ridiculous types under their changing clothes." Nevertheless, this fancy-dressed band had created an entire industry: "Tailors, Bootmakers, Cravatmakers, Corsetmakers, Clothers, Vestmakers are all creators of high works of fashion." Fashion, moreover, is represented by Grandville as a gigantic woman as threatening as she is alluring: "Feminine dictator, absolute queen, she travels with an entourage of followers and executioners. Today anyone may become their victim," wrote Delord.

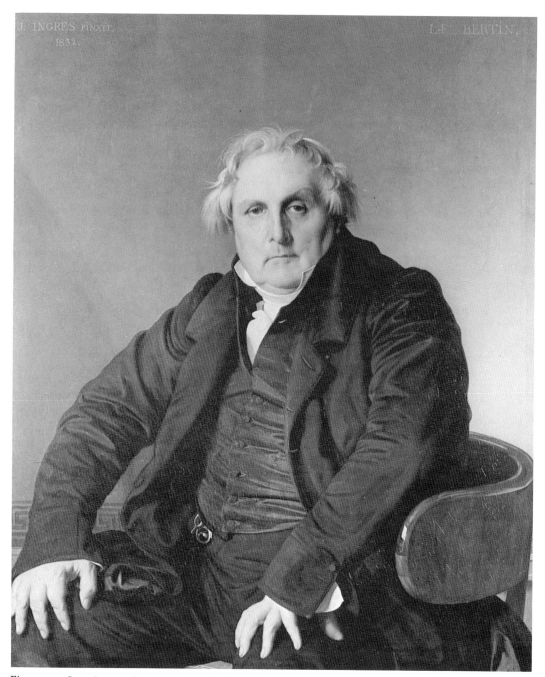

Figure 1–13. Jean-Auguste-Dominique INGRES, *M. Bertin.* Oil on canvas, 1832. Paris, Musée du Louvre.

Louis-François Bertin (1766–1841) was already known as Bertin the Elder by the time Ingres painted this famous portrait of him soon after the July Revolution. Along with his brother, Bertin was the publisher and principal owner of the *Journal des Débats*, a prominent Paris newspaper that had rallied support for Louis Philippe and the Orleanist compromise. Monsieur Bertin was not always so stern in private, for Casimir Périer and Guizot (both prime ministers of the period) used to amuse themselves by playing whist in the publisher's office while he corrected proofs for the next day's edition. Here Ingres has captured the public face of a man who holds political power in his hands.

The *Journal des Débats* was particularly influential among the *haute bourgeoisie* (that is, the wealthy) and was also known for the excellence of its critics: the composer Hector Berlioz, for example, wrote on music. In 1837, the staid *Débats* startled its subscribers by beginning to print a daily dollop of potboiler fiction in order to increase sales by appealing to a wider readership. In 1842–1843, it published Eugène Sue's serial novel *Les Mystères de Paris*, an adventure set among the lowlife of the capital, which became the best-seller of the period. The Bertins were shrewd businessmen who knew how to change with the times.

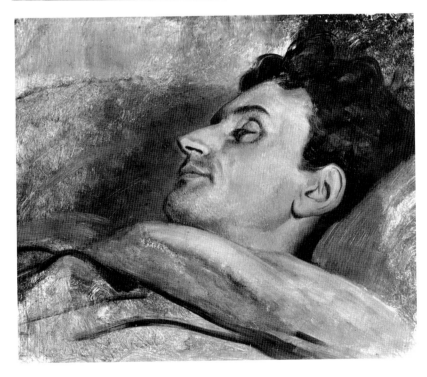

Plate 15. Ary SCHEFFER, *Armand Carrel sur son lit de mort* (Armand Carrel on his deathbed). See cat. no. 76.

Armand Carrel (1800–1836) was another famous journalist of the July Monarchy. Unlike Monsieur Bertin, however, he never tasted power. Instead, he died young—killed in a duel, no less. Contemporaries read significance into this tragic event. In Ary Scheffer's painting of the dead Carrel, the editor retains his handsome looks and shows little sign of the suffering he endured as he lay dying with a bullet in the stomach for two days. David d'Angers's bust of Carrel (Plate 2) is a representation of his friend and fellow republican worthy of a pantheon of the political opposition. And Gustave

Flaubert later recalled that during his youth in Rouen in the late 1830s, some of his schoolmates fantasized growing up to be like the fallen prince from their hometown, Armand Carrel.

Carrel's following among the young and the left was built on his reputation for political and journalistic integrity, as well as the consciously passionate and romantic figure he cut for himself. A founder-editor (along with Adolphe Thiers) of *Le National* just before the Revolution of 1830, Carrel refused high government office from the *juste milieu* and later broke openly with the Orleanist compro-

mise. *Le National* became France's leading republican newspaper, and Carrel was often fined and even jailed for his opinions. When the Press Laws of 1835 imposed censorship they threatened the very existence of his paper.

Unlike Bertin the Elder, Carrel was not a very sensible businessman, however. He opposed new advertising methods and editorially condemned the corruption of journalism, which he believed should continue to confine itself to serious commentary on politics and society. In 1836, this led to a challenge to a duel from Emile de Girardin, the father of the new commercial journalism, who objected to *Le National*'s implication that lowering newspaper prices and increasing circulation were somehow dishonest practices. Carrel's death at the hand of Girardin was also interpreted as the martyrdom of an idealist opposed to the pervasive atmosphere of materialism. He was a Lost Hero of the Orleanist era.

Figure 1–14. Jean-Ignace-Isidore GRANDVILLE, from *Un Autre Monde* (Another world), p. 272. See cat. no. 114.

This vignette from the illustrated book *Un Autre Monde* is a ringing commentary on the consumer revolution and the commercialization of authorship during the July Monarchy. The appropriate portion of Taxile Delord's text, a loose dialogue that amounts to a running list of contemporary criticisms, begins on the previous page:

"Conscience has become a commodity. . . ."
"Morality has deserted private and public life. All votes smell of corruption. They sell them cheap, like mushrooms, outside the stock exchange."
"Thought is now like a machine."
"Writing has become mechanical."
"Literature comes off a bolt like silk or cotton."

"The novel and the serial are sliced up in literary factories like cake on the counter of a pastryshop."

Then we come to Grandville's amusingly literal illustration, which portrays an author cranking out prose while a publisher cuts it up for sale, wielding his knife as professionally as a pastry chef. Grandville and Delord were making a serious point with this humor, however. The page is reminiscent, in fact, of Sainte-Beuve's then famous attack on what he called "industrial literature" in his essay "De la littérature industrielle" in the *Revue des Deux Mondes* in 1839. Sainte-Beuve's charge was aimed at Emile de Girardin, the entrepreneurial newspaper publisher who had killed Armand Carrel in a duel (see my comments on Plate 15). In particular, Sainte-Beuve deplored how the new journalism ignored true talent and took financial advantage of its ability to make or break literary careers. How can you honestly review a book if you also have accepted money to advertise it on the same page, he asked. Many successful authors rushed to defend Girardin from Sainte-Beuve's criticism that the old journalism of conviction was giving way to commerce. Balzac, who had been well paid to publish a novel in Girardin's newspaper *La Presse*, was at the head of the pack.

It is well to remember, nonetheless, that the same age that experienced the appearance of "industrial" or "mechanical" literature was also the era that saw the rise of a Left Bank counterculture opposed to commercial values. Contemporaries such as Henry Murger called it "Bohemia" after a land that was considered romantic and faraway. We are reminded of the title of Grandville's book: the Paris bohemians inhabited another world.

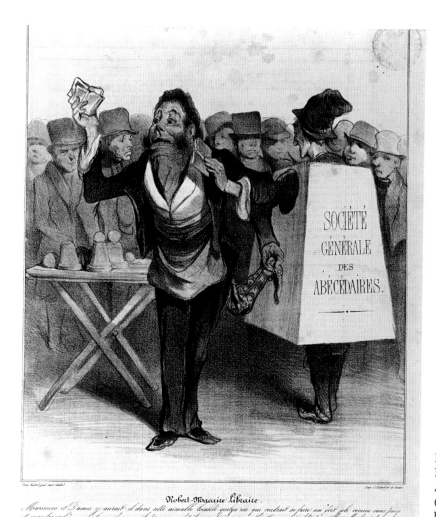

Figure 1–15. Honoré DAUMIER, *Robert Macaire libraire* (Robert Macaire bookseller). Lithograph, 1836. Los Angeles, The Armand Hammer Foundation.

This lithograph appeared in *Le Charivari* in November 1836, shortly after the death of Armand Carrel. It is the fourteenth in a series of 101 representations that Daumier drew of a character called Robert Macaire. Macaire was originally the comic creation of a popular actor, Frédérick Lemaître, who played him as a lovable lowlife scoundrel out of melodrama. It was Daumier who turned Robert Macaire into a symbol of the times, however, a figure who represented the vices of the bourgeoisie the way Don Juan embodied those of the aristocracy: with gusto. Even foreign residents of Paris recognized what was at work in Macaire's character. The poet Heinrich Heine spoke of the

"Robert Macairisme" of the July Monarchy. In a well-known passage from *Class Struggle in France,* an account of the Revolution of 1848 written for an American newspaper, Karl Marx wrote: "The July Monarchy was nothing more than a joint stock company for the exploitation of the French national wealth, the dividends of which were divided amongst ministers, chambers, 240,000 voters and their adherents. Louis-Philippe was the director of this company—Robert Macaire on the throne."

In this particular lithograph, Robert Macaire and his assistant Bertrand are booksellers hawking their wares on the sidewalk. They claim to be promoting literacy, and, indeed, the cheap volumes

they are selling are aimed at the swelling numbers of new readers in France. After the passage of a national primary-education law (the Guizot Act of 1833), the newly literate, particularly school children, became a significant market for reading materials of all kind. In the same year, 1833, Louis Hachette (age thirty-three) founded his publishing house specializing in books for young readers. In 1835, the year before Daumier created this scene, Hachette received a government contract for half a million copies of his primer, the *Alphabet des écoles.* Little wonder that the caricaturist shows Robert Macaire trying to cash in on the commercial promise of the fledgling textbook industry.

Question 3
Why Did the July Monarchy Fail?

The July Monarchy ended when Louis Philippe abdicated on 24 February 1848 in an attempt to end a growing insurrection in the streets of Paris that was threatening to spread to other cities. The man who had unexpectedly come to the throne as a result of the July Revolution of 1830 became the last king to rule France when he was unable to pass the throne to his young heir, the comte de Paris, whose father, the popular and respected duc d'Orléans, had been killed in a carriage accident nearly six years earlier (see Figures 1–7, 1–8, 1–18, and my comments on Plate 1). With shooting still going on outside the chamber and crowds clamoring from the galleries, the deputies had no interest in supporting an Orleanist regency headed by the duc de Nemours. The duc d'Orléans's widow failed in her last-gasp effort to be named regent for her son, and the July Monarchy was over. The Revolution of 1848 turned France once more into a republic.

The failure of the July Monarchy was not inevitable, as few things are, but historians are in general agreement about why it happened. The origins of the February Days of 1848 can be traced back to 1846, when Prime Minister Guizot increased his control over major policy decisions as the result of a general election for seats in the Chamber of Deputies. Guizot had been prime minister since 1840, and his successful "system" (as he called it) based on favors done and repaid was beginning to reek of corruption (see Figures 1–16 and 1–17). The elections were held in August in the midst of what proved to be accurate predictions of a disastrous harvest soon to follow. At the peak of their political power, the supporters of the Orleanist compromise panicked when grain prices doubled in the first half of 1847. Borrowing heavily on the gold reserves of the Banque de France, the government bought expensive grain abroad in order to keep Parisians (and the residents of other cities) in cheap bread and out of food riots at home. There was a better harvest that fall, but the damage had already been done. France entered the winter of 1847–1848 in the midst of a serious economic crisis.

"The hallmark of the old bourgeoisie was security, and that is what the new one lacks above all," wrote Michelet in *Le Peuple* in 1846.[16] Soon after, the Banque de France responded to the government's grain loans by raising its lending rates to 5 percent. This burst the bubble of speculation on which the Robert Macaires of the world had been floating (see Figure 1–15), and which had also allowed the Guizot ministry to sustain its popularity among the restricted world of French voters (two hundred and fifty thousand out of a population of 37.5 million). Some fledgling French railroad companies were forced to sell Banque shares in order to raise capital. More than four thousand businesses went bankrupt in 1847. The Banque de France lowered its lending rate to 4 percent in December, ending the second phase of the economic crisis. The third phase was fully evident in the cold early

16. Michelet, *Le Peuple,* 63.

months of 1848: unemployment became heavy, particularly in Paris. It strongly affected such major artisanal trades as building and ready-made tailoring that depended on the commercial investment of capital and hired large numbers of journeyworkers for day labor and piecework. Two-thirds of the construction workers in the capital were unemployed when the February uprising began, for example. They were just the sort of brawny men who could build stout barricades.

It is fair to say, at least in part, that the Revolution of 1848 was the result of a chain of economic setbacks that over time produced grumbling citizens and, eventually, an insurrection. The triggering event—the "accident" one always looks for in revolutions to explain their violent start—occurred on the evening of 23 February when someone shot at soldiers stationed in front of Guizot's headquarters on the boulevard des Capucines, located in the fashionable heart of the capital of Europe. The guards returned fire with a volley that killed fifty people on the spot. During the night, as news of the massacre spread, a cart filled with the victims rolled slowly through the streets displaying the grisly evidence. Paris exploded with fighting at dawn the next day, and the king had already abdicated and was leaving the Tuileries Palace by noon. In spite of the fact that the general placed in charge of the military situation had polished his tactics fighting in Algeria, the reign of Louis Philippe ended quickly on the morning of 24 February 1848—and with it the Orleanist compromise as well.[17]

The only thing wrong with the explanation given above is that it omits an essential fact: the crowd gathered outside Guizot's headquarters on the evening of 23 February was there to celebrate his fall from power. This fall

had been too long in coming, however. The second principal reason for the failure of the July Monarchy is political miscalculation by the king and the prime minister, beginning with the aftermath of the election of 1846 and extending down to the moment before the massacre on the boulevard des Capucines itself. The two men share the responsibility for stubbornly refusing to admit that political change was necessary. Louis Philippe made it clear in his annual throne speech in January 1848 that he intended to support Guizot's leadership no matter how loudly his detractors might raise their voices. When a serious crisis developed in February, moreover, the king still refused to seek the resignation of his suddenly unpopular prime minister.

One of Guizot's bold and challenging acts at the end of 1847 had been to sack Michelet as professor of history at the Sorbonne for producing books that were considered too favorable to the Revolution of 1789 and lectures that were too popular with his impressionable students. If this example is evidence of how conservative the prime minister (who was himself a distinguished historian) had become, his gravest miscalculation was the decision to remain deaf to every voice calling for lowering the economic restrictions on voting in order to increase the size of the electorate. Guizot believed this would undermine the political stability of the *juste-milieu* position (see Question 1). He even ignored the warning signal that came from *Le Siècle,* the daily newspaper read by the small shopkeepers and master artisans who made up the bulk of the regiments of the National Guard. The editor complained that the "little man" was still excluded from full political participation in spite of nearly two decades of willingness to serve in the National Guard and defend the July Monarchy, as had happened several times in the 1830s. By this time *Le Siècle*'s readers were also feeling the effects of the economic crisis, and

17. A summary of recent scholarship on the February Days of 1848 is found in Mark Traugott, "The Crowd in the French Revolution of February, 1848."

nine thousand of the fourteen thousand voters in the capital had already registered their opposition to Guizot's intransigence in the 1846 general elections.

A political "reform movement," as it was called, had begun shortly after the 1846 election as a dangerous gamble on the part of Guizot's enemies to arouse public opinion on the issue of expanding the *pays légal* by means of a rousing campaign of political banquets, where speaker after speaker denounced the prime minister as the symbol of the repressive status quo. Some of the banquets in the provinces were attended by thousands of ticket holders.

The "reform" campaign, at first an effective means of symbolic politics, got out of hand at the start of 1848. On 14 January, Guizot forbade a banquet organized by a group of National Guard officers whose political opinions he felt were too far to the left. The legality of the event, which had been scheduled to take place in Paris on 22 February, was defended in the Chamber of Deputies by a coalition of the prime minister's opponents, who narrowly failed in a vote of no confidence. By the time the awaited date arrived a month later, the forbidden National Guard banquet had become the focus of a mass demonstration by the people of Paris in support of peaceful change. There were plans for workers, National Guardsmen, students, and politicians to march together to the banquet site in solidarity with the cause of "reform." The only problem (this being February in Paris) was that it rained.

The mass demonstration of 22 February never really came off, but there were plenty of people in the streets that day, particularly around the Church of the Madeleine, where the march was supposed to begin. That is when the first cries of *à bas Guizot* (down with Guizot) were heard coming from the throats of uniformed National Guardsmen, and also when Louis Philippe, faced with the potential defection of the militia to an insurrectionary crowd, first thought about finding a new prime minister. It took until the next day, 23 February, for him to turn to Comte Molé, a former prime minister who had been out of public office for years. By then a few barricades had gone up in poorer neighborhoods, but public order had to this point generally been maintained. That evening a crowd gathered outside Guizot's headquarters to cheer the end of the old *juste milieu* and the expectation of an electoral broadening of the Orleanist compromise. Then a shot rang out, and we know what happened after that.

Having learned some of the principal reasons for the apparently sudden failure of the July Monarchy in February 1848, we can appreciate the truth in Tocqueville's comment, recorded in his *Recollections,* that Louis Philippe "was like a man refusing to believe that his house had been on fire because he had the key to it in his pocket."[18] This remark by the most insightful of the king's contemporaries may also be read as an epitaph for the regime itself.

18. Tocqueville, *Recollections,* 14.

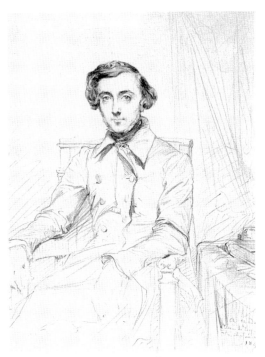

Figure 1–16. Théodore CHASSÉRIAU, *Portrait de Tocqueville.* See cat. no. 26.

Alexis de Tocqueville (1805–1859) was one of the most important intellectual figures of the July Monarchy. This pencil drawing was probably done in preparation for a portrait that Chassériau painted in 1844. The artist has succeeded in capturing the energy and insightful gaze of the small, frail man of thirty-nine. The son of a prominent Old Regime noble who had narrowly escaped the guillotine, Alexis de Tocqueville became a literary sensation at the age of thirty, when the first volume of *De la démocratie en Amérique* (Democracy in America), his account of a visit to the United States during the presidency of Andrew Jackson, was published in 1835. He became a member of the Academy of Moral and Political Sciences and was elected to the Chamber of Deputies in 1839. His firsthand account of the final days of the July Monarchy is recorded in his *Recollections,* which was published in 1893, many years after his death. Tocqueville supported Louis Philippe as a constitutional monarch but believed that democracy was inevitably in France's future. His principal concern was that his countrymen would confuse political with economic equality, rather than demanding that a democratic government defend private property, as he had seen it do in America.

In a speech in the Chamber of Deputies on 27 January 1848—four weeks before the February Revolution toppled the July Monarchy—Tocqueville compared the political situation of the moment to that of France on the eve of 1789. As he put it: "When I come to study what has been, at different times and epochs of history among different peoples, the effective reason why ruling classes have been ruined, I note the various events and men and accidental or superficial causes, but believe me, the real cause, the effective one, that makes men lose power is that they have become unworthy of exercising it." The Old Regime fell, he said, "because the class that was ruling then had, through its indifference, selfishness, and vices, become incapable and unworthy of ruling." Returning to his own day, he asked: "Do you not feel—how should I say it—a revolutionary wind in the air? We do not know whence it comes, or whither it goes, or what it will carry away; and at the same time you remain calm in the face of the degradation of public mores—the expression is not too strong."

Figure 1–17. Thomas COUTURE, *Les Romains de la décadence* (The Romans of the decadence). Oil on canvas, 1847. Paris, Musée d'Orsay.

In his January 1848 speech Tocqueville proclaimed his "profound and fixed conviction . . . that public mores are becoming degraded, and this degradation will lead you shortly, very shortly perhaps, into new revolutions." Indeed, there was much discussion of decadence around this time. In its review of the Salon of 1847, the republican journal *La Réforme* characterized Thomas Couture's history painting as a veiled commentary on the July Monarchy itself. This was not a solitary opinion. High crime and corruption were daily subjects of public debate and gossip: a duke killed his wife and was allowed to commit suicide before coming to trial, a peer went mad and threatened to kill his children, an ambassador slit his own throat, a former minister of war was found guilty of influence peddling, and the sale of public offices was traced to the office of Prime Minister Guizot himself. There were so many public and private scandals in the year before the regime collapsed that one writer sought to restore public confidence at the end of 1847 with the argument that "the number of passengers who fall into the sea presages nothing about the sailing of the ship." Tocqueville gave his speech only a few weeks later.

Couture's monumental canvas hangs today on a central axis of the Musée d'Orsay as a prominent example of *pompier* art from the last Salon held before the Revolution of 1848.

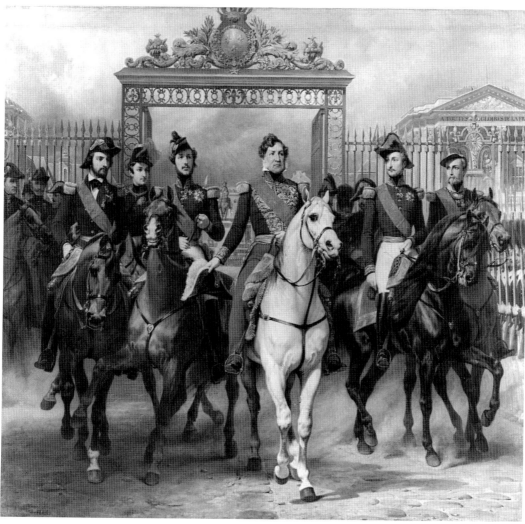

Figure 1–18. Horace VERNET, *Louis Philippe and His Sons Leaving the Palace of Versailles.* Oil on canvas, 1847. Versailles, Musée du Château de Versailles.

As the Citizen King turned into King Louis Philippe the First, he failed to establish much enthusiasm for an enduring Orleanist dynasty. It was not for lack of trying, however. In 1846, for example, the king commissioned Horace Vernet to create this painting, which was shown at the Salon of 1847. The work is historically interesting for two reasons. First, it is set at Versailles, not the Palais Royal (the site of Vernet's earlier painting of Louis Philippe in 1830 [see Figure 1–4]), and represents an attempt to merge the Orléans and Bourbon branches of the royal family into a single monarchical tradition. The tricolor flag of the Revolution

of 1830 has receded into the background, behind a monument to the mighty ruler who built the great château: Louis XIV. The Sun King's statue is visible in the wedge-shaped gap between Louis Philippe and his eldest son, the duc d'Orléans. The fleur-de-lis, the medieval symbol of French monarchy, is displayed on the ornamental gate through which the king and his male progeny have just passed. In 1830, Parisian crowds had torn the fleur-de-lis off the walls of churches and public buildings. Louis Philippe brought it back with this work of art.

The second historical point of interest in Ver-

net's group equestrian portrait is the fact that it includes the duc d'Orléans, who had been killed in a carriage accident in 1842. This, apparently, was done according to the wish of the king himself. The resulting work, therefore, can also be read as a veiled lament over the tragic loss of the heir to the throne, an image in which history is rewritten and the prince royal reappears to ride at his father's right hand. In any case, Louis Philippe was seventy-three years old when this work was first shown, and France faced a prolonged regency lead by the duc de Nemours (see my comments on Plate 1), who is portrayed on his father's left hand. In his 27 January 1848 speech in the Chamber of Deputies, Alexis de Tocqueville dared to ask the difficult question on everyone's mind: "Are the lives of kings supported by stronger threads which are harder to snap than the lives of other men? . . . Do you know what may happen in France a year, a month, or perhaps a day from now?"

These two works from the Salon of 1847, Couture's *Les Romains de la décadence* (Figure 1–17) and Vernet's *Louis Philippe and His Sons,* provide a double commentary on the last months of the July Monarchy. Each of them might bear a final added caption taken from Tocqueville's January 1848 speech: "Gentlemen, my profound conviction is that we are lulling ourselves to sleep over an active volcano."

2 AN INTRODUCTION TO THE ART

When one attempts to write an introduction to a body of works executed during a specific political regime, a question arises immediately as to whether the focus should be simply the most distinguished art produced during that period, or whether priority should be given to works that in some sense "belong" to the regime. By this second formulation is meant art that was officially commissioned by that particular government, or that in some direct way reflected, mediated, or reacted against social, cultural, and economic concerns that occupied a place of primary importance during its rule. In the present survey emphasis will be placed on works that could be said to conform to the latter alternative. This should not be taken to mean, however, that either this choice or the ascription of possession are unproblematical.

Many of the artists featured in this exhibition appear in a caricature by Bertall that was published in one of the major illustrated books of the 1840s (Figure 2–1).[1] At the center of his panoply of figures stand two famous adversaries, Delacroix and Ingres, one supporting a shaggy paintbrush and carrying a sack labeled "law of colors," the other holding a fine-tipped brush in one hand and pointing to the "line of Raphael" on the ground with the other. Around this confrontation between figureheads of the romantic and classical schools, or this clear-cut polarity of painterly theory and practice, other artists, such as Paul Delaroche, Ary Scheffer, and Alexandre Decamps, are placed in attitudes of relative detachment. But in the background, Horace

Vernet, suspended in a bos'n's chair and using both arms and legs to paint a gigantic wall, is completely oblivious to the confrontation below. Of all the personages in this satirical image, it might be argued that Vernet is most representative of the art of the July Monarchy and of the stylistic eclecticism that has been claimed to be one of its defining features.

Léon Rosenthal, in a pioneering book that has shaped our conception of the artistic production of this period, devoted a chapter to the *juste milieu,* singling out Vernet as the most salient example of an artist to whom the term was applicable. According to Rosenthal, artists adopting this "middle way," or golden mean, trod a path between stylistic extremes and were wantonly eclectic in their choice of pictorial methods. As he wielded them, the terms *juste milieu* and *eclecticism* were interchangeable, and both carried undisguised pejorative meanings. They signified a personal failing, a refusal to take a stand or to embrace a well-defined aesthetic position, such as those of Delacroix and Ingres: "While the slightest work of Delacroix or Ingres leads our thought to the personality with which it is impregnated, a piece signed by one of these timid masters can reveal only ingenuity and virtuosity; . . . they often paint well, but never better: they have no 'style.' "[2] For him a *juste-milieu* method of painting produced an absence of "style." Commitment to a well-defined modality of painting in his scheme of values was both a precondition to stylistic integrity and an expression of individuality.

In making this assertion, Rosenthal was simply repeating an argument set forth by a

1. *Le Diable à Paris,* ed. P. J. Hetzel (Paris, 1846), vol. 2. This was an anthology of essays by major writers concerning aspects of contemporary life in France. Bertall was the pseudonym of Albert d'Arnoux.

2. Léon Rosenthal, *Du romantisme au réalisme: La peinture en France de 1830 à 1848,* 203.

La Musique, la Peinture, la Sculpture

Figure 2–1. BERTALL (Albert d'Arnoux), "La Musique, la peinture, la sculpture" (Music, painting, sculpture), from *Le Diable à Paris* (The devil in Paris), vol. 2. Book, 1846. Providence, Brown University.

renowned predecessor, Charles Baudelaire, in his review of the Salon of 1846. The section entitled "Of Eclecticism and Doubt" was a vitriolic attack upon artists of the *juste milieu,* the principal of whom was Baudelaire's nem-

esis Vernet. In his review Baudelaire drew an invidious distinction between those who clearly took sides in the battle of line and color and those who, like Vernet, declined. He further likened eclecticism to a contagious dis-

ease, one caused by doubt, "which is today the primary cause of all morbid affections in the moral world."[3] Baudelaire's conception of progressive art necessarily entailed choice, commitment, and specialization.

What is assumed, but unproved and ultimately unprovable, in the criticism of both Baudelaire and Rosenthal is the idea that refusal to commit oneself to a clearly demarcated stylistic alternative bespeaks individual weakness or unauthentic behavior. Equally dubious are two other assumptions underlying their verdict: that allegiance to a single stylistic modality necessarily made an artist's personality "visible" to the beholder and, more importantly, that the visible presence of the personality of the artist in a work of art is an aesthetic virtue in and of itself. Inasmuch as eclecticism has become an operative procedure in much Postmodern art, the subjective nature of these claims is more easily perceived. But, to put these negative views in better perspective, one might set them in opposition to Bertall's representation of Vernet, in which the painter ignores the aesthetic dispute behind him *because* of his strong-willed individualism and his total absorption in his own art. Regardless of the satirical context of the image, Vernet is presented in a positive light. It thus appears that the question of whether Vernet's art contains the quality of "individualism" or an individual vision hinges upon how the terms are defined.

Although Vernet's eclecticism of formal means was well established before the advent of the July Monarchy, his manner of proceeding was in complete accord with the guiding political theory of the regime that favored him with more patronage than any of his contemporaries.[4] For Louis Philippe and his most

important ministers, the wisest course for a government that wished to stay in power was to attempt to occupy a *via media*, or middle way, between competing political and social ideologies and to promote a representation of the July Monarchy as a regime that encompassed and mediated opposing political positions. This policy was elaborated upon at various times by both François Guizot and Adolphe Thiers, the two most important ministers to serve the government of the July Monarchy, who were inclined to proclaim that the French tricolored flag, readopted with the advent of Louis Philippe, was a symbolic representation of their position in that it contained colors traditionally associated with three distinct political ideologies. This interpretation of the *tricolore* seems implicit in Vernet's depiction of Louis Philippe leaving the Palais Royal for the Hôtel de Ville on 31 July 1830, a royal commission in which the soon-to-be Citizen King follows a very prominent tricolored flag, while around him one sees a crowd composed of members of the various social and professional classes, their differences presumably effaced in the wake of the Revolution of 1830 (see Julien's painting after Vernet, Figure 1–4 [cat. no. 1]).

If it were necessary to select an official philosopher for the July Monarchy, it would undoubtedly be Victor Cousin, who occupied important positions in the government and in the university system and made eclecticism a cornerstone of his philosophical system. Many intellectuals who served the July Monarchy took the theories of Cousin as the philosophical or theoretical underpinning for their political ideology. But an obvious question arises: can one establish a causal or a reciprocal relationship between the stylistic eclecticism of Vernet's art and that of other *juste-milieu* painters in the manner that one can link the political theory of the government and the thought of its preferred philosopher? In response one must consider the fact that eclec-

3. Charles Baudelaire, "Salon de 1846," in *Oeuvres complètes de Charles Baudelaire,* 2:167.

4. For the strongest argument that has been made for the interrelation of political and philosophical eclecticism and the fine arts, see Albert Boime, *Thomas Couture and the Eclectic Vision.*

ticism in the visual arts was hardly a new
phenomenon appearing around 1830; perhaps
the majority of artists since the Renaissance
have been eclectic to one degree or another in
their adoption of painterly means. The strong-
est claim that can be made is that the political
ideology of the July Monarchy fostered, or
provided a nurturing environment for, eclec-
ticism and gave it official sanction. But more
important perhaps than its causes is the *mean-
ing* that was attached to eclecticism in the arts.
For many this modality was simply a pictorial
equivalent to the political philosophy of the
government of Louis Philippe. One instance
of this equation appeared in 1839 in an article
by the editor of *L'Artiste,* a prestigious art peri-
odical that was founded at the beginning of
the July Monarchy and was highly critical of
many of its policies. After stating that the jour-
nal was opposed to those who practiced the
principle of fusion, or "bastard eclecticism,"
the author concluded that "experience has
shown that the *juste milieu* is as impotent in
matters of art as in matters of social doc-
trine."[5]

But Vernet was related to concerns of the
July Monarchy in ways more specific than his
service as an official portraitist of the king or
a shared commitment to eclecticism. This is
another point that is made by the caricature of
Bertall, in which Vernet is not suspended
from a fixed support but is attached to a
steam engine that conveys him across the
pictorial field. The caricaturist's use of this
conspicuous totem of the machine age ap-
pears to refer to a mural painting that Ver-
net was then in the process of completing in
the Salle de la Paix of the Palais Bourbon,
the building that served as the seat of the
Chamber of Deputies.[6] Vernet received his

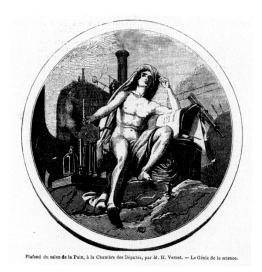

Plafond du salon de la Paix, à la Chambre des Députés, par M. H. Vernet. — Le Génie de la science.

Figure 2–2. Anonymous, after the mural by Horace
VERNET, *Le Génie de la Science* (The genius of Sci-
ence), mural, 1838–1847, Salle de la Paix, Chambre
des Députés, Paris. Engraving, 1847. Providence,
Brown University.

commission for this project in 1838, a year in
which concessions for the construction of rail-
roads were a subject of passionate debate,
and many of the deputies were carried away
by visions of the glorious future this new
invention would usher in, typical of which was
the speech of the director of bridges and rail-
roads in which he proclaimed that, after the
invention of the printing press, railroads rep-
resented the greatest advance in the history of
civilization.[7] In response to this enthusiasm
Vernet broke traditional rules of decorum in
his enormous mural, combining classical fig-
ures and traditional allegorical emblems with
products of the industrial revolution. In one
section of his mural composition, usually
entitled *Le Génie de la Science* (The genius of
Science), a nude allegorical figure is seated in
the foreground, one hand on an air pump, the
other on an anvil, while a modern steam loco-
motive is driven toward a railroad tunnel in

5. Arsène Houssaye, "La Chambre des Députés et les
peintures de M. Eugène Delacroix," 390.
6. On the project, see Robert N. Beetem, "Horace
Vernet's Mural in the Palais Bourbon: Contemporary
Imagery, Modern Technology, and Classical Allegory
during the July Monarchy."

7. Excerpts are quoted in Alfred Picard, *Les Chemins
de fer,* 256.

Figure 2–3. Antoine ETEX, *Projet de monument destiné à être érigé à la place de l'Europe* (Project for a monument to be erected on the place de l'Europe). See cat. no. 119A.

Figure 2–4. Antoine ETEX, *Projet de monument à la place de l'Europe* (Project for the monument on the place de l'Europe). See cat. no. 119B.

the background (see Figure 2–2). If Vernet had been limited to one symbol to characterize the social and economic reality of the July Monarchy, it is doubtful that he could have found a better one. This is a point that probably would have gained the agreement of the poet and critic Théophile Gautier, who in 1846 compared the newly constructed railroad stations in France to its most recent churches, declaring that it was easy to see that the "religion of our century is the religion of the railroad."[8]

Vernet's mural might also be considered the painted equivalent to an architectural monument that was in the planning stages at the time the mural was begun but, for various reasons, was never realized. In 1839 the sculptor Antoine Etex executed a drawing for a monument that would have been a much more conspicuous tribute to the steam engine and the industrial class that was aggressively promoting the expansion of the railway system (Figure 2–3 [cat. no. 119A]). This project was intended to occupy the place de l'Europe in Paris, a site very near the Saint-Lazare railway station, and was to have been a joint undertaking of the state, the city of Paris, and the

Paris–Saint Germain Railroad Company. In Etex's conception of the fountain an allegorical figure of steam, with one hand placed on a smokestack and the other on an anchor, would have been supported by personifications of the forces of nature that it dominates. In a shift from allegory to realism, the bas-relief below the figure of steam would have featured a locomotive and railway cars, the most visible manifestation of this physical force. At some point in the discussion of this project it was decided to change the monument to one that represented Napoleon on horseback traversing a colossal globe, and Etex produced another study for the new conception (Figure 2–4 [cat. no. 119B]). Dedicated to what was thought to be a human incarnation of the dynamic principle, this likewise unrealized project is nonetheless a concrete index of the growing concern with the legend of Napoleon.[9]

In part of Vernet's mural program, adjacent to his representation of the Genius of Science, is another work depicting an allegorical figure of peace enthroned before modern Paris. Behind the beehive, an emblem of industry, is

8. Théophile Gautier, "Inauguration du chemin de fer du nord," *La Presse,* 16 June 1846.

9. On these projects, see Antoine Etex, *Souvenirs d'un artiste,* 324–28.

seen the reality of industrial production in the
guise of two smoking industrial chimneys.
The image of the locomotive and these signs of
industry were closely linked, of course, in that
construction of the railroad lines lowered
transportation costs, stimulated economic
growth, and led to the development of mod-
ern coal, iron, and engineering industries. It
should be noted, however, that while pro-
gressive industrialization may have been a
defining characteristic of economic life during
the July Monarchy, few painters actually dealt
with this aspect of contemporary reality in a
direct way. This points up the fact that while
Vernet's mural may have been most represen-
tative of its time, it was *not* typical of the art of
his contemporaries. This should caution us
against making easy generalizations about the
relations between art and society, or believing
that art necessarily reflects its social context in
a direct and unmediated way. The relative
paucity of visual depictions of the indus-
trialization process does, however, make the
work of artists like François Bonhommé, who
devoted much of his career to chronicling the
process of industrialization at places such as
the ironworks at Fourchambault, all the more
interesting (see Figures 4–5 through 4–8).

In his celebration of the potential of the
steam engine, Vernet may be said to belong to
his time more than an artist such as Delacroix,
whom we place in the artistic avant-garde of
the century and whose dynamic painting
entitled *Le 28 juillet: La Liberté guidant le peuple*
(28 July: Liberty leading the people; Figure
1–3) probably captures the general enthusiasm
that followed the Revolution of 1830 better
than any of its contemporaries. While the
immediacy and emotional intensity of Dela-
croix's famous image capture the spirit of the
moment, one should not infer that he was in
sympathy with the belief in progress of the
industrial bourgeoisie, whom the Revolution
entrenched in positions of power. It is signifi-
cant that Delacroix failed to follow this work

with any other major depictions of contem-
porary subject matter, preferring to seek
material for his pictures for the most part in
history and literature, or in what was thought
to be the timeless and exotic Orient. By the
middle of the century his social views were of
a decidedly conservative cast, but long before
then the modernity in his conception of paint-
ing had become a matter of style and emo-
tional expressiveness rather than of content.
The locomotive came to symbolize not the
excitement of speed and movement, but the
dangers of social change and displacement in
the social order.[10]

Similar sentiments were expressed by
another major figure of the period who oc-
cupied a position in the artistic rearguard.
Victor Orsel was a leader in what, for lack
of a better name, one might call French Pre-
Raphaelitism. This artistic tendency has
received much less attention than related
movements in England and Germany, but it
shared with them the desire to return to prin-
ciples of painting that were predominant in
art prior to the emergence of Raphael. Orsel's
Le Bien et le mal (Good and evil), exhibited at
the Salon of 1833, provides one example of his
manner of combining primitive form and the
principles of academic teaching (see cat. no.
122). Orsel was a confirmed social reactionary,
so his return to the past for inspiration in his
art was in keeping with his world view. Scorn-
ing the religion of the railroad, he was ada-
mantly opposed to the spread of this revo-
lution in transportation, which he perceived
as a conspicuous symptom of the malaise
afflicting contemporary society. This inven-
tion had disrupted the social hierarchy, dis-
turbed the delicate balance between city and
country, and brought with it an invasion of

10. See, for example, an entry in his diary dated 31
August 1857: "This fever for movement in those classes
whose material occupations ought to keep attached to
the places where they earn their livelihood is a sign of
revolt against the eternal laws" (*Journal de Eugène
Delacroix,* ed. A. Joubin, 3:123).

Figure 2–5. Interior view, Salle de Constantine, Musée de Versailles. See also cat. no. 120.

alien ideas: "Morally speaking, the railroad is everywhere, in government, in business, in the family. Society will only reestablish itself on its foundations when it has been extirpated."[11] It can be maintained that his style of painting and choice of subject matter were conceived at least in part as a reaction to the emblem of progress celebrated by Vernet.

Of all the projects in which Vernet was involved, his most ambitious undertaking was the glorification of France's war of conquest and campaign of colonization in Algeria. The war in Algeria was inherited, rather than initiated, by Louis Philippe, and during the first three years of his reign it was the focus of vehement debate in the Chambers. After a parliamentary commission recommended in 1833 that France colonize the coastal areas, the French military presence began to grow apace, and in 1835 Gen. Bertrand Clauzel, a strong proponent of more extensive colonization, was made the head of the Regency of Algeria. The following year Clauzel led a military expedition to conquer the fortified inland

city of Constantine, but met with failure. The forced but heroic retreat was the subject of six major lithographs by Auguste Raffet in 1837 in which the orchestrated movement of battle is celebrated and defeat is deemphasized (see cat. no. 53). In 1838 Raffet was able to devote a whole album of twelve lithographs to the capture of the reputedly impenetrable city, as the French army finally succeeded in taking it after an epic battle in October 1837.[12] Shortly after the fall of the city, Vernet was commissioned by the king to execute three pictures in a series commemorating this victory; these were intended to be installed in the Salle de Constantine in the newly founded historical museum at Versailles (Figure 2–5).[13] The first of these mammoth works was exhibited at the Salon of 1839, and the room at Versailles was inaugurated by the king in March 1842.

Although this room was the most monumental representation of the French conquest in North Africa, visual imagery describing the

11. Excerpted from a discourse Orsel presented to a fraternal organization around 1840. See "Les Chemins de fer," in *Oeuvres diverses de Victor Orsel,* ed. A. Périn, 2:n.p.

12. On the circumstances behind Raffet's lithographs, see Pierre Ladoué, *Un peintre de l'épopée française: Raffet,* 58–63.
13. This project is discussed and studies for it are reproduced in the exhibition catalogue *Horace Vernet, 1789–1863,* 95–97.

LE MAURE

Figure 2–6. Adrien DAUZATS, "Le Maure" (The moor), color etching from *Les Français peints par eux-mêmes* (The French painted by themselves). See cat. no. 61.

area proliferated during the 1830s as artists, working in both high and low art forms, adopted orientalist themes. The Salons from 1831 until the end of the century were filled with images of the Arab world, and artists as diverse as Delacroix, Ingres, Théodore Chassériau, Alexandre Decamps, Adrien Dauzats, Eugène Fromentin, and Prosper Marilhat devoted a significant part of their creative energies to picturing or imagining this exotic, seemingly primitive civilization, relatively untouched by the industrialization process (see Figure 2–6 [cat. no. 61], Figure 3–7 [cat. no. 63], Figure 5–1 [cat. no. 58], and cat. nos. 56, 57, 59, 60, and 62). Romantic writers such as Hugo, Lamartine, Nerval, and Gautier and

a score of others added a literary component to this vision of the Orient, in which a variety of sexual desires, projections, and repressions were implicated. The harem picture, a natural locus for erotic fantasy, was a staple of visual imagery of the time, but images of the virile and heroic Arab warrior, such as those in the lithographs of Raffet, found an enthusiastic reception as well. As surprising as it might at first seem, empathy with the Arab warrior, the enemy of the French occupation army, was a regular feature of the visual reportage of the Algerian war and of Salon pictures. Indeed the leader of the Algerian resistance, Abd el-Kader, became something of a national hero in France. One might argue that the growing modernization process contributed to a widespread longing for its antithesis, for an exotic alternative to the quotidian reality of contemporary France, and dovetailed with the politics of colonization. Thus, orientalism may have predated and postdated the July Monarchy but was nonetheless a defining feature of sociocultural life during its span.

One artist who spent more than three years traveling and recording life in North Africa and the Middle East, often under conditions of extreme hardship, was Charles Gleyre.[14] When Horace Vernet was approached in 1834 by the wealthy American traveler John Lowell and asked for the name of a painter who could accompany Lowell on a long voyage to the Orient and provide a visual record of his travels, Vernet suggested Gleyre. Gleyre eagerly accepted the offer and spent the first year of his voyage making watercolor studies of the topography and monuments of the Middle East and executing portraits of the inhabitants and of Lowell and other foreigners decked out in eastern costume (see cat. no. 65). After Gleyre parted company with his patron, he continued his search for the exotic East for

14. For an account of his travels, see Jacques-Edouard Berger, "Gleyre et l'orient."

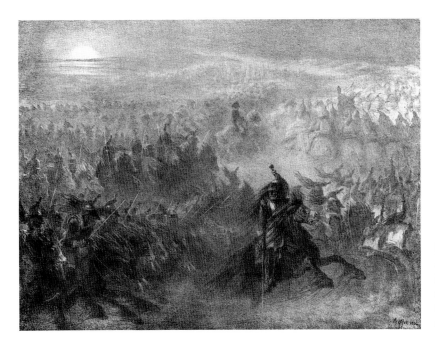

Figure 2–7. Denis Auguste Marie RAFFET, *Revue nocturne* (Nocturnal review). See cat. no. 47.

another two years and made a series of studies that were perhaps more objective than those of any orientalist during the century. When failing health and eyesight forced his return to France, he continued to paint oriental subjects, but he dropped his attempt to give objective representations, choosing instead to provide pictures that conformed to European stereotypes of life in the East.

Still another way in which Vernet was a man of his time is in his celebration of, and elaboration upon, the myth of Napoleon. During the Restoration, Vernet's studio had been a gathering place for members of the romantic generation who were enthralled by the memory of the emperor, and during and after Napoleon's exile to Saint Helena, Vernet continued to evoke the imperial legend in his work. He was therefore a logical choice to illustrate Laurent de L'Ardèche's 1839 *Histoire de l'empereur Napoléon* (History of the emperor Napoleon). Containing more than five hundred wood engravings after drawings by Vernet, this was one of the major books on Napoleon published during the July Mon-

archy. In the same year Jacques de Norvin's *Histoire de Napoléon* (History of Napoleon) was republished with many illustrations by Raffet, one of the main promulgators of the Napoleonic legend. Two years earlier, for his *Album de 1837* (Album of 1837), Raffet had produced what is both one of the masterpieces of romantic lithography and a landmark in the mystification of the figure of Napoleon. His *Revue nocturne* (Nocturnal review) is set in an eerie Valhalla for the fallen members of the Napoleonic legions, who swirl in eternity around the spectral fulcrum of Napoleon (Figure 2–7 [cat. no. 47]). Another lithographer who enjoyed enormous popularity and was perhaps even more active in providing visual panegyrics for Napoleon was Nicolas-Toussaint Charlet. Like Vernet and Raffet, he illustrated one of the most important books devoted to Napoleon to be published during the century, the 1842 edition of Count de Las Cases's *Mémorial de Sainte-Hélène* (Memorial of Saint Helena; see cat. no. 48). Written by a soldier who had accompanied Napoleon into exile at Saint Helena, and supposedly based

Figure 2–8. C. Francesco ANTOMMARCHI,
Death Mask of Napoleon on a Cushion. See cat. no. 50.

on his firsthand discussions with Napoleon,
the book became a canonical text in the
emerging religion of Napoleon, which was to
find literary priests in poets as diverse as
Hugo, Nerval, P.-J. Béranger, and Emile
Debraux.

 Although bonapartism was to prove in-
effectual as a political force during the July
Monarchy, the legend of Napoleon grew enor-
mously and became an amorphous ideological
force with which the regime of Louis Philippe
had to reckon. Typical of the many sentimen-
tal and now-forgotten images evoking the
Napoleonic legend was a picture exhibited at
the Salon of 1841 by Alexandre Guillemin in
which an old soldier sits on his bed rapt in
memory.[15] At the head of the bed, where one
might normally expect to find a crucifix, is
placed a death mask of Napoleon that was
surrounded in controversy at the time. In
1833, Francesco Antommarchi, the mysterious
Corsican doctor who had been in attendance
at Napoleon's death, announced that he was
going to make available to subscribers repro-
ductions of the plaster cast of Napoleon's
visage that he allegedly had made at Saint Hele-
na after Napoleon's death. This act resulted
in accusations of fraud and charlatanism
against Antommarchi, but the effigy nonethe-

less quickly became an emotionally charged
cult object, possessing the sacredness of a relic
for many in France (Figure 2–8 [cat. no. 50]).

 Another icon for the worship of Napoleon
was provided by Vernet on the occasion of the
announcement in May 1840 that Napoleon's
remains were at last to be returned to France.
In Vernet's image, made for reproduction in
the form of a popular engraving, Napoleon
arises from a tomb, his head surrounded by a
glowing halo, creating an unmistakable paral-
lel with the resurrection of Christ. In making
this visual analogy Vernet was simply giving
form to contemporary discourse in which the
divinity of Napoleon was proclaimed. But
Napoleon was not only likened to the Chris-
tian divinity, he was also frequently associated
with classical deities such as Jupiter or Her-
cules, and in particular with Prometheus. It
was in the guise of this latter deity, for exam-
ple, that the sculptor Mathieu-Meusnier
represented him in 1847 in a more than life-
size nude statue that was erected on a public
square in Paris several years later.

 The mystification surrounding the figure of
Napoleon adds special interest to several pic-
tures by Paul Delaroche, another prototypical
juste-milieu artist. In 1845 Delaroche executed a
painting of Napoleon seated in his study at
Fontainebleau brooding upon his fate on the
day Paris capitulated to the allied armies. Lit-
tle or no attempt was made to idealize the
portly and prosaic figure, who displays none
of the signs of the dominant personality that
brought him to power. Three years later
Delaroche painted a monumental, but totally
unheroicized, depiction of Napoleon's cross-
ing of the pass at Saint Bernard, in which the
young general is mounted unceremoniously
upon a mule in a pose that is at total odds
with his dramatic pose in Jacques-Louis
David's celebrated rendition of the event. In
creating these relatively realistic representa-
tions, Delaroche consulted Norvin's *Histoire de
Napoléon* and drew upon Charlet's illustrations

15. A lithograph reproducing the painting is found in
Wilhelm Ténint, *Album du Salon de 1841–1843.*

Figure 2–9. Interior view, Salle de 1830, Musée de Versailles. See also cat. no. 120.

for de Las Cases's *Mémorial de Sainte-Hélène* (cat. no. 48), but he translated his sources into large-scale history painting, the most esteemed genre of art at the time.[16] The reasons for this act may be obscure, but it was in keeping with a growing tendency toward naturalism in the representation of history that characterized art during the July Monarchy.

* * *

The single most conspicuous visual representation of the political strategy of the July Monarchy must be the great museum that Louis Philippe began at Versailles in 1831. When he was voted into power in 1830, the château of Versailles was in a state of great

disrepair and in need of restoration. Instead of restoring it to its condition at the end of the reign of Louis XVI, Louis Philippe proceeded to convert the complex of buildings to a new purpose. The great palace was turned into a museum illustrating the history of France from the reign of Clovis to that of Louis Philippe. Within the museum separate rooms were dedicated to the different historical periods, with older works and newly commissioned pictures hung in them. When this museum opened in 1837, with some rooms still to be completed, the motto at the entrance succinctly proclaimed the official policy behind the project: "To All The Glories Of France." The implicit message in the program was that the July Monarchy was strong enough to display the "glories" of its ideological adversaries and to encompass within its *juste-milieu* synthesis *all* aspects of the past and all the social divisions in French society. The

16. On his representations of Napoleon, see Norman D. Ziff, *Paul Delaroche: A Study in Nineteenth-Century French History Painting,* 194–98, 214–16, 226–28.

program said that unity could be achieved by remembering rather than forgetting the past. In keeping with the all-embracing nature of the museum, commissions for pictures were awarded to almost every artist who possessed minimal qualifications as a history painter.[17] In this eclectic distribution of royal patronage the king demonstrated his latitudinarian views on the questions of artistic schools and, at the same time, made his role as the primary bene-factor of the arts in France apparent for all to see.[18]

The culmination of the historical tour of the new museum, as it existed at its opening in 1837, was the Salle de 1830, in which the events that brought Louis Philippe to power were celebrated on a colossal scale (Figure 2–9). In each of the five paintings on the walls of this room the Citizen King occupies center stage, implying that the history of the July Revolution and its resolution were physi-cally embodied in his person. As would be expected in a royal commission of this kind, historical objectivity was not the primary goal. Thus, the fact that Louis Philippe's selection as the ruler of France was the result of a com-promise, and that support for his appoint-ment was strongly opposed by many republi-cans, bonapartists, and legitimists in France, is completely belied by the painting of Charles Larivière, which measures more than thirty-six feet and occupies the position opposite the windows. Larivière's picture—the largest in the museum at the time—depicts the arrival

of Louis Philippe at the Hôtel de Ville on 31 July 1830, where he is about to be received by the "provisory government" that had just proclaimed him "Lieutenant-général du royaume," or ruler of France whose powers still remained to be defined. All traces of opposition are erased in this scene of triumph in which members of all social classes enthusi-astically hail the advent of the new head of state. Probably the most important work in the room, in terms of significance of the sub-ject, however, is Eugène Devéria's representa-tion of Louis Philippe taking an oath on 9 August 1830 before the two houses of Parlia-ment to uphold the Charter of 1830 (see Fig-ure 1–1 [cat. no. 2] and Figure 2–10 [cat. no. 120]). The prelude to this ceremony occurred when the chambers voted for a constitutional monarchy based on a new charter and re-quired that Louis Philippe swear allegiance to it as a precondition to receiving the French crown. In Devéria's painting Louis Philippe stands before the throne and raises his arm in a dramatic gesture of oath-taking, while behind him two generals hold the crown and scepter that will be his as a consequence of the act. What is probably most important about this event is that, breaking with historical prec-edent, the king received his crown from the representatives of the people rather than from a representative of the Church: what is de-picted is not a coronation but the formal conclusion to a contractual agreement. But, despite the ostensibly democratic nature of the transaction, Devéria's depiction, placing the new king at the top of a pyramidal composi-tion and setting him apart from everyone else in the room by his elegant pose and white trousers, leaves no doubt as to the separate-ness and ascendancy of his position.

The strategy of syncretic appropriation underlying the program of the new museum at Versailles was crystallized in one monu-mental mural completed at the church of the

17. The cycles of paintings in this museum have recently been discussed and interpreted at length by Thomas W. Gaehtgens, *Versailles: De la résidence royale au Musée historique,* and Michael Marrinan, *Painting Politics for Louis-Philippe: Art and Ideology in Orléanist France, 1830–1848.*

18. The works in the museum were also made avail-able in the multivolume album of engravings published by Charles Gavard from 1839 to 1848, *Galeries historiques du Palais de Versailles.* This was published in several dif-ferently priced editions and was, as Gavard stated in his prospectus included in volume 1, meant to be a book made "for everyone."

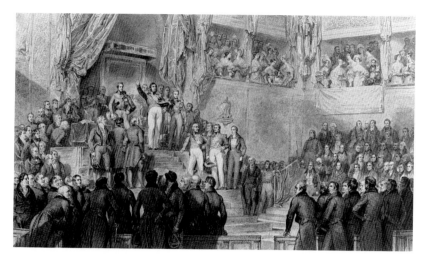

Figure 2–10. Eugène DEVÉRIA, *Le Roi Louis-Philippe prête serment* (The King Louis Philippe takes the oath), from Charles GAVARD, *Galeries historiques de Versailles* (Historical galleries of Versailles). See cat. no. 120.

Figure 2–11. Jules-Claude ZIEGLER, *The History of Christianity*. Mural, 1835–1837. Paris, The Madeleine.

Madeleine in Paris in 1837 by Jules-Claude Ziegler (Figure 2–11).[19] In terms of its scale and the scope and variety of personages included in this representation of the history of Christianity, it is the most ambitious painting executed during the July Monarchy. Unlike the pictures at Versailles, this was a commission awarded by the state's arts admin-

istration, then under the charge of Adolphe Thiers, who appears to have been ultimately responsible for its program. The composition is filled by an enormous circle of civil and religious figures, from the early Christian era until the nineteenth century. This circle is tilted at an oblique angle to the floor of the nave; at one of its antipodes Christ sits enthroned, while at the opposite pole Napoleon is depicted in his coronation robes receiving his crown from the hands of Pius VII. Behind the emperor kneels a bishop hold-

19. For a detailed discussion of its political implications, see Michael Paul Driskel, "Eclecticism and Ideology in the July Monarchy: Jules-Claude Ziegler's Vision of Christianity at the Madeleine."

ing a scroll bearing the inscription "Concordat 1802," clearly signifying that what is being depicted is not only Napoleon's coronation but also his "reconciliation" with the Church. The reason for giving such prominence to this scene, apart from the fact that during his reign Napoleon had taken a special interest in the unfinished church and considered converting it into a "Temple of Glory," seems to have been the desire to appropriate symbolically the legend of Napoleon by making his image the centerpiece of a building Louis Philippe was to inaugurate. But it had another meaning as well. The early months of the July Monarchy were marked by intense anticlericalism, which the government did little to suppress, hoping to use this popular hostility as a means of making the Church more amenable to its policies. In August 1835 what was known as a "moral concordat" was worked out between the Church and the July Monarchy, and this mural seems to commemorate this reconciliation by proxy. Louis Philippe is not himself represented in this great assembly, but his presence is implied nonetheless. In the immediate foreground, on the right, is a prominent pedestal on which his name is inscribed. The message seems to be that one day a representation of the Citizen King will occupy this pedestal, in a way not too dissimilar perhaps to the manner in which Charlemagne is enthroned in the middle ground of the composition.

In 1833 the commission for the apse mural and six other paintings in the church had been awarded to Paul Delaroche, but while he was in Italy studying examples of the great fresco tradition, the mural in the apse was taken from him and given to Ziegler. This action caused Delaroche to withdraw from the project entirely. In recompense for the loss of this commission, Delaroche was given another at the Ecole des Beaux-Arts in Paris. In 1836 he set to work decorating the semicircular room in which prizes were awarded with an encyclopedic assemblage of the stellar figures in the history of art from antiquity to the seventeenth century. Very difficult to photograph in its entirety, the composition of the mural can most easily be studied in Delaroche's later reduction (cat. no. 121).[20] The work owes an obvious debt to Ingres's *L'Apothéose d'Homère* (Apotheosis of Homer), executed for a ceiling in the Louvre in 1827, but unlike the work of Ingres, which only features visual artists who fall within the classical tradition, Delaroche's mural is far more syncretic, including figures from most historical schools. Given Delaroche's *juste-milieu* propensities, one might interpret the work as his representation of the whole range of stylistic possibilities from which he could choose. However, one must also bear in mind that the nineteenth-century tendency to create encyclopedic assemblages of worthies from art and literature was not restricted to France.[21]

Monumental painting in public buildings, both secular and religious, experienced a dramatic resurgence during the July Monarchy. This was due in part to the state's wish to make a public display of its concern with culture and in part to the increasing number of artists who depended on official patronage for their livelihood. These public works provided an opportunity to furnish institutional largesse to a large number of clamoring voices. Charles de Rémusat, the minister of the interior in 1840 and the official in charge of the distribution of most state commissions, stated flatly in his memoirs that one of the functions of his department was to act as a "public welfare office for painters."[22] This

20. This reduction was executed in 1841 for Goupil and Company, which used it to make an engraving of the mural. In 1853 it was repainted by Delaroche, with notable changes.
21. On this tendency as it relates to Delaroche's painting, see Francis Haskell, *Rediscoveries in Art: Some Aspects of Taste, Fashion and Collecting in England and France,* 9–17.
22. Charles de Rémusat, *Mémoires de ma vie,* 343.

does not, however, explain why the state employed Delacroix to undertake major mural commissions in the Salon du Roi, the library of the Palais Bourbon, and the library of the Palais du Luxembourg. Nor does it account for Rémusat's attempt to persuade Ingres to decorate the Salle du Trône at the Palais Luxembourg, offering him complete freedom to depict whatever subject he wished, in whatever manner, and promising that he would be the "master" of the project.[23] Although he proposed an encyclopedic composition, such as Ingres's *L'Apothéose d'Homère,* for the ceiling, it is clear that Rémusat was willing to agree in advance that the state would not interfere in any way with Ingres's work. The nature of Rémusat's plea should caution us against believing that the state necessarily exercised control over the content of all the public art it commissioned.

Ingres declined this project at the Palais Luxembourg and the other public mural commissions he was offered but actively encouraged his many students to pursue this kind of art. One of these students, Théodore Chassériau, who is known for his synthesis of the classical aesthetic of Ingres and the coloristic effects of Delacroix, executed one of the largest and most remarkable decorative ensembles of the century at the Palais de la Cour des Comptes, another building that housed part of the state's administrative machinery. This project, which occupied Chassériau from 1844 to 1848, attempted to give synoptic coverage to all the areas of human social life.

One of the provisions of the concordat Napoleon concluded with the Pope in 1802 was that the state and municipal governments would assume most of the burden of maintaining churches and other ecclesiastical buildings. Maintenance came to entail com-

missions for the restoration and decoration of these religious edifices, providing a source of patronage for the art community in France. Civil authorities also assumed the task of constructing new churches as they were required. It was not simply to satisfy a contractual obligation, however, that the restoration of churches from France's medieval and Renaissance periods was undertaken during the July Monarchy. Shortly after the advent of Louis Philippe, the movement to save France's architectural heritage began in earnest. One of the more important acts in this preservation campaign occurred shortly after the July Revolution, when the official post of inspector of historical monuments was created; then, seven years later, the Commission on Historical Monuments was established, with Prosper Mérimée, the renowned novelist and passionate archaeologist, at its head. Under the auspices of this agency surveys were made of monuments all over France, and requests for funds for restorations were directed to Parliament. At odds with our present notion that a good restoration is a minimal one, the nineteenth-century concept included additions that were in some way in keeping with the spirit of the building. This entailed adding intense polychromy and mural paintings to the walls of many of these newly appreciated edifices.

During the Restoration a number of new churches were begun in Paris. Because these were nearing completion when the regime of Louis Philippe came to power, the city of Paris inherited the task of decorating them. One of these, Hippolyte Lebas's church of Notre-Dame de Lorette, was among the earliest decorative projects begun by the municipal government after the Revolution of 1830. It has the distinction of containing what is perhaps the most eclectic assemblage of styles of mural decoration to be found under one roof in nineteenth-century France. When one enters the building, works by twenty-three different painters of all artistic persuasions vie

23. Letter from Rémusat to Ingres, dated 6 September 1840, in the Municipal Archives, Toulouse, Rémusat Papers, 5S181(4).

Figure 2–12. Hippolyte LEBAS, *Notre-Dame de Lorette,* interior view. Completed 1832. Paris.

Figure 2–13. Hippolyte LEBAS, *Dessin d'architecture pour l'église Notre-Dame de Lorette* (Design for the architecture of the church Notre-Dame de Lorette). See cat. no. 124.

for attention (Figure 2–12). In the apse alone one encounters a neo-Byzantine image of the Coronation of the Virgin, paintings in the pendentives recalling the Bolognese school, a cupola painted in the illusionistic idiom of the great ceilings of the Baroque era, and two monumental neoclassical paintings that open a window onto still another conception of pictorial space. While some of the paintings attempt to respect the integrity of the walls of the structure, others, such as the murals of Eugène Devéria in the chapel dedicated to Sainte Geneviève and those of Hippolyte Lebas (see cat. no. 123 and Figure 2–13 [cat. no. 124]), contain figures that are thrust almost horizontally into illusionistic space, denying the solidity of the architectural support. Devéria's work, combining rich coloristic effects derived from the Venetian tradition and a classical sense of line and composition, might be considered symbolic of the process informing the entire decorative program in this building, which, bracketing its

religious function, might be described as a Temple of Eclecticism.

A perhaps predictable consequence of the eclecticism in decorative projects such as the one at Notre-Dame de Lorette was that it generated a demand for its antithesis. One leader in the demand for unity in decorative programs was the architect Jakob Ignaz Hittorff, whose own project, the church of Saint-Vincent de Paul in Paris, was nearing completion and in need of decoration when the results of the eclectic distribution of paintings at Notre-Dame de Lorette were provoking intense discussion. In opposition to what he considered displays of incoherence in contemporary decorative projects such as that at Notre-Dame de Lorette, in 1838 Hittorff addressed a long letter to the prefect of the city of Paris, who was ultimately responsible for awarding municipal commissions, demanding that a single artist be employed to decorate his own church or, failing that, at least a small number working within an agreed-upon set of decorative principles. When it was subsequently published, his letter became something of a manifesto for a new mural aesthetic.[24] Throughout it, he

24. Jakob Ignaz Hittorff, "Mémoire présenté à M. le Préfet de la Seine."

argued that the painted decoration of a monument should have the same degree of unity as the building itself and should be subservient to architecture and the planarity of the wall. During the 1840s this demand for decorative unity became a leitmotiv of art criticism as new criteria were established for mural painting.

* * *

Of all the paintings executed at Notre-Dame de Lorette, the ones that attracted the most interest were by Victor Orsel and Alphonse Périn, who used their commissions to promote a new aesthetic both for mural decoration and for modern religious art. Orsel received his commission to decorate the Chapel of the Virgin the same year he exhibited his controversial *Le Bien et le mal* at the Salon, and he undertook a complex symbolic and allegorical program representing the attributes of the Virgin as they appear in her litanies.[25] He began the actual process of painting the walls of his chapel in 1836, employing assistants to execute much of the work from cartoons he meticulously prepared for each part of the scheme. In this relatively small chapel, where every available inch of wall space is crammed with symbolic detail, concern for the pictographic aspects of painting is balanced by a remarkable attention to anatomical accuracy in the representation of the figures (see cat. no. 125). Thus, Orsel's attempt to revive religious art consisted in combining a laboriously obtained knowledge of the human body, the basis of the classical aesthetic, with the symbolic tradition in Christian art. Or, as he put it, "to baptize Greek art." One might equally describe his conception of painting as a "Christian hieroglyphics,"

a term that is not inappropriate since it was used frequently by Catholic writers in the 1840s. Théophile Gautier succinctly summarized the aim of Orsel's art, asserting that he was committed to this mode of painting because he was "persuaded that the more the forms in art are primitive, the more they approach the rigidity of dogma."[26] The same intention seems to inform the work of Orsel's lifelong friend Alphonse Périn in the chapel directly across the nave, which takes the Eucharist as the basis for an equally complex system of emblems and symbolic representation.[27] Yet, like Orsel's work, the paintings of Périn balance a scrupulous attention to anatomical detail with the symbolic aspects of composition (see cat. no. 126).

To be understood properly the work of Orsel and Périn must be placed in the context of another major cultural development that occurred during the 1830s: a revival of ultramontanism, or a religious revival that had as its primary goal to restore the absolute authority of the Pope in ecclesiastical matters and to wrest control of the church from the hands of the state. This movement of ideas, while pan-European in scope, was particularly strong in France, where it took as one of its principal objectives the abolition of the state's monopoly on higher education.[28] Consequently, during much of the July Monarchy a fierce polemical battle raged in the press and in both houses of parliament between defenders of the secular university system—the principal of whom were Victor Cousin, Jules Michelet, and

25. Orsel's complete program for the chapel and its complex symbolism was published shortly after his death. See *Explication des peintures de la chapelle de la Vierge à l'église de Notre-Dame-de-Lorette.*

26. Théophile Gautier, "La chapelle de la Vierge à Notre-Dame-de-Lorette," *Le Moniteur universel,* 15 April 1854.
27. On Périn's chapel, see Alphonse Gosset, *Notice sur Alphonse Périn, peintre d'histoire: Ses peintures murales de Notre-Dame-de-Lorette.* Adolphe Roger, who shared the aesthetic beliefs of Orsel and Périn, but was not as rigorous in their application, executed a third chapel, dedicated to the sacrament of baptism, in a similarly symbolic mode.
28. The movement is discussed at length in Paul Bénichou, *Le Temps des prophètes: Doctrines de l'âge romantique,* 121–220.

Edgar Quinet—and their ultramontane adversaries.

The ultramontane movement had a well-defined aesthetic agenda: to return art to the simplicity and symbolic form that characterized it before the Renaissance. The most articulate spokesman for this position was Charles de Montalembert, a prolific writer and politician, but more than a score of Catholic writers were engaged in the same cause.[29] One of the early manifestos in this cause is Montalembert's essay of 1833 entitled "Du vandalisme en France," which called upon the nation to embark on a campaign of restoration of France's medieval heritage and to combat those secular forces responsible for its destruction.[30] Montalembert also had words of praise for several artists who were returning to the purest traditions of "Christian" art, the most important being Orsel.

Although religious art was executed in a plurality of styles during the period, works conforming in one way or another to this newly formulated ultramontane aesthetic have a place apart. This attempt to return to primitive simplicity and give priority to the symbolic aspects of painting was particularly prevalent among the students of Ingres. Chief among them was Hippolyte Flandrin, who is known today primarily as a portraitist (see Plate 41 [cat. no. 166]) but in his own day was widely regarded as the most important religious painter to work in France during the century.[31] Among Flandrin's most important projects was the redecoration of the choir of the Romanesque church of Saint-Germain-des-Prés between 1842 and 1848 with a pro-

gram of paintings set against a gold ground and surrounded by richly polychromed architectural elements. This was undoubtedly the best known of the many religious mural projects of the July Monarchy, and it provoked admiration even from many who were not in sympathy with the message encoded by its hieratic form.

While Flandrin was at work in this venerable church, Eugène Delacroix was in the process of executing a mural painting for Saint-Denis du Saint Sacrement, one of the new basilican plan churches completed during the July Monarchy, which might be considered an antithesis to Flandrin's mural aesthetic. Despite the unusually architectonic compositional structure of Delacroix's picture, it is alive with movement as bodies, limbs, and heads seem to bob and weave in rhythmical patterns and vibrant color heightens the emotional intensity of his scene of the Lamentation of Christ. The same sense of implied movement and emotional vibrancy characterizes Delacroix's numerous easel paintings of religious subjects, such as the Crucifixion that he exhibited in the Salon of 1847 (Plate 44 [cat. no. 169]). Needless to say, the religious painting of Delacroix, as superbly executed as it may have been, was in total opposition to the ultramontane aesthetic, and many Catholic writers declared his work to be completely devoid of spiritual content. This judgment was generally extended to the art of Rubens, a prototype for Delacroix's painterly style. The opposition of line and color caricatured by Bertall had a religious, political, and ideological dimension that far exceeded simple differences between adherents to classical and romantic theories.

Dominique Papety, who was one of Ingres's strongest students and consequently classed as an adherent to the school of line, was much preoccupied with the debate over the aesthetics of religious art and the primitive tra-

29. On the aesthetic ideology of ultramontanism during the July Monarchy, see Michael Paul Driskel, "Raphael, Savonarola and the Neo-Catholic Use of 'Decadence' in the 1830s."

30. Charles de Montalembert, "Du vandalisme en France: Lettre à M. Victor Hugo."

31. The scope of Flandrin's art is seen in the exhibition catalogue *Hippolyte, Auguste et Paul Flandrin: Une fraternité picturale au XIXe siècle.*

Figure 2–14. Dominique Louis PAPETY, *Cyprien et Justine s'exhortant mutuellement* (Cyprien and Justine exhort each other). See cat. no. 141E.

ditions.[32] This concern is registered in a number of drawings from his student years at the French Academy in Rome in the 1830s. In one series he illustrated a medieval story of the love of saints Cyprian and Justine in which physical consummation is renounced in favor of a spiritual union, and he rendered the images in a manner he thought to correspond to the simplicity of religious art contemporaneous with his narrative (see cat. no. 141, Plate 24 [cat. no. 141A], and Figure 2–14 [cat. no. 141E]). Papety's preoccupation with the hieratic tradition and with the problematics of the flesh in the Christian religion is evident in another series of drawings illustrating epi-

sodes from the life of Saint Mary of Egypt (see cat. no. 142 and Plate 25 [cat. no. 142B]). In one of the scenes the rigid and austere figure of Father Zosima hands the penitent saint and former prostitute a cloak to hide her nakedness, resolutely averting his eyes as he does so. The hieratic immobility of the ascetic, echoed and emphasized by the pictographs on the rock behind him, forms a radical contrast with the opulent, curvilinear forms of the former sinner. In addition to contrasting attitudes toward the flesh, this juxtaposition might be seen to illustrate two different stylistic modalities that were in conflict in the July Monarchy. These illustrations are made all the more remarkable when one recalls that Papety achieved considerable publicity several years later, at the Salon of 1843, with his thinly veiled Fourierist allegory, *Rêve de bonheur* (Dream of happiness), which is filled with seminude figures enjoying sensual bliss in the precincts of a phalanstery. But what created even more controversy was the inclusion of a steam locomotive in the background, which added a jarring note of contemporaneity to the composition.

One of Papety's last major paintings was *La Vierge consolatrice* (The consoling Virgin), which he exhibited at the Salon of 1846 (Plate 43 [cat. no. 168]). Since Papety had shown works at the Salon of 1845 that had a much different appearance, Baudelaire was quick to see this painting as symptomatic of the malady of eclecticism and to place Papety in the category of "doubters" in his Salon review that year. The symmetrical composition of the afflicted disposed around the figure of the Virgin is a traditional format, but what probably provoked Baudelaire's accusation of doubt is the sharp contrast between the idealized figure of the Virgin and the naturalism in the treatment of the two homeless children in the lower right, who bear a family resemblance to the children in works such as Jeanron's *Les*

32. For a discussion of Papety's views on religious art, see François Tamisier, *Dominique Papety: Sa vie et ses oeuvres*, 128–29.

Figure 2–15. Ary SCHEFFER, *Christ consolateur* (Christ the consoler). Oil on canvas, 1837. Amsterdam, Amsterdams Historisch Museum.

Petits Patriotes (The little patriots; Plate 28 [cat. no. 144]). Another element of naturalism in the work is the unidealized portrait of the queen, Marie Amélie, in the right background, wearing her diadem. Many visitors to the Salon would have recognized that this work was the artist's reworking of Ary Scheffer's *Christ consolateur* (Christ the consoler; 1837), which became the best-known religious image produced during the July Monarchy when it was engraved and distributed by the Goupil gallery in 1842 (see Figure 2–15). In the center of Scheffer's symmetrical composition Christ sits enframed by an assemblage of personages, representing the forlorn, who are being offered consolation for their sorrows; opposing them are those who have been or who ought to be freed from servitude. Among the latter category are an African slave, a Greek freedom fighter, and a Polish patriot suffering from the oppression of Russian occupation. Inasmuch as the artist was a Protestant and very active in liberal causes during

the twenties and thirties, the picture could be considered a Protestant version of the social gospel.[33]

An artist whom Léon Rosenthal placed in the *juste-milieu* category, but judged to have executed the finest small-scale history paintings of the July Monarchy, was Joseph Nicolas Robert-Fleury. However, even his work provoked Rosenthal's disdain. Discounting the content of Robert-Fleury's painting, Rosenthal concluded on purely formal grounds that the artist was plagued by a "timidity . . . that constantly paralyzed his brush."[34] But if one places the subjects of Robert-Fleury's paintings in the context of their time and considers commitment to be more than a matter of form, a much different conception should emerge. More than any other history painter of his day, he used his art as a means of responding to the religious conflict of the July

33. Scheffer's political beliefs and activities are dealt with at length in Marthe Kolbe, *Ary Scheffer et son temps*.
34. Rosenthal, *Du romantisme au réalisme*, 220–21.

Monarchy or of engaging a major social issue of his day. This response consisted of a series of pictures illustrating the atrocities produced by the Wars of Religion and the Inquisition that were intended to remind the forgetful of the fruits of religious fanaticism.[35] One of these representations of religious strife was *Colloque de Poissy en 1561* (The colloquy of Poissy in 1561), exhibited at the Salon of 1840 (Plate 38 [cat. no. 157]). The picture represents a dramatic moment at the conference convened in 1561 at the town of Poissy to attempt to resolve the strife between Catholics and Protestants and avoid a religious war. On the left stands the noble figure of the famous Protestant theologian Theodore Beza calmly setting forth his argument, while to the right the figure of a fanatical monk glares in hatred at him. Condensed into these two figures is a historical conflict between reason and emotional obscurantism that Robert-Fleury appears to have believed to be in the process of reenactment on a smaller scale in 1840. His representation of the past had an immediate referent in the present. It might also be viewed as an antithetical response to the art of Victor Orsel.

Figure 2–16. François RUDE, *Departure of the Volunteers in 1792.* Relief sculpture, 1833–1836. Paris, Arc de Triomphe.

* * *

Patronage by the July Monarchy was not restricted to painters: a large number of sculptors were also employed to decorate various public buildings and collaborate on monuments erected in Paris and the provinces. Undoubtedly the monument of the greatest magnitude completed during the regime was the Arc de Triomphe de l'Etoile, which, after the Eiffel Tower, is probably the best-known structure in France. Begun in 1806, during the First Empire, it was originally intended to

commemorate the victories of the French armies, but in 1823 the Restoration decided to consecrate it to the victories of the duc d'Angoulême during the Spanish Campaign. The decoration had not advanced very far at the time of the Revolution of 1830, and the July Monarchy inherited a monument that it could make its own. Adolphe Thiers took a close interest in the project and resolved to redesign and implement an ambitious sculptural program commemorating French victories of the First Republic and the Napoleonic era. Many narrative reliefs and allegorical figures, employing the talents of a score of sculptors, were undertaken, but four gargantuan compositions or "trophies" at the base of the arch dwarf the other decoration and were, in terms of their scale, the largest sculptural reliefs produced during the first

35. These pictures are discussed by Michael Paul Driskel, "'To Be of One's Own Time': Modernization, Secularism and the Art of Two Embattled Academicians."

Figure 2–17. François RUDE, *Head of the Genius of Liberty.* See cat. no. 117.

half of the century. The most celebrated of these reliefs is the group by François Rude depicting the departure for war in 1792 of the volunteer army of ordinary Frenchmen, who are dressed as ancient Gauls (Figure 2–16).[36] While the other three compositions are relatively static and conform to the architectonic structure they decorate, Rude's dynamic group, commonly known as the *Marseillaise,* is filled with implied movement and appears ready to burst the bounds of the rectilinear mass of stone containing it. The most memorable figure in Rude's composition is the winged genius of Liberty, or Marianne, the symbol of France, who directs and incites the warriors below. Her head, mouth opened in a fierce cry, encapsulates the energy and emotional intensity of the entire relief (see Figure 2–17 [cat. no. 117]). Rude's composition is made even more dramatic by its juxtaposition to Cortot's relief on the pillar opposite it, in which Napoleon, dressed in a classical toga, is

being crowned by Victory. In regard to its political significance, this contrast of Cortot's representation of the Emperor Napoleon and the common soldiers of the republican armies, or of the principles of imperial authority and democracy, is a vivid illustration of the extremes that the authors of the political theory of the *juste milieu* were trying to mediate.

Another major project, both begun and completed during the reign of Louis Philippe, is the enormous columnar monument that occupies the center of the place de la Bastille in Paris and is dedicated to those who died during the Revolution of 1830. This column, which is four meters higher than the Vendôme Column and surmounts a huge underground mausoleum, was begun by the architect Alavoine and completed in 1840 by Louis Duc. It is crowned by a nude allegorical figure by Auguste Dumont, based on Giambologna's *Mercury,* who bears a torch in one hand and broken chains in the other, while on the base of the column are reliefs of two lions by Barye.

The great celebration of social unity that inaugurated the monument on 27 July 1840 belied the struggle over its commission. Shortly after the Chamber of Deputies voted to erect a monument to commemorate the victims of the July Revolution, the largest organization of artists in France began a campaign to institute an open competition for its design. The strength of this demand for a contest was due in part to the political doctrine of the *juste milieu* and the system of constitutional monarchy that created uncertainty as to who had the final authority to make decisions concerning the erection of national monuments. The plea of the organization was to no avail, however, as Adolphe Thiers, in an address before the Chamber of Deputies seeking funds for its construction, expressed his strong opposition to holding a contest for it, and he was supported by a vote of the deputies.[37] In response

36. Rude was originally asked to execute all four reliefs. On his involvement with this project, see Louis de Fourcaud, *François Rude, sculpteur: Ses oeuvres et son temps (1784–1855).*

37. *Procès-verbaux des séances de la Chambre des Députés, session 1832,* 1:187–89.

the Société Libre des Beaux-Arts formed a delegation to carry its protest to Louis Philippe himself.[38] Its action was unsuccessful, but the question of public competitions for public monuments continued to be a burning artistic and political issue until the end of the July Monarchy.

Of all the sculptors active during the July Monarchy, probably the most important, in terms of the commissions he executed and his official position in the academic system and on various governmental committees, was Pierre-Jean David d'Angers. In the cultural arena of the day he occupied a place comparable to that of Horace Vernet, but unlike the painter he was a vocal member of the republican opposition to the July Monarchy. His resistance to the government of Louis Philippe seems to be suggested by Bertall's caricature, in which he occupies a position on the bottom row, on the extreme left, and strikes a resolute and defiant pose (see Figure 2–1). The most prestigious commission that David d'Angers was awarded by the government during this period was the enormous bas-relief for the main pediment of the building in Paris now known as the Panthéon, which had originally been conceived as a church and had experienced many changes in destination or function during the years required to complete and decorate it.[39] This relief provoked a political controversy when it was completed in 1837, and the sculptor became involved in a widely publicized struggle with the government. The conflict began when changes were demanded in its cast of historical figures in order to quiet the opposition of Catholics and monarchists to potentially republican, bonapartist, and anticlerical implications in its composition. The sculptor persisted in his refusal to make any changes,

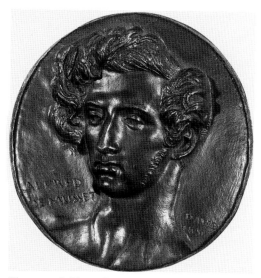

Figure 2–18. Pierre-Jean DAVID, called DAVID D'ANGERS, *Alfred de Musset.* See cat. no. 33.

and the pediment was eventually unveiled as David d'Angers had conceived it.

David d'Angers's political views and his problematic relationship with the July Monarchy are evidenced by a small statue he completed in 1839 (cat. no. 37). On the base are inscribed two lines from the famous hymn *La Marseillaise,* which the beholder of the work could have continued with the words "Aux armes citoyens" (Take arms citizens), and on the scroll in the figure's right hand are imprinted the dates of two revolutions, 1789 and 1830, followed by a partial date, "18—," that the viewer was invited to complete. This statuette also bears a resemblance to a statue that David d'Angers imagined as a crown for the Arc de Triomphe. He described this statue in a radical republican publication in 1842, and evidence suggests that he intended that plaster models would be distributed throughout France by the radical publisher Pagnerre.[40] In the social context of the year 1840, this would have been widely construed as a

38. A copy of the petition is in the Bibliothèque Historique de la Ville de Paris, manuscript C.P.4063.
39. On this project, see Neil McWilliam, "David D'Angers and the Panthéon Commission: Politics and Public Works under the July Monarchy."

40. See his entry "Arc de Triomphe" in Laurent Antoine Pagnerre, *Dictionnaire politique,* 88. The circumstances behind the creation of this work are discussed by Jacques de Caso, *David d'Angers: L'avenir de la mémoire,* 216, n. 45.

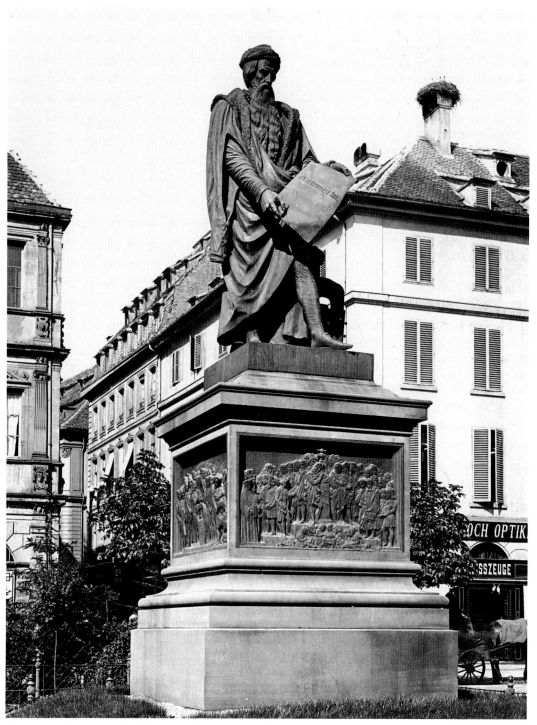

Figure 2–19. Pierre-Jean DAVID, called DAVID D'ANGERS, *Monument to Johann Gutenberg.* 1840.
Strasbourg, France.

call for another revolution.[41]

The works for which David d'Angers is perhaps best known are the many portrait busts and medallions of the most important people of his era (see Figure 2–18 [cat. no. 33] and cat. nos. 29–31 and 34–36). One of these portraits that had great emotional resonance was his representation of his friend Armand Carrel in both a full-length statue and a bust (see Plate 2 [cat. no. 16]). Carrel was one of the most articulate and vehement opponents of the July Monarchy and the founder of the opposition newspaper *Le National.* He was also one of the strongest opponents of censorship and most militant advocates of freedom of the press. When Carrel died in July 1836, as the result of wounds suffered in a duel with the editor of another daily newspaper, David d'Angers and Ary Scheffer (who painted his portrait; see Plate 15 [cat. no. 76]) were in attendance at his wake. David d'Angers executed the bust of Carrel in 1838 and the following year completed the life-size statue of Carrel as a monument for his grave in the cemetery of Saint Mandé. In this statue Carrel is represented in the act of reading a famous speech before the Chamber of Peers in defense of one of the editors of his newspaper, who was being tried for printing seditious articles. For many in France the journalist had died in defense of free speech inasmuch as the reason for his duel with Emile de Girardin, owner of *La Presse,* was that Girardin had cut the price of his newspapers in half in order to attract greater circulation and consequently more advertising, a development Carrel perceived as a threat to the function of the press as a forum for political ideas. Thus, David d'Angers's statue was more than a funeral monument: it was also a monument to the concept of a free and politically committed press.

41. On the revolutionary implications in the *Marseillaise* at the time, see Michael Paul Driskel, "Singing the *Marseillaise* in 1840: The Case of Charlet's Censored Prints."

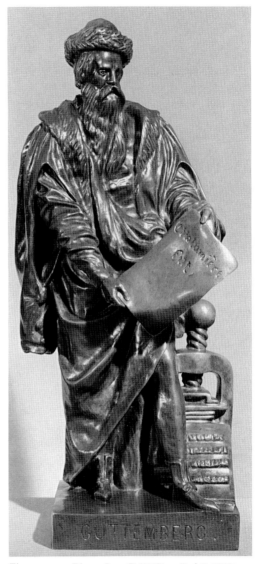

Figure 2–20. Pierre-Jean DAVID, called DAVID D'ANGERS, *Johann Gensfleisch Gutenberg.* See cat. no. 70.

Shortly after completing his statue of Carrel, David d'Angers finished a much more conspicuous tribute to those engaged in the movement for a free press during the July Monarchy. This is his monument to Johann Gutenberg, the inventor of the movable-type printing press, which was erected in the center of Strasbourg in June 1840 (Figures 2–19 and 2–20 [cat. no. 70]). On a pedestal surrounded

Figure 2–21. Honoré DAUMIER, *Ah! Tu veux te
frotter à la presse!!* (Ah! you want to meddle with the
press!!). See cat. no. 99.

by four bas-reliefs, the printer stands next to
his press, an instrument that had become a
political emblem in France in the 1830s. The
reliefs represent the benefits his invention
conferred on the four continents. The political
discourse encoded by this emblematic monu-
ment is easily heard in the published tran-
script of the speeches made at the banquet
held at the monument's inauguration in
Strasbourg. Speaker after speaker, most of
whom belonged to the political opposition,
celebrated the printed word as the liberator of
mankind and as a weapon that could be used
to crush tyranny.[42] From the militant tone
of these speeches, it appears clear that the
monument was the high-art equivalent to the
caricatures by Daumier that addressed the
issue of freedom of the press, such as his
lithograph of 1833 entitled *Ah! Tu veux te frotter*

à la presse!! (Ah! you want to meddle with the
press!!), in which a burly printer, wearing a
hat on which is written the name of Armand
Carrel's newspaper, crushes a figure resem-
bling Louis Philippe in his printing press
(Figure 2–21 [cat. no. 99]).

While Louis Philippe had himself repre-
sented on a monumental scale in the pictures
decorating the Salle de 1830 at Versailles, the
government commissioned no major sculp-
tural equivalents for the public places in
France. The idea of erecting an equestrian
statue of the king in the city of Paris was
apparently rejected because the July Mon-
archy wanted to distance itself from Bourbon
monarchs such as Louis XIV and Henri IV,
who were represented on horseback in two
prominent locations. However, an important
equestrian monument of the king's eldest son,
Ferdinand duc d'Orléans, who was killed in a
carriage accident on 13 July 1842, was commis-
sioned by the government. This bronze statue
with historical bas-reliefs on its pedestal was
executed by Charles Marochetti and erected
in the courtyard of the Louvre in 1844. But the
hostility of its critical reception indicates that
the government was wise not to construct
other monuments to the Orléans family in the
city. "A species of intolerable despotism" was
how one of the leading art periodicals charac-
terized the royal commission for this public
space that theoretically belonged to all the
nation.[43] The modestly scaled memorial
chapel for the prince, designed by Pierre Fon-
taine and erected just outside Paris at Neuilly,
met a much different reception when it was
inaugurated in 1843. Not only was the de-
signer of this private monument the most
distinguished architect of the first half of the
century, but Ingres provided the cartoons for
the stained-glass windows (see Figure 3–8 [cat.
no. 127B] and cat. no. 127A) and Ary Scheffer

42. *Récit de l'inauguration de la Statue de Gutenberg et des
fêtes données par la ville de Strasbourg les 24, 24 et 26 Juin
1840.*

43. Anon., "Statue équestre du duc d'Orléans dans la
cour du Louvre."

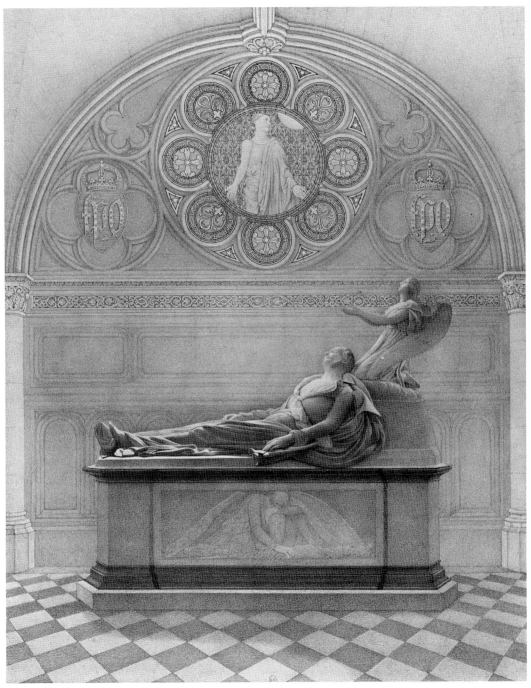

Figure 2–22. Henri Joseph François Baron de TRIQUETI, *Funeral Monument for the duc d'Orléans, Saint Ferdinand Chapel, Neuilly.* Engraving, 1843. Paris, Bibliothèque nationale, Cabinet des estampes.

Figure 2–23. François-Fortuné-Antoine FEROGIO, *Passage du cortège dans les Champs Elysées* (The procession moving along the Champs Elysées). See cat. no. 52A.

Figure 2–24. François-Fortuné-Antoine FERO-GIO, *Intérieur de l'Eglise des Invalides pendant la cérémonie religieuse 15 octobre 1840* (Interior of the Church of the Invalides during the religious ceremony 15 October 1840). See cat. no. 52B.

designed the simple funeral monument that was carved by Henri de Triqueti, one of the major sculptors of the period (Figure 2–22). This chapel soon became a pilgrimage place for the many in France who were enamored of the image of the dashing young prince.

The most important funeral monument begun during the July Monarchy was not for a member of the Orléans family but for Napoleon Bonaparte. When Rémusat made his sudden announcement on 12 May 1840 that the body of Napoleon was to be returned to France, he also decreed that Napoleon's remains were to be taken to the Church of the Invalides in Paris, where "a solemn ceremony . . . will inaugurate the tomb that will retain them forever."[44] Regardless of the tone of authority in this pronouncement, the location of the tomb soon became a topic of emotional debate as many declared both the choice of

44. "Exposé des motifs et projet de loi tendant à ouvrir un crédit spécial pour la translation des restes mortels de l'Empereur Napoléon," *Chambre des Députés, Session 1840*, no. 150, 12 May 1840, 337–38.

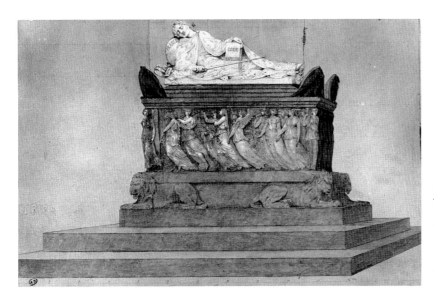

Figure 2–25. Henri Joseph François Baron de TRIQUETI, *Projet pour le tombeau de Napoléon* (Project for the tomb of Napoleon). See cat. no. 118A.

a location and the procedure by which the location was decided to be unacceptable. Undeterred by this opposition, Rémusat and Adolphe Thiers, the acting prime minister, wasted little time in engaging an architect and a sculptor to design and execute the monument, but it was impossible to complete it before the emperor's body arrived in Paris on 15 December 1840, an event that provided the occasion for the grandest spectacle held during the reign of Louis Philippe.[45] After the disembarkation at Courbevoie, the funeral cortege passed under the Arc de Triomphe, which had been crowned with a temporary statue of the apotheosis of the emperor, continued down the Champs Elysées, across the Seine, and on to the Church of the Invalides (see Figure 2–23 [cat. no. 52A]). Once inside it was placed in a huge, temporary catafalque where dignitaries from all over the realm came to pay homage (see Figure 2–24 [cat. no. 52B]). Enhancing the pomp and circumstance, scores of temporary statues of allegorical figures and historical personages commissioned from the leading sculptors in France lined the route and the esplanade of the Invalides.

45. The authoritative study of this ceremony and the procession is Jean Boisson, *Le Retour des cendres*.

Once Napoleon's body had been installed in its temporary resting place at the Invalides, an intense campaign was mounted in the press to nullify what was considered to be an authoritarian decision on the part of the administration in choosing individuals to design and execute his tomb. After months of pressure, the minister of the interior caved in and announced that a contest was to be held for the design, but since no information was forthcoming as to who was eligible to enter or how the projects were to be selected, exhibited, and judged, charges that the contest was a sham were quickly leveled by the leading art journals. Before the exhibition of the projects ever opened, many were convinced that the administration had already secretly decided who was to be given the commission. More than being just a dispute over the most equitable and efficient means of awarding commissions for public monuments, the issue mirrored deeper ideological tensions in French society, whether those involved in the dispute recognized it or not.

Despite the government's attempt to discourage entries in the contest, eighty-one different projects greeted the visitor when the exhibition of the entries opened to the public

in November 1841.[46] Of the twenty-six pro-
jects in which sculptors were involved, the one
that probably received the most praise was
that of Henri de Triqueti. Rather than pre-
senting an architectural plan that would
integrate the tomb and its architectural
matrix, he simply submitted a three-dimen-
sional model of a sarcophagus and a drawing
that offered a variant on it (see Figure 2–25
[cat. no. 118A]). Known as one of the finest
relief sculptors of the period, he included in
his design a frieze of allegorical figures that
was wrapped around the four sides of the sar-
cophagus and recapitulated the various phases
of Napoleon's career (see cat. no. 118B-C).

After the contest concluded and the com-
mittee appointed to make a report came to no
conclusion as to the winner, in April 1842 the
government awarded a contract to Louis Vi-
sconti to implement his design, which con-
sisted of an open crypt under the dome of
the church, with the sarcophagus of Napoleon
in the center and a subterranean passageway
leading to it from the central courtyard. Since
the opposition press had declared before the
contest began that the project was going to be
awarded to Visconti, this decision only exacer-
bated the conflict between the administration
and the art community in France. Undeterred
by criticism directed at him, Visconti con-
tinued to develop his plans for the tomb and
managed to expand his initial conception to
include an ambitious sculptural program
executed by a number of sculptors, the most
important being Pradier, Simart, Duret, Tri-
queti, and Marochetti. Although this project
was not completed before the fall of Louis
Philippe, the crypt, as it exists today, was
finished for all intents and purposes before his
exit from the political arena in February 1848
(see Figure 2–26). What is extraordinary

46. On this contest and the controversy surrounding
it, see Michael Paul Driskel, "By Competition or
Administrative Decree?: The Contest for the Tomb of
Napoleon in 1841."

Figure 2–26. Philippe BENOIST, *View of the Tomb of
Napoleon, The Invalides, Paris.* Lithograph, 1842–1853.
Paris, Bibliothèque nationale, Cabinet des
estampes.

about this monument is that, while it appears
today to be the perfect solution to a problem,
when one examines the documents that sur-
vive for its construction, it quickly becomes
apparent that it was beset by institutional and
political conflicts from inception to conclu-
sion. The discord began with the administra-
tion and its critics, proceeded to the admin-
istration and the architect, and continued with
a running battle between Visconti and the
various sculptors on the project. While most
nineteenth-century beholders of the monu-
ment were not privy to this struggle, they
brought with them a variety of preconcep-
tions, emotions, and sentiments about Napo-
leon, about the July Monarchy, and about the
artists involved in the project that were like-
wise conditioned by social and institutional
conflicts. Thus, in order to understand the
monument historically, one cannot avoid

attending to both the conflicting forces that were implicated in the generative process and the ideas and meanings that were imposed on it by the contemporary viewer.

In like manner, if one strives for a historical comprehension of the art in this exhibition, the context in which it was enmeshed must be given careful consideration. Though the works on display here were executed in a wide variety of media, by many quite different artistic personalities, for many different purposes, the social, political, and cultural context in France between 1830 and 1848, to which we have affixed the label *July Monarchy,* established interrelations between them all and conditioned the manner in which they were both conceived and received. One primary function of an exhibition of works framed by the temporal bracket of a particular political regime is to aid this reconstructive process and suggest that it can be extended to other periods as well.

3 HISTORICAL SUBJECTS

The treatment of historical subjects in the art of the July Monarchy was determined to a great extent by a mixture of aesthetic and practical forces: aesthetically by the tradition of history painting and its interaction with the intellectual currents of nineteenth-century historical thinking, and practically by the demands and expectations of government patrons, the Salon, and bourgeois collectors. First, these forces will be described briefly. Then this essay will focus in part upon the Salon of a particular year—1839, chosen more or less at random—and will discuss a number of its significant historical paintings. This focus will provide an opportunity for consideration of some of the major artists, subject areas, and issues of criticism of the middle years of the July Monarchy. Finally, a pair of paintings by two major artists who were not represented in the Salon of 1839 will be examined for what they tell us about changing preferences and emphases in history painting.

The Tradition of History Painting

In the early decades of the nineteenth century, the conviction that history painting was the first of the genres in a rigid hierarchy determined by subject continued to infuse all aspects of the paternal French government program for the arts. This program was based on instruction, competition, critical review, patronage, and reward. The classical French academic system codified a canon of subjects and style, a *grande manière,* for history painting, based on the use of illustrious figures and stories on a large scale, which emphasized a moralizing, exemplary virtue. History painting thus told of humankind and its destiny. In descending order in the hierarchy below his-

tory painting came portraiture, landscape, and scenes from everyday life (*genre* painting). Within historical subjects, the divisions were further articulated by content: mythological subjects and ancient history, biblical and Christian subjects, literary themes, "modern" history (before 1789), and contemporary history (after 1789).

The grand tradition of history painting was formulated upon an ideal concept of beauty, with pose and gesture and body movement used to render inner states of being, creating compositions that represented the full range of human emotions. The story was conceptualized by the artist as a series of important actions from which the most revealing moment was selected for depiction. Certain subjects were seen as having the additional benefit of revealing a correspondence between a past heroic age and the present. Subjects at the highest level were those considered suitable for the *history painter;* on a lower (more anecdotal) level, the subjects were those more suited to the *painter of historical subjects,* an artist whose efforts were seen as sliding from the higher realms. Tragedy always held the highest place in painting, as it did in the theater.

The theoretically clear hierarchy of genres had already been challenged by Jacques-Louis David, whose subjects and compositions began to ignore the precise demarcation between history painting and anecdotal historical subjects. In both his school and the rival *romantique* camp, exemplified by Delacroix, the range of subjects was enlarged, as were the functions of traditional subjects. In the 1820s many artists realized the potential of realism and melodrama in combination as they confronted an audience nurtured by a burgeoning commercial press, who wanted painters to

leave the established paths—which were linked in their minds with the societal restrictions of the *ancien régime*—and search terrains of fresher content. The taste for sentimental or sensational subjects seems to have been accompanied by a demand for an abundance of accurate incidental detail.

This overemphasis on detail was condemned by the art critic Etienne Delécluze. Commenting in 1831 on sketches submitted for the competition to decorate the Chambre des Députés (for example, Plate 4 [cat. no. 38]), he complained that all the works shared a common fault of presenting the scene as a multitude of figures without a compositional focus. This he attributed to a habit prevalent in recent years and derived from genre painting, which put more emphasis on the treatment of clothing, styles, setting, and habits than on action. He saw this fault as relating to the rising importance of portraiture (with its emphasis on likeness) over other genres and to an interest in memoirs over history. In such painting, the search for truth is conducted in the details, in the minutiae, while the representation of larger truths and the relationship between them is ignored.[1]

The Interest in History and Louis Philippe's History Campaign

French historiography was undergoing significant changes in the 1830s. Factual reporting was receiving more emphasis, concurrent with a move away from seeing history in terms of a dynastic chronicle and a change in focus from the hero to the masses. The same "democratic" attitude that led to Louis Philippe's being named "king of the French" and not "king of France" reflected itself in the accepted mode of presenting the past. Manifestations of the new spirit can be seen in several popular trends in historical writing

during the 1830s and 1840s. One stressed that history should be told as a narrative with little commentary; a second recounted facts from an individual's point of view, often through memoirs; a third assembled the historic past (distant and near) in encyclopedic presentations of events and personages; and a fourth linked history and the historical novel, taking liberties with fact to recapture the spirit of earlier epochs.

Numerous journal advertisements give proof of the veritable explosion of enthusiasm for history in the publishing industry in the early 1830s. The relatively low price per volume of these historical works, the simultaneous printing of an edition on different quality papers, the supplying of such books through the mail, and the publication of selected works as serial editions indicate their wide availability. A personal reference library would have been easy to acquire to support the history painters' search for documentation. The popularity of these books also suggests that painters could rely on an audience having an appetite for arcane events or personalities, for new twists to old scenes, and certainly for an archaeological correctness of detail.

Louis Philippe himself had a strong interest in history and in using history painting to interpret the past to the advantage of his regime. The grandiose scheme of his patronage, second only to that of Louis XIV, emerged in his plan for the creation of a public Musée Historique in the first-floor galleries of the palace at Versailles.[2] He was convinced of the importance of establishing a national style of history painting through an ambitious program to paint, in awesome proportions, the entire history of France. In addition to a

1. Delécluze, *Journal des Débats*, 19 April 1831.

2. For the paintings in this museum, see Michael Marrinan, *Painting Politics for Louis-Philippe: Art and Ideology in Orléanist France, 1830–1848*, and Thomas W. Gaehtgens, *Versailles: De la résidence royale au musée historique. La Galerie des Batailles dans le musée historique de Louis-Philippe*.

chronological sequence of the principal battle triumphs from Tolbiac to Antwerp, this "historical museum" would display portraits of all the great French military leaders. It was Louis Philippe's intention to identify his monarchy with the outstanding French epochs and to establish a continuity of French history from Louis XIV to himself.

Both Louis Philippe's motives and his methods show him to be at one with his times. He chose representatives of all three of the major schools of painting (*romantique, classique, juste milieu*): Delacroix, Devéria, Delaroche, Couder, Cogniet, Vinchon, Vernet, Picot, and Schnetz. He requested that historians prepare thoroughly researched and documented reports on each subject for the painters. The Museum of Versailles was inaugurated on 10 June 1837 with the Galerie des Batailles.

The Versailles paintings were done to suit the building's massive proportions. The presence of these works in the annual Salon during these years did much to fuel the criticism regarding the discontinuity between grandeur of scale and grandeur of idea.

Salon Exhibition

The tradition of history painting is intimately linked with the Salon in French art. The biennial institutional exhibition screened by a jury delegated by the government became an annual event in 1833 by Louis Philippe's decree. Eager crowds flocked to the openings. There were heated discussions of new works in the press. This led to public adulation and increased celebrity for some artists. A successful painter could expect to make large sums of money far beyond the amount awarded for a medal (gold at 4,000 francs, silver at 1,500 francs). Not only was the Salon the best opportunity to show off new work to prospective buyers, both government and private, but a good press review also assured future fame and fortune. Moreover, the popu-

larization of reproductive prints of Salon paintings brought the most-discussed entries into the homes of all but the lowest level of society. The price for reproductive rights for a famous work often exceeded the sale price of the canvas itself. State purchases and commissions were highly dependent on Salon success. The king and the government were the major buyers from the Salon.[3]

The carefully crafted summaries of the annual Salon written by critics for the major Parisian journals provided, for the art world and the public, a synopsis of the artistic issues of the day, an attempt to define the major directions in art, and a critique of that year's most interesting entries. In the reviews of such critics as Delécluze (*Journal des Débats*) and Jules Janin (*L'Artiste*), one sees several recurrent themes that are integrally related to history painting in the July Monarchy.

The first of the general themes has to do with the institution of the Salon itself. The number of works submitted was a testament to ever-expanding artistic activity (which had reached almost mob-scene proportions by the 1840s). While the juries had fairly conservative rather than avant-garde tastes, they were anything but consistent in their selections. Artists were admitted on a work-by-work basis and, no matter what their status, were never exempted from this judging process. The list of artists who had paintings turned away each year read like the who's who of art. These rejections fueled hysteria and vexation in artistic circles. The jury system and government purchases were structured to reward on the basis of a single outstanding work—a "masterpiece"—rather than being

3. How directly linked the "high art" of the institutional Salon was to the new commercialism in these years is hinted at by a *Journal des Débats* advertisement of 3 April 1831, which proposes to business clients as a commercial venture the publication of an edition of the Salon *livrets* from 1761 to the present. The notice included figures to show what return an investor could expect.

the opportunity for established artists to show the most significant examples of their recent production, or to show selections that allowed current work to be seen in the context of previous work.

The shift of the Salon to an annual occurrence was alternately praised and damned by artists and critics. While it did open the way to a more constant dialogue between artists and potential patrons, it was criticized as not allowing history painters adequate time to create something worthy of sending. The frequency of Salons was also blamed for a lessening of public interest after the 1830s, in part because there was less perceivable change in stylistic direction from one Salon to the next.

The absence of a number of the major painters from the exhibition roster of any given Salon (a frequent occurrence after 1840) was attributable to a variety of causes: their occupation with monumental decorative projects; their distrust of the juried system; and the intrusion of small alternative exhibitions organized by the artists themselves. On the positive side, these alternative exhibitions represented artistic autonomy, which opened the potential for freedom of expression. On the negative side, they represented the failure of the official Salon system to function in a satisfactory way.

The nature of the Salon audience, the effect of popular press coverage, and the new commercialism were interrelated. While artists still sent work to the Salon to make their mark with other artists and members of the inner circle and to chase official tokens of honor, they had to appeal to other, newly important segments of the audience. The patronage habits of Louis Philippe and the sizable budget his government had allocated for art meant that the royal presence represented a significant monetary factor. Delécluze saw this as the reason for all the canvases that were massive in scale beyond any practical purpose save for catching the government's attention. He compared the whole scene to an arts lottery: "With the distant hope that they might be able to win, artists ruin themselves."[4]

At the opposite extreme from the aristocratic audience was the public at large, who had the opportunity for the first time by way of the popular press to be swept up firsthand in the process of artistic success or failure. The effect of this was celebrity status for artists—fleeting glory based on a work or two that captured the mood of a moment, rather than lasting fame built on the slower cumulative results of a long career's effort.

The Bourgeois Collector

In the middle between high and low in the Salon audience, setting a new tone for the whole affair, were the growing ranks of private collectors. Delécluze said that because of this sector there were more works by mediocre painters in the Salon of 1839, and also more "pretty" works:

> The average level of talent, like the average income, has risen in the last quarter of a century. Jacquand, one of these pretty painters, is typical of these prolific little masters in these times when there are so many bourgeois salons with Gothic cabinets, and tables filled with albums, Chinese vases, Florentine bronzes, and modish statuettes. Every apartment today has its own collection of curiosities. Nothing is more common than bourgeois *luxe*. One must recognize these works for what they are and seek out the few that remain something more.[5]

By 1847 he wrote that the passion for collecting had turned the Salon into a "merchandise bazaar" where fine artists and weak amateurs were confused by those "searching for a good bargain."[6]

4. Delécluze, *Journal des Débats*, 7 May 1831.
5. Ibid., 14 March 1839.
6. Ibid., 20 March 1847.

Figure 3–1. Jean-Jacques, called James PRADIER, *Venus and Cupid.* See cat. no. 129.

The newly installed nineteenth-century gallery at the Musée des Beaux-Arts in Nantes gives a good indication of what an astute private collector was apt to acquire during the July Monarchy. Installed together in the new side gallery is the collection of Clarke de Feltre (a gift to the museum in 1852). This installation numbers twenty-three paintings dating from 1827 to 1848.[7] Represented are works by Paul Delaroche (eleven), Hippolyte Flandrin (two), Alexandre Hesse (two), Claudius Jacquand (two), Dominique Papety (one), Léopold Robert (three), Baron de Steuben (one), and Horace Vernet (one).

7. See Olivier Merson, "La Collection Clarke de Feltre (Musée de Nantes)."

Several of the Delaroche paintings are oil studies for his *Hemicycle* mural, including a narrow horizontal composition of the whole and the allegorical figures of Renaissance and Gothic art (cat. no. 121). The Flandrin paintings are female figures, more sentimental than his normal style. Hesse's *Moissonneuse tenant sa faucille* (Harvester holding her sickle; Plate 33 [cat. no. 150]) is a classicized French peasant who has more in common with the Italian peasants of Léopold Robert than she does with the genre figures of the emerging French realists. The two Jacquand paintings, *Marie de Médicis visitant l'atelier de Rubens* (Marie de Medici visiting Rubens's studio) and *Un Cardinal vient chercher Ribère dans son atelier à Naples* (A cardinal comes to see Ribera in his studio in Naples), both dated 1839, are part of the tradition of "troubadour" painting, which favored themes from artists' lives. All the Clarke de Feltre paintings share a small scale, an intimate composition, and subject types suitable for private contemplation and enjoyment.

Of the works in section IX of this exhibition, an evocation of a private collector's study, Chassériau's *Le Souvenir* (The memory; Plate 23 [cat. no. 140]), the two Papety watercolor sequences (cat. nos. 141 and 142; see also Plates 24 [cat. no. 141A] and 25 [cat. no. 142B]), and the small bronzes by Pradier (Figure 3–1 [cat. no. 129] and cat. no. 128) and Barye (cat. nos. 55 and 134) are most appropriately seen from the perspective of their creation expressly for just such private collections. Likewise, the exquisite little painting by Lehmann, *Etude d'une femme nue* (Study of a nude woman; Figure 3–2 [cat. no. 130]), represents a working study prepared for the private collector. Lehmann's master, Ingres, had a passion for similar isolated figure studies, which he later sold or gave to friends.

The Salon of 1839

Pleasing the tastes of the Salon audiences

Figure 3–2. Karl-Ernest-Rodolphe-Heinrich-Salem, called Henri LEHMANN, *Etude d'une femme nue* (Study of a nude woman). See cat. no. 130.

assumed an ever greater importance between 1830 and 1848. The cumulative result of such contradictory pressures was an 1839 Salon that seemed, to a sensitive observer such as Delécluze, to be characterized by "diffusion and confusion."[8] Janin summed up his impression in 1839 even more colorfully:

Quel pandémonium! It was an incredible pell mell: battles, fresh landscapes, bloody dramas, lewd scenes, horrible bourgeois portraits, and noble historic heads, the ugly and the beautiful . . . a mosaic composed of as many strokes of the pencil as could be made in the space of three hundred days. Every color, every misery, infinite invention, all in the half-light of flickering lamps.[9]

8. Delécluze, *Journal des Débats,* 4 March 1839.
9. Jules Janin, "Salon de 1839," pt. 1, "Une Nuit au Louvre," *L'Artiste,* 2d ser., 2 (1839): 214–15.

Figure 3–3. BEN-JAMIN, *Vernet*, from *Panthéon charivarique* (A *Charivari* pantheon). See cat. no. 109D.

On Thursday, 28 February, the day before the Salon of 1839 was to begin, an announcement was made that the large number of works submitted by artists on the last reception days would delay the opening by two days. Of the works presented, 2,404 were accepted and 606 refused. Delécluze estimated (based on these figures and the massive scale of the numerous Musée Historique paintings that were exhibited) that in the nine months since the last Salon, French artists had done twelve thousand square feet of painting.[10] Of the paintings included, just over one-third were landscapes, just under one-third were portraits, and fewer than one-fifth were historical subjects. The remainder were genre scenes, still lifes, and animals. Nonetheless, because of critics' habits and the scale and artistic celebrity of the works, history painting gained the most attention.

The entrance to the 1839 Salon was dominated by Horace Vernet's *La Siège de Constantine*. This thirty-foot-wide painting, "a portrait of the whole French army in Algeria,"[11] recorded in a tripartite composition the capture of the heavily fortified city of Constantine in 1837. Two of the three scenes included the duc de Nemours (the second son of Louis Philippe). In the first scene the French army is shown advancing on the city on 10 October (Salon no. 2050). In the second and third scenes, the army takes its final orders, and the battle begins on 13 October (Salon nos. 2051 and 2052). This play-by-play documentary detailed the battle as an encyclopedic assemblage of the components: portraits (as though from life) of the individual soldiers, precisely detailed uniforms, battlefield accessories, and topographic landscape.

Janin's review criticized Vernet, "the most important man of war," as being too reliant on habit, too "systematized," with a painting style aimed at dazzling the public by a virtuoso display of surface details on a monumental scale.[12] A prolific artist, Vernet showed two

10. Delécluze, *Journal des Débats*, 4 March 1839.

11. Ibid., 7 March 1839.
12. Janin, "Salon de 1839," pt. 2, "Le Salon au Grand Jour," *L'Artiste*, 2d ser., 2 (1839): 229.

additional twenty-foot-wide Algerian subjects in the same Salon. A *Charivari* caricature of Vernet's artistic methods shows the artist painting from horseback as he gallops past his immense canvas (Figure 3–3 [cat. no. 109D]).

The Salle de Constantine (illustrated in Figure 2–5), for which *Siège de Constantine* was destined, was the most contemporary of the history galleries at Versailles. It accounted for the only subjects from recent history at the 1839 Salon. The battle was barely won when the artist was given the commission. Vernet's style here was precisely what Louis Philippe favored: narrative clarity in a detailed presentation of the historic fact on a large scale with easy readability.[13] Such an approach willingly sacrificed dramatic *focus* in favor of historically accurate *distance.* It rendered a battlefield stripped of individual heroics. The king's approval is attested by the financial records. Vernet's government commissions during the July Monarchy amounted to more than eight hundred thousand francs. Additionally, he received full expenses and a Versailles studio for over ten years.[14]

Orientalist and Religious Subjects

A final Vernet submission to the Salon of 1839 reveals a different side of his art and introduces a new subject. *Agar chassée par Abraham* (Hagar being sent away by Abraham; Figure 3–4) is an intimately scaled Old Testament subject. Such themes were a *juste-milieu* favorite. When depicted by painters like Vernet, these subjects reflect in a most direct way the influence of the French presence in the Islamic world.

At a time when the French colonization of Africa was expanding the idea of the "provincial" Frenchman to include a wider geo-graphic range (see Figure 3–5 [cat. no. 61]), Vernet, like many artists of his generation, was given ample government-sponsored opportunity for travel in Syria, Algeria, Turkey, and Egypt. These artists returned with their notebooks and imaginations filled with the local color, figures, costumes, habits, and landscape of the exotic Islamic world. Vernet quickly realized the potential for these observations to revitalize the visual iconography of the Bible.

Heretofore, European artists had used in biblical illustrations figures with western facial features garbed in flowing Florentine draperies or modified Roman togas. *Agar chassée par Abraham* (and other works like it painted from the mid-1830s by Vernet) introduced Arab dress and Semitic features. The continuity of costumes and habits in the Arab world permitted this derivation of the appearance of the distant past from Vernet's observations of contemporary life. His orientalism unveiled seductive new possibilities. Once archaeological exactitude was introduced—in combination with the anecdotal detail of a good story well told—biblical characters were made flesh and blood. The Old Testament stories, always good material for illustrating humankind's virtues and vices, now were depicted from vantage points that implied different customs and morals from those of Louis Philippe's Paris.

The interest of the story of *Agar chassée par Abraham* is equaled by the skill with which Vernet accessorized the scene. The episode is from Genesis 16:1–16. The handmaid Hagar had borne an heir for Abraham and his wife Sarah, who had advanced beyond childbearing years. When Sarah, in fulfillment of God's promise, miraculously gave birth to Isaac, she sent Hagar and her son into the desert. Typically representations had focused on the miracle that saved the two exiles from dying of thirst in the desert. Vernet's secularization of the theme focuses on the handsome figures of Abraham, Hagar, and their young son. The

13. Marrinan, *Painting Politics*, 25.
14. Albert Boime, *Thomas Couture and the Eclectic Vision*, 43.

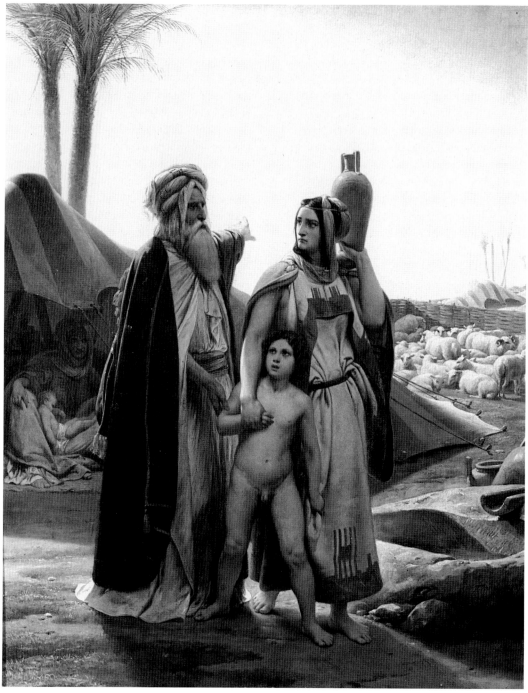

Figure 3–4. Horace VERNET, *Agar chassée par Abraham* (Hagar being sent away by Abraham). Oil on canvas, 1837. Nantes, Musée des Beaux-Arts, Clarke de Feltre Collection.

Figure 3–5. Frontispiece from *Les Français peints par eux-mêmes* (The French painted by themselves). See cat. no. 61.

entalist subjects (see Figure 3–7 [cat. no. 63]). By the Salon of 1831 he was exhibiting paintings that combined a love of genre subjects with the local color of the Islamic east. His artistic reputation with his contemporaries went far beyond what art history has accorded him. At the 1855 Retrospective he was granted one of three distinguished medals—the other two went to Delacroix and Ingres. At the Salon of 1839, only Decamps, Scheffer, and Vernet had the honor of seeing their works exhibited together. Janin described the effect of Decamps's work:

This improviser has stayed in his tent for the last two years, but this year he has revealed himself with eleven paintings. These paintings are brilliant and lively and very popular with the crowds. There is much discussion regarding his painting of *Joseph vendu par ses frères*! The jury must have thought he was pulling their leg when all they could see in it was two camels.[15]

At the first July Monarchy Salons, religious subjects were rare, but by the midthirties this trend had begun to reverse. In 1836 Rio published the first volume of his monumental study of Christian art in Italy. The following year, Montalembert published *L'état actuel de l'art religieux en France* (The present state of religious art in France), a study that became almost a textbook for religious painting. In 1839 there were more than one hundred fifty religious paintings in the Salon, more than in any other subject area. By 1844 religious paintings outnumbered all other history paintings combined. Such statistics reflect a variety of developments: Catholic revival and the Protestant response, mysticism, the renovation and decoration of the churches, the establishment of the brotherhood of Catholic artists (the Montalembert–Lacordaire–Société

details of costume and daily life that Vernet introduced enhance the immediacy, and the physicality, of the crisis.

Typically for the *juste milieu*—always a study in opposing tendencies—just as Vernet moved toward a closer, more intimately focused presentation of the Bible, at the same Salon, Decamps took archaeological correctness in the opposite direction with *Joseph vendu par ses frères* (Joseph sold by his brothers; compare Figure 3–6). Decamps renders the Old Testament scene from an extreme distance, without an emotional focus. One camel, taller than the others, in the middle ground serves as the only visual focus. It is as if the moment were an insignificant event in a desert world of timeless sand, where shifting patterns of light and shadow are of more significance than changing human relationships.

Decamps was one of the earliest and most committed of the French artists working ori-

15. Janin, "Salon de 1839," pts. 1–2, *L'Artiste*, 2d ser., 2 (1839): 216, 232.

Figure 3–6. Eugène LEROUX after the painting in the Salon of 1839 by Gabriel-Alexandre DECAMPS, *Joseph vendu par ses frères* (Joseph sold by his brothers). Lithograph. Washington D.C., The Library of Congress.

Figure 3–7. Alexandre-Gabriel DECAMPS, *Corps de Garde Turc* (A corps of the Turkish guard). See cat. no. 63.

de Saint Jean), and a heightened interest in German Nazarene and Italian "primitive" art.

Orsel, Périn, and Flandrin are typical of the artists who painted such subjects out of a profound commitment to the meaning of the images and to the function of art as a source of spiritual inspiration and edification. Ingres and Delaroche are examples of artists who

worked such subjects for exclusively artistic motives. Ingres's nonreligious stance is somewhat ironic in that it was primarily through his admiration of the religious frescoes of the fourteenth-century Italian "primitives," and through his teaching, that an entire generation of French "Pre-Raphaelite" religious muralists (like Flandrin) was prepared for the task of

composition was one of seventeen cartoons representing patron saints of the royal family created by Ingres for the stained-glass windows of the chapel of Saint Ferdinand, built on the site of the 13 July 1842 carriage accident that killed the thirty-two-year-old crown prince. In these designs Ingres employed a primitive style that recalls not only medieval stained glass but also Byzantine mosaics and Gothic architectural sculpture.

The tendency to introduce exoticism and sensuality into the realm of religion (as in Vernet's *Agar chassée par Abraham*) is typical of July Monarchy religious images. Such a tendency is the primary inspiration of the two watercolor sequences by Dominique Papety mentioned above, *Saint Cyprien et Sainte Justine* and *Saint Marie l'Egyptienne,* which illustrate stories based on the *Legenda Aurea,* a medieval collection (cat. nos. 141 and 142; see also Plates 24 [cat. no. 141A] and 25 [cat. no. 142B]). *Une Pèlerine soutenue par un religieux* (A pilgrim being supported by a monk; Plate 34 [cat. no. 151]) by the Lyon painter Bonnefond implies by a subtle gesture and the proximity of the two figures a possible breach of the boundaries between the worlds of the flesh and the spirit by the Franciscan and the woman.

Religious Genre

Bonnefond's combination of religious figures, genre presentation, and Italian scenery represents another of the distinctive subjects prevalent in these years, as does Edouard Picot's *Episode de la peste de Florence* (Episode from the plague in Florence; Plate 36 [cat. no. 153]) from the Salon of 1839. A mother with a baby in her arms is shown kneeling in an attitude of prayerful intercession before the body of her dying daughter, in a reference to the great plague of 1348. The historic reference was intensified by the French memory of the 1832 cholera epidemic. Such motifs—which defy standard subject categorization—

Figure 3–8. Jean-Auguste-Dominique INGRES, *Sainte Amélie, reine de Hongrie* (Saint Amélie, queen of Hungary). See cat. no. 127B.

decorating Parisian churches under the patronage of Louis Philippe's government.

Ingres's *Sainte Amélie, reine de Hongrie* (Saint Amélie, queen of Hungary; Figure 3–8 [cat. no. 127B]) honored the queen by endowing her patron saint with her own likeness. This

Figure 3–9. François-Marius GRANET, *La Religieuse malade* (The ailing nun). See cat. no. 143.

entered the history painting repertoire also in the works of Léopold Robert, Victor Schnetz, and François Granet. From the Salon of 1824 onward they were a constant feature. Most often these works, such as Granet's *La Religieuse malade* (The ailing nun) from the Salon of 1831 (Figure 3–9 [cat. no. 143]), were done at a *cabinet*-scale. However, the artists also introduced the novelty of executing such scenes on a grand scale. Picot's *Episode de la peste de Florence* is the largest painting in our exhibition.

Heinrich Heine's 1831 Salon review responded to a painting that is one of the direct sources for Picot's 1839 composition, Victor Schnetz's *La Vœu à la Madone* (The vow to the Madonna; La Rochelle, Musée des Beaux-Arts). It represents peasants imploring a miraculous cure from the Madonna for a boy affected with tetanus. Heine comments on how much simpler the difference between genres had been in earlier times when subjects drawn from the Bible,

from legends, and from history were easy to distinguish from subjects of everyday life. He attributed the new confusion to a decline of interest in traditional sacred subjects, combined with a desire for more intimacy and realistic detail. He saw an excuse for painting picturesque costumes: "Our modern frock . . . coat is really so very prosaic . . . that one can only use it as a caricature. . . . Other painters . . . choose for models populations from which progressive civilization has not stripped their originality or national garb."[16] Janin in 1839 equated this mixed genre in painting to a literary genre blending the elements of history, the novel, and poetry in an infinite number of possible proportions.[17]

Literary Subjects

Literary subjects as a whole enjoyed a great popularity at the Salon of 1839. France had a passionate addiction throughout the twenties and thirties to English literature, English history, and Goethe. This addiction is seen, for instance, in the extraordinary popularity of the historical novels of Walter Scott. Their pages held not only events and figures of profound interest to a history-curious society, but also a wealth of descriptive detail about the material side of life in other times: what people did, what their homes were like, how they spoke, how they dressed, what they fought about, what they believed in, and—most entertaining—whom they loved. These accounts, told by a fictional observer of the lower class, found universal favor. The educated admired Scott's erudition, while all social strata loved his use of local color, description, and melodramatic anecdotes.

Scott's historical novel, by format and

16. Heine, 1831 Salon review, cited by Elizabeth Gilmore Holt, *The Triumph of Art for the Public 1785–1848: The Emerging Role of Exhibitions and Critics,* 307.
17. Janin, "Salon de 1839," pt. 6, "Tableau de Genre," *L'Artiste,* 2d ser., 2 (1839): 285.

Figure 3–10. Alfred JOHANNOT, *Charles le téméraire* (Charles the bold). See cat. no. 66.

methods, is the primary literary source of the *genre historique* in history painting. Both were equally popular in the arts. Both directly reflect bourgeois tastes and were dependent for their proliferation on a new literate, commercial society.[18] By the early thirties, the Scott repertoire was so well known that a Salon audience would have found the stories recognizable without a catalog entry. Alfred Johannot's *Charles le téméraire* (Charles the bold; Figure 3–10 [cat. no. 66]) was one of a group of eight vignettes in oil of Scott subjects shown as a unit in the Salon of 1831. In the Salon of 1839 paintings from Scott were still numerous; one of the most notable was Tony Johannot's *Mort de Julien d'Avenel* (Death of Julien d'Avenel; Salon no. 1089) from Scott's novel *The Monastery*.

Shakespeare appealed to the French as a genius whose works were in no way subser-

vient to the rules of classical tragedy. Complete French translations of Shakespeare by Pierre-Prime-Félicien Le Tourneur and by François Guizot and Amédée Pichot were published in 1787 and 1821. From September 1827 the English troupe of Fanny Kemble and Harriet Smithson performed a Shakespeare repertoire (in English) at the Odéon, playing to a full house for more than a year. Hugo, Vigny, Dumas, Berlioz (who later married Smithson), Delacroix, Boulanger, and the brothers Devéria and Scheffer often attended.

Delacroix recognized in Shakespeare a kindred spirit. Shakespeare offered heroes and heroines suffering their tragic destinies as the direct consequence of a situation with no other solution. Delacroix did not so much illustrate these themes as reconstruct them from the inside out, analyzing the motives, envisioning the whole anew.

In 1839 Delacroix sent two paintings with Shakespearean subjects to the Salon. *Cleopatra and the Peasant* (Figure 3–11), based on *Antony and Cleopatra* 5.2, is a three-quarter profile view of the queen resting her chin on the back of her hand as she contemplates her death. To her right, a peasant approaches with the basket of figs and the asp. The work is brutally Caravaggesque in its realism, dark drama, and truncated composition. The format gives unusual prominence to the intruder. Delacroix's other Shakespearean subject that year, *Hamlet* (Salon no. 525), was purchased from the 1839 Salon by the duc d'Orléans. An earlier version, *Hamlet au cimetière* (Hamlet in the cemetery), had been rejected from the Salon of 1836.

Louis Boulanger's *Le Roi Lear et son fou pendant la tempête* (King Lear and his fool during the storm; Figure 3–12 [cat. no. 68]) was also refused from that same Salon. Boulanger, always an artist with an eye to commercial success, published his *Lear* immediately as a reproductive print and made more profit than

18. See Beth S. Wright and Paul Joannides, "Les Romans historiques de Walter Scott et la peinture française, 1822–1863."

Figure 3–11. Ferdinand-Victor-Eugène DELACROIX, *Cleopatra and the Peasant.* Oil on canvas, 1838. The Ackland Art Museum, University of North Carolina at Chapel Hill.

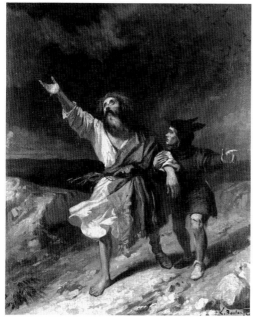

Figure 3–12. Louis BOULANGER, *Le Roi Lear et son fou pendant la tempête* (King Lear and his fool during the storm). See cat. no. 68.

he could have earned with a medal at the Salon.

The German *Sturm und Drang* provided another foreign literary impulse for French artists. Toward the end of the 1820s Goethe's *Faust* was much in vogue. In 1828 two French translations appeared, one by Gérard de Nerval, the other by Albert Stapfer. The latter was illustrated with lithographs by Delacroix that captured the artistic imagination of his generation. Goethe's world, like Scott's, was rich in medieval color and action; like Shakespeare's, it placed an emphasis on the individual and exalted emotions. Several theater productions of *Faust* with music were performed in Paris in the late twenties, culminating in Berlioz's first version of *Faust.*

No artist was more devoted to Goethe as a literary source than was Ary Scheffer. A native of the Dordrecht, Scheffer could read and write German. He sent his first two paintings from *Faust* to the Salon in 1831. They were purchased by Louis Philippe. To the Salon of 1839 he sent five paintings, four of which were based on Goethe: *Mignon exprimant le regret de*

la patrie (Mignon expressing her longing for home; Salon no. 1896) and *Mignon aspirant au ciel* (Mignon longing for heaven; Salon no. 1897), from the early ballad *William Meister's Lehrjahre; Faust apercevant Marguerite pour la première fois* (Faust seeing Marguerite for the first time; Plate 35, cat. no. 152); and *Le Roi de Thulé* (The king of Thule). The first two were in the collection of the duc d'Orléans at the time of the Salon.

Faust apercevant Marguerite pour la première fois is typical of Scheffer's distinctive style. The artist's primary emphasis in such works is on facial expression rather than bodily action. Delécluze compared Scheffer's Marguerite "to a rose that never blooms, who came into the world to taste a poisoned happiness, to cry, and to die, fragile, languid." He added, "Those who love *sentimental* genre find in it a high degree of perfection."[19] Given the number of Scheffer's paintings purchased by the king, the queen, and the duc d'Orléans, one must assume that such sentimentality was the order of the day.

Scheffer presents his Marguerite as Goethe did, innocent and chaste, having just said her prayers at the church. She is shown descending the steps. She is calm and simply dressed, with a face clear of all passions or care. Her glance is directed downward, yet she knows that someone is watching her. To her side a child carries a prayerbook. Behind her are an old man, an old woman, and a young peasant, each leaving their prayers to go back to the real world. Doctor Faust appears accompanied by his terrible guide, having already assumed his second youth. At the sight of Marguerite, he stops, stares, admires her. His entire destiny is revealed in his look, and thus her destiny as well.

Delécluze characterized the gallery with Scheffer's work at the Salon as a kind of *poésie*

at the opposite extreme from Vernet's opening trumpet blast at the Salon entrance.[20] The sense of suspension from the real world in a sweeter, timeless place pervades Scheffer's literary and religious paintings. Yet like most of his *juste-milieu* colleagues, Scheffer learned to be a "man for all seasons" capable both of monumental historic orchestrations in the noble history style and of bourgeois portraiture.

One might expect that with this literary enthusiasm in the ranks of history painters, there would have been an equivalent interest in representing subjects from contemporary French literature. In fact, such entries were rare. Baron de Steuben's *Esmeralda* (Nantes, Musée des Beaux-Arts, Salon of 1839, no. 1942) was from Victor Hugo's *Notre-Dame de Paris*. Critics complained that nothing happened in it—the heroine was just there. The same is true for Court's 1844 painting *Rigolette cherchant à se distraire pendant l'absence de Germain* (Rigolette trying to amuse herself during Germain's absence; Plate 40 [cat. no. 164]) after Eugène Sue's serial novel *Les Mystères de Paris* (The mysteries of Paris; cat. no. 86). The work has no narrative other than what the viewer brings to it. With her young lover in prison, Rigolette is forced to divert herself. The melodrama resides entirely in the mind of the beholder.

Scenes from the Lives of Artists

Immensely popular from the thirties into the forties and fifties were subjects derived from the biographies of famous persons, especially scenes from the lives of artists. Such life stories were particularly suited for rendering as intimate anecdotes in the manner of the *genre historique*. In the Salon of 1839 there were paintings on the lives of Molière (no. 490), Giotto (nos. 479, 1702), Tasso (no. 1003),

19. Delécluze, *Journal des Débats*, 7 May 1831.

20. Ibid., 7 March 1839.

Figure 3–13. Jules ZIEGLER, *Giotto dans l'atelier de Cimabue* (Giotto in Cimabue's studio). See cat. no. 147.

Dürer (no. 1055), Christopher Columbus (no. 1228), Ribera (no. 1242), and Dante (no. 1754). Such subjects satisfied the enthusiasm for history and served to counter a nineteenth-century image of the artist in society as a bohemian—a fringe character of disreputable, troublesome type. Episodes showing the personal lives of artists and presenting artists as cherished intimates of kings had been popular in the Restoration Salons, but they reached their peak in the July Monarchy. Whereas earlier works had typically been executed on a small *cabinet* scale, such subjects were now adapted to life-size figures. Brief biographical incidents were readily available, and they were perfectly attuned to the anecdotal genre. Vasari was the traditional source, although prior to 1842 one had to read him in Italian. Other

newer publications, reflecting the contemporary popular interest in the history of art, were easily accessible, such as Landon's *Vies et oeuvres des peintres les plus célèbres* (The lives and works of the most famous painters) and Stendhal's *Histoire de la peinture en Italie* (History of painting in Italy). *L'Artiste* and *Le Magasin Pittoresque* regularly featured accounts of the lives of the Old Masters—plagiarized from earlier sources.[21]

For the most part, depictions of the Italian "primitives" were limited, while artists of the sixteenth and seventeenth centuries were frequently shown. One of the earlier stories that was a constant theme was Cimabue discovering the talents of his student Giotto. No doubt the idea appealed to every artist who wanted to imagine the pleasure of an early recognition of precocious artistic talent. Ziegler's *Giotto dans l'atelier de Cimabue* (Giotto in Cimabue's studio; Figure 3–13 [cat. no. 147]), from the Salon of 1833, shows the young apprentice regarding with admiration the illuminations of a medieval manuscript open before him. In the background, Cimabue, palette in hand, is astonished by the lad's discerning eye and studies him with emotion. This was a variation on the more usual representation of Giotto's drawings being admired by the master.

Two Artists Absent from the Salon of 1839: Ingres and Delaroche

Considering works of two major artists not represented in the Salon of 1839 will help us understand the aesthetic and practical issues facing all French history painters in the middle years of the reign. J.-A.-D. Ingres did not participate because he had gone off to Rome in a huff after the Salon of 1834, swearing he would never again exhibit for the public or

21. Francis Haskell, "The Old Masters in Nineteenth-Century French Painting."

Figure 3-14. BENJAMIN, *Paul Delaroche,* from *Panthéon charivarique* (A *Charivari* pantheon). Lithograph. New York, The New York Public Library. See also cat. no. 109.

work for the government. Delaroche was also missing. He was directing his efforts toward the completion of the *Hemicycle* for the Ecole des Beaux-Arts. His absence was so significant that Jules Janin gave the artist as much attention in his Salon review as if he had been there, perhaps because his spirit was:

M. Delaroche, the great playwright, is to be remarked among those absent this year. It is a great disappointment for the popularity of the Salon. Each year, in effect, M. Delaroche attracts the crowds to the Louvre, where they rush in as they would for a free theater performance. In his abilities to render dramatic emotions and set the scene he surpasses M. Victor Hugo, and even M. Alexandre Dumas, the most famous of our melodramatists. . . . Who wouldn't give all of the last acts of Alexandre Dumas for the *Duc de Guise assassiné* with the king coming in from behind the

Figure 3-15. BENJAMIN, *Ingres,* from *Panthéon charivarique* (A *Charivari* pantheon). See cat. no. 109C.

door, without daring to approach that terrible body? . . . No one knows better how to arrange pity and terror than M. Paul Delaroche, no one dresses his characters better, or whets his swords and daggers so well. Ah yes! That is why the absence of M. Paul Delaroche necessarily caused a great void in this exhibition.[22]

Delaroche was caricatured by Benjamin standing with a shovel in a cemetery (Figure 3-14), an allusion to the unearthed subjects with which he had built his artistic fame. Benjamin's caricature of Ingres (Figure 3-15 [cat. no. 109C]) shows the great champion of the classical school preaching the gospel of Raphael to his initiates in a pose that captures his pompous, irascible personality.

Before Ingres left Paris for six years in Rome (accepting the duties of the director of

22. Janin, "Salon de 1839," pt. 1, *L'Artiste,* 2d ser., 2 (1839): 216.

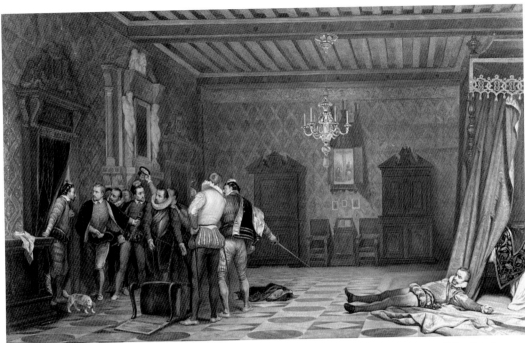

Figure 3–16. Hippolyte, called Paul DELAROCHE, *Assassinat du duc de Guise* (Assassination of the duc de Guise). Oil on canvas, ca. 1835. Chantilly, Musée Condé.

the French Academy as an honorable exit from the battlefield), he took on a private commission from the duc d'Orléans to paint a pendant to a work the duke had ordered from Delaroche. Delaroche finished his canvas in time for exhibition at the Salon of 1835. Ingres was still working on his during the Salon of 1839; it was finally delivered in August 1840. A close comparison of the two paintings provides an informative contrast.

Delaroche's painstakingly crafted *Assassinat du duc de Guise* (Assassination of the duc de Guise; Figure 3–16) pleased the duc d'Orléans so much that he awarded the artist ten thousand francs—double the original fee. The theme may have been selected because of its connection to the royal château of Blois. In 1588, the throne of Henry III had been threatened by the duc de Guise, the leader of the Roman Catholic party and a popular figure with the people. Plotting revenge, the king arranged for the duke to be lured into the

king's bedroom at a meeting of the Estates General at the château of Blois, where he was killed.

Delaroche shows Henry III entering from the left, as if onstage, after the deed has been done. The body of the duc de Guise is angled back into space with his feet directed toward the viewer. The tragedy is narrated with minor details at a comfortable distance. Our empathy is not invited. The center stage is empty.

So popular was the painting with the crowds at the Salon that getting near it was difficult. But there were inherent dangers in this type of painting, and one critic warned against a distracting richness of decoration: "This capacity for the artist to treat serious subjects in miniature, to give grace to an assassination, can become fatal to pathos and grandeur in the arts."[23]

23. "Salon de 1835," *Le Constitutionnel*, 30 March 1835, cited in Norman Ziff, *Paul Delaroche: A Study in Nineteenth-Century French History Painting*, 151.

Figure 3-17. Jean-Auguste-Dominique INGRES, *Antiochus et Stratonice* (Antiochus and Stratonice). Oil on canvas, 1840. Chantilly, Musée Condé.

In Rome, Ingres deliberated over how he would match Delaroche's success. In keeping with the period's eclecticism, he had not been asked to paint a subject that was a complement to the other work thematically. Instead, it was evidently determined at the time of the original commission that Ingres would deliver the antique love story of Antiochus and Stratonice, a motif he had begun many times but had never completed. How he revised it shows how well this champion of the classical school understood the taste of his time. He drove himself nearly insane trying to get the composition resolved; when he finally did, the result was so perfect that it made possible his triumphant return to Paris.

The story is from Plutarch. It tells of the fervent love of Antiochus for his father's second wife, Stratonice. Unable to deny or to express his feelings, he saw death as the only solution, and so turned away all nourishment and prepared to die. Only the doctor suspected the true cause when Stratonice entered

the room and the young man's pulse quickened.

In earlier versions of the subject, Ingres concentrated on the central figures, shown at large scale across a frontal plane. The background was insignificant compared to the facial expressions, which told all. In this painting (Figure 3-17) the priorities had to be shifted. As Delaroche's narrative was set in a deep box-stage interior, richly detailed in architectural accessories, so too was Ingres's. He surpassed Delaroche in transforming the picturesque interior into a fully rendered evocation of Pompeian splendor. The figures were then reduced in scale, and their rhetorical gestures were aggrandized to emphasize the story line.

Ingres knew precisely what he was trying to accomplish with this painting, which he called his *grande miniature historique*.[24] When he

24. Letter to Edouard Gatteaux, 27 November 1837, cited in Henri Delaborde, *Ingres, sa vie, ses travaux, sa doctrine, d'après les notes manuscrites et les lettres du maître,* 216.

finally had every element polished to perfection, he was beside himself with worry until he had word from Paris regarding its reception. The duc d'Orléans said it was a masterpiece without equal in all of France, and he sent the artist eighteen thousand francs and a personal letter. The painting was exhibited at the Tuileries for four days, then shown at 4:00 each afternoon at the Société de Paris; finally, it was sent to Saint Cloud for the royal family to see. The journals were filled with articles singing its praise. The master of the old school of history painting had played the new game of "historical subjects" most carefully, and he had won.

The stark drama and grave simplicity of history painting in the tradition of David were by now transformed. We are presented with scenes that appeal to our fascination with intrigue or romance, rather than instructing in ancient virtues. Compositions are less centrally focused, and the figures relatively smaller. Emphasis is placed on the detailed—and "accurate"—depiction of richly decorated settings. In short, under the influence of new audiences and new taste, history is domesticated.

4 EARLY REALISM

During the opening years of the July Monarchy, the country was racked with strife, assassination attempts, and civil uprisings, all of which signaled a gloomy future. In the visual arts a few painters were influenced by the era's creeping disillusionment and advanced new ways to examine society, ways that have not received the attention they deserve from art historians or historians. In looking at their environment, these painters created a type of proto-realism—a version of a style that was once thought to have emerged only after the Revolution of 1848—that presents the same inconsistencies in approach and differences in thematic content as the works completed after 1848.[1] In arguing that a form of early realism was markedly apparent in the public exhibitions of the July Monarchy, it is essential to look at the canvases and drawings of four artists whose works, for different reasons, encapsulate varied aspects of the realist doctrine of the time.

On one side are the fervent republican political statements of Philippe-Auguste Jeanron (1808–1877) and Charles Joseph Traviès (1804–1859). Social issues mixed with religious sentiment, as mirrored in paintings by Louis Trimolet (1812–1843), occupy the middle ground, while at the other extreme are objective realist images of France's new industry. Instances of realism in the service of the state are best represented by the neglected

drawings and paintings of François Bonhommé (1809–1881).[2] The most affecting of these images, those by Jeanron and Traviès, were also the works that confronted Louis Philippe and the Salon audience with the miserable conditions of French society. These depictions of destitution contributed to a strong political critique of the regime.

Largely blind to the needs of the poor, especially during the opening years of his reign, Louis Philippe found his regime undermined by oppressive social conditions and issues that accentuated the weakness and corruption of his rule.[3] To many, in particular those caricaturists who in 1831 were preparing lithographs for *La Caricature* (see Figure 4-1), it was apparent that the social order that had been ostensibly ushered in during the trium-

1. For a discussion of varied approaches to realism, largely after 1848, see Gabriel P. Weisberg, *The Realist Tradition: French Painting and Drawing, 1830–1900*. While attention has been directed to early examples of proto-realism, especially to drawings by Jeanron, the inability to locate a number of these early works has hampered the argument over the existence of a strong proto-realism. For further discussion of the use of proto-realist terminology, see Linda Nochlin, *Gustave Courbet: A Study of Style and Society*, 108ff.

2. For a discussion of the tendencies that led to realism, see Léon Rosenthal, *Du romantisme au réalisme: La peinture en France de 1830 à 1848*, esp. the section "Vers le réalisme," 345ff. The issue of the lower classes' misery under the July Monarchy is discussed by Robert Bezucha in "Misery in the July Monarchy." I am indebted to Bezucha for sharing his insights when his article was still in manuscript form. Statisticians and historians gauged misery in a way that at the time proved new to France. For an assessment of the use of statistics as a political necessity, see Aaron Sheon, "Parisian Social Statistics: Gavarni, 'Le Diable à Paris,' and Early Realism," 139ff. Sheon bases much of his interpretation of urban squalor on such nineteenth-century tracts as Louis Chevalier's *Laboring Classes and Dangerous Classes in Paris during the First Half of the Nineteenth Century*.

3. For further reference to conflicts within the July Monarchy, see Hugh Collingham, *The July Monarchy: A Political History of France, 1830–1848*. A detailed examination of the visual images published during the July Monarchy that negatively commented on the rule of Louis Philippe would center on many of the public issues and personalities that provided a demeaning aura to the regime. These images, collected during the nineteenth century and drawn from innumerable sources, are housed in the Musée Carnavalet, Paris. Further comment on the weakness of the regime is found in James Cuno, "The Business and Politics of Caricature: Charles Philipon and La Maison Aubert," 95–112.

Figure 4–1. Philippe-Auguste JEANRON, *Il meurt
d'inanition pour avoir vécu trop longtemps d'espérance* (He
dies of hunger for having lived too long on hope).
Lithograph, 1831. Paris, Musée Carnavalet.

phant July Days had been perverted. The
hope for new liberal laws, which had roused
the insurgents to the street barricades, had
been frustrated. Those who had felt enthusi-
astic and apparently liberated in July 1830
now saw themselves as disappointed street
fighters who had been led astray. The few
paintings of social events that made it into the
Salon, such as *Les Petits Patriotes* (The little
patriots; Plate 28 [cat. no. 144]), revealed that
even the youths who aped their elders on the
barricades had been ill advised to follow that
course of action. Even though they only took
to the barricades in mock imitation, the chil-
dren of the nation, or more correctly "les
enfants de Paris," had been badly served by
events that transpired around them. Escape
was not through direct confrontation but

through a romantic glorification of battle.

By the early 1830s, the same artist who had
completed *Les Petits Patriotes* for the Salon had
begun to prepare drawings that would culmi-
nate in *La Caricature* in the image of a defeated
street fighter. Philippe-Auguste Jeanron, among
many others, was sadly disillusioned by what
had occurred in French society. The images
he created generally chronicle the stifling of
civil liberties as they maintain a decided sym-
pathy for the lower classes, who were seen by
those in power as becoming more militant and
dangerous.[4]

Censorship of Realism in 1830

If those in power still believed in the essen-
tially idealistic goals of the July Days, it would
have seemed politic to allow artists the oppor-
tunity to chronicle the malaise of society as a
way to continue the fervor of 1830. In the
months immediately after the July Revolution,
however, and in the days before the next offi-
cial Salon (that of 1831), the opposite proved to
be the case. The social unrest and dissatisfac-
tion within the nation, which led to the am-
bience of *misérabilisme,* became quite diffi-
cult to identify in the paintings and drawings
publicly exhibited in the early years of the July

4. Philippe-Auguste Jeanron remains one of the more
mystifying figures in the annals of early realism, for he
has received only scant attention in art-historical liter-
ature. The most effective study of Jeanron and his
career continues to be the doctoral dissertation by
Madeleine Rousseau, "La Vie et l'oeuvre de Philippe
Auguste Jeanron, peintre, écrivain, directeur des
Musées Nationaux, 1808–1877." Rousseau was able to
consult some of Jeanron's relatives and piece together a
partial evaluation of his work and career. Jeanron was
placed in the context of realism by Nochlin in *Gustave
Courbet,* 108ff, and by Weisberg in *The Realist Tradition.*
Specific paintings have of late entered the art market
and have formed the focus of recent research on
Jeanron, including Marie Claude Chaudonneret's
"Chartres, Musée des Beaux-Arts, Jeanron et 'l'art
social': *Une Scène de Paris,*" and the more general work by
Marie Martine Dubreuil, "Philippe Auguste Jeanron."
No comprehensive study of Jeanron's work within
modern times has appeared because of the difficulty in
locating his early paintings and drawings.

Figure 4–2. Philippe-Auguste JEANRON, *Wounded Man*. Drawing, 1831. France, Private Collection.

Monarchy.[5] This leads to questions as to why a visualization of the lower classes' difficulties would have proved problematic.

A study of works recorded in the official Salon *livrets* of the early 1830s does not yield a wide range of artists involved with social themes. Realist images—themes that involved a direct and often brutal rendering of daily events—are more readily apparent in some of the graphic arts than in painting and sculpture, which were given pride of place in public exhibitions. A possible reason for this situation, and one that can be documented in the example of Jeanron, is that those images considered as being too harsh or as favoring revolutionary causes were either censored through rejection by Salon juries or placed in locations within a Salon that relegated them to oblivion.

One instance of this occurred in the Salon of 1831. Jeanron, an artist with ardent republican sympathies who undoubtedly fought on the barricades in July 1830, submitted three works to the annual Salon. Only one was eventually accepted: *Les Petits Patriotes.* This painting, with its strong allegorical overtones of the regeneration of France through its youth, could be seen as a patriotic canvas. The other works Jeanron submitted—both drawings—proved far more disconcerting and troubling.

In one (Figure 4–2), Jeanron focused on a member of the proletariat aiding a wounded comrade during the intense street fighting of 1830.[6] Its companion piece, a realistic portrayal of compassionate concern for the people, ultimately proved its undoing. That drawing (Figure 4–3), which showed emaciated figures huddled together in a poorly

5. For further comments on misery in the July Monarchy, see Bezucha, "Misery in the July Monarchy." Paintings with such themes that were submitted to the Salon may have been rejected on a regular basis, or artists may have been unwilling to produce images that were not destined to receive support either publicly or from an appreciative collector. Such images were completed nonetheless, as Jeanron's works provide ample evidence that he was consistent in what he wanted to provoke. This perseverance might have influenced the paintings and drawings of other early proto-realists.

6. This drawing, not publicly seen for over a century, was housed with a collection of watercolors by Paul Huet, an artist with strongly republican sentiments who was well established within the July Monarchy. Huet was closely linked to both Jeanron and Honoré Daumier, which also suggests how he obtained such significant drawings. The current location of this drawing remains unclear despite repeated attempts by the author to study the work in detail. Other drawings from the episodes of 1830 have been reproduced as *Combattants de Juillet, 1830,* in *L'Art* 5 (1876): 190. One of the reproduced drawings resembles the young street fighters in *Les Petits Patriotes,* implying that there could be an entire series of unlocated drawings for this and other paintings. According to Chaudonneret, "Chartres, Musée des Beaux-Arts," 319, Jeanron's two drawings for the 1831 Salon were entitled *Homme blessé* and *Homme expirant,* works that were discussed by the critic V. Schoelcher in "MM. Delacroix, Léon Cogniet, Decamps," 228, who notes that one drawing was entitled *1830* and showed a wounded man on a barricade. This documentation is slightly contradicted in "Tableaux présentés au Salon par Philippe Auguste Jeanron, 1830–1852," in which the 1830 drawing is found under the title *La Place publique* as being rejected along with a second drawing entitled *Le Grenier.*

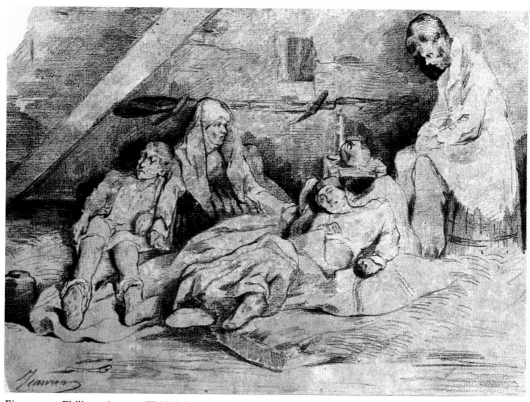

Figure 4–3. Philippe-Auguste JEANRON, *Dying Man.* Drawing, 1831. France, Private Collection.

furnished attic, was interpreted by one critic, who saw the works as they were presented to the Salon jury, as a continuation of the story outlined in the first image. The critic concluded that the first drawing represented 1830 and the second image 1831, thus implying that the wounded fighter was now dying in his attic not only from his injuries but also from neglect, starvation, and the intense misery and gloom that pervaded the environment.[7] Since Jeanron may have been trying to draw parallels between events in 1830 and the situation of many in 1831, this interpretation, possibly developed from conversations with the artist, led to the jury's censoring of these works. Nei-

ther drawing was ever publicly displayed.

Even given the fact that the drawings emphasized the unheroic present and the terrible social conditions that plagued the proletariat, confusion remains as to why the images were not accepted.[8] There is the likelihood, especially in light of the critical mention of the drawings in *L'Artiste,* that writers had viewed the drawings either in a studio space where other artists of a republican persuasion could have shown them on Jeanron's behalf or that the works had become familiar to many artists since the themes they under-

7. Schoelcher, "Delacroix," 228 ("nous montrant le même homme expirant dans son galetas moins des suites de sa blessure que de la plus affreuse misère!"). This critic gave the second drawing the title *1831,* thus underscoring the lost illusions and frustrations that had emerged from the failure of the 1830 revolution to lead to fundamental social changes.

8. No notation in the Archives du Louvre explains why these drawings were rejected by the Salon. It should be added, however, that at the 1833 Salon most of the rejected works by Jeanron were drawings. This could suggest both that his themes were objectionable and that a general policy to limit the number of drawings in the Salons may have been in effect. Breaking this tradition, Jeanron had the watercolor *Jeune Fileuse* accepted by the Salon jury in 1834.

scored were obvious dilemmas of the day.

Whatever the situation, Jeanron was not forgotten. He was considered an artist with staunchly democratic opinions allied with the liberal left (recall his images in *La Caricature*) and a figure whose independence continually proved bothersome to the July Monarchy. Instead of burying his images in graphic publications, he produced increasingly larger paintings with social messages that were difficult to stifle fully. In fact, throughout the 1830s, Jeanron illustrated themes and helped to create a vocabulary for realist imagery that placed him at the forefront of those painters and draftsmen who chose alternate ways to present artistic ideas to the public.

A Street Scene—Paris

Jeanron's idealistic attachment to the causes of the people permeated the majority of his paintings during the 1830s and 1840s. He created numerous canvases that embodied a commitment to improving the conditions of the Parisian worker, to elevating the artisan in provincial centers, and to postulating a veritable *art social,* one that focused on the lives and mores of the lower classes.9 Appreciated by the more liberal critics and grudgingly acknowledged by those who accepted paintings for the annual Salons, Jeanron's works were at odds—both in style and in content— with the majority of images included in official exhibitions. His style appeared crude and awkward in comparison to the followers of Ingres; his use of color often seemed dour and gloomy next to works by those who preferred the romantic tradition. Yet Jeanron was not really interested in creating pleasing pictures, for his paintings and drawings contained messages that he wanted to convey intelligently to

a broad public. Thus, through works that were occasionally rejected during the July Monarchy and today have often been neglected or lost, Jeanron became a primary proto-realist.10 While not alone in his efforts or avocation, Jeanron was extremely visible and outspoken, a position that eventually led to his appointment as director of the Louvre and the National Museums of France at the time of the 1848 Revolution.11

Since so many of Jeanron's works cannot be found, it is significant that a crucial painting from the 1830s be studied and placed within the context of social change. In 1833, in time for the annual Salon, Jeanron completed the strongly propagandist *Une Scène de Paris* (Plate 29 {cat. no. 146]). Described by some of the critics who saw it (and only a very few actually mentioned it in their reviews) as a dismal, haunting depiction of an outcast family, the painting further labeled Jeanron as a leader of those who used their canvases to address social ideas that were not completely favorable to the government or to the different classes in society.

In this image of social outcasts and beggars, Jeanron indicated through the hat and emblem worn by the father that this family had originally displayed valor and heroism in 1830.12 The father had surrendered his youth, fought on the barricades, believed the promises of the day, and in the end won nothing.

9. For reference to Jeanron's involvement with a series of drawings that focus on the proletariat, see Théophile Thoré, "Le Salon," 2. This series has not been located.

10. His works during the 1830s include such images as *La Pauvre famille* (a drawing rejected by the 1833 Salon), *Pauvre famille* and *Mendiant* (two paintings exhibited at the 1836 Salon), and *Condemned Criminals* (a painting exhibited at the 1840 Salon).

11. For further reference, see Jules Raymond, "Une Dette nationale," 189–91. This article appeared as a special sale was being arranged to raise money to assist Jeanron, who had fallen on hard times.

12. For elucidation of this point, see Chaudonneret, "Chartres, Musée des Beaux-Arts," 317. While Chaudonneret correctly links the major figures to the events of 1830, she underplays the general influence this work would have had on the realist tradition of "destitute types." For further continuation and visualization of such themes, see Weisberg, *The Realist Tradition,* and Marilyn R. Brown, *Gypsies and Other Bohemians: The Myth of the Artist in Nineteenth-Century France.*

Even more heartrending and frustrating is that his actions also led to the demise of his family, a point implied in the drawings of 1831. This image thus becomes a prototypical example of a "fallen family" that is in such distress that it is forced to beg in the streets of Paris and along the quays of the Seine.

The feeling of destitution is further reinforced not only by the torn, dirty clothes that each person wears but also by the small wicker basket at the left, which may have held the flowers the young daughter sells to earn a few sous to survive. As a depiction of urban misery, this painting has few parallels in the early iconography of the July Monarchy. On another level, the painting offers a second message: that Paris was a decaying slum filled with homeless and poverty-stricken families whose lives consisted of battles with disease and filth. The section of the city Jeanron memorialized was in actuality a part of the environment that was infected. It was there, near the bridge in the background, that the veterans of 1830 tried to eke out an existence.

This historic painting also emphasizes another point: class discrimination. Jeanron reinforced the plight of these family members, who are so poor and exhausted that their bodies seem weighted with a malaise far beyond their years, not only through his depiction of the central figures but also through the contrast between them and the far wealthier group that moves briskly away from the foreground. By placing the second group at the right and in a position of being unsympathetic observers, Jeanron provided another dimension to his social art. These representatives of the growing leisure class, who were materially profiting from the reign of Louis Philippe, appear oblivious to the narrative that has unfolded before them. They neither share their wealth nor help to alleviate the hardship this family endures. Curiously, and a point missed by commentators in 1833, the locale in which these penniless figures have been

placed corresponds to a location where Louis Philippe and Queen Marie Amélie often strolled, the Tuileries Gardens in Paris. By implication, then, the question remains of whether Jeanron was doing more than castigating the wealthy middle class. Could he have been pointing a finger at the bankrupt policies of the king and queen, who often refused to do anything for such groups, even when they were dramatically underfoot?[13] If this was the case and if Jeanron was again striking out against an insensitive central administration, then this becomes another instance of a work in the annual Salon that chastised the policies adopted by the rich at the expense of the poor and further reinforced an atmosphere of disillusionment.

As an example of the introduction of realist themes into the Salon, this canvas also was significant in the evolution of populist iconography.[14] The painting in terms of both

13. Chaudonneret, "Chartres, Musée des Beaux-Arts," has identified the bridge in the background as the pont de la Concorde, a point reconfirmed by the architectural historian Bernard Marrey in conversations with the author in Paris during the summer of 1988. Chaudonneret also suggests that the building at the far left is the House of Representatives. She does not satisfactorily identify, however, the strolling figures at the right beyond calling them members of the wealthy middle class. In discussions with the author, Bezucha has convincingly identified the location of these figures and has drawn inferences that it was a popular place for Louis Philippe and his retinue to walk casually. Strolling middle-class figures appear in other, later realist images, especially in canvases by Gustave Courbet, for example his *Firemen Going to a Fire* and *The Artist's Studio*. Jeanron, however, used these types to demonstrate their fundamentally uncaring attitude toward the destitute since they are seen from the back and they move quickly away from the contaminated proletarians in the foreground.

14. Ibid., 319. Chaudonneret correctly assumes that social ideas within Jeanron's painting make it read like a text and force the consideration of this painting as more than a record of the concrete and the immediate. These ideas refer to the artist's understanding of social themes, especially the anonymous hero who has been deceived and ultimately ruined by his faith in an unyielding idealistic system. What Chaudonneret fails to acknowledge is that Jeanron's visual style contains elements of romantic sentimentalism (note the large eyes of the children), which allowed him to create types

theme and style established Jeanron early in his career as being sympathetic to the down-trodden in society. Through a sentimental treatment of this family and the use of dark, gloomy colors, Jeanron created a distressing image that implies social criticism of the failure of the Revolution of 1830 to benefit the lower classes of Paris. It turned out that he was not alone in advancing these issues in works destined for Salon exhibition.

The Populist Cause, Republicanism, and the Insurrection of 1834

A strong antagonism toward Louis Philippe during the 1830s came from liberal republi-cans and revolutionary activists who believed that the king was doing little for large portions of the country. They expressed concern that fundamental human rights, including personal liberties, were being seriously undermined by the new regime.[15] Opposition spread both in Paris and in the major cities of the provinces. Attempts to assassinate Louis Philippe in-creased as numerous secret societies stoked antagonism to his monarchy. New laws with seriously repressive overtones, such as those developed in Lyon in March 1834, were met with resistance and insurrection. When the four days of strife were followed by smaller sympathetic movements and the horrible mas-sacre in the rue Transnonain in Paris, it be-came obvious to intellectuals and republicans alike that Louis Philippe would do anything to maintain his power and to continue the illu-sion—for the rest of the world at least—that

the country was at peace.[16] An outgrowth of these insurrections was that those who were targeted as republican leaders were tried as a group and placed in prison, where they could no longer push for change or inflame others to take up the cudgels of opposition politics. In reality, then, by 1835 the liberal republican party had been reduced, and many of its lead-ers had been either imprisoned or forced to limit their attacks on the central administra-tion. These events were also mirrored in the type of images that some artists tried to ex-hibit in the annual Salons.

During the tumultuous days of 1834, the government carefully monitored the activities of those it considered dangerous. High on this list was Barbès (1809–1870), a republican with extremely outspoken views against Louis Phi-lippe. For his participation in the insurrection-ary activities of 1834, Barbès was imprisoned at Sainte Pélagie, the same detention area where Daumier and other caricaturists were placed for producing scathing images in their attacks on Louis Philippe. Barbès was set free due to lack of substantial evidence, only to be reapprehended after Giuseppe Maria Fieschi's failed assassination attempt on the royal family led to repressive measures aimed at members of the Parisian press and its car-icaturists. Again Barbès was released when it proved difficult to substantiate charges against him. Barbès's two stints in prison set many to thinking about his case and made him an able defender of those actually charged. He be-came a symbol of the oppressed revolutionary hounded by those in power for having con-trary ideas.

As a friend and colleague of a number of the artists and caricaturists of the time, especially of Traviès de Villiers, who worked extensively for Philipon on *La Caricature,* Barbès became the subject of a realist draw-

that appealed to emotions on a popular level. This ten-dency was also used by other realists in the early phases of their development, especially in the 1840s by Alex-andre Antigna, an artist with whom Jeanron should be more substantially compared.

15. For a discussion of some issues, see Edwin T. Bechtel, *Freedom of the Press and L'Association Mensuelle: Philipon versus Louis Philippe,* 27–40. Also see Bezucha, "Misery in the July Monarchy."

16. Bechtel, *Freedom of the Press,* and Charles Guigne-bert, *A Short History of the French People,* 2:551–78.

Figure 4–4. Charles Joseph TRAVIÈS, *Barbès en prison*. See cat. no. 84.

ing produced during one of his periods of imprisonment (Figure 4–4, cat. no. 84). Positioned against a stone wall in his cell, Barbès seems forlorn and contemplative, a leader of an insurrection pondering his fate while awaiting word of events. This work by Traviès is one of many the artist completed that inspired the young, emerging art critic Charles Baudelaire to champion Traviès as a major graphic artist and a draftsman of consummate power.[17]

The use of this drawing in the mid–1830s also raises significant issues about the role of realist imagery in reinforcing populist causes or personalities. On the one hand, the possibility exists that this drawing served as the basis for an oil painting by Traviès, which was purportedly rejected by the 1835 Salon jury, perhaps because the work's elevation of an insurrectionary leader to important status was

17. For reference to Baudelaire's evaluation of Traviès, see his "Some French Caricaturists." He wrote,

"Traviès, too, has had an ill-starred lot. In my opinion, he is an outstanding artist, and one who was not nicely appreciated in his own time."

deemed inappropriate for public exhibition.[18] On the other hand, since the image was also completed as a drawing—official Salons did indeed exhibit drawings, as Jeanron's submission of drawings in 1831 proved—it could have been the drawing itself that was rejected by the Salon jury.[19] This possibility is further bolstered by the fact that Traviès seldom completed oil paintings. He was more comfortable as a draftsman working in black and white. Whatever the status of the painting or drawing, Traviès's image of Barbès in prison did not go unknown.[20] It was apparently reproduced as a lithograph in *La Revue des peintres* (1835) and circulated widely as a reminder of Barbès's unjust malignment by the regime. The lithograph undoubtedly touched a nerve by demonstrating that liberal republicanism had its champions.

Curiously, other paintings by Jeanron also focused on the role of professional revolutionaries. With his portrait of Filippe Buonarotti,

18. For references to the supposed existence of a painting by Traviès that was rejected by the jury for the 1835 Salon, see *Exigences de réalisme dans la peinture française entre 1830 et 1870*, 25. Examination of documents from the 1835 Salon in the Archives du Louvre has not yielded reference to a rejected painting by Traviès linked to the theme of a political prisoner in jail. No such painting was listed in the Salon catalog of 1835.

19. No mention of the drawing was noted in *Exigences de réalisme*. Only a much smaller reproduction, developed as a lithograph after the primary image by Traviès, is reproduced. Similarly, a search of the Archives du Louvre has revealed no reference to a drawing by Traviès being submitted to the Salon and refused by the jury. Nevertheless, not every reference to attempted Salon entries has been preserved. The provenance of the drawing now in the collection of the Musée Carnavalet is similarly shrouded in obscurity. The drawing was secured from Prouté in 1911, but information on where the drawing might have been in the nineteenth century is not available. For further reference, see *Dessins parisiens de XIXe et XXe siècles (du Musée Carnavalet)*, 89.

20. The lithographic version was reproduced in *Exigences de réalisme*, 25. Currently on the art market is a drawing (on the same scale as the lithograph) with the figure of Barbès posed in the same direction as in the lithograph. It is likely that this drawing could have been completed over the lithograph or as a copy of it, which raises further questions about the availability of Traviès's work and how much it was appreciated at that time.

Jeanron immortalized an extremist whose roots in the revolutionary movement can be traced to Robespierre and the Reign of Terror. Buonarotti, honored as a hero of the first revolution, became a role model for figures such as Barbès. This type of painting, along with Traviès's drawing of Barbès, implies that a marked interest in glorifying professional revolutionaries coincided with the peaking of civil unrest during the July Monarchy.

The Realist Painter: A New Image

At this time some artists were developing themes derived from the condition of the lower classes and their frustration with the failed Revolution of 1830, while others were creating drawings of "fallen" colleagues of the insurrection as political statements. Still other painters were evolving views of themselves within their society that can be placed within the nascent realist camp. This self-image diverged from the cult of the romantic dandy—the creator as a self-proclaimed egotist—to rely on the evocation of humble truths and a compassionate rendering of individuals.

Painters (and some drafters) drew on their own responses to the contemporary scene and in turn displayed in their depictions an unusual fidelity to real events. By limiting flights of imagination, they grounded themselves in recording what was before them by stressing the details of humankind's daily existence. No subject proved too mundane. The realities of life led to a new artistic image, one that slowly emerged by the close of the 1830s.

While a fully ripened realism drawn from autobiographical experience was not widespread during the July Monarchy, some artists remained sincere in their responses to visual stimuli. Jeanron, for example, was inspired by what he witnessed, although how deeply he had been involved in some of the themes he painted in the 1830s is unclear. Perhaps his images had been animated only by his own

commitment to social causes or by travail
within his own family.[21] Such inferences as
suggested by his work cannot be carried fur-
ther without more information on Jeanron's
personal life. This, however, is not the case
with other of the proto-realists who, although
less conspicuous, did create major works in
the 1830s that drew praise and excited com-
ment.

One of these early proto-realists, Louis Tri-
molet, lived a miserable life.[22] As an orphan
supported by the state, Trimolet endured
destitution, and it remained deeply embedded
in his psyche, influencing his selection of the
theme for his one major Salon canvas. Trained
as a printmaker and highly regarded as an
illustrator of such books as *Chants et chansons
populaires de la France* (1843), Trimolet drew on
his childhood memories to formulate a vision
of the artist as itinerant craftsman. He con-
tinually garnered his themes from popular
literature, oral tradition, and the low social
class from which he had emerged. To survive,
Trimolet often had to scrape together funds
from a series of odd jobs, yet he maintained
the dream of succeeding as a painter whose
work would be honored at the official Salon.
Finally, after pooling his resources so he
would have time to work, Trimolet completed
in 1839 his only major canvas, the large-scale
Une Maison de secours (An almshouse; Plate 37
[cat. no. 155]).[23]

By situating the scene within a dark alms-
house run by Sisters of Charity, Trimolet
recalled an activity from his own background
and also emphasized the importance of Catho-
lic support of the poor. The penniless often
relied on the life-restoring generosity of the
nuns for food, clothing, and shelter, as is seen
in later realist images by Isidore Pils, for
example. If a family with a young child was
unable to support itself, as the scene at the
right of this composition suggests, the child
might end up a ward of the parish or city. The
role of the Sisters of Charity in helping the
poor escalated in midcentury France, for
religious orders took their social mission very
seriously. They often ministered to outcasts
and the unfortunate, and their activities were
recorded by several painters.[24] The sympathy
with which Trimolet imbued this scene and
the fact that it was a new theme for the annual
Salon brought him public recognition, espe-
cially at a moment when Louis Philippe was
trying to demonstrate greater sensitivity to
public issues and to improve ties with the
Church.

Despite the significance of the work and
Trimolet's receipt of a medal at the Salon for
it, the painting went unpurchased. Even offi-
cials of the state did not offer to acquire it,
possibly because they had no desire to put on
public display such a dour reminder of a
recurrent social problem. At the close of the
1839 Salon, Trimolet returned the work to his
studio, where it remained until his death in
1843. Since he was married to the sister of the
well-known painter Charles Daubigny, the

21. Considerable research into Jeanron's early years
remains to be done. It is known that he received the
"Croix de Juillet." His name appears on a list of *citoyens*
(published in *Le Constitutionnel* on 2/3 May 1831) who
were to be recognized for their republican activities
during the "glorious" days of July 1830. This special
award was developed by the government in December
1830 in recognition of what some *citoyens* had accom-
plished in and for the revolution.

22. Henri Béraldi, *Les Graveurs du XIXe siècle,* noted
that Trimolet lived a "miserable" existence. For further
reference, see "Louis Trimolet," 546–48.

23. See *Explication des ouvrages,* where the painting is
listed as number 1985. Even though Trimolet exhibited
only one large painting at the Salon, there is some
question as to the number of paintings he ultimately

finished. In 1841 he showed *La Prière* (number 1907 in
the Salon catalog). The article "Louis Trimolet" notes
other, smaller images completed in the early 1840s.
Baudelaire cited *La Prière* in his "Some French Car-
icaturists," 184. For further reference to *Une Maison de
secours,* see *Explication du Salon.*

24. For further references to images of Sisters of
Charity ministering to the poor, see Weisberg, *The Real-
ist Tradition,* 108–10, and especially the early works of
Isidore Pils under the Second Empire.

work then entered the Daubigny circle, where it was not well looked after, perhaps due both to its large size and to its being the product of an artist whose reputation faded after his death.[25] (The painting suffered considerable damage in the nineteenth century when it was hung too close to a family stove, which singed the paint on the canvas in several areas.) In its own way, the painting experienced just as miserable an existence as did its creator, who was never again able to muster the energy or the time to work on such a large scale. Trimolet's dream of completing a series of works depicting social conditions in France remained unrealized.

When the work was shown at the Salon, some critics commented on its efficacy. Alexandre Decamps, himself an advocate of everyday genre scenes and realism in art, wrote in the newspaper *Le National* on 25 April 1839 that this painting marked an innovation since it was "linked to the life of the people." The masses had become a new theme for artistic consideration, and Trimolet's canvas was judged to be closely tied to this development. With this one work, Trimolet guaranteed himself a place in the emerging realist tradition.

Later realists, such as Théodule Ribot, must have been aware of Trimolet's composition when they developed their own versions of almshouses or workhouses destined to look after suffering children. As an early example of the humanity of the streets and of the way in which the realists ultimately responded to this issue, this canvas by Trimolet held great significance. It is an important reminder that the realists were helping to create an awareness of the downtrodden and of how the grim realities of daily existence touched the life of the viewer as well as that of the artist.

The Realists and the Worker

As the July Monarchy tried to right itself toward the middle of the 1830s, it became apparent that France needed to be spurred along if it was going to compete with other European nations. The industrial revolution had taken hold in England. New factories and inventions were improving the economic picture of many there, particularly those with capital to invest in the name of progress. Expressions of improving France in similar ways were encouraged. In several key industries English entrepreneurial methods were adopted. Indeed, Englishmen traveled throughout the country to introduce advanced techniques of mechanization and management. English influence was noticeably strong in the industrial pursuits of ore extraction and iron production, ostensibly to aid in the mechanization of railroads.[26] As changes took shape, it became necessary for French industry to reach a large audience. Artists were sought who could create images that projected the benefits of industrialization accurately, directly, and intelligibly.

Since the cooperation of the worker (a figure of considerable concern since 1830) was valued, these images were intended to portray workers employing new industrial techniques and living in harmony with their mentors. Such artistic realism was designed to serve more than a propagandistic purpose. It was

25. For further reference to the painting, see Etienne Moreau-Nélaton, *Daubigny raconté par lui même,* 22–23. The painting was located in the family of Geoffroy-Dechaume, who originally offered the work to the Louvre before it was accepted by the Musée de l'Assistance Publique in Paris.

26. For further reference, see Collingham, *The July Monarchy.* Bezucha has pointed out that France changed under Louis Philippe due to growing consumerism, the necessity for France to prove itself, and the active participation of entrepreneurs in industrial pursuits. A successful economic policy meant that an *entente cordiale* existed with England, especially after 1840, which led to closer relations between the two countries. These changing attitudes emerged at different levels of society and in various types of industrial activity, including ore extraction and mechanization.

Figure 4–5. Ignace-François BONHOMMÉ, *Personnage masculin portant un mètre pliant* (Male figure carrying a folding rule), sketch for *The Forge at Fourchambault*. Drawing, 1839–1840. Paris, Musée Carnavalet.

Figure 4–6. Ignace-François BONHOMMÉ, *Lamineur* (Rolling mill operator), sketch for *The Forge at Fourchambault*. Drawing, 1839–1840. Paris, Musée Carnavalet.

hoped that, just as in the depictions of this new alliance, the actual conditions of some workers would improve through their association with the captains of industry. In reality, industrialization benefited only a small fraction of the entire population; most people remained in distress. The social position of the poorest worker continued to decline, while those linked to middle management benefited the most.

By looking at one artist, François Bonhommé, called le Forgeron (1809–1881), we can gain a sense of how the realist approach was used to the advantage of those in power. The extent to which Bonhommé was aware of events during the earliest phases of his career remains unclear, although the type of imagery he produced did reinforce the government's position of improving industry in certain sections of the country. Bonhommé's work could substantiate the implication that at an early date there was a decided cleavage or bifurcation within the ranks of the so-called proto-realists.[27] Some, like Jeanron, used a realist style largely for humanitarian purposes, calling attention to the problems of the poor in the hope of alleviating their plight. Others, such as Bonhommé, employed a realist approach as a positive piece of propaganda to meet the demands of the emerging industrial class. The fact that the interests of industry

27. Different types of realism were examined by Albert Boime in "The Second Empire's Official Realism." Although this article is ostensibly aimed at examining realism after 1850, the principles it presents can be fully applied to the July Monarchy.

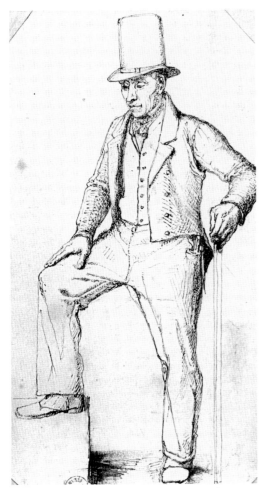

Figure 4–7. Ignace-François BONHOMMÉ, *Personnage masculin* (Male figure), sketch for *The Forge at Fourchambault*. Drawing, 1839–1840. Paris, Musée Carnavalet.

meshed with the needs of the government of Louis Philippe may have helped Bonhommé receive offers to document official ceremonies, such as the erection of the Egyptian obelisk in the center of the place de la Concorde in Paris.[28] Bonhommé's drawing of that

occasion is now lost. All that remains of the image is an engraving that was widely circulated at the time. Nevertheless, the work attests to Bonhommé's link to the court and his increasing ability to record events, whether historic or industrial, faithfully.[29]

Bonhommé's ties with the owners of the Fourchambault ironworks by 1836 indicate his relationship with important industrial leaders during the July Monarchy. By then Bonhommé had been identified as an astute recorder of contemporary history. His commission to document the industrialization of the iron mills and the lives of the men who worked in them, which resulted in sketches made on the scene (Figures 4–5 through 4–7), must be seen as indicative of the modifications the iron industry underwent in the 1830s.[30] Increasing numbers of English-style foundries produced iron and cast iron from coke, resulting in a more efficient production system and better working conditions. These modernized plants were both a threat to smaller firms that were unable to compete and a sign that the middle class (and the government) was investing heavily in innovative technology to sustain France's industrial evolution. In effect, Fourchambault became one of the first French ironworks to modernize by utilizing an English plan, which led to the complete revitalization of the central region of the nation. Eager to demonstrate its leadership and acu-

28. This drawing, listed in the collection of the Musée Carnavalet, Paris, as I.E.D. 5338, has not been located despite an extensive search of the collection. It was originally drawn by Bonhommé in 1836 when the obelisk from Luxor was being erected in the place de la Concorde. Apparently Bonhommé did a series of pen-and-ink drawings of various phases of the obelisk's placement. They have since been dispersed.

29. For reference to this engraving, see Musée Carnavalet, Cabinet des Estampes, Carton historique, grand format, (GC 16), 1831–1839. Dated 25 October 1836, the image is noted as being completed after François Bonhommé's original drawing. There is no clear documentation of which journal this image appeared in or the size of its circulation. Nevertheless, the fact that the image was completed as a print not only attests to the value that was placed on Bonhommé's work quite early in the July Monarchy but also helps to establish his origins as an artist/reporter in the early phases of proto-realism.

30. Two other drawings by Bonhommé in the collection of the Musée Carnavalet portray an English engineer who came to Fourchambault to work with the members of the group. Other drawings illustrate workmen and methods employed by the mill.

Figure 4–8. Ignace-François BON-HOMMÉ, *Interior of the Great Forge at Fourchambault*. Oil on canvas, 1839–1840. Fourchambault, Hôtel de Ville.

men, the administrative council of Fourchambault in essence advertised its accomplishments through Bonhommé's painting *Interior of the Great Forge at Fourchambault* (Figure 4–8).[31]

True to his realist inclinations, Bonhommé finished the painting of the forge's interior based on his numerous on-site drawings. The work's inclusion in the 1840 Salon confirmed the notion that realism could be used for didactic purposes. Instead of setting engineers, visitors, and workers in opposition, Bonhommé suggested that harmony could be established both within and beyond the boundaries of the factory to encompass all classes of society.

Bonhommé's obvious skill in illustrating a didactic scene provided another way for the realist approach to take hold in the early days of the July Monarchy. His commission from the administrators of Fourchambault helped to propel Bonhommé to the forefront. This made it easier for the members of the royal family to return to his work when in the 1850s they needed someone to record improvements in a country then under massive industrialization.

The State of Proto-Realism Under the July Monarchy

On the highest level of artistic creation, realism made significant advances during the July Monarchy. Repeated attempts to exhibit realist paintings and drawings made some viewers cognizant of this alternative artistic style, one that espoused a just cause and was increasingly identified with the aims and interests of the masses. Works like those by Jeanron were often seen as threatening the status quo, or at least those eager to assume power. Even though realist canvases often did not find a permanent home once they were rejected by a Salon jury, they did enjoy a public following. Members of the artistic community, including select critics and collectors, understood the necessity of early realism to reflect contemporary existence. Some asserted that social themes of broad appeal must be placed on public exhibition if art and society were to progress together.

Since many of the realist painters and drafters were also committed printmakers who often worked for radical publications, realism was considered almost an underground movement. Yet by the early 1840s realist themes appeared more frequently than ever before.[32]

31. For further reference to Bonhommé's career, see Gabriel P. Weisberg, "François Bonhommé and Early Realist Images of Industrialization, 1830–1870."

32. See the Salon catalogs of this decade for further reference as to when such titles as *Mendiant, Un Mar-*

The largely humanitarian issues that realist works addressed after 1848 were predominantly based on advances made in these early phases of the July Monarchy.

At the same time, however, there was another strain of realist imagery. As seen with Bonhommé, realism became a means of depicting those in power and in control of the changing capitalist scene. When painting was used to endorse industrialization, realism

assumed a propagandist edge. This tenor was developed and enlarged during the Second Empire, when more conservative realists created images that reinforced the policies of Napoleon III in a style that was didactic, contemporary, and easy to comprehend. In effect, later realist debates were rooted in the July Monarchy. What originally seemed a somewhat dormant period in painting actually appears more complex once specific images are assessed. The July Monarchy thus becomes a crucible for the proto-realists and the events that transpired after 1848.

chande de chiffon, Pauvre famille, Pauvre enfant, Famille de mendiant, Le deux orphelins (1836), or *La Charité* (1838) appeared.

5 AT HOME AND ABROAD
Landscape Representation

The July Monarchy was an exceptionally rich period as far as landscape art is concerned. This period not only witnessed the culmination of the rising popularity of landscape representation that had started after the French Revolution but also, in its brief span of eighteen years, saw the confluence of three different streams in landscape art, classical, romantic-picturesque, and romantic-realist. Before the advent of the July Monarchy, the romantic-realist landscape of the so-called School of 1830 had not yet been formulated; by 1848, the classical landscape had practically died out. Thus, only in the 1830s and 1840s was it possible to appreciate firsthand the full variety of French landscape painting from the first half of the nineteenth century.

For the student of landscape art under the July Monarchy, the diverse picture that presents itself is often confusing as scenes vie with each other: the French with the foreign; the familiar with the exotic; the colorful with the tonal; the mythical with the rustic; and the poetic with the descriptive. The first part of this essay will discuss this variety of landscape representation within the context of middle-class taste. It will relate the bourgeois interest in landscape representation to the preoccupation with topography and travel (both at home and abroad) that manifested itself in the popularity of the travelogue, the lithograph and photograph album, and, toward the end of the period, the travel guide. The second part of the essay will focus on the School of 1830. It will outline some of the strategies used by the artists belonging to that school to move away from the popular tradition of the picturesque "view," toward a landscape art in which nature was central.

Landscape was a much-beloved genre during the July Monarchy. A rapid survey of the catalogs of the annual Salons held between 1830 and 1848 indicates that landscapes made up from 25 to 30 percent of the two-dimensional works (paintings, drawings, engravings, and lithographs) on display. Those Salon landscapes may be categorized in the following groups (in order of importance): topographic landscapes; seascapes and marine paintings; composite landscapes; and historiated landscapes. Examples of all four categories may be found in the present exhibition: Théodore Caruelle d'Aligny's *Vue prise des carrières de grès du mont Saint-Père, forêt de Fontainebleau* (View of the sandstone quarries of mont Saint-Père, forest of Fontainebleau; Plate 30 [cat. no. 145]) and Adrien Dauzats's *Les Portes de Fer* (Figure 5–1 [cat. no. 58]), for instance, exemplify topographic landscape painting, depicting a domestic and a foreign site respectively. Prosper Marilhat's *Paysage d'Egypte* (Egyptian landscape; Plate 32 [cat. no. 149]) is an example of a composite landscape that combines various Egyptian motifs, such as palms and minarets, into an essentially imaginary composition. Camille Corot's *L'Avant-port de Rouen* (The outer harbor of Rouen; Plate 31 [cat. no. 148]) demonstrates the contemporary interest in marine subjects, while Paul-Jean Flandrin's *Les Pénitents dans la campagne romaine* (The penitents in the Roman Campagna; Figure 5–2 [cat. no. 156]) exemplifies the historiated landscape genre.

A more detailed study of several Salon catalogs of the July Monarchy indicates that topographical landscapes depicting both French and foreign scenes constituted the vast majority of the landscapes submitted. The

Figure 5–1. Adrien DAUZATS, *Les Portes de Fer*. See cat. no. 58.

Figure 5–2. Paul-Jean FLANDRIN, *Les Pénitents dans la campagne romaine* (The penitents in the Roman Campagna). See cat. no. 156.

exact location and/or viewpoint of these topo-
graphic landscapes was often carefully marked
in the catalogs. Thus a landscape by Théodore
Gudin at the 1830 Salon is referred to as *Vue
des environs d'Alger, route de Staonelli à Keleif*
(View of the surroundings of Algiers, the road
from Staonelli to Keleif), or a painting by Paul
Huet, at the Salon of 1834, is entitled *Vue
générale d'Avignon et de Villeneuve-les-Avignon, prise
de l'intérieur du Fort St. André* (General view of
Avignon and Villeneuve-les-Avignon, seen
from the interior of Fort St. André).

Among the topographic landscapes, French
views increasingly began to outnumber for-
eign ones as the July Monarchy progressed. At
the 1830 Salon, for example, 44 percent of the
accepted landscapes depicted French scenes,
while 34 percent depicted foreign scenes (the
remaining 22 percent consisted of composite
landscapes, seascapes, and historiated land-
scapes), while in 1844 49 percent of all land-
scapes represented local French sites and only
27 percent depicted foreign scenes. Composite
landscapes and historiated landscapes con-
stituted a steadily decreasing percentage of the
landscapes submitted during the period.
Indeed, by 1848, the historiated landscape had
practically disappeared.

The important presence of landscape art at
the Salons of the 1830s and 1840s reflects the
favorable market situation for this genre dur-
ing the July Monarchy. As Nicholas Green has
shown, landscapes formed the core of the
stock of most contemporary art and curio
shops—such as the Galeries des Beaux-Arts
and the Bazar Bonne Nouvelle—where land-
scape paintings, watercolors, drawings, and
lithographs were sold alongside bronzes, por-
celain vases, and other domestic decorations
to a growing bourgeois clientele. Those ob-
jects, as Green has pointed out, were bought
and sold without too much attention to invest-
ment or resale value but rather for the sake of
topographic interest and visual enjoyment—
and, no doubt, with a view to status as well.[1]

The importance of landscape art as a
middle-class consumer good found its most
powerful expression in the contemporary fad
for topographic landscape lithographs and
(toward the end of the period) photographs. In
a print by Achille Devéria from the 1830 series
Les Dix-huit heures d'une Parisienne (Eighteen
hours in the life of a Parisian woman; Figure
5–3), we see a young woman studying an
album of landscape lithographs. Devéria has
placed the album within a contextual frame-
work of elaborate fashions and interior
decorations—the material paraphernalia that
mark the middle class of the July Monarchy.
Significantly, Devéria's print shows a woman
as the main consumer of those parapher-
nalia—elegant manufactured goods that range
from personal adornment such as flounces,
laces, and ribbons to domestic decorations
like furniture, wallpapers, curtains, and, last
but not least, works of landscape art.

Contemporary literature confirms the
importance of landscape lithographs as a mid-
dle-class consumer good in the 1830s and
1840s. In Balzac's *Ursule Mirouet,* set around
1830, Madame Crémière, the "wife of the
lowliest type of financier, full of pretensions to
elegance and wit, was awaiting her uncle's
inheritance before she could really begin to
'live in style,' decorate her drawing-room and
be at home to the middle class of Nemours;
her husband refused to buy her any of the
Carcel lamps, lithographs and nicknacks that the
notary's wife had."[2]

Though the earliest lithographic landscape
albums were produced during the Restoration

1. Nicholas Green, "From Luxury Consumption to
Speculative Investment: Shifts in Value of French Nine-
teenth-Century Landscape Painting," paper presented
at the 76th annual meeting of the College Art Associa-
tion of America (Houston, 1988). See also Green's
recent "Circuits of Production, Circuits of Consump-
tion: The Case of Mid Nineteenth-Century French Art
Dealing."
2. Quoted from the English translation by Donald
Adamson (New York, 1976), 35. My italics.

Figure 5-3. Achille-Jacques-Jean-Marie DEVÉRIA, *Portrait, 9 heures du matin: Mme. Annette Boulanger* (Portrait, 9 a.m.: Mme. Annette Boulanger), from *Les Dix-huit heures d'une Parisienne* (Eighteen hours in the life of a Parisian woman). Hand-colored lithograph, ca. 1830. Minneapolis, The Minneapolis Institute of Art.

period, their popularity culminated under the
July Monarchy. In his comprehensive survey
of romantic landscape lithographs, Jean
Adhémar has demonstrated that these albums
were made up of topographic prints in a pic-
turesque mode, depicting both foreign and
French scenes. While albums depicting for-
eign scenes were generally devoted to a single
country, those showing French scenes usually
took the form of regional albums that featured
a department, a historic region (Normandy,
Brittany), or a mountain range (the Pyrenees
or the Jura). The importance they played may
be gauged not only from the considerable
number of albums that were published but
also from the substantial editions that were
printed, particularly of the albums that were
published in Paris.[3]

One of the first entrepreneurs to realize the
potential of lithography for cashing in on the
taste for the picturesque "view" was Baron
Isidore-Justin-Séverin Taylor, whose portrait
by Adrien Dauzats may be seen in the present
exhibition (Figure 5-4 [cat. no. 64]). Born in
Brussels in 1789, the son of British parents,
Taylor moved to France at an early age and
became a naturalized French citizen. He made
a career in arts administration under Louis
Philippe and was charged, among various
other missions, with acquiring Spanish paint-
ings in Spain for Louis Philippe's Musée
Espagnol.[4] Taylor's fascination with travel, his
acquaintance with numerous artists (including
Dauzats, who accompanied him on his trip to
Spain), as well as his own amateur interest in
drawing and printmaking made him an ideal
publisher/editor of topographic landscape
prints. Though he published a large number
of lithograph albums devoted to foreign coun-
tries, such as Spain, Portugal, North Africa,

Figure 5-4. Adrien DAUZATS, *Baron Taylor.*
See cat. no. 64.

Syria, Palestine, Egypt, Italy, Switzerland,
Greece, and England, Taylor's reputation rests
primarily on his seventeen-volume series of
albums depicting scenes from France, the so-
called *Voyages pittoresques et romantiques dans
l'ancienne France* (Picturesque and romantic
travels in old France), published in coopera-
tion with Alphonse de Cailleux and Charles
Nodier. The expressly stated purpose of
this series was the exploration of medieval
France—its cathedrals, castles, and other
Romanesque and Gothic structures (see
Eugène Isabey's *Eglise Saint Jean, Thiers* [cat.
no. 132]), but in most albums quite a few
plates are devoted not to the man-made but
rather to the natural wonders of a particular
region: its waterfalls, grottoes, or sweeping
panoramic views.

3. This entire paragraph is indebted to Jean
Adhémar, *Les Lithographies de paysage en France à l'époque
romantique.*
 4. On Baron Taylor, see Paul Guinard, *Dauzats et
Blanchard: Peintres de l'Espagne romantique,* and R. P.
Plazaola, "Le Baron Taylor et le théâtre romantique."

Taylor and other successful publishers of lithographic landscape albums were not mere businessmen out to make a profit. They were in fact quite interested in the quality of the albums they produced. They actively sought the cooperation of talented young draftsmen and printmakers, and it is worth noting that nearly all the major landscape painters of the School of 1830 made their debut as draftsmen working on the production of lithograph albums. Conversely, artists took pride in their association with lithographic album publications and frequently submitted their plates to the annual Salons, taking care to specify the albums for which they were produced.

The fascination of the July Monarchy public with lithographic albums was intimately related to the popularity of the travelogue, which constituted an important literary form at the time.[5] Professional travelers and scientists as well as many of the major writers of the period dedicated themselves to this genre. Stendhal's *Promenades dans Rome* (1829) and his *Mémoires d'un touriste* (1838); Alphonse de Lamartine's *Voyage en Orient* (1832–1833); Victor Hugo's *Rhin* (1842); George Sand's *Lettres d'un voyageur* (1834–1836); Théophile Gautier's *Tour en Belgique* (1836) and his *Tra los Montes* (1843); and Alexandre Dumas's *Quinze jours au Sinaï* are some of the outstanding examples of the travelogues published in the 1830s and 1840s.

Not only foreign countries but also local regions could be the subject of such descriptive accounts. Charles Nodier's *La Seine et ses bords* (1836), for example, describes the Seine from its source to its outlet into the Atlantic Ocean at Le Havre. Nodier was also responsible for much of the running text that accompanied the lithographs in Taylor's *Voyage pit-*

toresques et romantiques dans l'ancienne France. Books devoted to France and its various regions became increasingly popular toward the later part of the July Monarchy. This growing preoccupation with France itself—perhaps best exemplified in the novels of George Sand—was a complex phenomenon, related at once to romantic nationalism, to improving communications within France, and to the retreat, after the 1830 revolution, of the legitimist nobility to their country estates, which contributed to making the countryside fashionable.[6]

Though by no means a new genre—they had been widely published since the middle of the eighteenth century—the travelogues had a wider audience than ever before during the July Monarchy because, like novels, they often appeared initially as installments in newspapers, to be published only later in book form. Thus, they were read by a broad segment of the public. Indeed, from upper to lower middle class, the French during the July Monarchy were a nation of enthusiastic armchair travelers.

It is perhaps not superfluous to point out here that throughout the 1830s and 1840s travel was still for the most part an activity for the rich or the adventurous. Most transportation on the European continent was by ship or mail coach, and it was time-consuming, expensive, and uncomfortable. Not until the emergence of the train did travel become an activity for the middle and lower middle class. Yet the railroads were still in their infancy under the July Monarchy. The first passenger railway was not built until 1837, and by 1840 only 433 kilometers of rail had been laid down. Then railroad building picked up speed; by 1848, 1,592 kilometers of rail lines were in use while 2,144 more were under construction.[7] The railroads were to encourage

5. On the relationship that existed between landscape lithographs and travelogues, see Adhémar, *Les Lithographies de paysage,* 61–65. On the general subject of travel and illustrated travel accounts, see Barbara Stafford, *Voyage into Substance.*

6. For this last observation I am indebted to Jean-Luc Mayaud (conversation, 22 December 1988).

7. T. E. B. Howard, *Citizen King,* 283, n. 1.

yet a new kind of travel publication, the rail-
road guide or itinerary, which described and
illustrated (in wood engravings or lithographs)
the major sights along a particular line.[8] How-
ever, this new type of publication, though it
originated during the July Monarchy, did not
become widespread until the Second Empire.

The travelogues, the landscape albums, and
the submissions to the annual Salons during
the July Monarchy reflect a gradual shift in
focus with regard to the French regions and
foreign countries that are most often described
and depicted.[9] As for France itself, there was
an expanding interest in the provinces. While
during the Restoration period interest had
focused primarily on the Seine region and
Normandy, the July Monarchy public was fas-
cinated with all corners of France, from the
North to the Pyrenees, from Brittany to the
Jura.

With respect to foreign countries, Italy and
Switzerland, which during the Restoration
period still could spark the fascination they
had exercised over travelers since the eigh-
teenth century (see Ziegler's 1830 *Venise vue de
nuit* [Venice seen by night], Plate 26 [cat. no.
131]), gradually lost their hold over people's
imagination. Under the July Monarchy other
countries became fashionable instead, notably
Spain, Greece, England, Scotland, and the
Low Countries. Beyond the borders of
Europe, the Americas and Asia continued to
arouse curiosity, as they had done in the eigh-
teenth century, but the continent that was by
far the most featured, in paintings, prints, and
literature, was Africa. Africa, particularly its
northern shore, had, of course, a special
importance for the French at the time. From
its first invasion by French troops in 1830,
Algeria was the July Monarchy's major bat-
tlefield, where France fought a protracted
colonial war until 1848, when Algeria was offi-

Figure 5–5. Horace VERNET, *Le Duc d'Orléans
{Louis-Philippe} demandant l'hospitalité aux religieux
du Petit Saint Bernard* (The duc d'Orléans [Louis
Philippe] asking the monks of the Petit Saint
Bernard for hospitality). Oil on canvas, date
unknown. Chantilly, Musée Condé.

cially declared French territory.[10] As a result
Algeria was continually mentioned in the
newspapers, and the region became familiar
terrain to the French, who knew the major
place names and had some knowledge of the
country's inhabitants, climate, flora, and
fauna. Since the other North African coun-
tries all were to some extent involved in this
war as well, they shared the attention of the
French public. Egypt was particularly popular
as, in addition to its role in the war, it pro-
vided a reminder of a glorious past—the
Napoleonic era, which to many had culmi-

8. See Adhémar, *Les Lithographies de paysage,* 34.
9. Ibid., 33–43.

10. On France's involvement in Algeria, see G.
Esquer, *Les Commencements d'un empire: La prise d'Alger.*

Figure 5–6. François-Auguste BIARD, *Le Duc d'Orléans recevant l'hospitalité sous une tente de Lapons août 1795* (The duc d'Orléans receiving hospitality in a Lap tent August 1795). See cat. no. 161.

nated during Napoleon's campaign to Egypt from 1798 to 1799.

The interest in travel and travelogues had a powerful association with the ruling monarch and his family. Louis Philippe, as a young man, had spent eight months in Reichenau, Switzerland, where he had worked as an assistant schoolmaster at a local boarding school. As T. E. B. Howard has pointed out in his biography of Louis Philippe, the latter's stay in Reichenau was a never-failing topic of after-dinner conversation in the Tuileries,[11] and it inspired numerous representations of

11. Howard, *Citizen King,* 90.

Louis Philippe in Swiss settings, such as the painting by Horace Vernet in which the young duc d'Orléans asks the monks of the Petit Saint Bernard for hospitality (see Figure 5–5).

After he left Reichenau, Louis Philippe wandered the world for some six years, traveling in the Scandinavian countries all the way up to the North Cape. The last leg of his trip was made by reindeer-sledge and involved three weeks of camping out in northern Lapland. With that in mind, it is not surprising that in later years Louis Philippe acquired Biard's painting of Magdalena Bay (cat. no. 162) for his personal collection, as it must have struck a familiar note. The Scandinavian trip

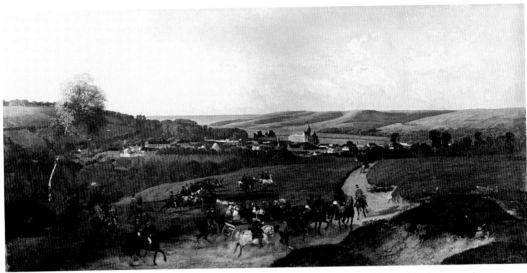

Figure 5–7. Eugène Louis LAMI, *Visite de la reine Victoria et du prince Albert au Château d'Eu le 3 septembre 1843* (Visit of Queen Victoria and Prince Albert to the Château d'Eu on 3 September 1843). See cat. no. 173.

was commemorated in another painting by Biard (Figure 5–6 [cat. no. 161]), which found a place in Louis Philippe's Musée Historique at Versailles.

In 1796 Louis Philippe set sail for Philadelphia, and during the next two years he traveled through America with his brothers, the duc de Beaujolais and the duc de Montpensier. Proceeding sometimes together, sometimes separately, they went as far south as Nashville, Tennessee, and as far north as Niagara Falls. The trip was quite adventurous and involved navigation of rapids and a night in the tent of an Indian chief, who bestowed upon Louis Philippe the honor of sleeping between the two leading ladies of the tribe, the chief's grandmother and great-aunt.[12]

The sons of Louis Philippe, to a greater or lesser extent, shared the adventurous spirit of their father. The duc d'Aumale, the duc de Nemours, and the duc d'Orléans all spent time in Africa as they took an active part in the conquest and occupation of Algeria. Among their more celebrated exploits was the

1839 expedition of the duc d'Orléans from Philippeville to Alger passing through the Portes de Fer, one of the major passes in the Djurdjura mountains. This expedition, which was geared partly to occupation, partly to exploration, was joined by Adrien Dauzats, who was hired to come along as the official recording artist (much the same way Dauzats's friend Eugène Delacroix had been asked seven years earlier to join the expedition of the comte de Mornay). On his return to France the duc d'Orléans requested Charles Nodier to edit his journal, which was published in 1844, richly illustrated with wood engravings made after watercolors and drawings by Dauzats, Decamps, and Raffet.[13] Dauzats's watercolor of the Portes de Fer (Figure 5–1 [cat. no. 58]) served as prototype for one of the illustrations in the *Journal* (cat. no. 59).

In spite of this extensive foreign travel, the royal family never lost its taste for France. The

12. On Louis Philippe's travels, see ibid., chap. 2.

13. Charles Nodier, *Journal de l'expédition des Portes de Fer.* According to Guinard, *Dauzats and Blanchard,* the text of this book is largely by Dauzats. Nodier, who had been asked by the prince to write the book, died shortly after he had written the preface, and Dauzats took his place.

family's numerous estates in France, such as the residence in Neuilly, the château de Randan in Auvergne, and the château d'Eu in Normandy, all were the sites of numerous holiday outings. The château d'Eu was a particular favorite, and it was here, in 1843, that Louis Philippe received Queen Victoria for a five-day visit filled with picnics in the forest and tours in the garden (see Figure 5–7 [cat. no. 173]).[14]

* * *

From an art-historical point of view, the period of the July Monarchy was especially important for the emergence of the so-called *Ecole de 1830,* or School of 1830,[15] the young generation of artists—including Louis Cabat (1812–1893), Camille Corot (1796–1875), Adrien Dauzats (1804–1868), Narcisse Diaz (1807–1876), Jules Dupré (1811–1889), Camille Flers (1802–1869), Paul Huet (1803–1869), Eugène Isabey (1803–1886), and Théodore Rousseau (1812–1867)—who reached maturity by the beginning of the July Monarchy. These artists altered the course of landscape painting in France by abandoning both the rule-bound classical landscape that had dominated French landscape art since its introduction by Nicolas Poussin and Claude Lorrain in the seventeenth century and the colorful romantic-picturesque topographic landscape imported by British watercolorists in the Restoration period, to turn instead to the depiction of the natural landscape.[16]

Though the importance of the School of 1830 cannot be questioned, there is much room for discussion as to what precisely its innovative aspects were. The interest in French rather than foreign scenes and the tendency to stay at home rather than to travel abroad are frequently mentioned as part of the novelty of these painters' approach to landscape painting. Yet many of the artists of the School of 1830 traveled abroad a great deal (for example, Corot and Dauzats), while on the other hand the interest in French scenes can be perceived long before 1830, in the works of such artists as Georges Michel, Lazare Bruandet, or Louis Demarne. Verisimilitude is another quality often mentioned as characteristic of the new school, but it too may be found well before 1830 in the sketches of the classical landscape painter Pierre Henri Valenciennes.

There were, however, a number of distinct characteristics that set the School of 1830 apart from earlier landscape painting. Perhaps the most important of these was the new emphasis on landscapes without a *point de vue,* that is, landscapes without a carefully chosen viewpoint that provided a picturesque view of a recognizable topographic element—a city, a church, a waterfall, or any other man-made or natural wonder. The "new" landscape art developed in the course of the 1830s and 1840s was increasingly geared to depicting a random corner of nature in which each element—sky, trees, grass, and so on—was treated with equal attention and devotion.

A comparison of two landscapes will serve as an example of this tendency away from the *point de vue.* Paul Huet's *Vue lointaine de Rouen* (Distant view of Rouen; Figure 5–8) of 1830 and Théodore Rousseau's *La Plaine de Tartas* (The Tartas Plain; Figure 5–9) of circa 1844 both present a panoramic landscape view. But whereas Paul Huet has carefully chosen his viewpoint so as to obtain a dramatic view of the silhouette of Rouen dominated by its famous Gothic cathedral, Rousseau focuses on the plain itself—its rugged terrain, marked by

14. Howard, *Citizen King,* 290–91.
15. The term *School of 1830* is not often used in Anglo-Saxon countries, where these artists are preferably (though less correctly) referred to as the "Barbizon School."
16. For a survey of classical and romantic French landscape painting, see Prosper Dorbec, *L'Art du paysage en France,* still one of the best books on French landscape painting available.

Figure 5–8. Paul HUET, *Vue lointaine de Rouen* (Distant view of Rouen). Oil on canvas, 1831. Rouen, Musée des Beaux-Arts.

deep cart ruts, puddles, low shrubbery, and tufts of grass. Huet's landscape is loaded with associations—to the long and eventful history of the city of Rouen and its inhabitants; to its presence as a prosperous river harbor; to the relation between the city and the surrounding countryside. It is intended to evoke the kind of sublime emotions that welled up in Flaubert's romantic Emma Bovary as she traveled by diligence to Rouen for her amorous encounters with Léon:

A kind of intoxication was wafted up to her from those closely packed lives, and her heart swelled as though the 120,000 souls palpitating

below had sent up to her as a collective offering the breath of all the passions she supposed them to be feeling. In the face of the vastness her love grew larger, and was filled with a turmoil that echoed the vague ascending hum. All this love she, in turn, poured out . . . and to her the old Norman city was like some fabulous capital, a Babylon into which she was making her entry.[17]

In contrast to Huet's dramatic panorama, Rousseau's landscape strikes us not by its poetic evocativeness but rather by its prosaic

17. Quoted from the English translation of Gustave Flaubert's *Madame Bovary* by Francis Steegmuller (New York, 1957), 299.

Figure 5–9. Théodore ROUSSEAU, *La Plaine de Tartas* (The Tartas Plain). Oil on canvas, ca. 1844. Private Collection.

descriptiveness, its immediacy, and its almost tangible physicality. It reminds us of Flaubert's more factual descriptions, such as this one, of the countryside between Tostes and Bertaux, as observed by the down-to-earth Charles Bovary: "The countryside stretched flat as far as the eye could see; and the tufts of trees clustered around the farmhouses were widely spaced dark purple stains on the vast grey surface that merged at the horizon into the dull tone of the sky."[18]

Rousseau's *La Plaine de Tartas* illustrates the new tendencies introduced by the School of 1830. Unlike other, belated classical or romantic landscapes (Flandrin's *Les Pénitents dans la campagne romaine,* Figure 5–2 [cat. no. 156], or Marilhat's *Paysage d'Egypte,* Plate 32 [cat. no. 149], respectively, may serve as examples), this painting does not show a landscape enlivened by historical or biblical figures, or a colorful scene in some faraway country, centered

around a picturesque exotic structure. Instead, nature itself is featured here without drama or embellishment.

The absence of architectural elements and colorful staffage in the landscapes of the painters of 1830, and their concomitant focus on natural elements, gradually led to a new, more tonal landscape style that became increasingly dominated by green. One of the main protagonists of this tendency away from color toward an increasingly tonal landscape palette was Théodore Rousseau. Writing in 1872, Rousseau's biographer Alfred Sensier concluded that the most vivid memory Rousseau's contemporaries had of his early beginnings was his use of a tonal palette: "The greens and greys of Rousseau to this day evoke vivid memories among the veterans of 1830. Rousseau was to them a brilliant toniste, belonging to the family of Weber."[19]

Sensier, like numerous other critics in the

18. Ibid., 15.

19. Alfred Sensier, *Souvenirs sur Th. Rousseau,* 24.

Figure 5–10. Gustave COURBET, *Portrait de l'artiste, dit Courbet au chien noir* (Portrait of the artist, called Courbet with black dog). See cat. no. 19.

nineteenth century, related Rousseau's new tonality to music, particularly the compositions of German romantic composers such as Ludwig van Beethoven, Carl Maria von Weber, and Richard Wagner. At the same time, however, his work was felt to be indebted to the tonal landscapes of early seventeenth-century Dutch landscapists, men like Jan van Goyen, Salomon van Ruysdael, Philips Koninck, and Jacob van Ruisdael.[20]

Though the new tonal landscape style was greatly admired by some (like the Dutchman

Ary Scheffer who, though himself a colorist, nevertheless became one of the early admirers of Rousseau), others did not take to the dull monochrome palette of Rousseau and his followers. The romantic critic Théophile Gautier, for example, was to refer to the new naturalist landscapes as *plats d'épinards,* or plates of spinach,[21] rejecting them in favor of a more colorful picturesque style.

Another major innovation of the School of 1830 was its emphasis on plein-air painting. Though the habit of drawing outdoors went

20. On this subject, see Petra ten-Doesschate Chu, *French Realism and the Dutch Masters,* chap. 3.

21. Gautier's pronouncement is quoted by Gustave Courbet in a letter to Francis Wey. See Pierre Courthion, ed., *Courbet raconté par lui-même et par ses amis,* 2:93.

back at least as far as the sixteenth century, it became particularly popular in the 1820s and 1830s when hundreds of draftsmen were sketching out in the field with pencils, crayons, or watercolors, to answer to the growing demand for landscape representations (see Courbet's self-portrait, Figure 5-10 [cat. no. 19]). Sketching outdoors became a popular pastime that was practiced not only by professional artists but also by amateurs, who had an increasing choice of *cours de paysage* available, instructing them how to choose a viewpoint, compose a landscape, draw different types of trees, or convey the atmospheric effects of the sky.[22] An important innovation in the 1820s was the introduction of the paint tube, which made it possible to sketch outdoors in oils.[23] No doubt the invention of the paint tube came partly as a response to an increased interest in sketching outdoors in oils—an interest that was linked in turn to a growing urge on the part of landscape painters to narrow the gap between the outdoor sketch, based on actual observation, and the finished painting done in the studio with the help of sketch and memory.[24]

A fourth important aspect of the art of the School of 1830 was the new emphasis placed on the scientific study of nature. The relationship between art and the natural sciences was a strong one in the nineteenth century. Artists frequently accompanied scientific explorers in order to draw the natural and/or anthropological specimens being studied. Thus the Swiss-born Karl Bodmer accompanied Maximilian, prince of Wied-Neuwied, on his expedition to North America and pro-

vided the watercolors that formed the basis for the illustrations in the prince's three-volume *Travels in the Interior of North America* (1832–1834). The German Joseph Dinkel accompanied Louis Agassiz on his travels in the Alps, Normandy, and England and made the plates for his geological treatises. The work of these artists was admired as much for its scientific accuracy as for its artistic merit (Louis Philippe offered Bodmer the Legion of Honor Cross for his drawings), and it was not unusual for these scientific draftsmen to submit their drawings and watercolors to the annual Salons. At the Salon of 1834, for example, one could admire a series of watercolors by Dinkel representing fish fossils and skeletons.

Many of the famous natural scientists of the period were accomplished draftsmen themselves. The German scientist Alexander von Humboldt drew incessantly on his various expeditions, and many of his notebook sketches served as prototypes for the plates in his printed publications. Not surprisingly Humboldt took a great deal of interest in art. Living in Paris between 1808 and 1827, he was a close friend of Karl von Steuben (the future teacher of Gustave Courbet), who painted his portrait against a Mexican background (see Figure 5-11). After 1830 Humboldt was sent on numerous diplomatic missions to Louis Philippe, with whom he had long maintained a close personal relationship.[25] It was during this time that Humboldt wrote his famous book, *Kosmos,* in which he devoted an entire chapter to the relationship between the study of nature and landscape painting.[26] Here he waxed eloquent about the landscapist's duty to wed artistry with scientific observation:

22. The subject of the *cours de paysage* is currently being studied by Jeremy Strick, who is preparing a doctoral dissertation on the subject at Harvard University.

23. On open-air oil sketching, see Lawrence Gowing and Philip Conisbee, *Painting from Nature: The Tradition of Open-Air Oil Sketching from the 17th to 19th Centuries.*

24. On the issue of sketch vs. finished painting, see esp. Albert Boime, *The Academy and French Painting in the Nineteenth Century.*

25. For a biography of Alexander von Humboldt, see Douglas Botting, *Humboldt and the Cosmos.*

26. The first volume of Humboldt's *Kosmos* was published in 1845 and immediately translated into French (first French edition, 1846). The second volume, which contains the chapter on landscape painting, was published in 1847 (French translation in 1848).

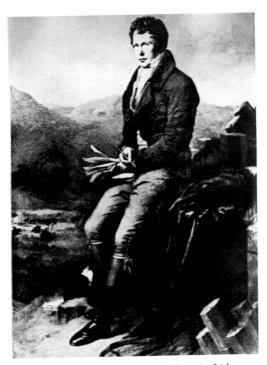

Figure 5–11. Karl von STEUBEN, *Portrait of Alexander von Humboldt*. Oil on canvas, 1814. Whereabouts unknown.

She [landscape painting] demands from the senses an infinite variety of immediate observations which the mind must assimilate, in order to fertilize them with its power, to form a work of art. Landscape painting in the grand style is the fruit of a profound contemplation of nature and the transformation that takes place in the mind's inner recesses.[27]

While scientists turned to art, artists turned to science, learning its methods of careful and patient observation. The interest in the natural sciences—botany, zoology, geology—by such artists as Théodore Rousseau and Gustave Courbet has been clearly documented. It is important to emphasize, however, that the sci-

entific approach to nature could be variously motivated and thus lead to quite different artistic results. To Théodore Rousseau the careful and patient observation of nature was a religious act in which he expressed his love and awe for his Maker. For Courbet, the study of natural history deepened his understanding of the evolutionary processes that were continuously shaping and reshaping nature. Hence, while for Rousseau the scientific study of nature was coupled with a painstaking rendering of each element of nature, Courbet was satisfied to imitate the processes of nature, boldly applying his paint to the canvas with both brush and palette knife. The roots of Courbet's mature landscape style may already be seen in his *Portrait de l'artiste, dit Courbet au chien noir* (Portrait of the artist, called Courbet with black dog; Figure 5–10 [cat. no. 19]).[28]

The painters of the School of 1830 developed a landscape style that went beyond, or even ran counter to, popular bourgeois taste under the July Monarchy. The "dull" monochrome coloring, the emphasis on humble sites, the sketchy aspect of the paintings, and, especially, the absence of a *point de vue* made the work of these painters difficult to appreciate for a public that was looking for just the opposite qualities in landscape painting. While some of the artists of the School of 1830 (especially the more compromising ones) saw some early successes in the 1830s and 1840s, the more principled and progressive painters did not achieve much success until the 1850s and 1860s. In final analysis it must be conceded that the popular landscapists of the July Monarchy were not Rousseau, Millet, or Dupré, but rather Isabey, Marilhat, and Gudin.

27. Alexander von Humboldt, *Cosmos: Essai d'une description physique du monde*, 2:100.

28. On Courbet and Rousseau's different scientific approaches to nature, see Petra ten-Doesschate Chu, "It Took Millions of Years to Compose That Picture."

6 THE CULT OF PERSONAL PORTRAITURE

Under the July Monarchy one type of artistic endeavor that was frequently well represented at the annual Salon exhibitions, and that attracted the interest of many private collectors, was portraiture. As before, families were eager to see themselves immortalized; now, however, recently enfranchised individuals who were climbing the social ladder also wanted their likenesses captured, but as powerful presences in the real world. Whether the portrait revealed dimensions of personality and character or accurately recorded the sitter's accomplishments, these works functioned primarily as reminders of status, although they also suggested ways in which artists could expand aesthetic boundaries to encompass a more deeply felt romanticism.

Portraiture increased in scope and range as many members of the middle class quickly became participants in the social life of the July Monarchy. (The significance of the royal family's efforts to redirect the energies of court life toward the cultivation of aristocratic pretensions of grace and elegance should also be considered.) Painters and sculptors from the opposing camps of romantic, classical, and realist styles watched as the interest in portraiture became a veritable cult during the reign of Louis Philippe. In tracing the evolution of the July Monarchy it is possible to identify a series of subtle changes or inflections that affected the perception and acceptance of portraiture.

Since portraiture often required thinking of an object as a prized possession, it was not reserved solely for the medium of oil painting or for exhibition in large-scale, public exhibitions. During the July Monarchy the use of sketches, drawings, sculptures, and prints completed on a small, intimate scale rapidly

increased. This implies that portraits were becoming completely transportable objects, allowing the mania for this type of object to escalate if the image could be produced as a multiple, that is, in more than one copy.[1]

Next on the list of portraiture requirements was the establishment of the sitter's identity. Even though figures from any section of the population could be depicted, often only those with fame or wealth were truly immortalized. Despite the problem that some sitters are no longer identifiable, it is nonetheless frequently possible to determine their position within society, usually by examining the environment in which the figure is placed. What often determined the significance of a portrait at the time was whether the sitter was recognizable, if the work had found a berth in an annual Salon, and if critics had commented on it in the daily press.

While some art critics continued to see the battle between the romantic and classical traditions as paramount to portraiture, others placed increasing emphasis on creating an accurate likeness and on including in the scene details from contemporary life, which further situated the fictive image within the real world of the July Monarchy. Even those artists who once practiced the classical tradition eschewed idealization in the hope of delineating the accurate likeness that the sitter often wanted. In effect, and to a degree that was commented on in the press, a "new" style

1. For reference to the proliferation and creation of multiples, see James Holderbaum, "Portrait Sculpture," 44. Issues raised in the creation of multiple sculptures are also discussed in Jacques de Caso, "Serial Sculpture in Nineteenth-Century France." Similar issues can be raised with regard to the print revolution and the mechanical reproduction of numerous pieces. Precise documentation and interpretation of the audience that collected these works are scarce.

of portraiture gradually evolved in which the sitter, whose feelings were more externalized, was portrayed more fully within his own milieu. Such efforts often replaced highly conventional modes of representation with a more thoroughly individualized image.[2]

The fact that the best portraits of the period did not follow prescribed paths was confirmed by a most independent and powerful work, Ingres's *M. Bertin* (Figure 1–13). The expectant and dominant qualities of personality and pose in this canvas reveal that an artist who was supposedly locked into the classical tradition was attempting a new way of intimating character. To depict a figure straining with energy and to symbolize an entrepreneur active within the July Monarchy, Ingres utilized a way of showing inner tension that defied tradition.[3] Yet not every portrait completed in this era explored a new direction. Some works suggested that previous styles were still in place. Attitudes had to be challenged and changed before a new type of portraiture would conclusively reign.

The Role of the Historically Based Portrait

Older approaches toward portrait painting, in which the sitter appeared in the dress and pose of earlier generations, did not disappear easily. A number of painters, especially those who worked for the more traditional and ultimately aesthetically conservative families,

maintained a repertoire of conventional compositions, which confirms their close awareness of Renaissance and Mannerist portraits. Among those artists who practiced this cult of portraiture was Alexandre Hesse, who achieved a somewhat fashionable status during the period through paintings that were often exhibited in the annual Salons.[4]

In one image, his *Portrait of an Unknown Woman* (Figure 6–1), Hesse heavily relied on past models for his portrait treatment. For example, this work closely imitates the portrait busts of wealthy members of the Italian aristocracy, in which the figure is posed close to the frontal plane and often dressed in excessively rich garments with jewels or pendants. Hesse turned to a well-understood formula to project a sense of extreme elegance and wealth. Without the viewer knowing the sitter's identity, this image implies the sitter wanted to be portrayed in this manner. Since the figure conforms to a social type, this historically rooted image also conveys much about the way portraiture eventually changed under the July Monarchy.

The New Portraiture: Contemporary Images in Sculpture

Against this background of traditionally conservative portraiture, artists in several spheres began to formulate models that came to break with former conventions. Sculpture in the Salons of 1831, 1833, and 1834 demonstrated a renewed sense of vitality brought about by the infusion of romanticism. Four sculptors in particular joined the heated controversy: Antonin Moine (1796–1849), Henri de Triqueti (1807–1849), Jehan Duseigneur (1808–1866), and Auguste Préault (1809–1877).

2. Many of these points were debated within the context of the romantic/classical aesthetics that dominated Salon criticism during the 1840s. For an example of such discussion, see Baudelaire duPays, *Salon de 1846*, v-xi, 75–79, with the latter focusing on a variety of issues pertinent to the creation of portraiture.

3. Although not fully appreciated at the 1832 Salon, Ingres's *M. Bertin* is more than an incarnation of a *grand bourgeois*. According to Lorenz Eitner, Bertin "embodies the energy, assertiveness and materialism of his class in its golden age" (*An Outline of Nineteenth-Century European Painting from David through Cézanne*, 166). Bertin, a businessman/politician, represents a major source of support for Louis Philippe's regime.

4. For further reference, see *Alexandre Hesse (1806–1879): Quelques aspects du portraitiste et du dessinateur.* Hesse received a number of significant official commissions during the July Monarchy, a time when he was exhibiting portraits at the annual Salons.

Figure 6–1. Alexandre-Jean-Baptiste HESSE, *Portrait of an Unknown Woman.* Oil on canvas, undated. France, Private Collection.

The best-known image was Antonin Moine's bust of Louis Philippe's queen, Marie Amélie (in the Musée Carnavalet, Paris), from the 1833 Salon, an image that epitomized much of the early years of the king's reign.[5] The queen is shown dressed in exuberant finery and with an idealized air about her facial features. Her demeanor—carved with a sense of flourish that borders on a latent rococo revival—caused commotion. Moine conveyed her haughtiness, which was already considered one of the many problems Louis Philippe had to confront, perhaps more forcefully than he originally realized or intended. Nevertheless, Moine's efforts underscored a new sense of energy in sculpture and a heightened freedom that discarded historicism.

Another member of this enthusiastic group was Auguste Préault. His busts and statues were commented upon by the press, even though his medallions and bas-reliefs were more original and unnerving. Their ugliness frequently repelled the viewer; because of this, Préault has been deemed a representative of another tendency—realism. His sense of passionate commitment and total involvement suggests that Préault was freeing his inner resources and emotions through a process that bordered on personalized romanticism. No matter how he is classified, his often sketch-like works project a tortured dimension that makes him a precursor to innovations in sculpture.[6]

An important feature of sculpture during the July Monarchy was the full-length stat-uette, a type of work often mechanically reduced through ingenious devices that were then being developed.[7] Nearly every major romantic sculptor produced portrait stat-uettes, which were avidly sold and collected, resulting in a vast miniature army of the men and women who populated the July Monarchy.[8] The majority of these statuettes were modeled after members of the royal family: Queen Marie Amélie, Louis Philippe, and certain of their sons, such as the duc d'Aumale (Figure 6-2 [cat. no. 8]) and the duc du Montpensier (cat. no. 9). Since these figures were shown in regal finery, often wearing their military uniforms—the cult of national militarism was at its height under Louis Philippe—and with a grand medal of the Legion of Honor emblazoned on their chests, as with the statuette of the duc d'Aumale, the implication remains that these statuettes were designed to propagandize the values and "cult of personality" of the royal family. Small statuettes of these reigning celebrities could be easily obtained and placed on a mantelpiece, thus reinforcing the illusion that the trappings of royalty were profusely distributed throughout society. In addition to increasing the visibility of the ruling family, these statuettes helped to spread the fame of certain artists, such as Jean Auguste Barre (1811–1896) and Charles Cumberworth (1811–1852).

Occasionally portrait statuettes represented the rulers of other countries who had entered into a close relationship with the French royal family. Barre's bronze images of Queen Victoria (Figure 6-3), for example, added to the innumerable engravings and paintings that

5. Moine developed small-scale sculpture when "conventional" Salon criticism denounced this vogue as a pronounced threat to the art of sculpture itself. Due to this, Moine suffered a virtual "exclusion from large commissions." For further reference, see de Caso, "Serial Sculpture," 5. Moine's marble bust of Queen Marie Amélie, exhibited at the 1833 Salon, became an emblem for the "middle-class monarchy of Louis Philippe." See Holderbaum, "Portrait Sculpture," 43, for a discussion and reproduction of this extremely significant work.

6. Holderbaum, "Portrait Sculpture," 43–46.

7. The major new device of the period was Achille Collas's reduction machine. For a reproduction of this device and a discussion of its implications, see *Metamorphoses in Nineteenth-century Sculpture*, ed. Jeanne L. Wasserman, 47, fig. 30, which emphasizes the fact that a number of extremely popular pieces were reduced, with casts of the smaller versions furnished in different sizes.

8. Holderbaum, "Portrait Sculpture," 44.

Figure 6–2. Louis MENNESSIER, *Statuette du duc d'Aumale*. See cat. no. 8.

Figure 6–3. Jean-Auguste BARRE, *Statuette of Queen Victoria*. Bronze, 1837. Paris, Musée des Arts Décoratifs.

Figure 6–4. Jean-Pierre DANTAN, called DAN-TAN LE JEUNE, *Lebas Carrying the Obelisk.* See cat. no. 116.

The 1830s saw a sudden surge in the appreciation of a corollary to statuettes—the plaster caricature figure. One of the primary sculptural caricaturists of the day, Jean-Pierre Dantan, produced a series that mocked the leading celebrities of the era. By 1833, many of his pieces composed the extensive Musée Dantan, where a great number of visitors gathered to laugh and gape.[10] Dantan created sketchy studies that, while amusing, were often deprecated by critics.[11] The personalities he singled out for comic abuse originated from the ranks of the government and from literary and social circles, implying that Dantan was familiar with the day's most visible figures. In one instance, Dantan caricaturized the engineer Jean Baptiste Lebas (Figure 6–4 [cat. no. 116])—the mastermind behind the transferal of the obelisk from the temple compound at Luxor, Egypt, to the place de la Concorde—showing him with the obelisk on his back.[12] In this way Lebas took his place alongside such notable entrepreneurs and collectors as Antoine Vivenel (Plate 42 [cat. no. 167]) as the object of Dantan's derision. The work's tactile qualities also verify the revival of interest in modeled sculpture, another major contribution of the sculpted portrait to the July Monarchy. Thus, it is conceivable that the exploration of these new areas and the sculptors' heightened interest in sketchlike effects carried over into the field of drawing.

documented her involvement with Louis Philippe.[9] While these statuettes are not fully detailed, much less realistic, they did advance the notion of the portrait as a transportable possession that often recorded societal changes.

9. For further reference to a print that records the involvement of the queen of England with Louis Philippe see Figure 6–11. The manufacturing of popular images underscored the close relationship between the two countries, especially after the full flowering of the *entente cordiale* in the early 1840s. Such images should be continually amassed and assessed to gauge the depth of the relationship between rulers and countries.

10. For further reference, see "Les Dantan du Musée Carnavalet: Portraits romantiques." Earlier discussion of Dantan is found in John Grand-Carteret, *Les Moeurs et la caricature en France,* and Janet Seligman, *Figures of Fun: The Caricature Statuettes of Jean Pierre Dantan.* Dantan also created a *musée secret* with erotic imagery that was censored by his wife. Dantan was extremely successful in introducing the grotesque into sculptural caricature, especially when he portrayed certain Parisian celebrities.

11. Holderbaum, "Portrait Sculpture," 44.

12. Information on this particular piece and the general removal of the obelisk from Luxor, Egypt, was initially supplied by Wheelock Whitney, New York, the owner of the original plaster by Dantan. For further reference to the piece in the collection of the Musée Carnavalet, see "Les Dantan."

The New Portraiture: Drawing

Just as sculpture underwent a strong creative
push during the July Monarchy, so did draw-
ing. Artists endeavored to have drawings
accepted into the official Salons (thus placing
them on a par with painting), and many por-
traits of leading individuals were first created
as small sketches done from life. Through *Por-
trait of a Young Man* (Figure 6–5), Auguste
Flandrin, one of the triumvirate of younger
artists trained in the Ingres tradition of por-
traiture, moved to establish a new sense of
vitality.

Flandrin's sitter, who might be a collector
of some importance, is asymmetrically posed
before a rather large drapery that has been
pulled to one side to reveal a framed image.
This tantalizing presentation of possibly a
section of a seascape in the manner of a
watercolor or oil study by Paul Huet is placed
on a back wall within a tightly constricted
space. Light and shade have been used dra-
matically to emphasize the sitter's powerful
facial features. His straightforward gaze elimi-
nates any hint of sentimentality, almost as if
this direct, realistic transcription of the sitter
had been made from firsthand observation.
Obviously this wealthy sitter, who was perhaps
a member of the Flandrin circle, desired a
portrait that would simultaneously suggest his
interest in contemporary dress and document
his involvement with the visual arts. The fig-
ure seems very much the private *amateur* who
utilized his personal resources to form artistic
collections to which only a few aesthetes or
connoisseurs would eventually gain admis-
sion.

Since the figure's identity and the work's
provenance remain unclear, it is unlikely that
this watercolor was publicly exhibited at an
annual Salon.[13] Nevertheless, with this image,

13. For further reference, see *Hippolyte, Auguste et Paul
Flandrin: Une fraternité picturale au XIXe siècle*, esp. the

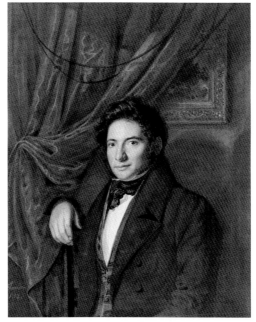

Figure 6–5. René-Auguste FLANDRIN, *Portrait of a
Young Man*. Watercolor, 1832. Private Collection.

Flandrin documented the arrival of a new
type: the patron of the arts who wanted to be
memorialized somewhat informally on an inti-
mate scale.

The role of artistic entrepreneur—the
individual who helped to promote an interest
in bronze statuettes, for example—did not
go unrecorded in the July Monarchy. Paul
Gavarni, a prolific draftsman and printmaker,
prepared in the 1830s two extremely evocative
watercolors of members of the Thomire fam-
ily. In his rapidly executed drawing of Pierre
Philippe Thomire, a founder in 1776 of one of
the first bronze factories in France, Gavarni
portrayed a wise and thoughtful businessman
seated in an armchair (Figure 6–6 [cat. no.

essay by Gilles Chomer, "Auguste Flandrin," 227–29.
Auguste Flandrin is the least known and studied of the
Flandrin brothers. This watercolor was made extremely
early in Auguste's career and just at the moment when
he was leaving Lyon for Paris. The drawing remains in
the collection of an art dealer who had little informa-
tion on its provenance and was reluctant to disclose
how he came to obtain the work.



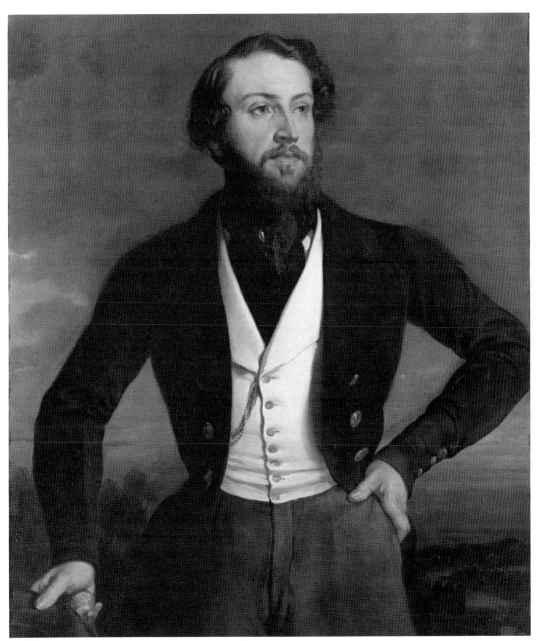

Figure 6–7. Eugène-François-Marie-Joseph DEVÉRIA, *Portrait of Comte Henri de Cambis d'Orsan*. Oil on canvas, 1839. London, Heim Gallery.

long family history in the region, the marquis d'Orsan owned extensive property near Avignon and must have employed a large number of workers. Like his eminent father, Henri Cambis was elected to the central government as a deputy from Avignon, and he remained one of the staunchest supporters of the July Monarchy until his premature death in 1847.[16] Henri, the eldest son, was also a landed gentleman, who took great pride in overseeing the family wealth and in monitoring how the lands were run and maintained. In effect, then, the Cambis d'Orsan family belonged to a segment of French society known as the privileged *notables,* individuals of high standing within the community who contributed their names and wealth to bettering their region by serving in parliament.

In that regard, this painting romantically glorified the Cambis family and in particular the emergence of Henri as a major political force in his native region. Completed in 1839 when Henri would have appeared his father's logical heir, and when he was entering regional politics in a forthright way, the painting was undoubtedly produced under specific agreement with Devéria.[17] It carefully elucidates the position of a young, dashing politician by drawing a parallel with the heroes depicted by the romantic circles of Paris.

The painting underscores another significant fact, namely, that the members of the Cambis d'Orsan family were wealthy aristocrats. Thus, the canvas presents another aspect of the political support Louis Philippe enjoyed in certain provincial areas. He could rely on the monied class not only to support his initiative to restore a sense of elegance to the crown but also to applaud economic policies that advocated industrialization and the forging of markets to promote entrepreneurial activity. Without the constant agitation for change fostered by the Parisian-based intelligentsia, regions such as Avignon experienced little unrest and remained somewhat conservative advocates of the July Monarchy.

On another level it is interesting that Eugène Devéria, a painter with a considerable reputation in Paris and at the Salons, was enlisted by the Cambis family. Obviously, Salon painters always looked for new commissions and for ways to improve themselves financially, especially if they were accomplished portrait painters. Since Eugène Devéria was actually in Avignon—he had gone to the region to restore his health—quite likely his reputation preceded him. He was enlisted by the duc d'Orsan to paint a member of the family, and the bravura pose suggests a degree of personal flair. Few could mistake Henri Cambis after they had confronted this portrait.[18]

The role the Devérias played in society is found in another noteworthy painting, a portrait of Achille Devéria by Louis Boulanger (Musée du Louvre, Paris). This half-length study brought the Salon audience of 1837

Jacques François Luc de Cambis (the marquis d'Orsan), who lived until 1860, see *Dictionnaire de biographie française,* 955.

16. Henri François Marie Augustin de Cambis was born in 1810 in Avignon and died 24 August 1847. He was elected twice to the parliament as a *député* from Avignon, first in 1842 and again in August 1846. Even though he was married twice, he had no children; subsequently that branch of the family ended with his death. For further information, see *Dictionnaire,* 955. A search of both the communal records of Avignon and the regional archives would undoubtedly establish the extent of the land and monetary holdings of this branch of the Cambis family.

17. This painting recently appeared on the English art market, where the author examined it in London during the early summer of 1988. The dealers who then held the work were noncommittal about the painting's provenance and how or where they had located it. The painting's perfect condition suggests that it had long remained in a safe collection where it had been appreciated and maintained. No specific documentation on the commissioning of this work has come to light, although such material might still exist either with descendants of the d'Orsan family or elsewhere.

18. This painting, which was not exhibited at a public Salon, must have been hung within the confines of the Cambis family home. No further images of Henri Cambis have been located by which to judge the portrait's accuracy or to test the theory that this is an incarnation of a romantic dandy.

into intimate contact with one of the major lithographers and engravers of the romantic movement. Similar to the portrait of Henri Cambis, the figure of Achille Devéria fills the frontal plane of the canvas; his gaze, however, is much more severe and penetrating than the somewhat distracted look of the duc d'Orsan. In the Boulanger portrait, Devéria seems to confront the viewer. His countenance appears stern and intense, suggesting the inner fire that consumed the personality of this artistic genius.[19] With a medallion in one hand and the other tensely resting on a table, Devéria seems to question both onlooker and himself about his role in society.

Vigorously painted with rich color, the work nevertheless conveys an aura of brooding melancholy. Boulanger went far toward intimating the role Achille was playing in the visual arts. Due to his overwhelming personality, Achille became a close confidante and recorder (through his lithographs) of many of the leaders of the romantic aesthetic. The canvas forcefully demonstrates how a romantic painting of a creative artist could play a central role in elevating portraiture to a new position of eminence in the July Monarchy.

In contrast to romantically derived portraits, other works from the period exhibit a more reserved attitude. Many of these images were by artists who had either been pupils of Ingres or had studied Ingres's works at numerous exhibitions. Often these portraits depict self-made men, once again revealing a link to the inherent policies of the July Mon-

archy. They are also works that were completed on a somewhat grandiose scale, one appropriate to the ambitions and accomplishments of the men portrayed.

Crucial to this discussion are paintings by Dominique Papety (1815–1849), an artist associated with Ingres and with achievements that occurred in the south of France. He worked concurrently in several thematic categories, painting everything from landscapes to religious/historical images, with portraiture being the least acclaimed of his works.[20] In time, Papety became the portraitist of some of the leaders of the July Monarchy, especially those individuals involved with improving the arts and the educational well-being of the public. A case in point is his large portrait of Antoine Vivenel, shown at the annual Salon of 1846 (Plate 42 [cat. no. 167]).

Papety constructed one of the period's richest and most evocative portraits from a detailed and quite realistic preliminary drawing. The painting followed the dictates of a classical heritage, and it is clear that line plays a more dominant role than does the muted color. Yet, stylistic concerns aside, the painting is worth examining on several levels for what it reveals about portraiture under Louis Philippe.

On the primary level, that of the sitter, the role of Antoine Vivenel during the July Monarchy must be taken into account. Initially an active entrepreneur involved in civic plans such as the remodeling of several key buildings in Paris, including the Hôtel de Ville, Vivenel aligned himself closely with the wishes

19. For further reference, see *Louis Boulanger: Peintre-graveur de l'époque romantique, 1806–1867.* From early in his career, Louis Boulanger was closely linked to Eugène and Achille Devéria and through them made the acquaintance of the romantic writer Victor Hugo. The *Portrait of Achille Devéria* remains one of Boulanger's best works, although critics of the time commented on an aspect of the "vampire" in this portrait (ibid., 13). The question of the cult of genius being perceived and utilized by many in the romantic camp remains significant. For a discussion of images of "artist's life" and the new consciousness of the artist as a creator, see Hugh Honour, *Romanticism,* 245ff.

20. For a discussion of the works of Dominique Papety and an introduction to his extensive oeuvre, see François-Xavier Amprimoz, *Dominique Papety, peintre d'histoire, Marseille 12 août 1815–20 septembre 1849.* While this study provides a biographical essay and an inventory of the primary works by Papety, it is not interpretive and lacks a substantial evaluation of Papety's career. Amprimoz's overview is still helpful, although Papety deserves a far more systematic examination. The author is indebted to Bénédicte Pradié, of the Musées de Marseille in the summer of 1988, for helping to obtain a copy of this unpublished thesis.

of the government to beautify and improve the center of the city. Beyond this, and through the utilization of his considerable personal wealth, Vivenel became an enlightened art connoisseur who wanted to use his acumen and collections to educate the citizens and children of his native Compiègne. Since Vivenel commanded immense renown and visibility under the July Monarchy, it is not surprising that he called on the talents of a friend and a most able painter to produce a portrait that would both underscore many of his achievements and attract attention when it was officially exhibited at the Salon of 1846.[21]

Whether Vivenel intended that his portrait by Papety would one day hang in the main staircase of the museum that bears his name in Compiègne now matters little.[22] What is crucial is that during the 1840s, when Vivenel was implementing his policies in support of the crown, he wanted to exhibit a grand painting that would be filled with enough allusions to his work and efforts that few could deny his celebrity status within the July Monarchy. In a sense, then, Papety set out to illustrate the essentials of Vivenel's character and to reveal aspects of his patron's artistic goals.

As the architectural plans in the background of the painting suggest, Vivenel had emerged as an influential designer of the new Hôtel de Ville, a building central to the sense of purpose and energy that Louis Philippe was directing toward reviving the core of Paris. The overall success of the building established Vivenel within the ranks of the architectural entrepreneurs of the city; it also elevated him to a special status.[23] In addition to highlighting this facet of Vivenel's career, Papety has shown the sitter amid his own constructed environment—Vivenel's private cabinet—in which his collection of artworks is carefully positioned for admiration and study. The woodwork of the room and the desk at the right are also important ingredients since their Renaissance revival style further attests to the way in which Vivenel appointed his quarters in Compiègne. Thus, Vivenel is depicted not only as an active participant in society but also as a personality with a rare sense of erudition. He later served as a benefactor for the museum that he founded for his own permanent collection in his native city of Compiègne.[24]

Papety's symbolism includes what Vivenel holds in his hands and spreads to encompass the works inside this painted environment. Enamels, sculptures, and ceramics drawn from the classical and medieval worlds dominate the space. Vivenel often obtained such works through archaeological digs for the purpose of establishing a collection that would eventually benefit his countrymen. Both in reality and in this painting, Vivenel had become a prime example of the enlightened entrepreneur/collector. By commemorating his activities in a painting, the July Monarchy could point to Vivenel with considerable pride. Indeed, the museum he established in Compiègne must have interested many of those in government service, since members of the royal entourage were invited to attend

21. The painting was listed as number 1377 in the Salon catalog of 1846. For reference see *Explication des ouvrages de peinture, sculpture, architecture, gravure et lithographie des artistes vivants*, 158. The Vivenel portrait was included with two other paintings by Papety: *Consolatrix afflictorum* (number 1375) and *Solon dictant ses lois* (number 1376).

22. For reference, see J. Blu, *Musée Vivenel, catalogue illustré des peintures, dessins, sculptures*, 22–23. The catalog contains an essay on the museum and another study on Vivenel's role in formulating and establishing the art institution. Many artists came to the Musée Vivenel to examine the extensive holding of prints amassed by the museum's founder.

23. For a discussion of Vivenel's role in society and in the creation of his museum, see Sylvie Forestier, "A propos de la création à Compiègne du Musée Vivenel."

24. Ibid., 129ff. Vivenel clearly stated in founding the museum that he did not want to create a *cabinet d'amateur* but rather a *musée des Etudes*. The formation of the museum was officially accepted by Louis Philippe in March 1844, at the same time that he authorized opening the Musée de Cluny to the French public.

its official opening.[25] Throughout the 1840s, Vivenel was such an active personality that few could have failed to chart his progress and interests through articles about him that frequently appeared in the regional press.[26]

An awareness of Vivenel's ideas, emerging as they did at the time his portrait was being painted by Papety, will help to place this work within the wider framework of issues and implications. One essential notion is that Vivenel chose to organize his museum historically. He did not want visitors to be disoriented when they confronted pieces from various periods. To ensure that the educational function of his museum would be carried out, Vivenel established an art school alongside his museum so young students could actually study works from the collection and learn to draw out concepts and sources directly rather than from reproductions or plaster casts. With a substantial amount of money at his disposal, Vivenel endorsed contests with lucrative prizes to reward the best students in draftsmanship. In this way he encouraged the young to pursue a professional interest in the visual arts. Perhaps he hoped that some would even follow a practical course in design or the industrial arts.

From this portrait, which propagandized his role as a public Maecenas at the Salon, Vivenel was recognized as a supporter of the visual arts, an advocate of art education, and a promoter of innovative ideas about both sexes actively participating in the arts and society.[27] His love of art objects and books made Vivenel, in essence, a model for the engaged private collector. As an advocate of Louis Philippe's regime, and potentially of the royal family's interest in the arts, Vivenel nurtured the visual arts in a way that combined practice with idealism.[28]

Vivenel was not the only architect during the July Monarchy to find himself immortalized in a Salon painting. In 1841, Thomas Couture exhibited his portrait of M. Ohnet (cat. no. 160); at the time, the sitter was gravely ill, and the artist had to stretch his memory to complete the canvas. The final image shows Ohnet looking to one side, carrying himself somewhat haughtily but in a way that suggests inner animation.[29] In memorializing Ohnet, Couture became connected, as Papety was with Vivenel, with another prominent architect who was involved in rebuilding sections of Paris. Similarly, Couture depicted Ohnet in an informal pose that played upon his liberated outlook and his ability to solve problems with new ideas.

A renowned oil portrait that gravitates toward the realism of the late 1840s is a work by Gustave Courbet, the recognized dean of the realist tradition after 1848.[30] In his *Portrait de l'artiste, dit Courbet au chien noir* (Portrait of the artist, called Courbet with black dog; Figure 5–10 [cat. no. 19]), Courbet, much as Devéria had done with his study of Henri

25. For a transcript of the *Ordonnance royale du 19 Mars 1844,* see ibid., 133–34. According to the regional press, members of the royal family came to Compiègne on other business—usually military—and visited the nascent museum during the early 1840s. See ibid., 119–21.

26. For further discussion and reference see, for example, *Progrès de l'Oise,* 17 June 1843, 24 June 1843, and 8 July 1843, for mentions of Vivenel's activities that often touched on the creation of the museum in Compiègne. He was undoubtedly regarded as one of the major celebrities from the region, and his portrait was reproduced in the publication on at least one occasion. On Vivenel's death, see "Mort de M. Antoine Vivenel," *Progrès de l'Oise,* 22 February 1862.

27. For reference on this see *Progrès de l'Oise,* 8 November 1845.

28. The practical support that Vivenel gave to many projects and issues was extensively reviewed in his death notice. See *Progrès de l'Oise,* 22 February 1862.

29. For reference, see Albert Boime, *Thomas Couture and the Eclectic Vision,* 405. Critics greatly admired this painting for its "brushwork."

30. The standard reference on Courbet is *Gustave Courbet (1819–1877).* Courbet remains the subject of considerable debate since art historians continually place his work at the center of discussions and new methodologies. See *Courbet Reconsidered* and the extensive discussion in press reviews, including Gabriel P. Weisberg, "Hallucinatory Art History: The Bizarre Case of Gustave Courbet."

Cambis d'Orsan, presented himself as a personality both drawn from and linked to a precise region of the French provinces. Like Devéria, Courbet adhered to the concept that when illustrating a regional landowner, it was best to show him situated within his familiar surroundings. Thus, Courbet placed himself before the rocks and countryside of the Franche Comté near his birthplace of Ornans. Courbet, however, went much further than Devéria in examining character and attitudes. He dressed himself rather flamboyantly with a large black hat and included a family dog that dominates the foreground, all of which intimates that Courbet considered himself lord of his domain. Yet it implies much more.[31] By portraying himself with his head cast backward and a somewhat haughty expression on his face, Courbet provided a glimpse into his own mind: he viewed local traditions with some disdain and the grand manner of regally depicting landowners with a touch of sarcasm. At the same time, the particular locale and his exactitude in painting the dog and in recording the time of day establishes certain realist proclivities that would become more pronounced in his later works. In this context Courbet's self-fascination set the stage for advances in portraiture that would be undertaken during the Second Empire when traditions were further altered and new, more informal postures adopted to represent underlying life and energy.

The Print Revolution and the Portrait

As a continuation of, and a corollary to, the massive production of portraits during the July Monarchy, the industries of lithography and engraving that burgeoned during the reign of Louis Philippe followed basic con-

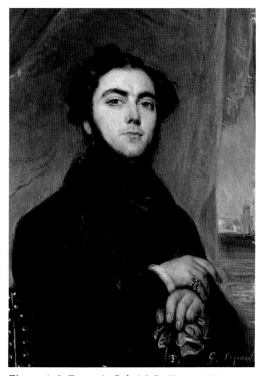

Figure 6–8. François Gabriel Guillaume LE-PAULLE, *Eugène Sue*. Oil on canvas, undated. Paris, Musée Carnavalet.

cepts that predominated in other media. Some artists sought to immortalize their colleagues in intimate, romantic drawings, much like Paul Delaroche did with his *Portrait du peintre Steuben* (Portrait of the painter Steuben; cat. no. 21). Others tried to present themselves or their friends in images that conveyed differing degrees of romantic infatuation with self and with attitudes of genius (see Figure 1–16 [cat. no. 26]). Since leading artists such as Eugène Sue (Figure 6–8) or Franz Liszt (Figure 6–9) had been studied in paintings and drawings, printmakers decided to follow the same path. Achille Devéria emerged as one of the primary witnesses to the intellectual side of Paris-based romanticism.

Devéria's detailed lithographs, which were widely available, fulfilled a basic need of the collector or passionate admirer: to possess an

31. For a brief discussion of some of the issues inherent in this painting, see *Gustave Courbet*, 83–84, where it is suggested that the composition could be linked to the portraiture tradition of eighteenth-century England.

Figure 6–9. Henri LEHMANN, *Liszt*. Oil on canvas, undated. Paris, Musée Carnavalet.

image—in essence, an icon—of a cultural hero at the height of power and influence. These lithographs often captured the easy spontaneity of the circle of friends and creators who visited the Devérias' apartments in Paris. A crucial element of these works is the way in which Achille Devéria concentrated on expressing an individual personality rather than solely portraying a characteristic pose or mannerism.[32] Through portraits of such popular personalities of the era as Alexandre Dumas and Liszt, Devéria conveyed the impression that these images were produced quickly and directly from life. His extensive series of notable figures not only transmitted the intensity of many of these cultural leaders but also signaled that the vignette portrait was becoming a major contribution of the period.

32. For reference see *Achille Devéria*.

While these portraits achieved a relatively good circulation and helped to popularize members of the artistic elite, some lithographic (and detailed engraved) portraits were produced for other purposes. One aim was to silence the satirists and caricaturists who maligned the persons and policies of the royal household, subjects of intense controversy especially during the opening years of the July Monarchy. Even though strict laws on censorship, court penalties, and imprisonments took their toll on the liberal press, a far more insidious and conservative use of the print media created icons of benign reinforcement that endorsed Louis Philippe and his methods. Similar to the massive production and dissemination of small-scale statuettes, members of the royal family were next immortalized in large engravings and lithographs.

One full-face vignette portrait of Louis Philippe (Figure 6–10) was designed to propagandize the royalty and demeanor of the king. He is shown dressed in military uniform and given a most dignified bearing, and his heavy jowls are even reduced. (They had been the object of extensive ridicule, especially by the circle around Philipon, whose illustrations of the king made him resemble a pear.) In fact, this majestic image resulted from a beautification, if not a sanctification, program that saw the production of thousands of such prints so all the king's promoters could display an image for themselves. Likewise, a range of full-length engravings of all the members of the royal family, from Queen Marie Amélie to Louis Philippe's sons, was available during the late 1830s and into the 1840s as part of an extensive propagandistic process intended to counter harsh criticism of the monarchy. When lithographs immortalized contemporary history, as in the print of the king and Marie Amélie greeting Prince Albert and Queen Victoria of England at the Château d'Eu in 1843 (Figure 6–11), it became apparent

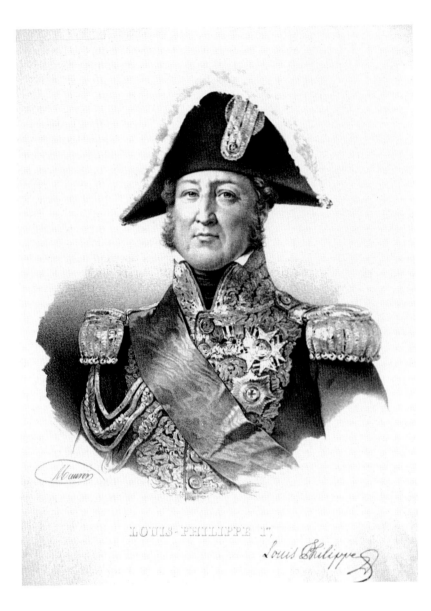

Figure 6–10. Nicolas-Eustache MAURIN, *Portrait of Louis Philippe*. Lithograph, date unknown. London, The Victoria and Albert Museum.

that official portraitists were not only creating icons for the Salon but were also being paid to impress upon the French public the international stature and acceptance of the Citizen King. Through the cultivation and manipulation of conservative portraiture, the king and the policies of the July Monarchy were continually reaffirmed and bolstered from attack.

In light of the range of portraiture produced during the July Monarchy, we can see it as a period of contrasts and challenges to tradition. Artistic attitudes and stylistic directions were tested, while the day's political, cultural, and financial leaders were immortalized for a curious public. The personalities and events these portraits record, and the ways in which artists responded to their media, all signal a society in flux—one of the fundamental hallmarks of the bourgeois society of Louis Philippe.

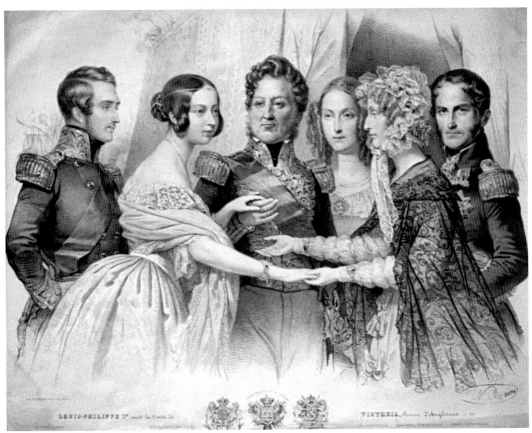

Figure 6–11. Nicolas-Eustache MAURIN, *Portrait of Louis Philippe, Queen Marie Amélie and Queen Victoria of England and Her Consort.* Lithograph, date unknown. London, The Victoria and Albert Museum.

7 THE CODED IMAGE
Agitation in Aspects of Political and Social Caricature

During the July Monarchy artists and entrepreneurs recognized the increasing significance of the visual image in formulating public opinion. Today the caricatures and political cartoons of the 1830s and 1840s are well known, with some, especially lithographs by Honoré Daumier (1808–1879), forming a body of material that has been seen as paradigmatic of the caricature tradition and as exemplifying the nineteenth century's involvement with realism.[1] The power of these images was often so pervasive, particularly during the 1830s when topical political issues were ferociously satirized, that members of the government became deeply offended. They reacted by restricting the freedom of the press, which had been bitterly won in the Revolution of 1830, through the institution of censorship control invoked by the September Laws of 1835.[2]

Lithographs were regulated because they were said to speak to the eyes, to train people to acknowledge the existence of severe problems, and to isolate issues that were often unfavorable to those in power. After the institution of the September Laws, artists were forced to be extremely careful about their themes, for otherwise they would be heavily fined, imprisoned, or both because of their political stance. Since the government censor was rigid about what could be published, lithographs lost their political dimension. Artists focused on issues linked to the social classes rather than directing their energies toward lampooning the king or the royal entourage. Yet, no matter what their themes, lithographic images were widely disseminated through newspapers, as individual prints, or as specially prepared editions.[3] During a period that saw the growth of newspapers as a major force in society, lithographs often reached a diverse audience who, for the first time in history, found themselves decoding and reacting to these images' actual intent, a development that held far-reaching implications for the concept of a media explosion.[4]

Caricatures with an agitational stance were available in books, magazines, specialty shops, and occasionally in public exhibitions. This

1. Recent evaluations of Daumier's prints have placed them squarely within the realist movement. For further reference, see Gerald Needham, *Nineteenth-Century Realist Art,* 52–63.

2. For a discussion of the September Laws, see Edwin T. Bechtel, *Freedom of the Press and L'Association Mensuelle: Philipon versus Louis Philippe,* 37–40. The September Laws gave the prosecution the unqualified right to try groups of defendants en masse. Most damning to the cause of the free press was the second section of the law, which required newspapers to deposit *cautionnement*—in essence, bail—to secure their full obedience to the law. The third section of the law defined new press crimes, including direct or indirect attacks against the king and any attack against the character or form of the government established by the charter. Caricatures, which had angered the government as a political weapon of the left, could not be placed for sale or exhibited without the prior authorization of the minister of the interior. These laws effectively curbed the outpouring of material aimed at Louis Philippe, since they were strictly enforced in the name of the security of the realm.

3. The growth of newspapers in France is ably chronicled by Irene Collins in *The Government and the Newspaper Press in France, 1814–1881.* Some of the leading members of the July Monarchy's elite were powerful newspaper magnates.

4. Ibid. The availability of lithographs, often in the form of caricatures, was rivaled by the serialization of novels in numerous newspapers, which made it possible for many to read a contemporary work in daily installments. The media explosion encompassed not only prints but also the printed word, marking the July Monarchy as a fruitful period in the attempted education of the middle class. For further reference, see *The Cult of Images: Baudelaire and the Nineteenth-Century Media Explosion,* 5.

liberated and marketable art form was effectively used by many, some of whom became quite notorious during the July Monarchy but were eventually eclipsed by the recognition given to Daumier.[5] These other caricaturists not only used exaggeration as a pointed means of social satire and as a way to advance issues, but their efforts also eventually led to an elevation of printmaking to what in retrospect resembles a golden age.[6] Many printmakers were aware of each others' work, ideas, and social concerns. Often these artists were supported by the same entrepreneurs who wanted to see the print media encouraged so that a broad base of the public could be educated and brought to new heights of social awareness. In effect, the same entrepreneurial enthusiasm that was mobilized for many industries began to affect this aspect of the visual arts. Unhindered speculation was avidly pursued, even if the money seldom reached the artists to alleviate their financial difficulties.

These images often contained several layers of allusion so that various sectors of society could respond to their perceptions of the works' messages. Levels of meaning are often difficult to reconstruct thoroughly, for artists tied their images to transitory issues while they revealed universal truths. And the intricacies of political allegiances and the subtleties of the July Monarchy have been muted with time, which makes the reading of these caricatures all the more difficult. With this in mind, an examination of specific images will commence along the following lines of study.

Figure 7-1. Charles PHILIPON, *La Cuisinière bourgeoise* (The bourgeois cook). Lithograph, ca. 1828–1829. London, The Victoria and Albert Museum.

First, caricatures with a political nature will be assessed against the historical events and changes in government policy that were then being advocated. Second, images of social "types" will be judged for what they reveal about a society in transition. Third, symbols that incarnated the tenor of the period will be probed to see how they alluded to the July Monarchy and its code of a *juste milieu*. By approaching caricatures in this way, we will be close to decoding their implied messages and to understanding why these works became such a potent force for agitation.

The Entrepreneurial Patronage of Charles Philipon

As a seminal figure in the advancement of lithography, especially as a vehicle for radical propaganda, Charles Philipon revolutionized the art form to make it a powerful mechanism

5. On Daumier, see Roger Passeron, *Daumier.* Literature on Daumier's prints and paintings is vast, and Passeron provides an adequate bibliography of publications up until 1980.
6. For a fundamental discussion of caricature in the period, see Jules Champfleury, *Histoire de la caricature moderne.* Champfleury recognizes that Daumier, Traviès, and Henri Monnier could be classified as the "démolisseurs de la bourgeoisie" (demolishers of the bourgeoisie) because of their charged satirical imagery.

Figure 7–2. Charles PHILIPON, *Promenade bour-geoise* (Bourgeois stroll). See cat. no. 89.

for media agitation.[7] As an image-maker, Phi-lipon also completed numerous drawings in the late 1820s that were used by editors as the basis for prints to promote popular tastes dur-ing the reign of Charles X. Prints that remain from Philipon's early years demonstrate that he was capable of depicting social types that appealed to the erotic and modish inclinations of his audience (see Figure 7–1).[8] When Phi-lipon began to produce his own prints through

his own outlet in January 1830, he continued to pander to common taste. In *Promenade bour-geoise* (Bourgeois stroll; Figure 7–2 [cat. no. 89]), he revealed his capability of identifying in society Louis Philippe and his wife Marie Amélie.[9] Philipon showed the portly physique of the king in this early double icon of two burghers taking a walk. Although he has not ridiculed Louis Philippe, he has concentrated on one of the king's favorite pastimes—stroll-ing through the streets and gardens of Paris accompanied by his wife. The print also estab-lishes early on Philipon's acute observation of the manners and life-style of Louis Philippe.

These early prints notwithstanding, Phi-lipon quickly became a most perspicacious editor of images. He published works of a political nature along with others that would appear to his audience less aggressive in tone.[10] He fully acknowledged the contribu-tions and ideas of others, and his unbridled energy led to his founding a series of journals in which his caustic wit was reinforced by images created by others. Finally, his hatred of injustice, intolerance, and mediocrity—qualities he perceived as rampant during the early phases of the July Monarchy—made Philipon and his circle of artists marked men.

As early as 1829, when France was still under the reign of Charles X, Philipon and others organized the caricature journal *La Sil-houette,* which began to ridicule those in power. This publication, as the first of three to estab-lish Philipon's fame—the others were *La Caricature* and *Le Charivari*—launched lithog-

7. For a discussion of Philipon's inventiveness as a print entrepreneur, see James Cuno's "Charles Philipon, La Maison Aubert, and the Business of Car-icature in Paris, 1829–41" and his "The Business and Politics of Caricature: Charles Philipon and La Maison Aubert." In the first article, Cuno evaluates some of the earliest images created by Philipon, noting that a large number of these works are preserved in the collection of the Cabinet des Estampes, Bibliothèque Nationale, Paris.

8. Cuno, "Charles Philipon," 347.

9. The signature identifies this as an early work by Philipon. The parallels with Louis Philippe are re-inforced by the fact that after his return to France, around 1820, he lived peacefully in a Palais Royal resi-dence. He was genial and given to promenades around Paris, where he wore a "worn greatcoat and an old tile hat." He was a good bourgeois citizen who often tried to shake everyone's hand. For further reference to these aspects, see Bechtel, *Freedom of the Press,* 27. The address on this print is different from others found on Phili-pon's prints at this time.

10. Cuno, "Charles Philipon," 348.

raphy as a volatile medium that could be used for radical propagandist purposes. Without knowing the exact audience that read these publications, Philipon likely recognized the need to educate a public that was just beginning to appreciate the benefits of the hardwon freedom of the press. By enlisting the support of the most creative and republican-spirited printmakers, including Raffet, Traviès, Grandville, Monnier, and ultimately Daumier, Philipon escalated his visual attacks against those he believed were misusing power. Consequently, he opened himself to severe criticism and was subjected to excessive fines and, eventually, imprisonment.

Philipon initially contributed to his journals specific images, which were often lithographed by others, as well as ideas that he instilled in his printmakers. There can be little doubt that the concept of portraying Louis Philippe in the shape of a pear, both as a reflection of the king's physique and as a comment on his supposed lack of intellectual acumen, can be traced to drawings by Philipon. This concept was then picked up by other artists in his circle.[11] Similarly, with cartoon-like figures who became recurring icons of the age, such as the odious and manip-

ulative hunchback M. Mayeux, the original derivation most likely came from other early prints and drawings by Philipon.[12] Thus, he engineered press campaigns by initiating ideas, developing visual images as puns on slang words or personalities, and targeting political and social issues. In meetings with his staff and fellow caricaturists, Philipon helped others to visualize his wishes. These images in turn became some of the most caustic of the July Monarchy.

These early prints, completed shortly after the 1830 Revolution, provide ample evidence of the range of Philipon's targets. They also point to the subtly created symbols and visual puns that continually reappeared in lithographs Philipon published, almost as if he were creating a comic-strip character in order to agitate his audience and increase awareness of social issues. These images should be studied at some length since they demonstrate the full mastery of liberal propaganda in direct confrontation with the government of the *juste milieu*.

Philipon and Liberal Political Ideology

In establishing himself as a financial captain of the lithographic industry, Philipon gained exposure to all avenues of promotion. He became a successful shop owner, he printed his own images for his publications, he sold illustrated books, and he continually commissioned works.[13] The fact that Philipon sold

11. Cuno, ibid., 350, notes, "Philipon worked out certain visual ideas and passed them on to his artists . . . he was very much involved in and, indeed, responsible for, the content of the images he published." For a reproduction of the print demonstrating the evolution of Louis Philippe's head into a pear, see Cuno, "Business and Politics of Caricature," 102, where he reproduces a lithograph originally published in *La Caricature* on 24 November 1831. Judith Wechsler, *A Human Comedy: Physiognomy and Caricature in Nineteenth-Century Paris*, 71–75, discusses the development and association of the pear image with Louis Philippe but does not examine the origins of the icon or fully explore the shades of interpretation of the French word *poire* as slang. The latter seems an especially useful route to follow given the interpretive possibilities and the ways in which the pear came to symbolize Louis Philippe and his regime. The imbecility of a *poire* is noted in Henri Bauche, *Le Langage populaire: Grammaire, syntaxe, et dictionnaire du français tel qu'on le parle dans le peuple de Paris*, 241. See also James Cuno, "Charles Philipon and 'la Poire': Politics and Pornography in Emblematic Satire, 1830–1835."

12. For reference to images of Mayeux, see Bibliothèque Nationale, Paris, "Caricatures sur Mayeux" (BN Tf 53). A Mayeux-like image is found in prints by Philipon housed in the Cabinet des Estampes, Musée Carnavalet, Paris, which thus raises the issue as to who might have originated this character. For further reference to the interaction between Traviès and Philipon on prints of Mayeux, see Cuno, "Charles Philipon," 354, n. 19, where he notes that through the published criticism of Charles Baudelaire it can be documented that Philipon drew the female figures in Traviès's caricatures of Mayeux.

13. Cuno, "Business and Politics of Caricature."

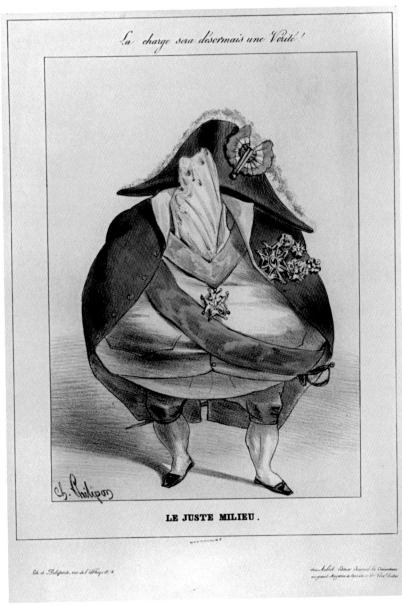

La charge sera désormais une Vérité!

LE JUSTE MILIEU.

Figure 7–3. Charles PHILIPON, *Le Juste Milieu*. Lithograph, undated. Paris, Musée Carnavalet.

books in his shop at the same time he published his hotly debated journals suggests that he was trying to hedge his bets. As an astute businessman, he recognized that if one venture failed he would need other ways to reach members of the middle class who were eager to educate their eyes as well as their minds.[14]

Shortly after 1830, Philipon was buoyed by

the new atmosphere, but this attitude changed the more he and others challenged contemporary beliefs. Yet not until he was arrested for publishing an image that criticized Louis Philippe directly did Philipon clearly realize that the apparent liberal atmosphere of the July Monarchy was a sham. Deciding that he had endured enough repression, Philipon chose to vent his dissatisfaction through confrontational politics. By 1831, Philipon had dedicated

14. Cuno, "Charles Philipon," 349.

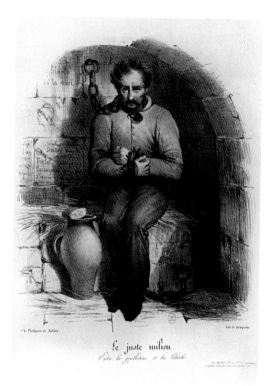

Figure 7–4. Charles PHILIPON, *Le Juste Milieu.* See cat. no. 95.

himself to exposing the "wrongheadedness" of Louis Philippe's policies by unmasking the foibles of the *juste milieu* and publishing images that castigated injustices.

Attacked by the ever-present government censor (something Grandville satirized in a lithograph of 1832) and weighed down by fines and the fear—and actuality—of imprisonment, Philipon was forced to define the larger moral issues for himself and for his colleagues. He was soon perceived as the artistic conscience of the nation, a figure who was upholding the rights of a free press much as they had existed in England.[15] Among Philipon's early lithographs lampooning the new era was one of *Le Juste Milieu* (Figure 7–3), signified by its aura of aristocratic pretension and its superficial appreciation of republican

15. Cuno, "Business and Politics of Caricature," 102ff.

principles. Through a faceless form that resembled an overripe pear, this *juste milieu* was deemed overly inflated with self-importance. Philipon utilized sophisticated manners and elegant dress to represent both the trappings of a new court and the truth of the situation. In that way, he created images that visualized abstract issues as they mocked those in power.

A second lithograph, also entitled *Le Juste Milieu* (Figure 7–4 [cat. no. 95]), further underlined the moral dilemmas that faced those who were speaking out. A solitary figure has been confined in a type of straitjacket and shackled to the wall of a prison cell. Philipon thus presented his own situation as a prisoner of a government that wanted to silence its opposition. This image emphasized the plight not only of the editor but also of his artists. Through the scratched graffiti of the republican figure of France wearing a revolutionary Phrygian cap, Philipon reiterated that supporters of a free press were advocating liberty or death. In entitling this lithograph *Le Juste Milieu,* Philipon stressed that justice did not exist. Instead, those in power were fully subverting what they had been called upon to uphold in the Charter of 1830.

A similar hatred of oppression is found in a later image by Daumier dedicated to a remembrance of the prison at Sainte Pélagie (Figure 7–5). Here, the troubled young republicans, including Daumier, have only themselves and an occasional newspaper for company. They too have been put away so they cannot cause further problems. Nevertheless, the repression implied in these images did not deter Philipon from continuing to publish *La Caricature* or from urging artists to voice their animosity toward the cancer that was infecting different segments of French life.

According to historical records of the era, the political situation in 1831 remained tense both within Paris and in outlying cities such as

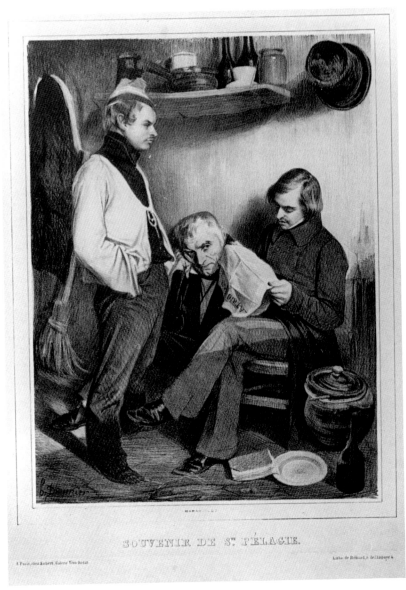

SOUVENIR DE S^T. PÉLAGIE.

Figure 7–5. Honoré DAUMIER, *Souvenir de Sainte Pélagie* (Memory of Sainte Pélagie). Lithograph, 1834. Paris, Musée Carnavalet.

Lyon.[16] The National Guard was called upon to quell disturbances that plagued the city of Paris between April and September. Under the banner of maintaining public order during the election of 5 July, the National Guard was directed to quiet the streets. Grandville, who had become one of the major caricaturists for

Philipon, seized on these incidents for his print *La Grippe* (Influenza; Figure 7–6).[17] This image compared the military to a fast-spreading flu, suppressing activity that was not perceived to be in its favor or for the good of the country. While not as blatant as other images, this print signaled that printmakers

16. For a discussion of the situation in Lyon and its relationship to events in Paris, see Robert Bezucha, *The Lyon Uprising of 1834: Social and Political Conflict in the Early July Monarchy,* esp. 1–122.

17. For a discussion of some of the political implications associated with this print, see the entry by S. Guillaume in *Grandville: Dessins originaux,* 234.

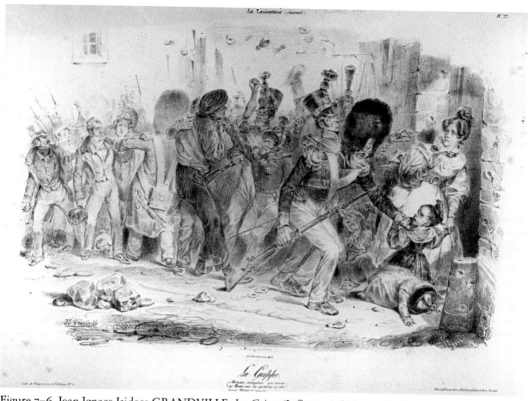

Figure 7–6. Jean-Ignace-Isidore GRANDVILLE, *La Grippe* (Influenza). Lithograph, 1831. Paris, Musée Carnavalet.

were scrutinizing the indiscriminate use and abuse of power.

As the political situation intensified in Paris and Lyon, many images again focused on the personality of Louis Philippe as well as on his ministers and policies. He was perceived as deviating from the tenets of the charter that had first enabled him to assume control of the country. Artists pictured him in a number of guises or disguises, their images repeatedly attacking his reign and his intelligence. In the end, France itself was depicted as being in extreme jeopardy, with vultures picking apart the nation. Lithographs that directly related to these issues escalated the press wars and ultimately brought the censor more fully into control once the radical left was blamed for undermining the government.

Contemporary History: The Guises of Louis Philippe

As Louis Philippe's government was formulated during the opening years of the 1830s, certain fundamental values were subverted. Those in power seemed willing to maintain order through a dull middle-of-the-road policy that appeased some groups and supported others. According to the lower classes and those with intense republican opinions, Louis Philippe and his ministers were the reason human values were eroding. Caricatures, of course, played upon these perceptions. They ridiculed Louis Philippe's policies by depicting him as a pear, a form by which the king was identified in numerous lithographs.

By 1831 and with the situation in Paris still

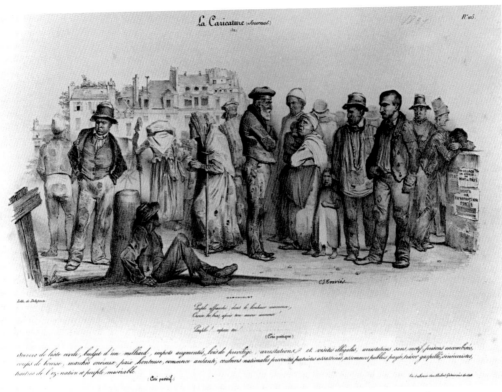

Figure 7–7. Charles Joseph TRAVIÈS, *Peuple affranchi* (The emancipated people). See cat. no. 83.

Figure 7–8. Honoré DAUMIER, *Pauvres moutons, ah!* (Oh! poor lambs!). See cat. no. 90.

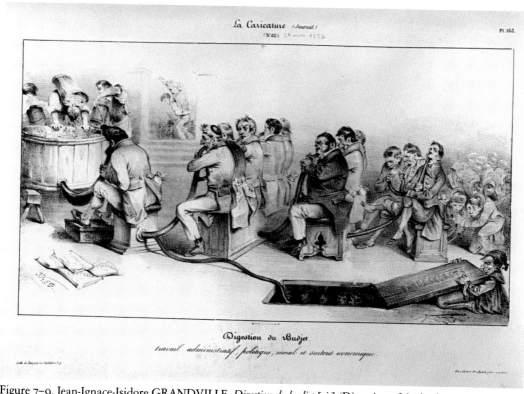

Figure 7–9. Jean-Ignace-Isidore GRANDVILLE, *Digestion du budjet* [*sic*] (Digestion of the budget). Lithograph, 1832. Paris, Musée Carnavalet.

unsettled, it had become clear to those working closely with Philipon, and especially to Traviès, that the lower classes were in serious trouble. A work by Traviès titled *Peuple affranchi* (The emancipated people; Figure 7–7 [cat. no. 83]) provided a panorama of lower-class types who were then out of work. In addition, the accompanying caption, which was possibly prepared by Philipon, commented on government policies that paid little attention to those at the bottom of the social ladder but supplied special favors and money to the already powerful. Daumier explored this attitude in another lithograph in which one figure, remarkably resembling a young Louis Philippe, shears sheep (Figure 7–8 [cat. no. 90]). Surrounded by the military, the trapped sheep can be compared with the republican *citoyens* who were being fleeced and

denied access to government support.[18] In these and other images completed during the opening days of the *juste milieu*, caricaturists communicated that the new mundane government actually represented a very select portion of the electorate and was dedicated to supporting conservative business and professional interests. The *juste milieu*, as these images imply, was not sympathetic to the conditions of the general populace.

Grandville's image of the *Digestion du budjet* [*sic*] (Digestion of the budget; Figure 7–9) further satirized ways in which government funds were being siphoned off. In this print, which appeared on 25 May 1832 in *La Caricature*, Grandville caustically demonstrated that funds were first sucked up by the king and

18. For further reference to this print, see Loys-Delteil, *H. Daumier, peintre-graveur.*

Figure 7–10. Charles Joseph TRAVIÈS, *Pot de mélasse* (Crock of shit). Lithograph, 1832.
Paris, Musée Carnavalet.

then passed on to his ministers and admin-
istrators, with a certain amount going under
the table to "secret funds," such as those used
by the police.[19] This bold step in castigating
government interests and the distribution of
funds centered on Louis Philippe himself.
Seen from behind, gratifying himself, the king
was easily recognizable to all. No one could
miss his involvement in this budgetary dinner.
Coming early in his reign, this lithograph pro-
vided added ammunition to those who noted
the ill practices of the regime.

Such focus on the oral and anal aspects of
the distribution of the budget followed an ear-
lier and more biting representation of the king
in Daumier's *Gargantua*.[20] Submitted for regis-
tration in December 1831, this print led to
Daumier's condemnation by the assize court
and to his imprisonment at Sainte Pélagie in
August 1832 for insulting the government
and specifically the person of the king.[21] Dau-
mier's image, based on scatological pro-
totypes that had appeared in anonymous
eighteenth-century prints of royalty, scathingly
denounced the treatment of the poor, who

19. For a discussion of the implications of this image,
see *Grandville: Dessins originaux*, 246. The original draw-
ing does not identify the area in the foreground, visible
through the open trapdoor, as "secret funds." This
identification was added to the published print, and
Philipon may have had a hand in making the message
more precise for his audience. Cuno identifies the
scatological references in the Grandville print in
"Review of Musée des Beaux-Arts, Nancy, *Grandville:
Dessins originaux*," 533.

20. For a brief discussion of *Gargantua*, see Cuno,
"Business and Politics of Caricature," 103. *Gargantua*
originated from earlier prints that emphasized the
gargantuan tastes of the king or the middle class as
being fed by the funds and produce of the workers. For
further reference to these images, see *French Caricature
and the French Revolution, 1789–1799*, figs. 67, 68, 182,
and 183.
21. Passeron, *Daumier*, 66.

functioned merely as servants of the regime, as it emphasized the rapacious appetite of the king, whose massive frame dominated the countryside.[22] This print and the similarly odious image by Grandville implied that funds were being misused and misdirected, that monies were being diverted for the gain of the privileged, and that the common people were the fundamental losers in this process. *Gargantua* also marked the full use of a scatological framework with references to Louis Philippe, an attitude assumed by other members of Philipon's circle.

The imprisonment of Daumier and others, and the control of the press, compounded by the general difficulties and inconsistencies of the early reign of Louis Philippe, led to Traviès's further visual denunciation of the regime in *Pot de mélasse* (Crock of shit; Figure 7–10), a print with several layers of meaning linked to the highly popular interpretation of the word *mélasse*.[23] On one level, the gigantic molasses container has been surmounted by another incarnation of a pear, this one with a face, which implies that the image was identified not only with Louis Philippe but also with the entire July Monarchy. Since the word *mélasse* can refer to a person being in severe difficulties, much like the slang of "being in the soup," the problems of the government were further underscored. On another level, the pear and the molasses pot are surrounded by a cross section of society but remain protected by a nervous group of soldiers, who realize that the pear is poised precariously above the vat. Adorned with a celebratory ribbon, the

round vat has in turn become the body of the king, with the pear representing his head and the wicker chair legs serving as his lower body. Before the audience's eyes, the molasses pot has become the pot-bellied leader of France, who thus symbolizes the nation. Traviès thus alluded to the fact that the *juste milieu* was trapped in its own policies and could not free itself. On a third, scatological level, the slang interpretation of the word *mélasse* furnished two other messages to the print: to be deep in excrement, and to be in misery.[24] The latter allusion stemmed from Traviès's lower-class allegiances and the fact that he was concerned about miserable conditions under the July Monarchy. Thus, by utilizing slang and popular visual puns, and by coding the image with various shades of meaning, Traviès assured that the print reached a broader audience. Traviès also appealed to the basest interpretation of image and words, making the print accessible to the illiterate. That ability points up another virtue of a caricature: it taught through the image itself.

By mid-July 1832, Traviès was including scatological references in another image, the lithograph *Le Juste Milieu se crotte* (The *juste milieu* dirties itself; Figure 7–11 [cat. no. 97]). The image of two allegorical figures—a harlequin and a pierrot—carrying an oversized pear across a muddy street implies that the two jesters were companions of the court and that the king was sullied by those who worked with him. Simultaneously, the pear's obvious weight and the muddy surroundings translated into the foolishness of the regime. These incongruous helpmates of the symbolic king and the way in which the pear is treated as "heavy" royalty further underscored the perceptions of the populace and those preparing

22. Scatological references from an earlier period are discussed in Albert Boime, "Jacques Louis David, Scatological Discourse in the French Revolution and the Art of Caricature."

23. For further reference, see Claude Ferment, *Charles Joseph Traviès: Catalogue de son oeuvre, lithographiée et gravée*, 38, no. 355, and 36, no. 324. See Lucien Rigaud, *Dictionnaire d'argot moderne*, 247, for a nineteenth-century interpretation of *mélasse* and further reference to the incorporation of slang terms into this image.

24. For reference to this interpretation of *mélasse*, see Bauche, *Le Langage populaire*, 232. The levels of interpretation and the references to class consciousness are implied through this interpretation of the word with which Traviès titled his image.

Figure 7–11. Charles Joseph TRAVIÈS, *Le Juste Milieu se crotte* (The *juste milieu* dirties itself). See cat. no 97.

La Caricature that the *juste milieu* was covering itself with excrement.

Louis Philippe's presence also dominated many of Daumier's early prints. In some, Louis Philippe appeared in a nightmare begging for funds. Once these funds were appropriated, he himself became a monstrous dream. Even at the moment of serious insurrections and the soldiers' massacre of the poor on the rue Transnonain, nothing seemed sacred. The king was then depicted in the guise of a Sister of Charity trying to collect alms from the poor who had been slaughtered on the rue Transnonain. The image obviously implied that the world had turned upside down and that those in power could no longer be trusted.

Judging from these and other references to Louis Philippe that continually appeared in such works, the printmakers were highly inventive in drawing allusions to the king.

Seen in a variety of guises or emanations, Louis Philippe was portrayed as a rapacious monster that tarnished all he touched. In him, the modern caricaturist had someone to attack, and his presence in the prints generated an easy target for the opposition.

France in Jeopardy: The New Message of the Caricaturists

If the images created by the caricaturists seemed at first more focused on Louis Philippe's personality than on the state of the nation, the illusion was short-lived. A series of powerful images, beginning late in 1831, directed attention toward issues and deceptions that were eroding the values of the country. Presentation of these problems created the impression that France was heading toward a very serious confrontation.

Of the early prints, *La France livrée aux corbeaux de toute espérance* (France, robbed of all hope by the crows; Plate 16 [cat. no. 94]) remains one of the most violent and hallucinatory. Published in *La Caricature* on 15 October 1831, this print hinted that France was being "picked to death" by those who wanted to assert control. The desolate environment in which the prostate form of France lies reinforced the notion that the Revolution had been defeated, a point echoed by the tattered tricolor in the foreground.[25] The scavenging black birds, which represent different potential ministers, further implied that the country was about to be plundered. As a satirical harbinger of what would happen after 1832, this image heightened awareness of the dangers lurking in government if many problems were not solved.

25. For further reference, see *La Caricature: Bildsatire in Frankreich, 1830–1835, aus der Sammlung von Kritter,* 89–90. Also see *Grandville: Caricatures et illustrations,* no. 80. A hand-colored proof of this print is in the collection of the Musée Carnavalet, Paris. The reason for the existence of a hand-colored version of the print needs further examination.

Plate 30. Claude-Félix-Théodore Caruelle D'ALIGNY, *Vue prise des carrières de grès* . . . (View of the sandstone quarries . . .). See cat. no. 145.

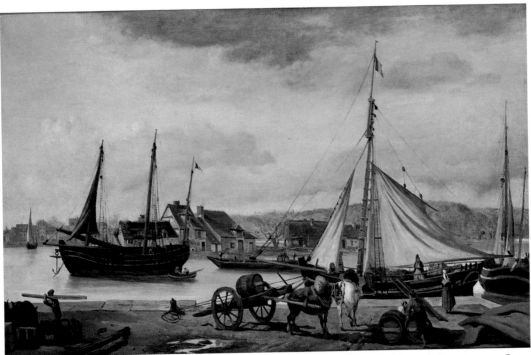

Plate 31. Jean-Baptiste-Camille COROT, *L'Avant-port de Rouen* (The outer harbor of Rouen). See cat. no. 148.

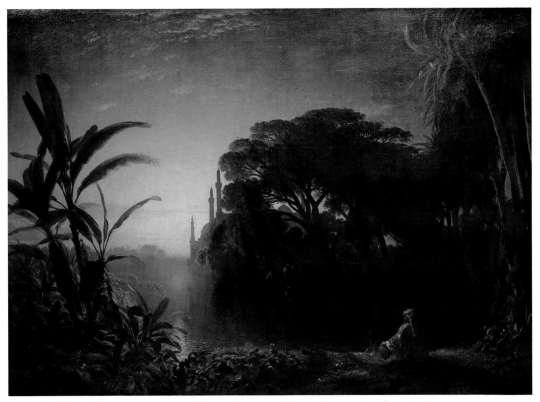

Plate 32. Prosper-Georges-Antoine MARILHAT, *Paysage d'Egypte* (Egyptian landscape). See cat. no. 149.

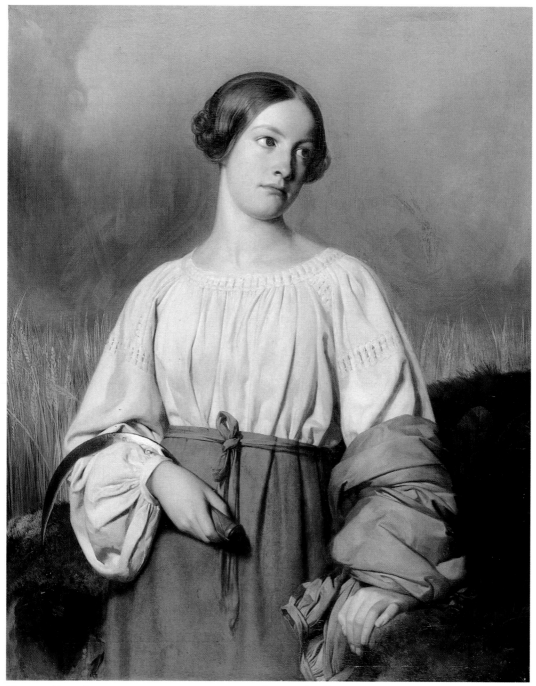

Plate 33. Alexandre-Jean-Baptiste HESSE, *Moissonneuse tenant sa faucille* (Harvester holding her sickle).
See cat. no. 150.

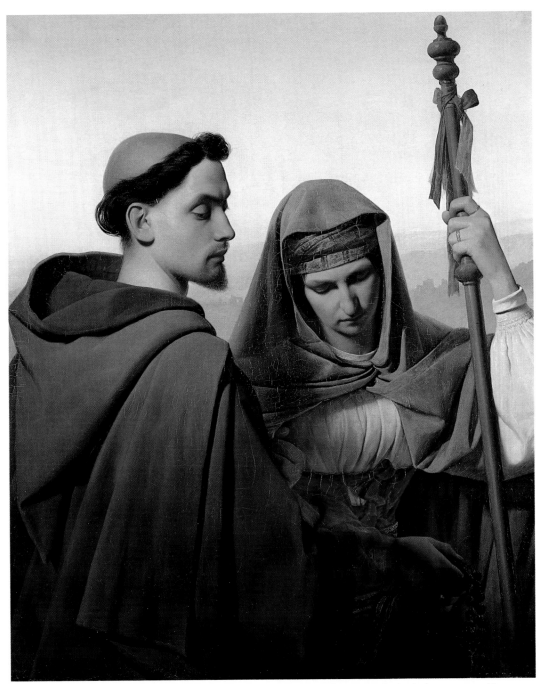

Plate 34. Jean-Claude BONNEFOND, *Une Pèlerine soutenue par un religieux* (A pilgrim being supported by a monk). See cat. no. 151.

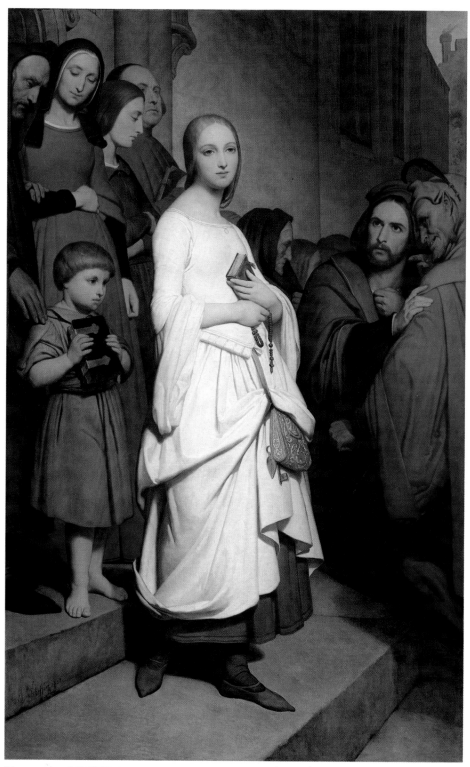

Plate 35. Ary SCHEFFER, *Faust apercevant Marguerite pour la première fois* (Faust seeing Marguerite for the first time). See cat. no. 152.

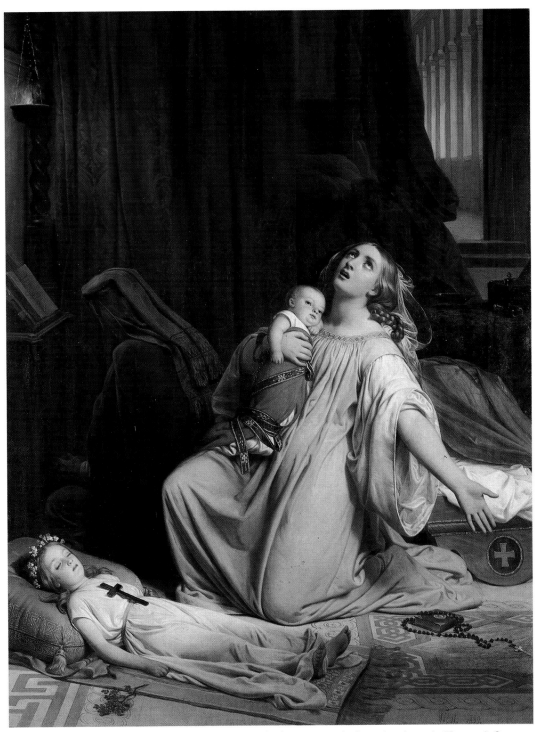

Plate 36. François-Edouard PICOT, *Episode de la peste de Florence* (Episode from the plague in Florence). See cat. no. 153.

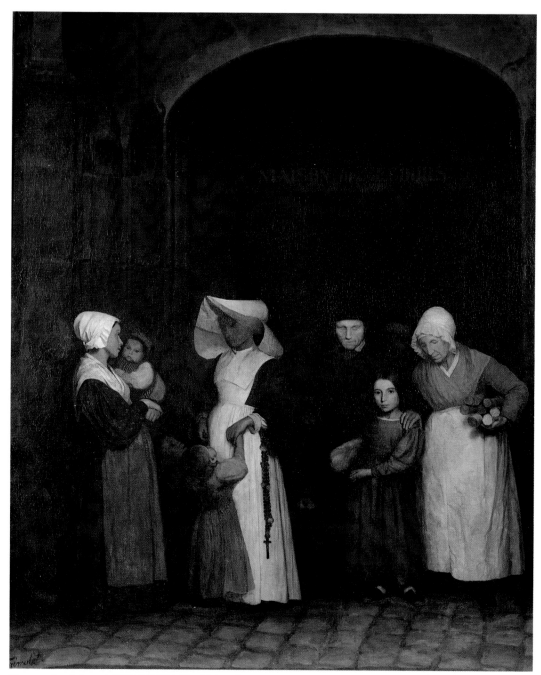

Plate 37. Louis Joseph TRIMOLET, *Une Maison de secours* (An almshouse). See cat. no. 155.

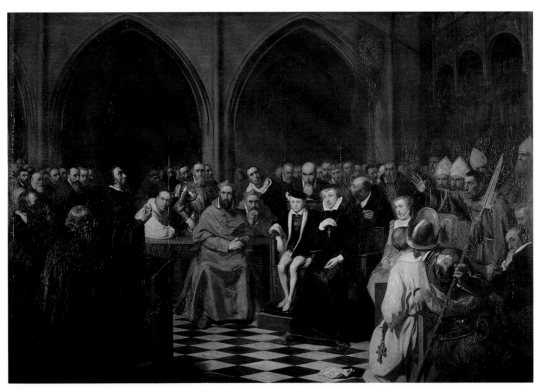

Plate 38. Joseph Nicolas ROBERT-FLEURY, *Colloque de Poissy en 1561* (The colloquy of Poissy in 1561). See cat. no. 157.

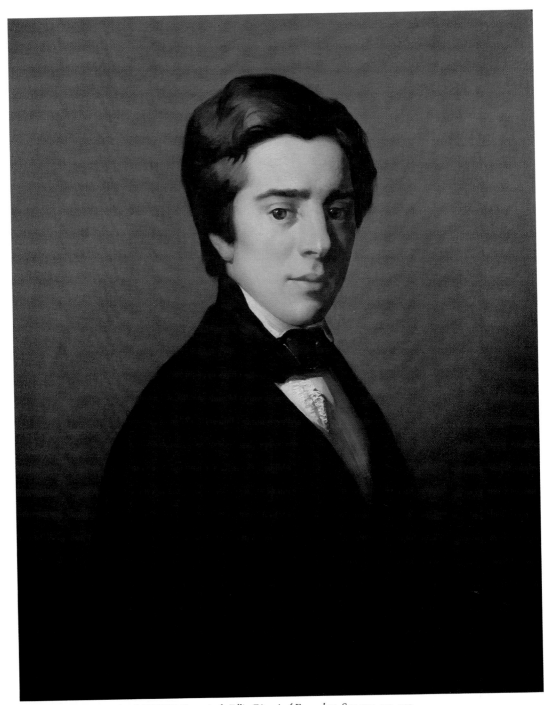

Plate 39. Jean Françoise MILLET, *Portrait de Félix-Bienaimé Feuardent*. See cat. no. 159.

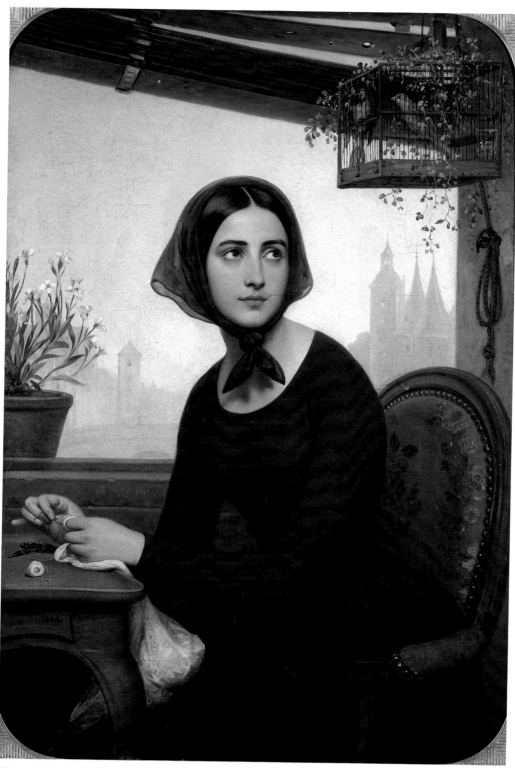

Plate 40. Joseph Désiré COURT, *Rigolette cherchant à se distraire pendant l'absence de Germain* (Rigolette trying to amuse herself during Germain's absence). See cat. no. 164.

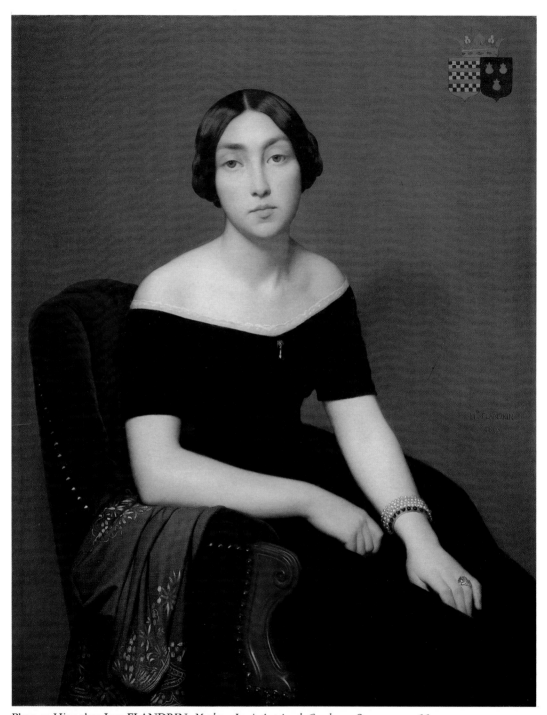

Plate 41. Hippolyte-Jean FLANDRIN, *Madame Louis Antoine de Cambourg.* See cat. no. 166.

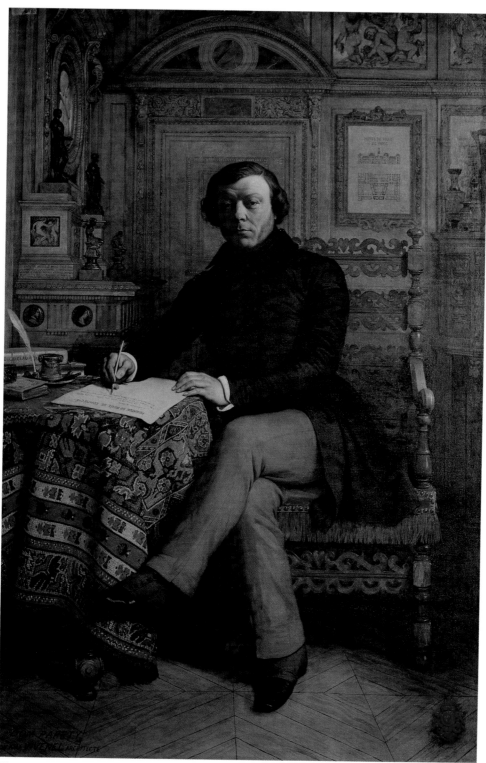

Plate 42. Dominique Louis PAPETY, *Portrait d'Antoine Vivenel.* See cat. no. 167.

Plate 43. Dominique Louis PAPETY, *La Vierge consolatrice* (The consoling Virgin). See cat. no. 168.

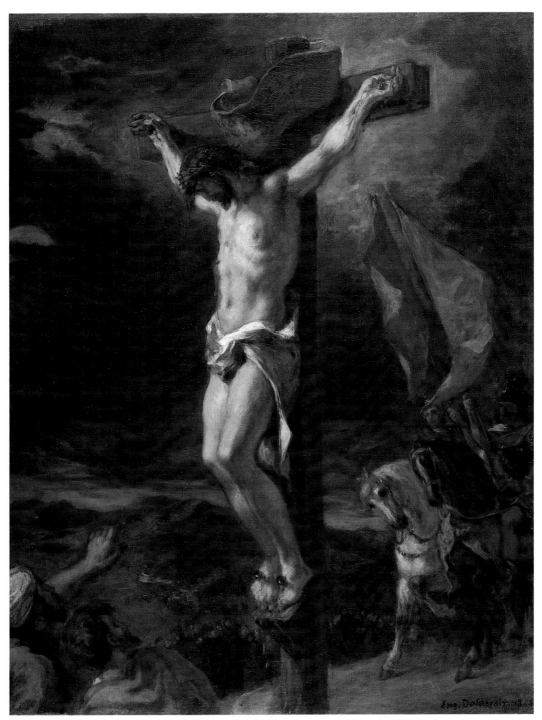

Plate 44. Ferdinand-Victor-Eugène DELACROIX, *Christ on the Cross.* See cat. no. 169.

Plate 45. François-Auguste BIARD, *Quatre heures au Salon* (Four o'clock at the Salon). See cat. no. 170.

Among the prints that heralded a change in perceptions was Grandville's *Naissance du juste milieu* (Birth of the *juste milieu*; Figure 1-2 [cat. no. 96]).[26] Initially conceived as a parody of Eugène Devéria's regal history painting of the *Birth of Henry IV*, exhibited at the 1827 Salon, Grandville's caricature concluded in a pointed commentary on the installation of a new ministry (which occurred in October 1832) composed of supporters of the *juste milieu* and Louis Philippe's henchmen. As the Citizen King elevates the newborn child of the *juste milieu*, those slated to become its officers and heads of state hover around the bed, offering suggestions about the delivery and ministering to the forlorn figure of an exhausted Liberty. Among the major personalities chronicled in this print is Marshal Soult, who was hated by the republicans and by Philipon and was soon asked to form the new ministry. Others depicted are Guizot, who became minister of education, and Thiers, who would later be installed as minister of the interior. Also present at the birth in the foreground is the duc d'Orléans. These men, all recognizable as portrait studies, are shown acting on the advice of the king and in service of the new regime. By presenting the cast of characters and their growing importance so clearly, Grandville intimated that a more restrictive regime was about to be instituted.

Through 1832 and 1833, and in spite of some changes in educational laws that favored the lower classes, the proletariat found itself at the mercy of France's new industrial order. There were many who thought they were being robbed of their rights. Insurrectionary cells were formed, their members eager to champion the Rights of Man and to follow the unfinished business of the French Revolu-

tion.[27] Opposition groups distributed propaganda materials, either selling or giving them away on the streets of Paris. Criers who disseminated this material attracted attention as the public became increasingly familiar with issues. In 1833, it was estimated that more than 6 million pieces of propaganda, including published papers of all types, had been distributed since the inception of the July Monarchy.[28] The extent of these documents, which represent a veritable media explosion designed to reach the broadest audience, also attests to a new way of influencing people. A steady array of visual images, often accompanied by a minimum amount of text, assaulted the public. The average citizen could easily grasp topics of discussion through reactionary images. It was impossible to remain complacent when facing one of these satirical broadsides.

Allusions to Louis Philippe's anger at being the brunt of satire increased as the king renewed his attack against the press. This reached a climax in another image by Grandville, *Barbe bleue, blanche et rouge* (Red, white, and bluebeard; Figure 7-12).[29] In a print that recalls one aspect of romantic Salon paintings as well as romantic illustrations in popular novels, Louis Philippe savagely attacks France and the charter by dragging a young maiden

27. For a brief discussion of the atmosphere in the country, see Bechtel, *Freedom of the Press*, 31. These insurrectionary groups grew rapidly and greatly alarmed the leaders of the *juste milieu*.

28. Ibid., 32. The exact nature of the pamphlets and circulars that were then distributed should be pursued more fully in order to establish the range and diversity of the huge number of pieces of public propaganda that were disseminated. The flood of materials in such a short period of time remained unparalleled in the July Monarchy.

29. For further reference, see *La Caricature*, 164–66. The way caricaturists utilized the convention of romantic Salon painting as the basis of a number of images suggests they regarded the Salon as a bastion for official taste and propaganda image-making that often favored the inclinations of the royal family. Caricaturists began to make serious intrusions into the sanctity of Salon exhibitions through their print satires.

26. *La Caricature*, 112–13. Also see Robert Bezucha's "Misery in the July Monarchy" for further implications of this image.

Barbe bleue, blanche et rouge.

Figure 7–12. Jean-Ignace-Isidore GRANDVILLE, *Barbe bleue, blanche et rouge* (Red, white, and bluebeard). Lithograph, 1833. Paris, Musée Carnavalet.

off to a chamber where other bodies hang from walls and pillars like so much discarded meat. Since the print referred to Louis Philippe's countermeasures against the press and caricaturists, it cast the monarch and his rule in a brutish guise. The king was seen as a Bluebeard who continually molested the innocent. The print further raised the specter of freedom of the press. As a portent of the full institutionalization of the September Laws, Grandville intimated the direction in which the country was headed as even the courts were being used to suppress rather than to defend fundamental rights.

The Broader Dissemination of Images

With *La Caricature* at the center of agitation against the regime, Philipon in 1832 launched another journal, the daily *Le Charivari*.[30] Why Philipon initiated an entirely new publication at the moment he was seemingly doing well with another is still uncertain. One explanation is his business astuteness and his desire to continue to appeal to a middle-class market with a journal that did not heavily espouse radical social protest. A second reason lies in Philipon's reading of the situation within France. The public was being bombarded by new demands on its imagination and time, and Philipon wanted to stay ahead of what was happening. Most importantly, he knew that he needed a means for profit in order to

30. For further discussion of the formation of *Le Charivari*, see Cuno, "Business and Politics of Caricature," 106–7. When Philipon organized *Le Charivari* in 1832, he had already surpassed most of his competition in caricature to become "the only game in town."

remain solvent. (Producing prints for his shop and his journals was costing a small fortune.) Simply stated, Philipon required another way to get money from his financial backers, especially if anything happened to *La Caricature.*

Philipon organized the magazine and staff of *Le Charivari* along well-established lines. He retained all authority, hired whoever he wanted, and chose the journal's editors. At the height of his influence, Philipon was most likely the subject of many drawings by members of his entourage. One, by the young satirist and soon-to-be theatrical performer Henri Monnier, provided his champion with a decidedly romantic cast.

By the early 1830s, Philipon had become an artistic broker who controlled lithographic images and the radical press. He also incited the ire of many in the government. To counter attacks, and perhaps realizing that he would eventually be forced to surrender his hold on *La Caricature,* Philipon undertook a truly innovative venture: he liberated prints from the context in which they were first appreciated. Philipon instituted *L'Association Mensuelle,* one of the first modern organizations in which subscribers financially backed the print medium. After paying a fee, a subscriber received each month a lithographic caricature accompanied by a text that could be exhibited as an independent image. Aside from freeing the image from the confines of a printed publication, Philipon originally designed the association to generate additional funds so he could persevere in his fight with the courts and maintain his view of the significance of a free press. *L'Association Mensuelle* also received staunch opposition, for the images it circulated continued to plague the July Monarchy.[31]

One image published in *La Caricature* in

1833, *Ah! Tu veux te frotter à la presse!!* (Ah! you want to meddle with the press; Figure 2–21 [cat. no. 99]), set the tone of this confrontation by focusing on the role of the worker in resisting the mounting pressures of Louis Philippe's government. By March 1834, the debate again centered on the role of the worker when *L'Association Mensuelle* circulated to its subscribers *Ne vous y frottez pas* (Don't meddle with it; cat. no. 100). With the worker standing up for his rights and positioned on a rock with the slogan "Freedom of the Press" behind him, the implication was clear that the dispute was escalating. In the background of this image fly government officials, some of whom clutch money as they attempt to escape. Since the regimes of Louis Philippe and Charles X were emphasized, the point was further made that only the press presented the truth. Both regimes had proved corrupt, and only the steadfast worker, functioning as a watchdog of freedom, was able to expose the dishonesty. This fitting image persuasively argued its position as it stressed the role of the association, although how many individuals readily collected this print is a matter of speculation.

Daumier acidly focused attention on those in public office through his lithograph of *Le Ventre législatif* (The legislative paunch; Figure 1–5). After observing a number of the members of parliament in action and after producing, like Dantan, a series of small plaster busts of most of them, Daumier arranged these greedy ministers around a circular area, similar to a human belly and rib cage, and then satirized their characteristics and personalities. Much like images by Grandville, Daumier's print was caustic. No one missed its point.

At the time these prints were published, the debate over freedom of the press was raging. Early in 1834 came a government demand for further legislation to regulate any agency or

31. Ibid., 107; Segolene LeMen, " 'M'Amuse, t'amuse, s'amuse': Philipon et L'Association Mensuelle (1832–1834)."

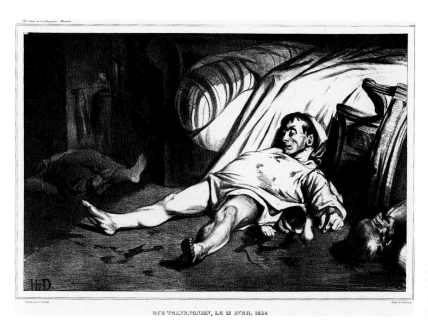

Figure 7–13. Honoré DAUMIER, *Rue Trans-nonain, le 15 avril, 1834.* See cat. no. 101.

association believed to advocate liberal ideas.[32] A law passed on 10 April 1834 placed associations of all sizes under direct government supervision, requiring preliminary authorization from the government before they could take any action. In the case of lithographs, an approved version of the print often had to be annotated by government controllers before the image could be fully processed in a publication.[33] People were outraged by these events. A public insurrection broke out in Lyon, which was subdued only after four days of bloodshed.[34] In Paris, where many were concerned by events in Lyon and where republican ideas were partially supported, insurgents armed themselves and

erected a series of street barricades.[35] The specter of yet another revolution occurring four short years after that of 1830 was becoming a reality. It was fomented by the issues of freedom of association, speech, and the press.

Despite the workers' uprisings, not everyone followed the call to arms. Nevertheless, the government was ready to quell the civil disturbances, fortified by a standing garrison of forty thousand troops in Paris. Since the insurrection in Paris took place within the constricted city center near the Marais, the revolt was easily stilled. Many prisoners were taken and held for trial on charges of treason and sedition.

The Revolution of 1834 was, however, the inspiration for one of the most inflammatory lithographs distributed by *L'Association Mensuelle*: Daumier's *Rue Transnonain, le 15 avril, 1834* (Figure 7–13 [cat. no. 101]). It depicted the aftermath of the government troops' action during the insurrection when, believing

32. Bechtel, *Freedom of the Press,* 33.
33. Many of the lithographs of this period now housed in the Musée Carnavalet, Paris, bear in the margin the ink inscription of the representative who authorized the image to be disseminated. This suggests that the censor or another government authority who was involved in approving images worked only from the proof of a lithograph and not from a preliminary drawing. Thus, no further changes could be made in the image as it was printed.
34. For further reference, see Bezucha, *Lyon Uprising.*

35. Bechtel, *Freedom of the Press,* 33. The revolution in Paris, inspired by the friction in Lyon, has not received the attention it deserves.

they were being fired upon from house windows, they stormed an apartment complex and massacred everyone in sight. Incensed by the slaughter of innocent victims, Daumier heightened the brutality of the attack by focusing on the dead strewn about a bedroom. With its dramatically simple legend—*Rue Transnonain, le 15 avril, 1834*—the print became an accusatory document, and the last one sponsored by *L'Association Mensuelle* to appear. Police seized numerous impressions of the print and confiscated the lithographic stone so additional images could not be produced. Philipon was so distressed by what happened both to the murdered and to Daumier's print that he intensified his opposition. In *Le Charivari* in late 1834, he published eyewitness accounts of the episode's horror. These statements verified that the soldiers had been out of control. He further denounced the government for failing to punish the assassins and for refusing to pursue an investigation so all the facts could be appropriately aired. In effect, Philipon accused the *juste milieu* of a cover-up.[36]

The atmosphere in Paris became so tense that the government vowed to act directly against the republican opposition by arresting 164 of its prominent members, many of whom were journalists. Those who were caught were thrown into prison at Sainte Pélagie, where they awaited trial for eight months. In spite of the arrests, the opposition stepped up pressure on Louis Philippe, sometimes recklessly pointing out the problems of the regime.[37] Regardless of this, government authorities were united in their efforts to force Philipon and his artists to capitulate. A prohibitive stamp tax as well as an actual stamp affixed to the figure's face were demanded on each caricature that appeared through *L'Association Mensuelle*. Obviously, such a stamp would have

destroyed the lithograph by disfiguring the image.

Philipon tried to weather these new attacks; he did not suspend production of *La Caricature* or *Le Charivari* in 1834. Instead, he used his resources to assure the liberty of the press, just as other journalists were doing for their respective publications. He was aware, however, that the government was prepared to crush the insurrectionary forces, no matter the cost. Attention now turned not to the dissemination of images or to the presentation of issues before the public, but to the court trial of the republicans, which began in March 1835.

Caricature Changes:
The Press Laws of September 1835

The institutionalization of the September Laws resulted from the government's apparent success in trying numerous republicans.[38] Louis Philippe, aided by strong ministers, presented the government's case by bringing the enemies of the *juste milieu* to court. They in turn refused to take part in the proceedings and instead shouted protests and insults. The defendants also resisted the courtroom guards, hoping thereby to disrupt the trial, which they believed to be a sham. The courtroom drama became increasingly tense. Disorder reigned for days as defendants were literally dragged before the president of the court and forced to plead their case or give some account of their actions. A spectacle of a violent circus developed as the scales of justice tipped in favor of corruption.

Numerous witnesses came forward both for

36. Ibid., 34.
37. Ibid., 35.

38. Ibid., 37ff. For a discussion of the varied approaches used by the prosecution and the defense in the *procès monstre*, see Bezucha, *Lyon Uprising*, 175–96. For a discussion of another facet of law functioning in the July Monarchy, see Jonathan P. Ribner, "Henri de Triqueti, Auguste Préault and the Glorification of Law under the July Monarchy."

Figure 7–14. Charles Joseph TRAVIÈS, *Histoire naturelle—le coiffeur* (Natural history—the hairdresser). Lithograph, 1835–1836. Paris, Musée Carnavalet.

Figure 7–15. Charles Joseph TRAVIÈS, *L'Amateur d'huitres / The Lover of Oisters* [*sic*]. Lithograph, 1836. Paris, Musée Carnavalet.

the defense and for the prosecution. Since the republican defendants believed their case was not being adequately heard or pleaded, continual commotion in the daily press tracked the trial's development. As a result, the 1835 trial attracted unprecedented popular attention. Yet, despite these tactics, many of those who were tried, whether they came from Paris, Lyon, or other cities, were eventually found guilty. Most were either imprisoned in France or deported to Algeria as a signal that this was the way Louis Philippe dealt with his enemies.

What was most significant about this monstrous trial was that the freedoms of the press and of speech were ultimately being weighed.[39] In the end, Louis Philippe man-

aged to silence all opposition and virtually eliminate those who frequently attacked him. Artists such as Daumier, who caustically commented upon what had happened with his print *Vous avez la parole, expliquez-vous, vous êtes libre!* (You have the floor, explain yourself, you are free!; Figure 1–6 [cat. no. 98]), were forced to obey new dictums that squashed open attacks against those in power. The institution of the September Laws prohibited free expression and the publication of opposing political views. Philipon and his coterie were forced to redirect their energies. *La Caricature* was discontinued, although *Le Charivari*, Philipon's other journal, was saved from obliteration after August 1835 by a

39. Those republican caricaturists, especially Dau-

mier, who were able to cover the trial conveyed this attitude. See Bezucha, *Lyon Uprising,* for Daumier's presence at the trial.

reduction of its political discourse. In effect, a repressive policy reigned, forcing caricature to move into other spheres and to link up with traditions that were already established during the opening years of the July Monarchy.

Reign of the Popular Type

If the utilization of political imagery was one of the ways by which the opposition visualized its attacks against those in power, other, less direct means ultimately exerted a similar effect on the public. A vast number of images referred to large segments of the population, essentially those far down the social scale, and the fact that caricaturists were interested in such types must be considered somewhat revolutionary. It was as if caricaturists recognized that many aspects of contemporary society needed to be recorded. Through the creation of typologies that linked individuals to different sections of society or to a given city, a cross section of the populace of the July Monarchy was eventually documented.

One important point is that while satirists such as Traviès captured the foibles and pretensions of the middle class getting ready to wear a wig (Figure 7-14), eating in restaurants (Figure 7-15), or primping in front of a hand mirror, numerous other artists focused on the lower classes who lived in misery and travail, and for whom little had changed since the French Revolution.[40] Traviès was certainly not alone in recording such personalities, and Daumier's early lithographs may ultimately be more amusing. Yet Traviès seems to have been closer to the origins of realism when he expressed the idea that the lower classes constituted a powerful force on the brink of explosion.[41] These troublesome types must

also be seen against the background of urban change and expansion that marked some of the efforts of the July Monarchy.

The government wanted to beautify the center of Paris and to make it more inviting by improving a number of older buildings through renovations or additions, just as the Hôtel de Ville had been rejuvenated under the supervision of Antoine Vivenel. Consequently, the often odious characters who sought shelter in the old streets or lived in the quarter would be displaced to other sections of the city.[42] Some feared that this change might lead to class confrontation and even violence, as the old gave way to the new. Against this shift in the urban scene, caricatures of lower-class urban types began to play an increasingly public role. By disseminating these images, artists hoped viewers would distinguish between different individuals, or types, and learn which figures were cause for alarm and which were simply picturesque reminders of a way of life that was being pushed aside by urban transformation.

Traviès and Daumier, both masters of physiognomic caricature, observed the types carefully and recorded their most appropriate characteristics so individuals could be easily identified. In some cases, Traviès ably captured the defiance, crudity, and grotesqueness of working-class types (see Figure 7-16 [cat. no. 103] and cat. no. 104) in images that became penetrating behavioral studies that owed a certain debt to the works of Boilly.[43]

40. For further discussion of these issues, see James Cuno, "The Ideology of Types and the Crisis of the City: Paris during the July Monarchy." Also see Wechsler, *A Human Comedy,* 96ff.

41. Cuno, "Ideology of Types." Traviès's connections

with early realism are noted elsewhere in this publication. Although not all of his early drawings have been located, he has been linked to proto-naturalism as a prefiguration of the novels by Emile Zola. See Wechsler, *A Human Comedy,* 96, n. 55, who also comments that little has been written on this artist.

42. Cuno, "Ideology of Types."

43. Boilly was well known during this period and would have provided substantial references for many artists. See Wechsler, *A Human Comedy,* 98. For reference to these images by Traviès, see Ferment, *Traviès,* 47–48, and *Galerie physionomique,* nos. 28 and 30. These images exist as hand-colored lithographs in the Cabinet

GALERIE PHYSIONOMIQUE N° 26

Industriel de bas étage. | *The man who lives by his wits.*

Figure 7–16. Charles Joseph TRAVIÈS, *Industriel de bas étage / The man who lives by his wits* (Low-born industrialist). See cat. no. 103.

Philipon was attracted by these interesting social types and their significance. He published numerous of them as parts of series, including one on *Types français* and another, by Traviès, entitled *Galerie physionomique* in

1837.[44] The prints in this latter series, with their exacting attention to dress, frightening expressions (see Figure 7–17), and revealing character, are among the most realistic that can be ascribed to caricature. Reminiscent of types found in contemporary novels, especially works associated with the lower

des Estampes, Musée Carnavalet, Paris. Wechsler notes that these images had an "edge of brutality," which hinted that they did not survive long in "the milder world of social satire."

44. Ferment, *Traviès*. A number of these images were published in *Le Charivari* in 1837.

GALERIE PHYSIONOMIQUE. N°26

Titi le talocheur, employé aux trognons de pommiat
du théâtre des funambulat

Figure 7–17. Charles
Joseph TRAVIÈS, *Titi
le talocheur . . .* (Titi,
the clout . . .).
Lithograph,
1835–1836. Paris,
Musée Carnavalet.

classes, Traviès's hand-colored images pro-
vided memorable figures, including those
linked to the more dangerous elements in
society.[45]

The depiction of types from a specific

45. Cuno, "Ideology of Types." Traviès's working-
class types living in squalid homes on the outskirts of
Paris could be considered precursors of some of the
types depicted by Jean François Raffaelli in his early
naturalist images.

social class indicated that the dominant mid-
dle class felt threatened from below. In certain
caricatures, the poor were not seen as amusing
but instead as monstrous (Plate 17 [cat. no.
105]). Traviès, along with Philipon, touched a
nerve when he focused on a group ill at ease
with developments during the *juste milieu*.
Since these images were actually a subset in
the domain of caricature and functioned as a
reminder of misery within the human com-

edy, these works proved bothersome to a print audience that preferred to be entertained rather than confronted with social concerns that would not be fully addressed by the end of the century.

The Creation of Characters as Symbols of the Age: Macaire, Mayeux, and Monsieur Prudhomme

The July Monarchy was also an era of extensive role-playing, one in which artists developed characters that often mirrored the games and ferocious manipulations inflicted on unsuspecting members of society by ruthless confidence men. Since Philipon was cognizant of many of these ruses, he urged his artists to develop appropriate types that could appear in a continuous caricature series, much like modern cartoon characters. These personalities would be placed in a wide variety of situations to mock and expose the corruption evident in almost every aspect of the new bourgeois society.

Among the first of these caricatured personalities was Robert Macaire, a stereotype of the rough, coarse, unscrupulous man on the make. Popularized through lithographs by Daumier and portrayals on the stage, Macaire incarnated the almost unbridled and unhindered pursuit of money. Daumier showed him fleecing members of the middle class in industry and finance—indeed, in all aspects of the burgeoning business world—in a successful series that appeared in *Le Charivari* late in the 1830s. These works warned that rogues were everywhere and that con men of all sorts were out to deceive ordinary people.[46]

Of the figures ridiculed in the July Mon-

archy, M. Mayeux, which was essentially the creation of Traviès, became more odious and sinister than even Robert Macaire. Representing the curious ways of the middle class, Mayeux developed into a fantastic conception that surpassed the perverse realm of reality associated with the July Monarchy. He was drawn as a deformed hunchback with an ugly face, whose manners still seemed to beguile many (see Plate 17 [cat. no. 105] and Figure 7–18). Mayeux appeared in a series of lithographs in almost every conceivable situation and adventure, yet he was always the triumphant man-about-town and seducer of the powerful.[47] Since Mayeux was shown to have ties with apes, he became an outgrowth of an overriding interest in physiognomic representation, which then dominated caricature, even while he symbolized the grotesque in human form. Most significantly, in an early work created by Philipon in which the face of Mayeux was depicted as a small mirror (Figure 7–19), the hunchback can be seen to embody Parisian fascination with itself. Mayeux mocked the mores and manners of the upwardly mobile middle class just when young dandies eager to make their mark sought these fashionable qualities. In the hands of Traviès, Mayeux was much more than a buffoon. He incarnated evil and the troubles that afflicted a society absorbed with material gain and role-playing.

In a later lithograph, Mayeux and Macaire converse at a café (Figure 7–20 [cat. no. 106]). This image clearly suggests that both characters had by that time become so familiar to Parisians that it seemed appropriate for them

46. On Robert Macaire, see Passeron, *Daumier,* 113–16. Wechsler, *A Human Comedy,* 82, notes that in the realm of caricature, Macaire was the invention of Daumier, although the character (along with M. Prudhomme) was taken over from the theater. Wechsler sees Macaire as the "quintessential con man" and a satire of the July Monarchy and its financial oligarchy.

47. On Mayeux, see Champfleury, *Histoire de la Caricature Moderne,* 193–201. For further reference, see Claude Ferment, "Monsieur Mayeux curieux personnage de caricature." Mayeux was even the subject of an occasional small sculpture, which attests to his widespread popularity. Wechsler, *A Human Comedy,* 82, notes that Mayeux was the creation of Traviès, a contention that may not be supported by the fact that early images of Mayeux were originally drafted by Philipon.

Figure 7-18. Charles Joseph TRAVIÈS (attr.), *Tonnerre de D . . . ! . . . (G—— damn! . . .)*. Lithograph, undated. Paris, Musée Carnavalet.

Figure 7-19. Charles PHILIPON, *M. Mahieux*. Lithograph (with added mirror), ca. 1830. Paris, Musée Carnavalet.

to appear together to discuss the current state of affairs. Amusingly, this encounter also provided the opportunity for a printmaker to disclose that the characters transcended the property of a single artist. Both Macaire and Mayeux were drawn by Traviès, thus attesting to the interchangeable aspects and guises that led printmakers to work on the "heroes" of the caricature revolution.

Another printmaker involved in creating an imposing character associated with the July Monarchy deserves mention—Henri Monnier.[48] The role of his most important figure, M. Prudhomme, was frequently enacted in the

theater (Monnier eventually fulfilled his ambition to play the character onstage himself). Monnier, recognized as a draftsman and as a friend of the caricaturists who surrounded Philipon, was the artist who most closely depicted reality in his works. This fact was underlined by his frequent drawings and watercolors during the 1830s, when he captured the lively spirit of children lining up to go to school (Figure 7-21 [cat. no. 79]) or centered attention on the interior of a rural household, where the family takes up as much space as the farmyard animals (cat. no. 80).[49]

Yet Monnier made his lasting mark on the

48. For Monnier's invention of Prudhomme and his relation to the larger issues of caricature in the July Monarchy, see Edith Melcher, *The Life and Times of Henri Monnier*, 73–87. Wechsler, *A Human Comedy*, 112, sees Joseph Prudhomme as the "most enduring of the emblematic figures" of the July Monarchy.

49. Drawings by Monnier have not been studied. While their traits belong to caricature, their overall feeling reveals how close Monnier came to the origins of realism. Since his numerous works have not been collected, this aspect of his career cannot yet be fully appreciated.

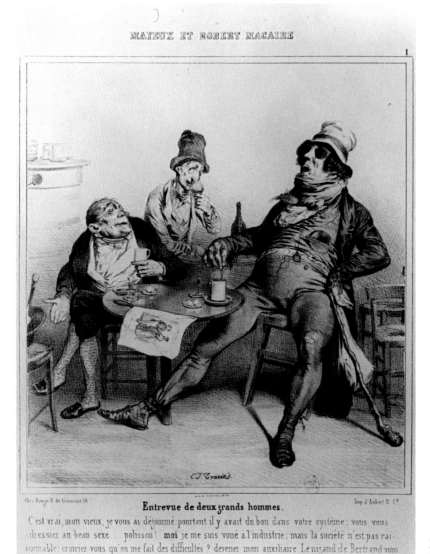

MAYEUX ET ROBERT MACAIRE

Entrevue de deux grands hommes.

C'est vrai, mon vieux, je vous ai déjommé, pourtant il y avait du bon dans votre système; vous vous
adressiez au beau sexe.. polisson! **moi** je me suis voué à l'industrie; mais la société n'est pas rai-
sonnable! croiriez vous qu'on me fait des difficultés ? devenez mon auxiliaire. Le nigaud de Bertrand vous
servira de page. Parcourez les boudoirs, emparez vous des femmes !.... j'ai mon plan ?

Figure 7–20. Charles
Joseph TRAVIÈS,
*Mayeux et Robert Ma-
caire.* See cat. no. 106.

July Monarchy as a theatrical performer play-
ing the role of M. Prudhomme. Short and
stout like the character he portrayed, Monnier
convincingly demonstrated that Prudhomme
was the true incarnation of the middle-class
Everyman who eschewed the latest fads for
substantial quality. Most importantly, Prud-
homme emerged as the stage figure that
other caricaturists chose to utilize more than
any other. In this way, Prudhomme's person-

ality and dress achieved a lasting fame that
can be attributed to Monnier's shaping of the
character on the Parisian stage. In effect, Prud-
homme's pedantry, his silly prejudices, and
his empty rhetoric—qualities Monnier fully
conveyed to his audience—made him, more
than Macaire or Mayeux, the symbol of the
juste milieu.[50] The fact that Monnier mastered

50. Melcher, *Henri Monnier,* 206.

Figure 7–21. Henry Bonaventure MONNIER, *Les Ecoliers* (The schoolboys). See cat. no. 79.

his portrayal of Prudhomme and formed him into the spokesman of an era remains one of the major marvels of caricature's translation to the stage, especially at a time when other such figures abounded in the July Monarchy. In retrospect, it was the sense of ordinariness about Prudhomme that seems to have defined his character and attached him so closely to middle-class values.

Other Satirical Dimensions

Later in the July Monarchy caricaturists continued to select themes to satirize, including the dining pretensions of the middle class, contemporary fascination with rural and urban change, and the issues surrounding women's liberation (see cat. no. 107 and Fig-

ure 7–22 [cat. no. 107C]). Indeed, women's rights formed the basis of an entire series of lithographs that commented on shifting values. Feminism became a potent force, with drawings depicting themes from the rejection of traditional family life to the necessity of forging an important, creative position within the home.[51] While these were not the only aspects of middle-class life to draw the ire of several caricaturists, feminist concerns did provoke strong reactions among viewers. Caricaturists such as Daumier were again sensitive to current issues, even though by 1840

51. Such concern with the disintegration of family life may have evolved from earlier attacks on the home. For a discussion of some of these issues during the French Revolution, see Lynn Hunt, "The Political Psychology of Revolutionary Caricatures."

LES BAS-BLEUS.

7.

Chez Aubert, Pl. de la Bourse, 29.

Imp. d'Aubert & C.ie.

La mère est dans le feu de la composition, l'enfant est dans l'eau de la baignoire !

their political inclinations had been severely blunted.

An examination of the debates that enveloped caricature during the July Monarchy leaves the impression that the most aggressive images were those that encouraged revolutionary agitation by challenging accepted codes and by undermining those in power. Once the atmosphere of freedom was broken[52] and the attacks of the artists were muffled, the creation of remarkably strong social types and satirical symbols linked to changes in society allowed caricaturists to function on a high level of visibility again. Considering this, as well as the range of issues and the depth of emotions generated, caricature during the July Monarchy remains unparalleled. That era and its drawings forced viewers to come to terms with themselves and to confront often-unpleasant episodes or types at a time when order and caution were the watchwords of the *juste milieu*.

52. For the importance of caricature functioning only in an atmosphere of opposition, see Michel Melot, "Caricature and the Revolution: The Situation in France in 1789." Melot asserts that the use of caricature as a "subversive weapon" was one of the key ways in which it was viewed and implemented during the July Monarchy.

Figure 7–22. Honoré DAUMIER, *La Mère est dans le feu de la composition, l'enfant est dans l'eau de la baignoire!* (The mother is in the throes of composition, the child is in the bathwater!), from *Les Bas-Bleus* (The bluestockings). See cat. no. 107C.

8 THE RENAISSANCE OF BOOK ILLUSTRATION

American museum-goers are in the process of discovering that the "French illustrated book has become a province of art in its own right."[1] They are also learning that a prominent place should be reserved in this creative territory for a remarkable group of volumes produced during the July Monarchy. This was already the opinion of the French bibliophile Jules Brivois, whose *Bibliographie des ouvrages illustrés du XIXe siècle* (Bibliography of illustrated works of the nineteenth century) was published more than a century ago. Brivois, a founding member of the Société des Amis des Livres (Society of the Friends of Books), advised collectors, "It is principally from 1835 to 1845 . . . that one finds the most beautiful wood-engraved books . . . magnificent editions which . . . characterize this genre of print [*gravure*] in the era of its renaissance." To be included in this special category, he stated, a wood-engraved book from that period had to meet a "double condition: artistic illustration, meticulous impression."[2] It is these works that have now found their way into art museums.

The purpose of this essay is to demonstrate how the flowering of French book illustration during the reign of Louis Philippe was the result of the intersection of four contemporary developments. The first was cultural: the diffusion of romanticism throughout daily life, which took place through the mass circulation of wood-engraved images. (We should recall also the discussion in Chapter 1 of the expansion of the reading public in these years, and the fact that many more people were now able to own and enjoy books than in the past.) The second was technical: the introduction of a new craft, wood engraving, that opened new opportunities for illustration at a decisive moment in the history of printed books. The third was economic: the fine-edition works that are so admired today were part of a new marketing strategy in the publishing industry when they first appeared. The final development was aesthetic: the creative ways that were found to represent the relationship between image and text in these works can still challenge us to consider the meaning of the term *illustration* itself.

* * *

In 1872, when he was over fifty, Gustave Flaubert recalled the heady atmosphere of his youth in Rouen during the July Monarchy:

I don't know what the dreams of today's students are, but ours were superbly extravagant—last expansions of the romanticism reaching us and which, compressed by the provincial milieu, produced a strange effervescence in our brains . . . enthusiastic hearts longed for dramatic amours with gondolas, black masks, and highborn ladies fainting in postal carriages in the middle of Calabria.[3]

The diffusion of the sort of romantic imagination described by the author of *Madame Bovary* was accomplished, in significant measure, by means of the "vignette," which at that time was a new type of illustration whose name came from the little vines and tendrils with which medieval monks once decorated the

1. Gordon N. Ray, *The Art of the French Illustrated Book 1700–1914*, viii.
2. Jules Brivois, *Bibliographie des ouvrages illustrés du XIXe siècle. Principalement des livres à gravures sur bois*, v, vii, xi.

3. Gustave Flaubert, preface to Louis Bouilhet, *Dernières Chansons* (Paris, 1872), 7.

Figure 8–1. Tony JOHANNOT, *Vignette.* 1830–1834. Published in Jules Champfleury, *Les Vignettes romantiques. Histoire de la littérature et de l'art: 1825–1840* (Paris, 1883), 3. Amherst College Library.

margins of their manuscripts. Flaubert's contemporary, the critic Jules Champfleury, referred to vignettes as "petit art" in his pioneer study of the men who created them, *Les Vignettes romantiques: Histoire de la littérature et de l'art* (Romantic vignettes: History of literature and art). "Do they not have the right to occupy an artist's table in the entry hall of the romantic Pantheon?" he asked.[4] Another member of the same generation and a leader in nineteenth-century art instruction, Charles Blanc, noted their remarkable ability to engage the mind. "All these little works . . . seem to speak to the reader in a language brief, unfinished, that it is his task to finish."[5] Charles Rosen and Henri Zerner consider this to be "the perfect Romantic formula." They note:

The vignette, by its general appearance, presents itself both as a global metaphor for the world and as a fragment. . . . Apparently unassuming as an artistic form, the vignette launches a powerful attack on the classical definition of representation, a window on the world. The vignette is not a window because it has no limit, no frame. The image, defined from its center rather than its edges, emerges from the paper as an apparition or a fantasy. The uncertainty of contour often makes it impossible to distinguish the edge of the vignette from the paper: the whiteness of the paper, which represents the play of light within the image, changes imperceptibly into the paper of the book, and realizes, in small, the Romantic blurring of art and reality.[6]

We need only look at a vignette by Tony Johannot (1803–1853) to grasp Rosen and Zerner's meaning (Figure 8–1). Previously unpublished when Champfleury selected it to

4. Jules Champfleury, *Les Vignettes romantiques: Histoire de la littérature et de l'art: 1825–1840,* vi.

5. Charles Blanc, *The Grammar of Painting and Engraving,* 310. This is a translation of the *Grammaire des arts du dessin* of 1867.

6. Charles Rosen and Henri Zerner, "The Romantic Vignette and Thomas Bewick," in *Romanticism & Realism,* 81, 84.

L'ARTISTE.

TONY ET ALFRED JOHANNOT.
Lithographié d'après nature par Gigoux.

Figure 8–2. Jean-François GIGOUX, *Tony and Alfred Johannot*. Lithograph, undated. Baltimore, The Baltimore Museum of Art.

accompany the introduction to *Les Vignettes romantiques,* the work is like a miniature romantic universe: moonlight and mountains reflected in the water of a lake, a weeping willow, a ruined column in a deserted cemetery, and a solitary figure posed to suggest profound emotion. The evocative power of the tiny scene is undeniable.

The vignettes drawn by artists such as the celebrated Johannot brothers (see Figure 8–2) were generally encountered by the public in the form of wood-engraved reproductions. In 1835, a writer in the journal *L'Artiste* described this process as "an art so poor and disdained

only a few years ago, and whose revival has been so rich and so popular that I do not believe there is a cottage in France where it has not penetrated at this hour."[7] We are in the era of the novel *Madame Bovary* here, and its author, Flaubert, with his vivid memory of the time and keen sense for telling detail, provides evidence that there was a broad circulation of these images: when Emma Bovary visits her daughter at the wet nurse there is a wood engraving of Fame blowing her trumpets torn out of a perfume advertisement and

7. *L'Artiste* 9, no. 17 (1835): 194.

Figure 8–3. Tony JOHANNOT, *Title Page of "L'Entr'acte."* 1832. Published in Champfleury, *Les Vignettes romantiques,* 229. Amherst College Library.

tacked on the wall of the humble peasant dwelling. Tony Johannot's stylish vignette of a group of men and women flirting between acts of an opera performance, drawn for the title page of the theater review *L'Entr'acte* in 1832 (Figure 8–3), was precisely the sort of image Emma encountered as she passed the long evenings in the village of Yonville by poring over the latest journals from Paris with her soon-to-be-lover Rodolphe. She would also have seen the work of Sulpice-Guillaume Chevalier, called Gavarni, who perfected the fashion plate for the journal *La Mode*. And Brivois makes reference to the appearance of a "countless army" of illustrated magazines in the 1840s, naming the *Magasin Pittoresque* and *L'Illustration* as examples;[8] Flaubert, thoughtfully, provided the Bovary household with a

fictional subscription to the latter. Wood-engraved images created dream worlds everywhere during the July Monarchy, fanning and molding a broad range of desires in French society.

In the midst of this widespread diffusion of romantic imagery, there were those who agreed with Charles Blanc's judgment that "wood engraving seems above all suitable for the illustration of books."[9] The illustrated books of the July Monarchy, in which scores, even hundreds, of vignettes were inserted on the same page as a printed text, while others were displayed as full-page plates, helped to shape the personality of an entire generation of readers. In one of the most famous chapter transitions in French literature, for example, Flaubert attributes the origins of Madame

8. Brivois, *Bibliographie des ouvrages illustrés,* ix.

9. Blanc, *Grammar of Painting and Engraving,* 312.

Figure 8–4. Tony JOHANNOT, plate opposite p. 50 of *Paul et Virginie*. See cat. no. 73.

Bernardin de Saint-Pierre's novel *Paul et Virginie* was first published in 1788. Marie Antoinette is said to have wept over the tragic ending to the tale of two French children raised together from infancy on a tropical island in the Indian Ocean.

This full-page wood-engraved plate by Tony Johannot is from the famous edition published by Curmer in 1838. Gordon Ray calls it "the representative illustrated book of the Romantic period" (*Art of the French Illustrated Book*, 305).

Bovary's sense of unfulfilled longing to adolescent visions inspired by her experience with a volume illustrated with Tony Johannot's vignettes:

> Emma sought to learn what was meant in life by the words 'happiness', 'passion', and 'intoxication'—words that had seemed so beautiful to her in books.
>
> vi
>
> She had read *Paul et Virginie* and dreamed . . . most of all about the sweet friendship of some sweet brother who gathers ripe fruit for you in huge trees taller than steeples or who runs barefoot over the sand, bringing you a bird's nest.[10]

* * *

Book illustration began almost with Gutenberg's introduction of typographic printing in the 1450s. By the time Columbus sailed the Atlantic a variety of volumes were already being published with woodcut images (some of them hand colored) reproduced on the same page as a printed text. One expert on the subject considers this to have been an early golden age in the history of books: "Its highest point is exemplified in the multitude of devotional books produced between 1490–1525, from which time the art began to decline, probably from the increasing demand, necessitating the employment of more numerous (and consequently inferior) hands in the decoration of these books."[11] Their popularity, he suggests, did them in. A page from a book of epigrams based on the theme of the Ship of Fools, printed in Basel in 1507, is representative of the excellent work of this period (Figure 8–5): a Latin text in movable Gothic type supplies a title for, a poem about, and a

Figure 8–5. Page from *Iodici Badii Ascensii in operis huius compositionem ac finem Epigramma extemporaneu* (Basel: Nicolau Lamparter, 1507). Amherst College Library.

commentary on the foolish action illustrated by an emblematic scene. The decoration on the left side of the woodcut harks back to the vignettes of medieval manuscripts, but now multiple copies could be produced by the means of a new invention, the printing press. Woodcuts were made "by cutting the image in relief with a knife on the long grain, or plank, of a soft wood . . . a technique which does not favour fine detail."[12] This inherent limitation may also help explain why the woodcutter's craft never surpassed the peak it reached throughout Europe during the sixteenth century. By the beginning of the nineteenth century, in any case, woodcuts were commonly associated with the crude chapbooks and almanacs distributed by peddlers, while

10. *Madame Bovary,* trans. Mildred Marmur (New York: New American Library, 1964), 55.

11. *Catalogue of a Collection of Early French Books in the Library of C. Fairfax Murray, Compiled by Hugh Wm. Davies,* preface.

12. Clive Ashwin, "Graphic Imagery 1837–1901: A Victorian Revolution."

Figure 8–6. *Wood engraver at work,* in John Jackson, *A Treatise on Wood Engraving* (1838), 561. Amherst College Library.

finer books were illustrated with metal engravings and plates drawn from a lithographer's stone. Both had to be printed separately and later bound along with the text. This situation changed rapidly around 1830, however, with the introduction in France of a new form of relief impression: wood engraving.

Paris was justly famous for its artisans such as Jean-Baptiste Papillon (1698–1776), who helped invent the process, but the type of wood engraving associated with the book illustrations of the July Monarchy was initially imported from abroad. It was an Englishman, Thomas Bewick (1753–1828), who first perfected the "end wood" (*bois de bout*) method. An ornate capital "P," engraved according to Bewick's technique by his countryman R. W. Buss (Figure 8–6), depicts a wood engraver at work: a transparent glass globe filled with clear water was recommended in order to shield the artisan's forehead from the heat generated by the intense light necessary for the

task. Most wood engravers wore eye shades, and one of Buss's colleagues also praised the proper use of the *mentonnière,* a pasteboard shield invented by Papillon that covered the nose, mouth, and chin. "Its object," he explained, "is to prevent the drawing . . . from being injured by the breath in damp or frosty weather. Without such a precaution, a drawing made on the block with black-lead pencil would, in a great measure be effaced by the breath of the engraver passing freely over it in such weather."[13]

Clive Ashwin has described the actual preparation process:

The wood-engraving is cut with tools similar to the metal engraver's burin on the end grain of a very hard wood. . . . The wood-engraver . . . pushes his tool into the hard surface of the block, each cut shearing away minute bundles of tough, fibrous, ends of the grain. The wood-engraving can depict any shape, size or direction of form within the competence and eyesight of the engraver, and it became customary for wood-engravers to work on such a microscopic scale, often with the aid of a magnifying lens, that it is hardly possible to analyse the graphic effects achieved with the naked eye.[14]

Bewick and his disciples in France (some of whom were English) made it technically possible to reintegrate image and text in romantic illustrated books; that is why Brivois called it a "renaissance." They broke with the woodcut tradition, however, by refusing to conceive of the final image "as a white space on which black outlines and solids made a linear design printed in relief" on a page. Wood engraving allowed them to treat the print as though it were "a black void out of which the subject appears in a varying range of grey tones with pure white for the lightest parts."[15] Both of these innovations, microscopic detail and the

13. John Jackson [and W. A. Chatto], *A Treatise on Wood Engraving,* 574.
14. Ashwin, "Graphic Imagery."
15. Philip James, *English Book Illustration, 1800–1900*

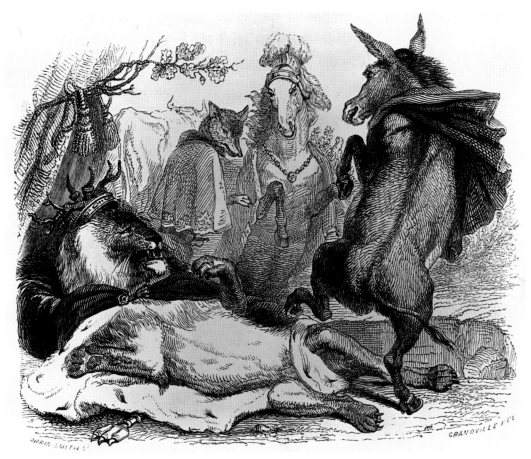

Figure 8–7. Jean-Ignace-Isidore GRANDVILLE, "Le Lion devenu vieux" (The lion grown old), from *Les Fables de La Fontaine,* book 3, fable 14. See cat. no. 74.

effect of shading, can be seen by noting the way that animal fur was represented in the early sixteenth-century woodcut shown in Figure 8–5 and then comparing it with Figure 8–7 (cat. no. 74), a wood engraving made from Grandville's drawing for La Fontaine's fable "Le Lion devenu vieux" (The lion grown old), published in Paris in 1838.

The same year, 1838, saw the publication of *A Treatise on Wood Engraving,* in which an English practitioner, John Jackson, conceded, "we are behind our French neighbors"; he thought this was because Parisian artists were

better trained in drawing and therefore took illustration more seriously. A "designer on wood, even of moderate ability, is better paid for his drawings than a second-rate painter is for his pictures," he added.[16] These contemporary insights are useful; indeed, we will return to Jackson's economic argument for French superiority below. Moreover, his speculation about different teaching methods may help explain the remarkable constellation of great illustrators—Tony Johannot, Grandville, Gavarni, and others—who contributed to the best wood-engraved books of the period (see cat. nos. 72–74, 87, 112–15). The term then in

(1947) cited by Gordon N. Ray in *The Illustrator and the Book in England from 1790 to 1914,* 33.

16. Jackson, *Treatise on Wood Engraving,* 610.

use for these artists was, after all, *dessinateurs* (literally, drawers).

"All art involves compromises between the expressive intention of the artist and the technical potential of the medium,"[17] however, and one should not neglect the contribution of artisans to book illustration. Wood engravings were cheap to use because they were long-lasting and fitted easily with type in a page design, but good ones were also expensive to prepare. The list was short of master engravers, men who carved their names on their work at the bottom of the vignette, while apprenticeship was long. For example, when the publisher Curmer totaled up the expenses for the heavily illustrated version of *Paul et Virginie* (cat. no. 73), which he published in 1838, he found that he had spent 28,623 francs on *Dessins sur bois* and 32,382 francs for *Gravure sur bois*.[18] He paid more money to the engravers than he did to the artists who created the drawings, in other words. Publishers often advertised the quality of an illustrated book that was about to appear by mentioning the names of the wood engravers hired to reproduce the art. Hetzel's prospectus for *Scènes de la vie privée et publique des animaux* (Scenes from the private and public lives of animals; cat. no. 113) states: "The prints that we are announcing have been confided to the able hands of Messieurs Andrew, Best and Leloir, Brévière, Caque and Godard. We affirm that never will a series of prints have been executed with more religious care, and never will Grandville have been more faithfully interpreted."[19]

Interpretation, of course, was a touchy issue for a *dessinateur* like Grandville, who would eventually prepare nearly two hundred full-page plates for engraving, as well as 120 smaller vignettes to be inserted in the text, before the two volumes were completed (see Figures 8–9 and 8–14 and cat. no. 113). He

lamented about the "deterioration" of his work once it left his hands and wished he could "protest or explain . . . the sorrow" he felt "in seeing it reproduced twenty-five thousand times and distributed as far as America."[20] Grandville was not the only vignette artist to complain about the accuracy of execution and the difficulty of working with a team of engravers. The one engraver whose work he never criticized, however, was Brévière,[21] whose magnificent translation of Grandville's self-portrait may be seen in Figure 8–9 below. Their collaboration on *Scènes* appeared as the final plate of the massive and successful project.

The heyday of book illustration during the July Monarchy, we can now see, was the offspring of the marriage between a distinctly romantic art form and an innovative graphic method. And, since vignettes could be and were reproduced by means of lithography (as in the double portrait by Gigoux, Figure 8–2), the significance of this technical development cannot be underestimated. Just as woodcut illustration was an essential part of the cultural revolution that was unleashed by Gutenberg's hand-operated printing press, so did wood engraving help create a new taste for industrially produced images that French publishers assiduously catered to during the reign of Louis Philippe.

* * *

Illustrated books are surely among the most alluring artifacts of social history. The beauty of the wood-engraved volumes associated principally with the years between 1835 and 1845, for example, offers evidence of the consumer revolution that was transforming print culture at that time. The brevity of the period in which the best of these works were produced is, moreover, testimony to the economic

17. Ashwin, "Graphic Imagery."
18. Brivois, *Bibliographie des ouvrages illustrés*, 396.
19. Ibid., 366.

20. Cited in Clive Getty, *Grandville: Dessins originaux*, 1.
21. Ray, *Art of the French Illustrated Book*, 273.

uncertainty of the French publishing industry during the first half of the nineteenth century. Other factors also affected the book industry during this period. First, the industrialization of manufacturing (printing, papermaking, binding, and so forth) made it possible to increase the number of books produced and sold, while lowering the cost per volume. Second, in spite of the growing number of potential readers (including women and children), the market for books was severely challenged, after 1835, by the introduction of inexpensive newspapers that printed popular novels in serial form. Finally, the commercial organization of the book trade was reshaped as a result of the previous factors; the conservative business practices of the *libraires,* or booksellers, gave way to the aggressive entrepreneurship of a group of men called *éditeurs,* or publishers.[22] One of these newcomers, Léon Curmer, commented on the origin of this important differentiation in an article written for the Universal Exposition of 1839:

The *libraire*'s business, as it is now generally understood, consists of nothing more than collecting money in exchange for printed pages bound together as a book. The *libraire* . . . has lost the intellectual character once held by his forerunners. . . . The *libraire* of today has acquired a new importance, [however,] and it is due to the profession of *ÉDITEUR,* which has taken hold since the introduction of illustrated books.[23]

Since illustrated books played a significant role in the emergence of these *éditeurs,* it is appropriate that we should turn to one of Curmer's own ventures, the multivolume *Les Français peints par eux-mêmes* [The French

painted by themselves], to find out what they looked like (see Figures 2–6 and 3–5 [cat. no. 61] and cat. no. 115). Gavarni's vignettes for the opening of Elias Regnault's essay "L'Éditeur" (Figure 8–8 [cat. no. 115]) effectively illustrate the dual nature of the job. On the one hand, the *éditeur* played an active role in the creation of these lavish volumes; he dreamed up projects, found manuscripts or commissioned authors, hired illustrators and wood engravers, oversaw their progress, and then designed the pages of the book to combine the literary and artistic results. On the other hand, he was also a businessman intent on protecting his considerable investment and turning a profit in a risky and competitive environment. As Curmer put it:

The *éditeur,* intelligent intermediary between the public and all the laborers who combine in the making of a book, should not be a stranger to the details of the work of each of these persons; master of sure taste, attentive to the preferences of the public, he should sometimes sacrifice his own feelings to that of the greater number. . . . This profession is more than a trade, it has become a difficult art to exercise.

The first of the great illustrated books of the July Monarchy was a well-known early-eighteenth-century adventure story, Alain René Le Sage's *Histoire de Gil Blas de Santillane,* which appeared in an 1835 edition accompanied by wood-engraved vignettes made from drawings by the artist Gigoux (Figure 8–11 [cat. no. 71]). Five years earlier, to be sure, Tony Johannot had produced fifty vignettes for Charles Nodier's tale *Histoire du Roi de Bohême et de ses sept châteaux* (History of the king of Bohemia, and his seven châteaus), but no one had ever seen a book with six hundred illustrations before. Even today *Gil Blas* seems Balzacian in scope; indeed, there is evidence that it was Balzac himself who first suggested the audacious idea to the *libraire-éditeur* Alexandre

22. See James Smith Allen, *Popular French Romanticism: Authors, Readers, and Books in the 19th Century.*

23. Cited in Odile and Henri-Jean Martin, "Le Monde des éditeurs," in Henri-Jean Martin and Roger Chartier, eds., *Histoire de l'édition française,* vol. 3, *Le temps des éditeurs: Du romantisme à la belle époque,* 182.

L'ÉDITEUR.

É DITEUR! Puissance redoutable qui sers au talent d'introducteur et de soutien! talisman magique qui ouvres les portes de l'immortalité, chaîne aimantée qui sers de conducteur à la pensée et la fais jaillir au loin en étincelles brillantes, lien mystérieux du monde des intelligences; éditeur, d'où vient que je ne sais de quelle épithète te nommer? Je t'ai vu invoqué avec humilité et attaqué avec fureur, poursuivi du glaive et salué de l'encensoir; j'ai vu les princes de la littérature t'attendre à ton lever comme un monarque puissant, et les plus obscurs écrivains te jeter la pierre comme à un tyran de bas étage. Objet d'espoir et de colère; de respect et de haine, comment te qualifier sans injustice et sans préoccupations? « Ange ou démon, » dois-je t'adorer ou te maudire? T'appellerai-je notre providence? mais tu n'es rien sans nous. Te nommerai-je notre mauvais génie?

mais nous ne sommes quelque chose que par toi? Tu fécondes notre gloire, mais tu en récoltes le prix. Tu es le soleil vivifiant de notre renommée, mais tes rayons dévorants absorbent le fluide métallique des mines que nous exploitons. Nous avons beau nous séparer de toi, nous tenons à toi par tous les points. Nous avons beau

Figure 8–8. "L'Editeur" (The editor) from *Les Français peints par eux-mêmes* (The French painted by themselves). See cat. no. 115.

Paulin (1793–1859).[24] In any case, it was Paulin who introduced an equally revolutionary marketing technique. As his *prospectus,* or preliminary advertisement, announced:

We are undertaking a series of picturesque publications, a genre entirely new in France. [Heavily illustrated books had already appeared in England.] We propose to publish the most popular works of the French language . . . illustrated with an extraordinary number of vignettes and ornaments of every nature. . . . The French printing industry has never produced anything like it, but the progress of the past fifteen years permits us to attempt an enterprise which hitherto would have been materially impossible. . . . In order to place these editions at the door of the widest public, we have adopted a mode of publication by weekly installment (*livraison*). An installment will appear each week, containing four or five large vignettes, in addition to ornaments. The price of an installment will be *FIVE SOUS.* The entire work will be composed of 50 to 55 installments, so that *Gil Blas* will only cost 13 to 14 francs. By paying the sum of 12 francs in advance, the subscriber will receive each installment by home delivery. Persons living in the provinces will pay an additional 2 francs, 50 centimes for postage.[25]

The initial publication of illustrated books in installments offered an *éditeur* a number of distinct commercial advantages. The inexpensive *livraison* format allowed direct competition with Parisian newspapers for the audience who read their serial novels. The income generated through subscriptions and weekly sales provided the capital necessary to cover production costs throughout the course of the project; artists, wood engravers, and authors (if the text was an original one) required substantial payments over a period that might extend for a year or more. Finally, installment

circulation opened the opportunity for a second round of sales, this time as an actual book.

Livraison introduced two additional elements that influenced the appearance of the finished books. First of all, installments quickly became a standard genre of publication: a set number of pages, the promised number of vignettes, and a cheap paper cover with a vignette on the front and advertising on the back constituted each issue. This, in turn, imposed a segmented internal order, a regular visual rhythm, on the completed work. When we look at the pages of a work such as Jules Hetzel's *Scènes de la vie privée et publique des animaux* (Figures 8–9 and 8–14, Plate 19, and cat. no. 113), for example, we need recall that it originated as a book-in-pieces; it is a *livraison-livre,* if you will. The installment format, secondly, helps explain the wide variety we encounter in the material condition of these volumes. *Éditeurs* appealed to a range of customers by offering books in editions of different quality. There were paper-covered books printed on steam-driven presses, such as the second volume of La Fontaine's *Fables* (see Plate 18; another copy of this book is illustrated in Figure 8–7 and cat. no. 74). Many of these inexpensive volumes were bound by machines after 1840. There were also limited editions printed on fine paper, using hand-operated presses, and hand-stitched inside fine tooled-leather covers; a masterful example of the craft of *reliure* (binding) is the ornate copy of *Scènes de la vie privée et publique des animaux* illustrated in Plate 19. The latter is truly a work of art from the age of mechanical reproduction.

The *livraison-livre* introduced by Paulin was a flexible strategy born out of economic necessity. He followed *Gil Blas* by hiring Tony Johannot to do the vignettes for an illustrated edition of the *Oeuvres de Molière* sold in one hundred installments at twenty-five centimes

24. Frederic Barbier, "Les Imprimeurs," in Martin and Chartier, eds., *Le temps des éditeurs,* 77.

25. Cited by Brivois, *Bibliographie des ouvrages illustrés,* 257.

On recommande aussi aux curieux de ne point trop agacer les nouveaux hôtes du Jardin-des-Plantes.
Ceci pouvant, malgré les précautions qu'on a prises, n'être point sans danger !...

Figure 8–9. Jean-Ignace-Isidore GRANDVILLE, "On recommande aussi aux curieux de ne point trop agacer les nouveaux hôtes du Jardin-des-Plantes. Ceci pouvant, malgré les précautions qu'on a prises, n'être point sans danger!" (Spectators are advised to avoid disturbing the new inhabitants of the Jardin-des-Plantes, as this could well be dangerous, in spite of existing precautions) from *Scènes de la vie privée et publique des animaux* (Scenes from the private and public lives of animals), vol. 2, "Le Jardin des plantes" (The botanical garden). See cat. no. 113.

each in 1835–1836 (cat. no. 72). Another *éditeur,* Fournier, produced the *Fables* of La Fontaine, for which Grandville, in a remarkable burst of creative energy, drew 120 vignettes and 150 other decorations between the end of January and the beginning of November 1837 in order to meet the schedule demanded by forty separate installments. Published as a two-volume book in 1838, the *Fables* became a best-seller; Grandville added another 120 vignettes for a third volume in 1840.[26] Other classics followed: *Don Quixote, Robinson Crusoe, Gulliver's Travels,* and so forth. Indeed, these illustrated books and others—works of history and travel, contemporary novels, collected essays and songs—were creating a common visual culture among the members of the French bourgeoisie by midcentury. One critic later asked, speaking of the Fournier-Grandville edition of *Les Aventures de Robinson Crusoe* (1840), "Is there anyone among us who in youth did not receive it as a New Year's gift?"[27]

Illustrated books rode the wave of financial speculation that characterized the middle years of the July Monarchy. This can be seen in the careers of two of the most talented and audacious *éditeurs* of the day, Léon Curmer (1801–1870) and Jules Hetzel (1814–1886). Curmer, who was originally trained to be a notary, opened a bookstore and publishing house specializing in fine editions of religious literature in 1834. The Salons de la librairie Curmer were located on the rue de Richelieu near the Palais Royal, the Bibliothèque Nationale, and the Bourse (the stock exchange). It was a fashionable neighborhood for shopping—the Maison Aubert, where Philipon sold Daumier's lithographs, was nearby—and Curmer intentionally gave his salesroom the appearance of a private reception hall. He catered to the carriage trade, and

many of his customers were women. It was in this wealthy atmosphere that he first envisioned a luxurious illustrated edition of *Paul et Virginie* (see Figures 8–4 and 8–13 and cat. no. 73), which appeared in thirty installments costing one franc and twenty-five centimes each between October 1836 and December 1837; when supplements were added the total price came to forty-five francs before binding. The title page carried the date 1838 to encourage customers to give it as a New Year's gift. Ten thousand copies were printed. A limited edition on China paper and bound by the best craftsmen in Paris could cost as much as five hundred francs, or more than a year's income for most residents of the capital.

Curmer ignored no detail in the preparation of *Paul et Virginie.* He hired a cartographer to produce an accurate relief map of l'Ile de France, the island in the Indian Ocean where the story takes place, and he and his artists combed the botanical garden of Paris, the Jardin-des-Plantes, to make certain that the depiction of every tree, plant, and shrub would be accurate. And he spared no expense. Advertising alone came to over 14,000 francs. When, in 1849, he finally closed the ledger on the project, he estimated that his total costs had been over 233,000 francs and that his profit was around 82,000 francs.[28] Curmer displayed a similar taste for the grandiose in other projects. *Les Français peints par eux-mêmes,* for example, was published in 422 installments costing fifty centimes each for hand-colored vignettes and thirty centimes for black-and-white illustrations. The entire work eventually became a nine-volume set.[29] If Paulin pioneered the *livraison-livre,* Curmer was its king.

Hetzel, the son of an army saddler and a midwife, attended the prestigious College Stanislas on a scholarship, and he was a prizewinning student of classical literature.

26. Getty, *Grandville,* 312–13.
27. Beraldi cited by Ray in *Art of the French Illustrated Book,* 272.

28. Brivois, *Bibliographie des ouvrages illustrés,* 388–97.
29. Ibid., 159.

Abandoning his parents' dream of a law career, he was only twenty-one when he went to work for Paulin in 1835. The original link between them may have been political, for both opposed the July Monarchy and favored the establishment of a republic. (After the Revolution of 1848 Hetzel served in the ministry of foreign affairs and fled to exile in Belgium following the coup d'état of Louis-Napoleon Bonaparte in 1851.) In any case, conscious of Curmer's success with religious literature, one of the first illustrated books the two men published jointly was a *Livre d'heures* (a book of hours, "complete, in Latin and French, for use in Paris and its diocese and following the Parisian rite") in 1837.[30] Business was business, after all, and Hetzel learned it fast.

In 1840, the older *éditeur* turned his junior partner loose on a project of his own, a series of original stories, parodies, and satires commissioned from contemporary authors to be illustrated exclusively by Grandville, whose remarkable talent for metamorphosing the human condition into animal form had already been demonstrated by La Fontaine's *Fables* and other works. "The vignettes which will adorn our publication," Hetzel wrote, "will form a gallery, or . . . a menagerie" of humanity. The first installment of *Scènes de la vie privée et publique des animaux* appeared in November 1840 (at thirty centimes on ordinary paper and sixty centimes on China paper), and by the time enough of them were completed to become a book they had proved so popular that a second volume was begun at once; it was published in 1842.[31] Although Hetzel wrote a number of the stories himself under the pseudonym P.-J. Stahl, he also drew on his friendship with writers such as George Sand, Alfred de Musset, and Jules Janin to produce "scenes" for Grandville's illustra-

tions. Balzac contributed four tales to this social comedy: "Peines de coeur d'une chatte anglaise" (The heartaches of an English cat), "Guide-Ane à l'usage des animaux qui veulent parvenir aux honneurs" (The donkey's guide for animals seeking honors), "Voyage d'un lion d'Afrique à Paris et ce qui s'ensuivit" (The voyage of an African lion to Paris and all that ensued), and "Les Amours de deux bêtes" (The loves of two beasts), of which one installment was called "Le Paul et Virginie des animaux."

Hetzel also used Balzac as an intermediary in his relations with Grandville. On one occasion he suggested, "If you have finished your article for me be good enough to send it on to Grandville, and you would be most kind if you would go to see the Inscrutable One [*ce Chinois-là*] yourself and indoctrinate him about the vignettes. Tell him everything you know to say in order to obtain results from someone who does not want to produce them."[32]

Hetzel paid Grandville well for his work. A contract from 1841 indicates that the artist earned 10,000 francs for the vignettes for the second volume of the *Scènes* alone.[33] The next year the young *éditeur* even allowed Grandville to use his country home to recover from his grief over the death of his first wife following a postpartum infection. Nevertheless, Hetzel broke with the illustrator, even challenging him to a duel, after Grandville mistakenly claimed that Hetzel had stolen his idea for an illustrated book built around the literary devise of a trip into a fantasy world.[34] The work in question, *Voyage où il vous plaira* (Travel where you please), was a collaboration between Alfred de Musset, "P.-J. Stahl," and Tony Johannot. It appeared in 1843 and was

30. Ibid., 265.
31. Ibid., 364–67.

32. Cited by Getty, *Grandville*, 322.
33. Philippe Kaenel, "Autour de J.-J. Grandville: Les conditions de production socio-professionnelles du livre illustré 'romantique,'" 50–51.
34. Ibid., 53.

Hetzel's first project as an independent publisher. Grandville's own volume with this theme, *Un Autre Monde* (Another world; see Plate 21, Figures 1–12, 1–14, and 8–10, and cat. no 114), appeared the next year. The artist had returned to his old *éditeur,* Fournier.

Hetzel now discovered for himself the truth of Curmer's warning that "the profession" was "more than a trade" and had "become a difficult art to exercise." Having borrowed heavily to open a showroom on the rue de Richelieu, the same street as his rival, Hetzel's own strained finances were dealt a mortal blow when Curmer was suddenly cornered by his creditors, even to the point of being forced to sell the original plates to *Paul et Virginie* to another *éditeur* at a discount. As Hetzel later wrote: "When Curmer went bankrupt, the illustrated library itself was badly shaken. Its volumes were put on remainder. The value of our own editions was depreciated, and everything that constituted the illustrated library found itself in the position of a speculator who owns stock which some fateful event has reduced to fifty percent of its former value."[35]

Financial bubbles were bursting all over France after 1845, and the renaissance of book illustration during the July Monarchy was at an end.

* * *

What do we mean by the term *illustration?* There is no easy answer. From the Romans to the Enlightenment, the Latin analogy "ut pictura poesis" (as is painting so is poetry) was used by philosophers to suggest a parallel between literature and the fine arts, between visual and verbal modes of communication. "Particular emphasis was always placed on the ability of the poet . . . to make the listener see the object, and of the painter to make his

viewer understand meaning as well as imagine action."[36] This is not really "illustration," however. The art historian Meyer Shapiro calls it "the artist's reading of a text." "A great part of visual art in Europe from late antiquity to the 18th century," he states, "represents subjects taken from a written text. The painter and sculptor had the task of translating the word—religious, historical, or poetic—into a visual image." And, he adds, "the correspondence of words and pictures is often problematic and may be surprisingly vague."[37] Indeed, as W. J. T. Mitchell notes, "The question of the nature of imagery has been second only to the problem of language in the evolution of modern criticism." He proposes that we use the special term *iconology* (the study of the words we use to express what pictures say) when asking "what is the difference between images and words?"[38]

Some mention of the complexity involved in defining *illustration* helps us to appreciate the achievement of the artists whose vignettes saturate the illustrated books of the July Monarchy. Virtually every page could be considered by an illustrator as a semiotic contract, an agreement as to who controls meaning, forged between someone else's words and the pictures created to accompany them. Grandville chafed over precisely this issue and represented it in his drawings. In Figure 8–9, the artist portrays himself sketching at the Paris zoo. His subject is a caged quartet of authors (including Balzac, who is second from the left), whose stories he has just finished illustrating for *Scènes de la vie privée et publique des animaux.* The aesthetic point behind his humor becomes more explicit in a vignette from the opening pages of *Un Autre Monde,* where Grandville portrays an extraordinary

35. Martin and Martin, "Le Monde des éditeurs," in Martin and Chartier, eds., *Le temps des éditeurs,* 185.

36. John Graham, "Ut Pictura Poesis," 465.
37. Meyer Shapiro, *Words and Pictures: On the Literal and the Symbolic in the Illustration of a Text,* 9.
38. W. J. T. Mitchell, *Iconology: Image, Text, Ideology,* 1, 8.

Figure 8–10. Jean-Ignace-Isidore GRANDVILLE, "Le Crayon, le canif, et la plume" (The pencil, the penknife, and the quill), from *Un Autre Monde* (Another world). See cat. no. 114.

arrangement between the artist ("le Crayon," the pencil), and the writer ("la Plume," the pen), negotiated by the *éditeur* ("le Canif," the penknife), whose task it is to sharpen both creative instruments (Figure 8–10). Here the contract will allow the image to direct the text throughout the book on which they are embarking. "I'm happy to see you have finally agreed," says the penknife; "shake hands and get started." "It's done," replies the pen; "I have already written down our conversation." "I'll illustrate it," exalts the pencil; "and, finally, I have the key to the gate that opens the route of independence for me." Grandville, in other words, wanted to reverse Meyer Shapiro's formula: in *Un Autre Monde* illustration will be the author's reading of an image. Perhaps Baudelaire was right to criticize Grandville for being too philosophical.[39]

Yet, how do images work with words?

"Basically, all functions and effects of illustrations may be derived from two characteristics of pictures in texts," states psychologist Joan Peeck: "The first is that they depict some elements from the text; that is, they show what something or someone treated in the text looks like. But in doing so, they will do something more, and this establishes the second characteristic: that of providing additional information."[40]

Apart from their important decorative function, then, the book illustrations of the July Monarchy were principally intended to be descriptive. A page from Paulin's edition of *Gil Blas* (Figure 8–11) is a clear case: Gigoux's drawing illustrates the introduction of a swashbuckling new character to the story ("I am Captain Rolando, I am the leader of the company"). Accuracy of depiction, the artist's ability to fulfill the expectation created in the

39. Cited by Getty, *Grandville*, 342.

40. Joan Peeck, "The Role of Illustrations in Processing and Remembering Illustrated Text."

Figure 8–11. Jean-François GIGOUX, "Je m'appelle le capitaine Rolando" (My name is Captain Rolando), from *Histoire de Gil Blas de Santillane* (Story of Gil Blas de Santillane). See cat. no. 71.

reader's mind by an author's words, is a common way of measuring the quality of an illustration. The nineteenth-century English writer Anthony Trollope, for example, thought that the success of Millais's illustrations for his novels could be explained by his "supposed conscientiousness in reading and considering the text."[41] In the same fashion, Baudelaire contended that "the true glory and the true mission of Gavarni and Daumier has

41. Michael Mason, "The Way We Look Now: Millais' Illustrations to Trollope."

been to complete Balzac."[42] By this standard, a great illustration is one that exceeds ordinary expectations of visual description. When Goethe was shown the famous 1826 French edition of *Faust* illustrated with lithographic plates, he commented: "If I have to agree that M. Delacroix has surpassed the scenes my writing has conjured up in my own imagination, how much more will readers of the book find his compositions full of reality, and passing beyond the imagery which they envision."[43]

Some of the *livraison-livres* we have been considering add another dimension to this matter. Like *Faust,* Bernardin de Saint-Pierre's *Paul et Virginie* and La Fontaine's *Fables* were established works of literature to which illustrations were added later. In the original collaborations of the period, however, the authors commissioned to write the installments were encouraged to shape their prose around a verbal formula: every *livraison* should contain at least one moment or scene that was particularly appropriate for depiction in a full-page vignette, because customers were conditioned to expect it. In the words of one contemporary, "a book . . . is bought today not for the text but for the vignettes."[44] As the art historian Michel Melot notes about the development of illustration during the July Monarchy, "More and more it came about that the image . . . commanded the text."[45] Here, one might say, is one of the origins of our modern visual culture.

There are, in addition, two types of book illustration that can be linked to the diffusion of the distinctly romantic sensibilities of the time. The first may be characterized as "affec-

tive" because the "additional information" (to use Peeck's term) that they bring to the particular fragment of text they describe is meant to produce a state of feeling, an emotion, in the reader. Look, for example, at Gavarni's initial vignette for the Prologue of the illustrated edition of Eugène Sue's *Le Juif errant* (The wandering Jew), published by Paulin in 1845 (Figure 8-12), and then read the opening sentence: "The Polar ocean wraps a belt of eternal ice around the deserted shores of Siberia and North America! . . . these are the final limits of two worlds, separated by the narrow Bering canal [*sic*]." This certainly exceeds the mere requirement that the illustrator describe the Bering Strait. Gavarni tells us—visually— what it would feel like to be there, thereby transforming a bit of mediocre prose into a chilling picture of desolation. Similarly, an illustration from *Paul et Virginie* (Figure 8-13) works by internalizing Bernardin de Saint-Pierre's language ("at the appearance of the sea, where he had seen the vessel disappear . . . he cried abundantly") with which it shares a page. It is through the image, not the words, that the reader experiences Paul's grief over the tragic loss of his beloved companion. Ordinary sea birds seem like winged angels of Death.

The second type of book illustration is the "fantastic." Born in the imagination of the illustrator himself, this type of image surpasses the implications of any verbal text. Neither the author nor the audience may, in fact, be prepared for it or be able fully to comprehend its meaning. Take, for example, the frightening creature that Grandville created for Balzac's bizarre story "Les Amours de deux bêtes," which appeared in a *livraison* sometime in August 1842 and was later part of the second volume of *Scènes de la vie privée et publique des animaux.* The text itself was written in the spirit of the tales of the German romantic E. T. A. Hoffmann, and the atmosphere is intentionally irrational: in the opening para-

42. Cited by Ray in *Art of the French Illustrated Book,* 217.
43. Cited by Ray in ibid., 208.
44. Regnier Destourbet cited by Michel Melot, "Le texte et l'image," in Martin and Chartier, eds., *Le temps des éditeurs,* 295.
45. Ibid.

Figure 8–12. Sulpice-Guillaume Chevalier, called Paul GAVARNI, "Prologue" from *Le Juif errant* (The wandering Jew) by Eugène Sue. See cat. no. 87.

ET VIRGINIE. 165

il soupira, et lui dit : « Oh! tu ne la retrou-
» veras plus jamais. » Enfin, il fut s'asseoir sur
le rocher où il lui avait parlé la veille; et, à
l'aspect de la mer, où il avait vu disparaître
le vaisseau qui l'avait emmenée, il pleura abon-
damment.

Figure 8–13. "... à l'Aspect de la mer ..." (... at the appearance of the sea ...), from *Paul et Virginie* by J.-H. Bernardin de Saint-Pierre. See cat no. 73.

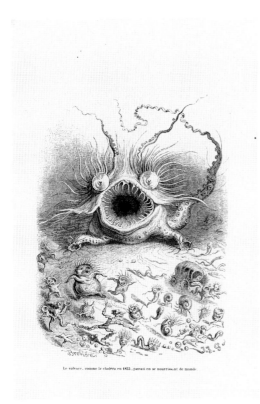

Le volvoce, comme le choléra en 1833, passait en se nourrissant de monde

Figure 8–14. Jean-Ignace-Isidore GRANDVILLE, "Le volvoce, comme le choléra en 1833, passait en se nourrissant de monde" (The Volvoce, like the cholera of 1833, passed by, feeding on people), from *Scènes de la vie privée et publique des animaux* (Scenes from the private and public lives of animals), vol. I, "Le Volvoce" (**). See cat. no. 113.

Grandville's illustration (Figure 8–14). Where in the artist's mind did the "Volvoce" come from? If, as is likely, Grandville created the open-mouthed monster with eyes resembling a woman's breasts during the previous month, then the fact that his wife gave birth to their third son on 9 July and died of a postpartum infection on the 27th suggests that the unforgettable image may be sexual in origin.[46] Its "meaning," in any case, is beyond recovery.

Un Autre Monde is perhaps the outstanding case in point, however, because it sustains the "fantastic" throughout the course of an entire volume. This *livraison-livre* is also unique because it began with Grandville's drawings themselves, which his collaborator, the writer Taxile Delord, struggled afterward to match with a verbal text. In Plate 21, for example, Delord's words ("There is a great celebration in the sky today. If you aren't short-sighted you should certainly see the Signs") are able merely to suggest the inadequacy of the reader's own powers of imagination. Like the animated scientific instruments that focus on the visible "conjugal eclipse" of the Sun and Moon, we are unprepared to encounter the harmonious dream world beyond the heavens where a comet glides to the music of the spheres. Little wonder that while *Un Autre Monde* was a commercial and critical failure in its own day, it was rediscovered as a masterpiece by the Surrealists in our century. Today it ranks as one of the greatest examples of the renaissance of book illustration during the July Monarchy.

graph one of the central characters, Professor Granarius, declares, "It is *REASON,* that attribute which swells human pride, which is the cause of all social ills." Nevertheless, nothing in Balzac's text ("The Volvoce, like cholera in 1833 [*sic*], was passing, devouring the world") suggests what is visually there in

46. Getty, *Grandville,* 412.

CATALOG OF THE EXHIBITION

I. Louis Philippe, The Citizen King

1. Bernard Romain JULIEN
Bayonne 1802–1871 Bayonne
After the painting by Horace VERNET
Paris 1789–1863 Paris
Louis Philippe Leaving the Palais Royal
Lithograph
27.4 x 32.1 cm
Washington, Library of Congress
 (Inv. XIX J94 A2 LP2)

Figure 1–4

2. Eugène-François-Marie-Joseph DEVÉRIA
Paris 1805–1865 Pau
Le Roi Louis-Philippe prêtant serment le 9 août 1830 or
 Serment du roi à la chambre des députés le 9 août 1830
 (King Louis Philippe taking the oath on 9
 August 1830, or The king's oath to the Chamber
 of Deputies on 9 August 1830), Salon of 1831
Oil on canvas (sketch for the painting commis-
 sioned by Louis Philippe for the Musée du
 Château de Versailles)
77 x 110 cm
Inscribed bottom center: Eugène Devéria
Versailles, Musée National du Château de Ver-
 sailles (Inv. MV 5121)
Purchased by the king, 1831

Figure 1–1

3. Jean-François-Théodore GECHTER
Paris 1796–1844 Paris
Louis-Philippe, roi des Français (Louis Philippe, king
 of the French), ca. 1839
Bronze
40 cm
Inscribed: T. Gechter
Minneapolis, The Minneapolis Institute of Arts
 (Inv. 72.19)
The Ethel Morrison Van Derlip Funds

Jean-François-Théodore GECHTER, *Louis-Philippe, roi des Français* (Louis Philippe, king of the French). Cat. no. 3.

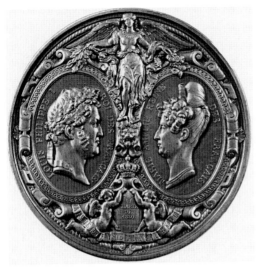
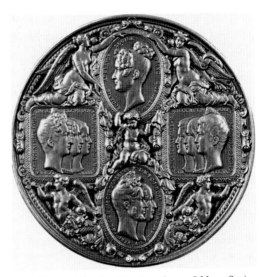

Jean-Auguste BARRE, *La Famille Royale visite la Monnaie le 8 nov. 1833* (The royal family visits the mint on 8 Nov. 1833). Cat. no. 4.

Jacques-Augustin DIEUDONNÉ, *Portrait Bust of Louis Philippe.* Cat. no. 6.

Jacques-Augustin DIEUDONNÉ, *Portrait Bust of Marie Amélie.* Cat. no. 7.

4. Jean-Auguste BARRE
Paris 1811–1896 Paris
La Famille Royale visite la Monnaie le 8 nov. 1833 (The
 royal family visits the mint on 8 Nov. 1833)
Bronze medallion with light brown patina
7.6 cm diameter
Inscribed: Barre / Fecit
Columbia, Mo., Museum of Art and Archaeology,
 University of Missouri–Columbia (Inv. 89.4)
Purchased 1989

5. J.-F. Antoine BOVY
Geneva 1795–1877 Switzerland
*Medal of Louis Philippe with Allegory of the Establish-
 ment of the French Railroad,* 1842
Copper medallion
11.2 cm diameter
Inscribed at bottom: A. BOVY FECIT
Columbia, Mo., Museum of Art and Archaeology,
 University of Missouri–Columbia (Inv. 89.5)

Figure 1–9

6. Jacques-Augustin DIEUDONNÉ
Paris 1795–1873 Paris
Portrait Bust of Louis Philippe, 1829
Bronze bust
35.7 x 31.8 x 14.1 cm
Inscribed on back: Dieudonné 1829
New York, Michael Hall Fine Arts, Inc.

7. Jacques-Augustin DIEUDONNÉ
Paris 1795–1873 Paris
Portrait Bust of Marie Amélie, 1829
Bronze with brown to dark gray patination
 mounted on round, gray marble pedestal base
38 x 30.3 x 16.5 cm
Inscribed under left shoulder drapery: Dieudonné /
 1829
New York, Michael Hall Fine Arts, Inc.

8. Louis MENNESSIER
(Dates unknown)
Statuette du duc d'Aumale (Statuette of the duc
 d'Aumale), 1843
Bronze
49 cm
Inscribed front of base: Lieutenant Général /
 Afrique
 on top: Louis Mennessier, 1843
Paris, Musée des Arts Décoratifs (Inv. 19676)
Purchased 1914

Figure 6–2

Charles CUMBERWORTH, *Le Duc de Montpensier.* Cat.
no. 9.

Claude-Aimé CHENAVARD, *Cheminée exécutée pour le Château d'Eu* (Fireplace created for the Château d'Eu). Cat. no. 10.

9. Charles CUMBERWORTH
Verdun 1811–1852 Paris
Le duc de Montpensier, Salon of 1847
Bronze
54 cm
Inscribed on front of base: Duc de Montpensier
 on canon: Cumberworth
 on left side: Susse Fres (?)
Paris, Musée des Arts Décoratifs (Inv. 39855)
Gift of Adolfo Blaquier, 1963

10. Claude-Aimé CHENAVARD
Lyon 1798–1838 Paris
Cheminée exécutée pour le château d'Eu (Fireplace
 created for the château d'Eu)
Graphite on paper
31.5 x 28.8 cm
Inscribed l.l.: Détail de / ———
Paris, Musée des Arts Décoratifs (Inv. CD 2955)

Henri Joseph François Baron de TRIQUETI, *Piedestal pour le vase du Palais de Saint Cloud* (Pedestal for the vase in the Palace of Saint Cloud). Cat. no. 11.

11. Henri Joseph François Baron de TRIQUETI
Conflans (Loiret) 1804–1874 Paris
Piédestal pour le vase du Palais de Saint Cloud (Pedestal for the vase in the Palace of Saint Cloud), 1838
Watercolor
48 x 26 cm
Inscribed l.r.: H. de Triqueti 1838
Paris, Musée des Arts Décoratifs (Inv. CD 6507)

12. François-Joseph HEIM
Belfort 1787–1865 Paris
Son altesse royale le duc de Nemours (His royal highness the duc de Nemours)

Charcoal heightened with white chalk on greenish paper
33 x 18 cm
Inscribed b.c.: Son A. Royal le Duc de Nemours
New York, Sandorval & Co., Inc.

Plate 1

13. Eugène Louis LAMI
Paris 1800–1890 Paris
Projets pour l'appartement du duc de Nemours dans les Tuileries (Projects for the suite of the duc de Nemours in the Tuileries Palace), 1842
Watercolor
Paris, Musée des Arts Décoratifs

A.
16 x 32 cm
(Inv. 32458 a)

B.
10 x 17.5 cm
(Inv. 32458 b)

14. A. PROVOST
Active Paris 1834–1855
Derniers moments du duc d'Orléans après l'accident de Neuilly, le 13 juillet 1842 (The last moments of the duc d'Orléans after the accident at Neuilly, 13 July 1842)
Black crayon with graphite and traces of color
22 x 35 cm
Paris, Musée Carnavalet (Inv. D2251)

Figure 1–8

15. Pierre-Louis, called Henri GREVEDON
Paris 1776–1860 Paris
After the painting by Franz Xaver WINTERHALTER (1806–1873) of 1842
S.A.R. Madame la Duchesse d'Orléans, Princesse Royale (H.R.H. the Duchess of Orléans, Princess Royal), 1843
Lithograph
57.8 x 39.2 cm
Inscribed l.l.: Peint par F. Winterhalter
 l.r.: Lith. par H. Grevedon en 1843
 b.c.: Imprimé par Lemercier à Paris
Chicago, The David and Alfred Smart Gallery, The University of Chicago (Inv. 1975.44)
Gift of J. Patrice Marandel

Eugène Louis LAMI, *Projet pour l'appartement du duc de Nemours dans les Tuileries* (Project for the suite of the duc de Nemours in the Tuileries Palace). Cat. no. 13A.

Eugène Louis LAMI, *Projet pour l'appartement du duc de Nemours dans les Tuileries* (Project for the suite of the duc de Nemours in the Tuileries Palace). Cat. no. 13B.

II. A Pantheon of Arts and Letters

16. Pierre-Jean DAVID, called DAVID D'ANGERS

Angers 1788–1856 Paris
Armand Carrel, 1836
Bronze bust
78 x 32.5 x 27 cm
Inscribed on left side: Fondu par Honoré Gonon /
 et ses deux fils, 1837.
 on front: Au courageux défenseur de
 la Liberté / ARMAND CAR-
 REL / né à Rouen en 1800
 tué à St. Mandé en 1836 /
 Son ami David
Rouen, Musée des Beaux-Arts (Inv. 66)
Gift of the artist at unknown date between 1837
 and 1845

Plate 2

David d'Angers's close friend Armand Carrel was a militant Republican, the founder of the newspaper *Le National.* He died in a duel with a rival newspaper editor in 1836, fought over the issue of freedom of the press.

Both David and the painter Ary Scheffer were at Carrel's deathbed in St. Mandé, and Scheffer's painting of his friend (see Plate 15 [cat. no. 76]) was made on the spot at that time. Upon Carrel's death, David was asked to make a bust of the hero. The terra-cotta model for this bronze is housed in the Museum of Angers.

After the bust, David made a full-length statue in 1839 that was placed on Carrel's grave in the cemetery of St. Mandé. It shows Carrel in modern dress and at a moment of action: when he defended freedom of the press in the Chamber of Peers in

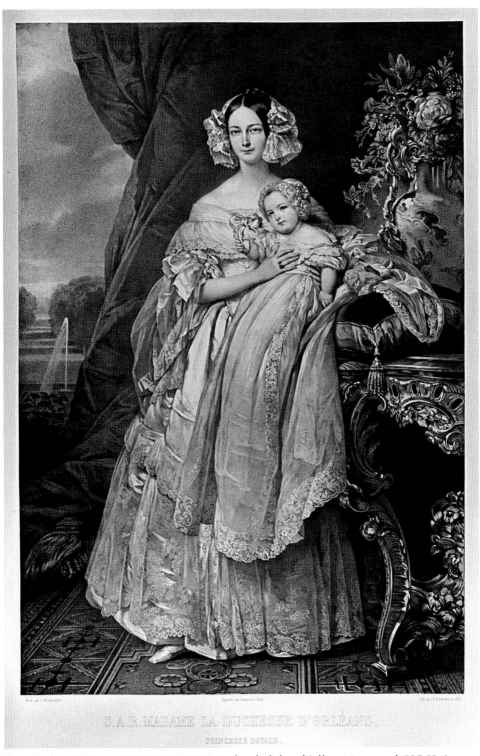

Pierre-Louis, called Henri GREVEDON, *S.A.R. Madame la duchesse d'Orléans, princesse royale* (H.R.H. the Duchess of Orléans, Princess Royal). Cat. no. 15.

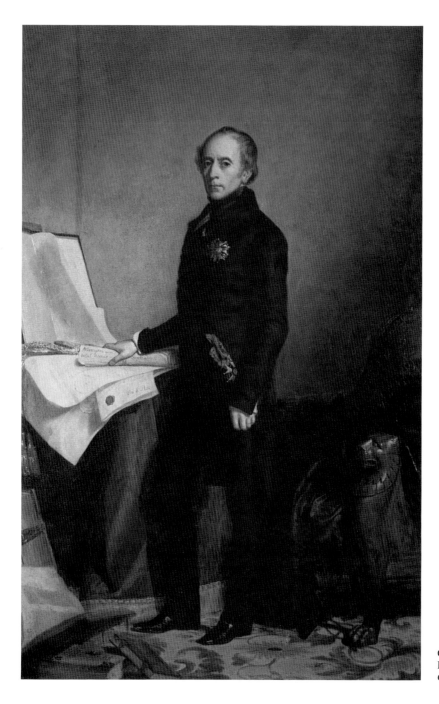

George Peter Alexander
HEALY, *Portrait de M.
Guizot*. Cat. no. 17.

Luigi CALAMATTA,
*Portrait of Adolphe Thiers
(1797–1877)*. Cat. no. 18.

1834. As a representative of this issue, Carrel can be seen as an equivalent to Daumier, for whom freedom of the press also was a central theme.

17. George Peter Alexander HEALY
Boston 1808–1894 Chicago
Portrait de M. Guizot
Oil on canvas
72 x 46.7 cm
Santa Barbara, The Santa Barbara Museum of Art
　(Inv. 60.86)
Gift of Abraham Adlers to the Preston Morton
　Collection

18. Luigi CALAMATTA
Civita-Vecchia 1802–1862 Milan
Portrait of Adolphe Thiers (1797–1877)
Engraving (artist's proof before the letters)
35.7 x 27.6 cm
Washington, Library of Congress
　(Inv. XIX C1412 C1)

19. Gustave COURBET
Ornans 1819–1877 Tour-de-Peilz
Portrait de l'artiste, dit Courbet au chien noir (Portrait of
　the artist, called Courbet with black dog), 1842,
　Salon of 1844
Oil on canvas

Paul-Jean FLANDRIN,
*Portrait d'Hippolyte
Flandrin*. Cat. no. 20.

46.3 x 55.5 cm
Inscribed l.l.: Gustave Courbet / 1842
Paris, Musée du Petit Palais (Inv.731)
Gift of Juliette Courbet to the City of Paris, 1909

Figure 5–10

As a struggling young artist in the 1840s,
Gustave Courbet suffered from the increasingly
conservative standards set by the Salon juries under
the July Monarchy. Among his few accepted works
of these early years was this self-portrait, painted in
1842 and first exhibited at the Salon of 1844.

The painting shows the artist seated on a moun-
tain slope in his native Franche-Comté, accompa-
nied by his black spaniel. This dog, which Courbet
had received as a present in 1842, also figured in
another self-portrait, now in the Pontarlier
museum.

The artist's pose and placement, dominating a
landscape panorama, follow a long-established por-
trait tradition introduced in the seventeenth
century (in the works of such artists as Anthony
van Dyck and Diego Velazquez) and then con-
tinued in England, where it became a stock-in-
trade for aristocratic portraiture. During the
Romantic period the pose remained popular but
was transferred from the aristocracy to the por-
trayal of scholars, artists, and scientists.

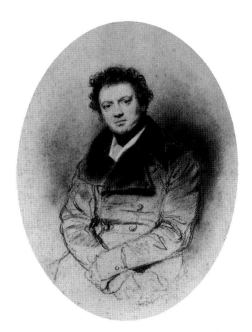

Hippolyte, called Paul DELAROCHE, *Portrait du peintre Steuben* (Portrait of the painter Steuben). Cat. no. 21.

Courbet has shown himself here as the artist-naturalist who, armed with sketchbook and pencil, hikes through the countryside. His poised, even arrogant attitude seems to express both his pride in his native region and his determination to succeed as a provincial artist in Paris.

20. Paul-Jean FLANDRIN

Lyon 1811–1902 Paris
Portrait d'Hippolyte Flandrin, 1835
Lead pencil
28 x 21.5 cm
Inscribed l.r.: Paul Flandrin / 1er Mai Rome 1835
Paris, Musée du Louvre, Département des Arts
 Graphiques (Inv. RF 2795)
Gift of the widow of Paul Flandrin to the Musée du
 Luxembourg, 1903
Collection of the Musée du Louvre, 1930
Exhibition in Columbia only

21. Hippolyte, called Paul DELAROCHE

Paris 1797–1856 Paris
Portrait du peintre Steuben (Portrait of the painter
 Steuben), 1831
Three crayons
30 x 24 cm

Inscribed l.r.: Paul Delaroche à Monsieur Steuben,
 1831
Paris, Musée du Petit Palais (Inv. 1481)

22. Hippolyte, called Paul DELAROCHE

Paris 1797–1856 Paris
Portrait of the Actress Marie Dorval (1798–1849), 1831
Colored chalk on off-white wove paper
40.3 x 30.2 cm
Inscribed l.r.: Paul Delaroche / 1831
New York, Private Collection

Plate 3

23. Alfred Vincent SIXDENIERS

Paris 1795–1846 Paris
After the painting by Auguste CHARPENTIER
Paris 1813–1880 Paris
Mlle. Rachel, secrétaire du Théâtre Français
 (Mademoiselle Rachel, secretary of the Théâtre
 Français)
Lithograph
39.8 x 31.8 cm
Washington, D.C., Library of Congress
 (Inv. XIX S625 B3)

24. René-Auguste FLANDRIN

Lyon 1804–1843 Lyon
Portrait de Georges Hainl, 1839
Graphite on paper
31 x 25.7 cm
Inscribed l.l.: Auguste Flandrin / à Georges Hainl /
 Lyon 1839
Paris, Musée Carnavalet (Inv.D 6245)
Gift of Mme. Grenier-Georges Hainl, 1913

25. Théodore CHASSÉRIAU

Santo Domingo 1819–1856 Paris
Portrait de Lamartine, 1844
Graphite on paper
34.5 x 21.5 cm
Inscribed l.r.: A Madame de Lamartine.
 Th. Chassériau. 1844
Paris, Musée du Petit Palais (Inv. 465)
Gift of Baron Arthur Chassériau, 1907

26. Théodore CHASSÉRIAU

Santo Domingo 1819–1856 Paris
Portrait de Tocqueville, 1844
Graphite on paper
30.5 x 23.5 cm
Inscribed l.r.: à Madame / Alexis de Tocqueville /
 Th. Cassériau / 1844

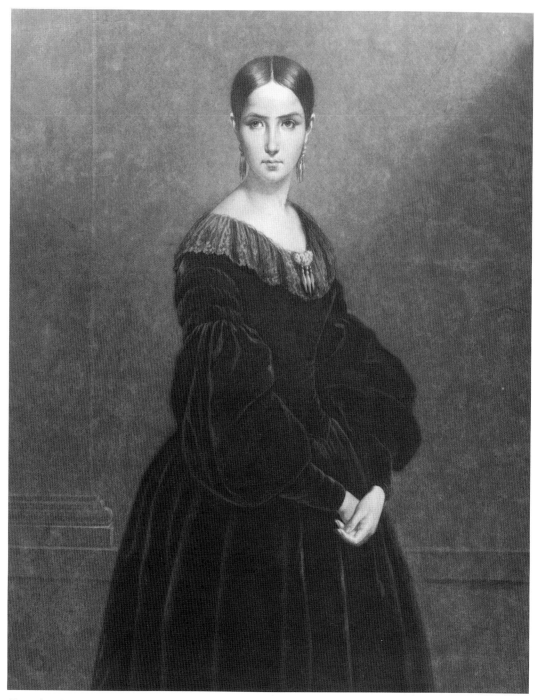

Alexander Vincent SIXDENIERS, *Mlle. Rachel, secrétaire du Théâtre Français* (Mademoiselle Rachel, secretary of the Théâtre Français). Cat. no. 23.

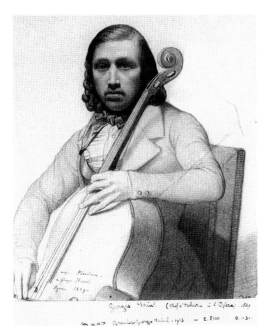

René-Auguste FLANDRIN, *Portrait de Georges Hainl.*
Cat. no. 24.

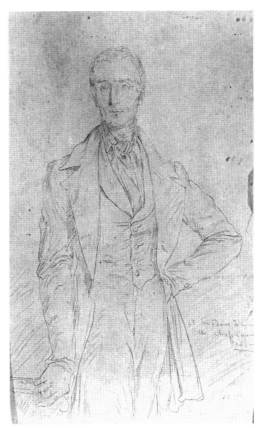

Théodore CHASSÉRIAU, *Portrait de Lamartine.* Cat. no.
25.

Paris, Musée Carnavalet (Inv. D7040)
Gift of Baron Arthur Chassériau, 1934

Figure 1–16

27. Eugène CICÉRI
Paris 1813–1890 Paris
Dumas père (Dumas the elder)
Graphite and watercolor
65 x 46 cm
Inscribed l.l.: Elle me résistait, je l'ai assassinée
 (She resisted me, I killed her).
 Alexandre Dumas
 l.r.: Jean Cicéri
Paris, Musée Carnavalet (Inv. D4200)

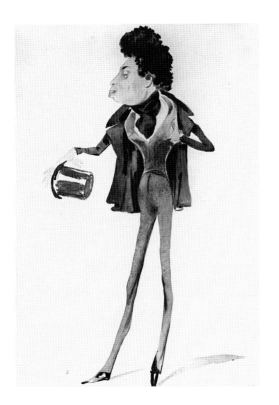

Eugène CICÉRI, *Dumas père* (Dumas the elder). Cat. no.
27.

Théodore CHASSÉRIAU, *La Princesse Belgiojoso*. Cat. no. 28.

28. Théodore CHASSÉRIAU
Santo Domingo 1819–1856 Paris
La Princesse Belgiojoso, 1847
Graphite on paper
30.5 x 22.8 cm
Inscribed r.c.: Théodore Chassériau. 1847.
Paris, Musée du Petit Palais (Inv. 463)
Gift of Baron Arthur Chassériau, 1907

**29. Pierre-Jean DAVID, called DAVID
 D'ANGERS**
Angers 1788–1856 Paris
Léon Cogniet, 1831
Bronze medallion
14.4 cm diameter
Inscribed on r. side: Léon Cognet [*sic*] Pictor
New York, Private Collection

**30. Pierre-Jean DAVID, called DAVID
 D'ANGERS**
Angers 1788–1856 Paris
Armand Carrel, 1832
Bronze medallion
16 x 23 x 2 cm
Inscribed at bottom: David 1832
 at r. side: Armand Carrel

Pierre-Jean DAVID, called DAVID D'ANGERS, *Léon Cogniet*. Cat. no. 29.

Pierre-Jean DAVID, called DAVID D'ANGERS, *Armand Carrel*. Cat. no. 30.

Rouen, Musée des Beaux-Arts (Inv. 1242)
Gift of Mme. E. Antoine, 1897

31. Pierre-Jean DAVID, called DAVID D'ANGERS
Angers 1788–1856 Paris
Honoré de Balzac, 1843
Bronze medallion
18.4 cm diameter
Inscribed on back: Thibault & Fils
New York, Private Collection

32. Antoine Augustin PRÉAULT
Paris 1810–1879 Paris
George Sand, ca. 1830
Bronze medallion
20.2 cm diameter
3 cm deep
New York, Michael Hall, Esq.

Pierre-Jean DAVID, called DAVID D'ANGERS, *Honoré de Balzac.* Cat. no. 31.

Antoine Augustin PRÉAULT, *George Sand.* Cat. no. 32.

Pierre-Jean DAVID, called DAVID D'ANGERS, *Victor Hugo*. Cat. no. 34.

Pierre-Jean DAVID, called DAVID D'ANGERS, *Nicolò Paganini*. Cat. no. 35.

Pierre-Jean DAVID, called DAVID D'ANGERS, *Cherubini*. Cat. no. 36.

33. Pierre-Jean DAVID, called DAVID D'ANGERS

Angers 1788–1856 Paris
Alfred de Musset, 1831
Bronze medallion
16.5 cm diameter
Inscribed on back: Thibault & Fils
New York, Private Collection

Figure 2–18

34. Pierre-Jean DAVID, called DAVID

D'ANGERS

Angers 1788–1856 Paris
Victor Hugo, 1828
Bronze medallion
12 cm diameter
Inscribed on back: Eck & Durand
New York, Private Collection

35. Pierre-Jean DAVID, called DAVID D'ANGERS

Angers 1788–1856 Paris
Nicolò Paganini, 1834
Bronze medallion
16 cm diameter
Inscribed l. side: Nicolò Paganini
 bottom: David 1834
New York, Michael Hall, Esq.

36. Pierre-Jean DAVID, called DAVID D'ANGERS

Angers 1788–1856 Paris
Cherubini, 1840
Bronze medallion
17.8 x 18.2 cm
Inscribed l. side: L. Cherubini
 bottom: David 1840
New York, Michael Hall, Esq.

III. Revolution and Napoleon

37. Pierre-Jean DAVID, called DAVID

Pierre-Jean DAVID, called DAVID D'ANGERS, *La Liberté* (Liberty). Cat. no. 37.

Denis Auguste Marie RAFFET, "20 Juin 1792. Le peuple aux Tuileries" (20 June 1792. The people at the Tuileries), from *Musée de la Révolution. Histoire chronologique de la Révolution Française* (Museum of the Revolution. Chronological history of the French Revolution). Cat. no. 39.

D'ANGERS

Angers 1788–1856 Paris
La Liberté (Liberty), 1839
Bronze with red marble base
58.5 x 23 x 17.5 cm
Inscribed left side of base: P. J. David / 1839
 front of base: Liberté, Liberté chérie /
 combats avec tes
 défenseurs
Paris, Musée des Arts Décoratifs (Inv. 12235)
Gift of Mme. Lefermé, née David d'Angers, 1905

The Musée Carnavalet in Paris owns a terra-cotta model of this bronze. It is signed by the artist and bears the date 1839. The terra-cotta figure holds a lance instead of a rifle, which means that the bronze is a variant on the original model.

Two lines from the *Marseillaise* are inscribed on the base of the statuette, while on the scroll the figure is holding can be read the dates 1789, 1830 (both revolutionary years), and 18—, pointing to some future revolution. On the whole then this figure represents a call for another revolution. David created this sculpture with the intention of having it reproduced and sold on a wide scale. To judge by his writings on the subject, *La Liberté* was also the kind of statue that he thought should crown the Arc de Triomphe.

38. Joseph Désiré COURT

Rouen 1797–1865 Rouen
La Protestation de Mirabeau contre le congé signifié par

Louis XVI aux Etats Généraux par la bouche du marquis de Dreux-Brézé or *Mirabeau devant Dreux-Brézé* (Mirabeau's protest against the dismissal conveyed to the general assembly by Louis XVI through the marquis de Dreux-Brézé, or Mirabeau before Dreux-Brézé), 1831
Oil on canvas
89 x 116.5 cm
Inscribed l.r.: Court
Rouen, Musée des Beaux-Arts (Inv. 866-2-2)
Acquired at sale of the artist's studio, 1866

Plate 4

39. Denis Auguste Marie RAFFET

Paris 1804–1860 Gênes
Musée de la Révolution. Histoire chronologique de la Révolution Française, ornée de gravures sur acier par Frilley, d'après les dessins de Raffet. Ouvrage destiné à servir de complément et d'illustration à toutes les histoires de la Révolution (Thiers, Montgaillard, Mignet, Lacretelle, etc.) (Museum of the Revolution. Chronological history of the French Revolution, decorated with steel engravings by Frilley, following sketches by Raffet. Work intended to complement and illustrate all histories of the revolution [Thiers, Montgaillard, Mignet, Lacratelle, etc.]), Paris, Perrotin, 1834, 1 volume in 8, imp. Auffray, 45 plates on China paper
Book
22.6 x 14 x 2 cm

Alexandre Vincent SIX-DENIERS, *Charlotte Corday.* Cat. no. 40.

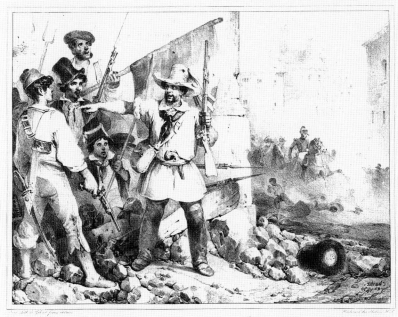

Nicolas-Toussaint CHARLET, *L'Allocution (28 juillet 1830)* (The short speech [28 July 1830]). Cat. no. 41.

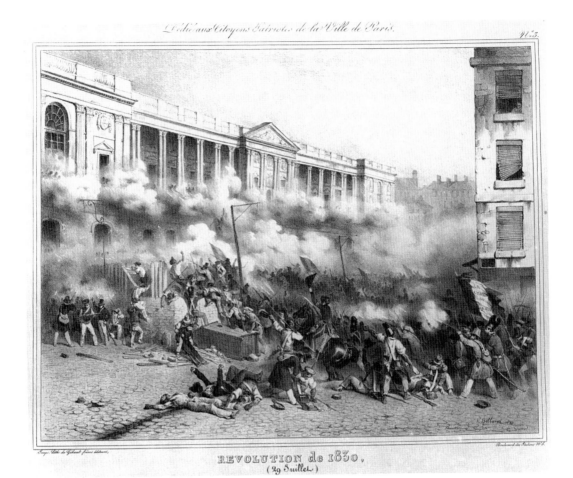

Joseph-Louis-Hippolyte BELLANGÉ, *Révolution de 1830 (29 juillet)—Attaque du Louvre par le Quai de l'Ecole* (Revolution of 1830 [29 July]—attack on the Louvre from the Quai de l'Ecole). Cat. no. 42.

Evanston, Ill., Special Collections Department,
 Northwestern University Library
 (Inv. 944.04/M 986)

40. Alexandre Vincent SIXDENIERS
Paris 1795–1846 Paris
After the painting by Henri SCHEFFER, Salon of
 1831, no. 190
Charlotte Corday
Lithograph
44.2 x 55.7 cm
Washington, Library of Congress
 (Inv. XIX S625 D12)

41. Nicolas-Toussaint CHARLET
Paris 1792–1845 Paris
L'Allocution (28 juillet 1830) (The short speech
 [28 July 1830]), 1830

Lithograph
42.5 x 58 cm
Providence, Anne S. K. Military Collection, Brown
 University Library (Inv. Fr P 18301 f-1)

42. Joseph-Louis-Hippolyte BELLANGÉ
Paris 1800–1860 Paris
*Révolution de 1830 (29 juillet)—Attaque du Louvre par
 le Quai de l'Ecole* (Revolution of 1830 [29 July]—
 attack on the Louvre from the Quai de l'Ecole)
Lithograph of a painting in the Salon of 1831,
 no. 3110
48 x 63 cm
Providence, Anne S. K. Military Collection, Brown
 University Library

43. M. Petit, *Histoire de la révolution de mil* [*sic*] *huit
 cent trente* (History of the revolution of eighteen

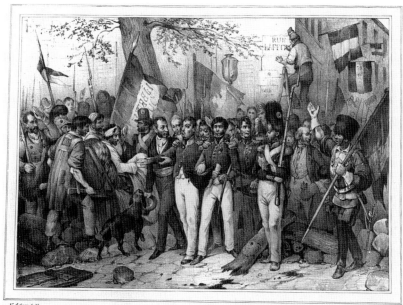

LE G.ᶜ LAFAYETTE SE RENDANT A L'HÔTEL DE VILLE.

M. PETIT, "29 juillet 1830, Le Gal. Lafayette se rendant à l'Hôtel de Ville" (29 July 1830, Gen. Lafayette returning to the Hôtel de Ville), from *Histoire de la révolution de mil* [*sic*] *huit cent trente* (History of the revolution of eighteen hundred thirty). Cat. no. 43.

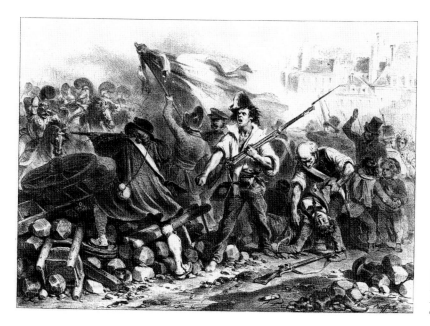

Denis Auguste Marie RAFFET, *A Mort pour la Liberté* (To death for Liberty). Cat. no. 44.

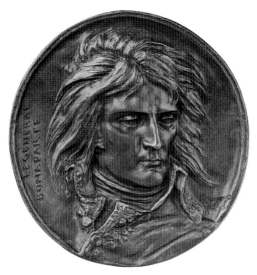

Pierre-Jean DAVID, called DAVID D'ANGERS,
Napoleon as a Revolutionary General. Cat. no. 45.

Anonymous, *Napoléon le grand* (Napoleon the great). Cat. no. 46.

hundred thirty), decorated with forty
lithographs after Raffet, Bellangé, Lami, Ada,
Charlet, Le Potevin, Hersent, Julien, et al. . . . ,
Paris, chez l'auteur, 1831
Book
43 x 30 x 2 cm
Providence, Anne S. K. Military Collection, Brown
 University Library (Inv. F 1831 FRANCE)

44. Denis Auguste Marie RAFFET
Paris 1804–1860 Gênes
A Mort pour la Liberté (To death for Liberty), ca. 1831
Lithograph
18.1 x 25.9 cm
Inscribed l.r.: Raffet
New Haven, Yale University Art Gallery, Everett
 V. Meeks, B.A. 1901, Fund (Inv. 1971.18.2)

**45. Pierre-Jean DAVID, called DAVID
 D'ANGERS**
Angers 1788–1856 Paris
Napoleon as a Revolutionary General, 1838
Bronze medallion
15.9 cm diameter
Inscribed l.r.: David / 1838
 left side: Le Général Bonaparte
New York, The Metropolitan Museum of Art,
 Rogers Fund (Inv. 08.70.1)

46. Anonymous
Napoléon le grand (Napoleon the great)
Bronze medallion
4.4 cm diameter
Inscribed recto: Napoléon Le Grand
 verso: A La Mémoire de L'Empereur, Loi
 de juin 1840
New York, Faber Donoughe

47. Denis Auguste Marie RAFFET
Paris 1804–1860 Gênes
Revue nocturne (Nocturnal review), 1836
Lithograph
20 x 27.2 cm
Issued by Gihaut
Inscribed l.r.: Raffet 1836
New Haven, Yale University Art Gallery, Everett
 V. Meeks, B.A. 1901, Fund (Inv. 1968.83.2)

Figure 2–7

48. Nicolas-Toussaint CHARLET
Paris 1792–1845 Paris
Mémorial de Sainte-Hélène, par le Cte. de Las Cases; suivi

*de Napoléon dans l'exil, par MM. O'Méara et Antom-
marchi; et l'historique de la translation des restes
mortels de l'empereur Napoléon aux Invalides* (Memo-
rial of Saint Helena, by the Count de Las Cases;
followed by Napoleon in exile, by messieurs
O'Méara and Antommarchi; and the historical
account of the transfer of the Emperor
Napoleon's remains to Les Invalides), Paris,
Ernest Bourdin, 1842, 2 volumes
Books
26.1 x 18 x 5.5 cm
Providence, Anne S. K. Military Collection, Brown
 University Library (Inv. FN 1842 FRANCE)

49. Alexis-Joseph DEPAULIS
Paris 1792–1867 Paris
Napoleon Lying Dead at Saint Helena, ca. 1840
Bronze medallion
6.3 cm diameter
On verso: The funerary barge carrying Napoleon's
 body up the Seine
New York, The Metropolitan Museum of Art
 (Inv. 1977.254.5)
Purchased by the Rogers Fund, 1977

50. C. Francesco ANTOMMARCHI
1780–1838
Death Mask of Napoleon on a Cushion, 1833
Bronze
19 x 12.4 x 30 cm (mask)
17.8 x 20.3 x 35.5 cm (cushion)
Inscribed l. side: Dr. F. Antommarchi
 r. side: Fondu par Richard et Quesnel à
 Paris
 inset medal: Napoleon Emp Et Roi. Souscrip-
 tion Dr. Antommarchi 1833
New York, Faber Donoughe

Figure 2–8

51. François-Joseph-Aimé de LEMUD
Thionville 1817–1887 Nancy
Le Retour en France (The return to France), 1841
Lithograph (printed by Lemercier, Benard et Ce.,
 issued by Rittner et Goupil, 1841)
46 x 40.2 cm
Chicago, The Art Institute of Chicago
 (Inv 1974.67 RX 9669/1)

52. François-Fortuné-Antoine FEROGIO
Marseille 1805–1888 Paris
and **Alexis-François GIRARD**
Vincennes 1787–1870 Paris

182 MÉMORIAL

« donné ce qui ne lui appartient pas : quel diable de présent ! » Cepen-
dant Duroc avait été payer le maître du bâtiment ; il en tenait la quit-
tance de vente qu'on remit à l'homme. Dès qu'il commença à compren-
dre, sa joie fut jusqu'au délire ; il fit des folies. La somme était encore
à peu près la même que ci-dessus. « Ainsi, disait l'Empereur, on voit
« que les désirs des hommes ne sont pas aussi immodérés qu'on le
« pense, et qu'il est plus facile de les rendre heureux qu'on ne croit ; car
« assurément ces deux hommes trouvèrent le bonheur. »

Napoléon répétait souvent des traits de la sorte ; en voici un écrit sous
sa dictée : il s'agit du passage du Saint-Bernard, avant la bataille de
Marengo.

« Le Consul montait, dans le plus mauvais temps, le mulet d'un ha-
« bitant de Saint-Pierre, désigné comme étant le mulet le plus sûr de
« tout le pays. Le guide du Consul était un grand et vigoureux jeune

« homme de vingt-deux ans, qui s'entretint beaucoup avec lui, en s'a-
« bandonnant à cette confiance propre à son âge et à la simplicité des
« habitants des montagnes. Il confia au Premier Consul toutes ses pei-
« nes, ainsi que les rêves de bonheur qu'il faisait pour l'avenir. Arrivé
« au couvent, le Premier Consul, qui jusque-là ne lui avait rien témoi-
« gné, écrivit un billet et le donna à ce paysan pour le remettre à son
« adresse. Ce billet était un ordre qui prescrivait diverses dispositions,

Nicolas-Toussaint
CHARLET, "Napoleon
Crossing the Alps,"
from *Mémorial de Sainte-
Hélène, par le cte. de Las
Cases* (Memorial of Saint
Helena, by the Count de
Las Cases), 2:182. Cat.
no. 48.

Alexis-Joseph DEPAULIS, *Napoleon Lying Dead at Saint Helena.* Verso: The funerary barge carrying Napoleon's body up the Seine. Cat. no. 49.

Funérailles de l'Empereur Napoléon (The funeral of the Emperor Napoleon)
Lithographs
The Library of Congress, Washington D.C.

A.
Passage du cortège dans les Champs Elysées (The procession moving along the Champs Elysées)
23.3 x 34.8 cm
(Inv. XIX F367 C3)

Figure 2–23

B.
Intérieur de l'Eglise des Invalides pendant la cérémonie religieuse 15 décembre 1840 (Interior of the Eglise des Invalides during the religious ceremony 15 December 1840)
33.3 x 25.5 cm
(Inv. XIX F367 C8)

Figure 2–24

IV. France in the Islamic World

53. Denis Auguste Marie RAFFET
Paris 1804–1860 Gênes
Le 2e Léger soutient le choc des arabes, 1836 (The 2d Light withstanding the clash with the Arabs, 1836), 1836
Lithograph
15.3 x 28.3 cm

Issued by Gihaut
Inscribed l.l.: Raffet 1836
New Haven, Yale University Art Gallery, Allen Evarts Foster, B.A. 1906, Fund (Inv. 1978.30)

54. Denis Auguste Marie RAFFET
Paris 1804–1860 Gênes
Combat d'Oued-Alleg (31 décembre 1839) (The battle of Oued-Alleg [31 December 1839]), 1840
Lithograph
24.4 x 37.3 cm
Washington, Library of Congress
(Inv. XIX R137 C82)

55. Antoine-Louis BARYE
Paris 1796–1875 Paris
Algerian Dromedary
Bronze
14.9 x 19.1 cm
Baltimore, The Walters Art Gallery (Inv. 27.102)

56. Ferdinand-Victor-Eugène DELACROIX
Charenton-Saint-Maurice 1798–1863 Paris
Un Lion à la source (A lion at the spring), 1841
Oil on canvas
46 x 51 cm
Inscribed l.l.: Eug. Delacroix 1841
Bordeaux, Musée des Beaux-Arts de Bordeaux
(Inv. E 400, M 6128)
Bequest of Général Delacroix, 1845

François-Joseph-Aimé de LEMUD, *Le Retour en France* (The return to France). Cat. no. 51.

Denis Auguste Marie RAFFET, *Le 2e Léger soutient le choc des arabes, 1836* (The 2d Light withstanding the clash with the Arabs, 1836). Cat. no. 53.

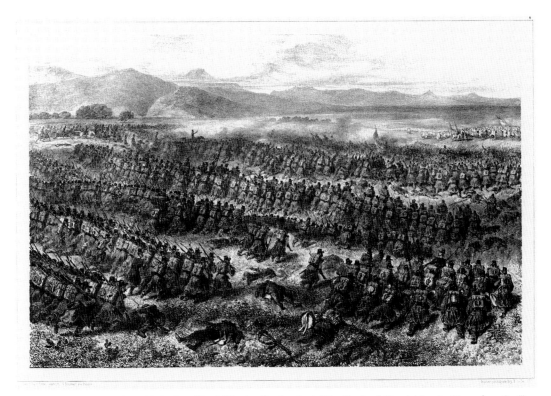

Denis Auguste Marie RAFFET, *Combat d'Oued-Alleg (31 décembre 1839),* (The Battle of Oued-Alleg [31 December 1839]). Cat. no. 54.

Antoine-Louis BARYE, *Algerian Dromedary.* Cat. no. 55.

Ferdinand-Victor-Eugène DELACROIX, *Un Lion à la source* (A lion at the spring). Cat. no. 56.

Ferdinand-Victor-Eugène DELACROIX, *Un Marocain de la garde de l'empereur* (A Moroccan of the emperor's guard). Cat. no. 57.

57. Ferdinand-Victor-Eugène DELACROIX

Charenton-Saint-Maurice 1798–1863 Paris
Un Marocain de la garde de l'empereur (A Moroccan of
 the emperor's guard), 1845
Oil on canvas
32 x 41 cm
Inscribed l.r.: Eug. Delacroix, 1845
Bordeaux, Musée des Beaux-Arts de Bordeaux
 (Inv. E 401, M 7197)
Bequest of Général Delacroix, 1845

58. Adrien DAUZATS

Bordeaux 1804–1868 Paris
Les Portes de Fer (The Portes de Fer), ca. 1839
Watercolor with traces of gouache
21.6 x 27.6 cm
Inscribed l.l.: Portes de Fer (Algérie)
 l.r.: A. Dauzats à son ami Salvador
 Chérubini
New York, Private Collection

Figure 5–1

 In 1839 Adrien Dauzats, already an accomplished artist known for his travel sketches and paintings, was asked to accompany Louis Philippe's son, the duc d'Orléans, on a politically motivated expedition in Algiers, passing through one of the major passes in the Djurdjura Mountains, the Portes de Fer.

 On his return to France the duc d'Orléans asked the well-known author Charles Nodier to edit the diary of this expedition. Due to Nodier's death the project was delayed, but the duc's *Journal* (see cat. no. 59) did finally appear in 1844, richly illustrated with wood engravings that were based in large part on Dauzat's sketches. The present watercolor served as prototype for one of the three illustrations of the Portes de Fer found in the *Journal*.

59. Denis Auguste Marie RAFFET

Paris 1804–1860 Gênes
Journal de l'expédition des Portes de Fer (Diary of the
 expedition through the Portes de Fer), edited by
 Charles Nodier of the Académie Française,
 Paris, Imprimerie Royale, 1844. 200 woodblock
 vignettes by Raffet, 40 of them printed in part
 on China paper and mounted on vellum
Book
28.4 x 20.5 x 4.8 cm
Evanston, IL, Melville J. Herskovitz Library of
 African Studies, Northwestern University
 (Inv. L 965/N 761 j)

284 LES PORTES DE FER.

fatigues, va visiter et panser les blessés, et le prince apprend avec bonheur qu'aucun d'eux n'est en danger. Le sentiment moral est si puissant parmi nos soldats, qu'il n'y a pas de malades.

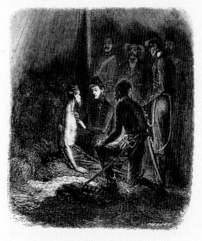

Ces résultats heureux sont dus en partie, à la vérité, aux soins habiles et actifs d'une excellente

LES PORTES DE FER. 285

administration, qui n'a laissé en souffrance aucune partie du service.

Demain nous serons au Fondouck, et le Fondouck, c'est la France!

Le vendredi 1er novembre, à six heures et demie, l'avant-garde, conduite par Mgr le duc d'Orléans, s'engage dans le défilé, qui commence sur la rive même d'un affluent de l'Isser, à une

portée de fusil du camp, pour aller, à deux lieues et demie au delà, occuper le col d'Aïn-Sultan,

Denis Auguste Marie RAFFET, "The duc d'Orléans Tending the Wounded" and "The Soldiers Going through the Mountain Pass," pp. 234–35 from *Journal de l'expédition des Portes de Fer* (Diary of the expedition through the Portes de Fer). Cat. no. 59.

"Mosque at Algiers," plate 1 from *Excursions Daguerriennes* by Lerebour. Cat. no. 60.

Adrien DAUZATS,
*Campement arabe au pied
du Sphinx* (Arab camp at
the foot of the Sphinx).
Cat. no. 62

60. *Excursions Daguerriennes* by Lerebour, 1839
Book
26.8 X 37.5 cm
Rochester, International Museum of Photography,
 Eastman House (Inv. RB PR 365 L3 1842 vl c2)

61. *Les Français peints par eux-mêmes. Encyclopédie morale du XIXe siècle. Les Français. Provinces.* (The French painted by themselves. Moral Encyclopedia of the 19th Century. The French. Provinces.), Paris, L. Curmer, 1842, volume III
Book
25.5 x 37 x 5 cm (open)
Providence, Brown University, John Hay Library
 (Inv. DC 33.6 F8 volume III)

Figures 2–6 and 3–5

62. Adrien DAUZATS
Bordeaux 1804–1868 Paris
Campement arabe au pied du Sphinx (Arab camp at the foot of the Sphinx), 1832
Watercolor and gouache, heightened with gum arabic
20.3 x 28.5 cm
Inscribed l.l.: A. Dauzats 1832
New York, Private Collection

63. Alexandre-Gabriel DECAMPS
Paris 1803–1860 Fontainebleau
Corps de Garde Turc (A corps of the Turkish guard)

(Beraldi 17), 1834
Engraving
26.1 x 29.2 cm
New York, S. P. Avery Collection, The Miriam and Ira D. Wallach Division of Art, Prints and Photographs, The New York Public Library, Astor, Lenox and Tilden Foundations (Inv. Ber. 17; MEZAC)

Figure 3–7

64. Adrien DAUZATS
Bordeaux 1804–1868 Paris
Baron Taylor
Graphite
40.4 x 27 cm
Inscribed u.r.: Baron Taylor par Dauzats
 l.r.: arabe
Paris, Musée Carnavalet (Inv. D3903)

Figure 5–4

65. Marc-Gabriel-Charles GLEYRE
Chevilly 1808–1874 Paris
Turkish Lady, Mrs. Langdon (Smyrna), 1834
Watercolor with pen and pencil
37.2 x 24.9 cm
Boston, Lent by the Trustee of the Lowell Institute, on Loan to the Museum of Fine Arts, Boston (Inv. 106.49)

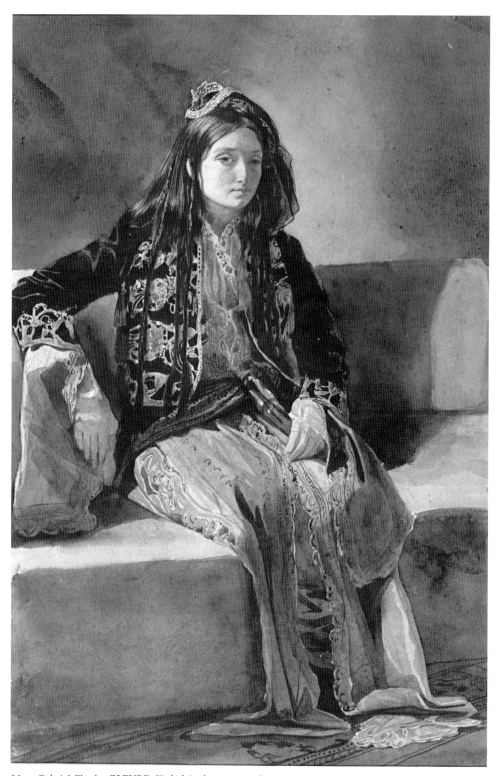

Marc-Gabriel-Charles GLEYRE, *Turkish Lady, Mrs. Langdon (Smyrna)*. Cat. no. 65.

V. Illustrating the Texts of a Common Culture

66. Alfred JOHANNOT
Offenbach 1800–1837 Paris
Charles le téméraire (Charles the bold), Salon of 1831,
 no. 1127 (exhibited as one of a group under "Un
 Cadre contenant plusieurs sujets tirés de Walter
 Scott" [A set containing several subjects drawn
 from Walter Scott])
Oil on canvas
27.1 x 21.9 cm
Inscribed l.r.: Alfred Johannot
New York, Private Collection
Originally in the collection of the duc de Nemours

Figure 3–10

67. Théodore CHASSÉRIAU
Santo Domingo 1819–1856 Paris
Othello ("La Romance du Saule"), 1844
Etching, plate 9 (before the letters)
14.7 x 10.8 cm
Chicago, The Art Institute of Chicago
 (Inv. 55.1096 RX 1638/3)

68. Louis BOULANGER
Vercelly 1806–1867 Dijon

Théodore CHASSÉRIAU, *Othello ("La Romance du Saule")*. Cat. no. 67.

Alexandre-Gabriel DECAMPS, *Don Quichotte et Sancho* (Don Quixote and Sancho). Cat. no. 69.

LIVRE QUATRIÈME.

CHAPITRE I.

GIL BLAS, NE POUVANT S'ACCOUTUMER AUX MŒURS DES COMÉDIENNES, QUITTE LE SERVICE
D'ARSÉNIE, ET TROUVE UNE PLUS HONNÊTE MAISON.

U

N reste d'honneur et de religion, que je ne
laissois pas de conserver parmi des mœurs
si corrompues, me fit résoudre, non-seu-
lement à quitter Arsénie, mais à rompre
même tout commerce avec Laure, que je
ne pouvois pourtant cesser d'aimer, quoique
je susse bien qu'elle me faisoit mille infi-
délités. Heureux qui peut ainsi profiter des
moments de raison qui viennent troubler
les plaisirs dont il est trop occupé! Un beau matin je fis mon paquet;
et, sans compter avec Arsénie, qui ne me devoit à la vérité presque

Jean-François
GIGOUX, opening of
chapter 1 from *Histoire de
Gil Blas de Santillane*
(Story of Gil Blas de
Santillane), book 4,
chap. 1, p. 1. Cat. no. 71.

Tony JOHANNOT, title page to "Le Misanthrope" from *Oeuvres de Molière*, vol. 2. Cat. no. 72.

Le Roi Lear et son fou pendant la tempête (King Lear and his fool during the storm), Salon of 1836 refusal
Oil on canvas
65.5 x 54.2 cm
Inscribed l.r.: L. Boulanger
Paris, Musée du Petit Palais (Inv. 2056)
Bequest of Jean Louis Adolphe Jullien to the City of Paris, 1923

Figure 3–12

69. Alexandre-Gabriel DECAMPS
Paris 1803–1860 Fontainebleau
Don Quichotte et Sancho (Don Quixote and Sancho)
Oil on canvas
33 x 40 cm
Pau, Musée des Beaux-Arts (Inv. 59.5.1)
Purchased by the City of Pau

70. Pierre-Jean DAVID called DAVID D'ANGERS
Angers 1788–1856 Paris

Paul Huet, "Ils écoutent le canon" (They listen to the canon), p. 236 from *Paul et Virginie* by J.-H. Bernardin de Saint-Pierre. Cat. no. 73.

Johann Gensfleisch Gutenberg
Bronze
40 cm
Inscribed front base: Guttemberg
on sheet of paper: Et la lumière fut
New York, Faber Donoughe

Figure 2–20

71. Jean-François GIGOUX
Besançon 1806–1894 Besançon
Histoire de Gil Blas de Santillane (Story of Gil Blas de Santillane) by Lesage, vignettes by Jean Gigoux, Paris, chez Paulin, 1835, 1 volume
Book
26 x 17 x 5.5 cm
New Haven, Yale University, The Beinecke Rare Book Library (Inv. HFD 22 103 D)
Exhibition in Columbia only

See also Figure 8–11

Jean-Ignace-Isidore GRANDVILLE, "Le Loup et le renard" (The wolf and the fox), from *Les Fables de La Fontaine,* vol. 1, book 11, fable 6. Cat. no. 74.

72. Tony JOHANNOT
Offenbach 1803–1852 Paris
Oeuvres de Molière, with a foreword on his life and
works by Monsieur Sainte-Beuve, vignettes by
Tony Johannot, Paris, chez Paulin, 1835–1836, 2
volumes, grand in 8 jésus, imp. Duverger, 769
pages, 800 wood engraving vignettes in the text,
published in 100 livraisons at 25 centimes
Book (2 volumes)
38.1 x 26 cm
Cambridge, The Houghton Library, Harvard Uni-
versity (Inv. Mol 8.35)

73. *Paul et Virginie* by **J.-H. Bernardin de Saint-
Pierre,** Paris, L. Curmer, 1838, 1 volume in 8,
typ. Everat et Cie, 458 p., 450 wood engravings
in the text by French and English artists, 29 full-
page wood-engraved plates on China paper, 7
portraits on copper plates, published in 30
livraisons at 1 franc 25 centimes each, the first
one appearing October 1836, 20 copies entirely
on China paper sold for 300 francs each
Book
26.5 x 17 x 5.5 cm
New Haven, Yale University, The Beinecke Rare
Book Library (Inv. HFD 29 033)
Exhibition in Columbia only

See also Figures 8–4 and 8–13

74. Jean-Ignace-Isidore GRANDVILLE
Nancy 1803–1847 Vanves
Les Fables de La Fontaine, illustrated by Grandville,
Paris, H. Fournier, 1838, 2 volumes in 8, 292
pages and 312 pages, 120 woodblock illustrations
per volume, sold in 40 livraisons at 50 centimes
each
Book (2 volumes)
22.5 x 18 cm
Chicago, The Newberry Library (Inv. Wing ZP
839.G 761 Vols. 1 and 2)
Exhibition in Columbia only

See also Figure 8–7
See Plate 18 for an illustration from a different
copy of this book

75. Tony JOHANNOT
Offenbach 1803–1852 Paris
Ten watercolors from the Musée des Beaux-Arts,
Rouen, illustrating Oliver Goldsmith's *The Vicar
of Wakefield*
Gift of Marjolin Scheffer, 1987

Plates 5 to 14

A.
Sophie sauvée du torrent (Sophie rescued from the
torrent)
11.3 x 8.6 cm
Inscribed l.l.: Tony Johannot
(Inv. 897.6.187)

B.
Le Coup de fusil (The gunshot)
11.3 x 8.7 cm
Inscribed l.l.: Tony Johannot
(Inv. 897.6.188)

C.
La Diseuse de bonne aventure (The fortune-teller)
11.2 x 8.7 cm
Inscribed l.l.: Tony Johannot 1836
(Inv. 897.6.189)

D.
Départ de Moïse pour le marché (Moses's departure for
the fair)
11.2 x 8.6 cm
Inscribed l.l.: Tony Johannot 1836
(Inv. 897.6.190)

E.
Vengeance (Revenge)
11.2 x 8.7 cm
Inscribed l.r.: Tony Johannot 1831
(Inv. 897.6.191)

F.
Olivia retrouvée (Olivia found)
11.2 x 8.6 cm
Inscribed l.r.: Tony Johannot 1836
(Inv. 897.6.192)

G.
L'Incendie (The conflagration)
11.2 x 8.7 cm
Inscribed l.r.: Tony Johannot
(Inv. 897.6.193)

H.
Le Départ pour la prison (The departure for prison)
11.3 x 8.6 cm
Inscribed l.l.: Tony Johannot 1836
(Inv. 897.6.194)

I.
La Visite dans la prison (The visit in prison)
11.3 x 8.7 cm
Inscribed l.l.: Tony Johannot 1836
(Inv. 897.6.195)

J.
Georges prisonnier (Georges as prisoner)

Alexandre-Gabriel
DECAMPS, *The Suicide*.
Cat. no. 77.

11.2 x 8.6 cm
Inscribed l.l.: Tony Johannot 1836
(Inv. 897.6.196)

A-E: exhibition in Columbia and Rochester only
F-J: exhibition in Rochester and Santa Barbara only

VI. The Infusion of the Realist Impulse

76. Ary SCHEFFER
Dordrecht 1795–1858 Argenteuil
Armand Carrel sur son lit de mort (Armand Carrel on
 his deathbed), 1836
Oil on canvas
38 x 46.5 cm
Rouen, Musée des Beaux-Arts (Inv. 897.3.1)
Bequest of Emilie Antoine, 1897

Plate 15

77. Alexandre-Gabriel DECAMPS
Paris 1803–1860 Fontainebleau
The Suicide, ca. 1836
Oil on canvas
40 x 56 cm
Inscribed l.l.: Decamps
Baltimore, The Walters Art Gallery (Inv. 37.42)
Gift of Mr. Walters

78. Denis Auguste Marie RAFFET
Paris 1804–1860 Gênes

Soldat de l'armée républicaine (Soldier of the
 republican army), 1832
Watercolor and gouache over traces of pencil
42.8 x 28.5 cm
Inscribed l.l.: Raffet / 1832
Paris, Musée du Louvre, Département des Arts
 Graphiques (Inv. RF 4546)
Bequest, 1919
Exhibition in Columbia only

In pose and dress details, specifically the hat,
this figure is related to several drawings by Raffet
from 1836 and 1837 representing soldiers of the
First Republic (for example, a drawing in Montpel-
lier, Inv. 868-1-72, entitled "Soldat de la Répub-
lique"). Raffet was one of the major lithographers
of the first half of the nineteenth century who spe-
cialized in military subjects, celebrating the
ordinary soldier and the myth of Napoleon and the
legends surrounding him. Like his counterpart
Nicolas Charlet he was concerned with accuracy in
representing uniforms.

79. Henry Bonaventure MONNIER
Paris 1805–1877 Paris
Les Ecoliers (The schoolboys), 1838
Watercolor and gouache over traces of pencil
24.9 x 33.1 cm
Inscribed l.l.: Henry Monnier / au Mans 1er 1838
Paris, Musée du Louvre, Département des Arts
 Graphiques (Inv. RF 34.467)

Denis Auguste Marie
RAFFET, *Soldat de
l'armée républicaine* (Sol-
dier of the republican
army). Cat. no. 78.

Henry Bonaventure MONNIER, *Femme et deux enfants dans une chambre* (Woman and two children in a room). Cat. no. 80.

Bequest, 1969
Exhibition in Columbia only

Figure 7–21

80. Henry Bonaventure MONNIER
Paris 1805–1877 Paris
Femme et deux enfants dans une chambre (Woman and two children in a room), 1842
Watercolor over traces of pencil
22.5 x 28.6 cm
Inscribed l.r.: Henry Monnier / Paris 1842
Paris, Musée du Louvre. Département des Arts Graphiques (Inv. RF 34.466)
Bequest, 1969
Exhibition in Columbia only

81. Henry Bonaventure MONNIER
Paris 1805–1877 Paris
Vieille Mendiante (Old beggar woman)
Lithograph

26.5 x 18.7 cm
Paris, Musée Carnavalet (Inv. RG 655)

82. Nicolas-Toussaint CHARLET
Paris 1792–1845 Paris
Invalide (Invalid), 1838
Graphite on paper
26.8 x 21 cm
Inscribed l.r.: Charlet / 1838
Paris, Musée Carnavalet (Inv. D3160)

83. Charles Joseph TRAVIÈS
Winterthur 1804–1859 Paris
Peuple affranchi (The emancipated people), 1831
Lithograph (published in *La Caricature,* 1831, no. 52, plate 105)
28.3 x 37.1 cm
Inscribed l.r.: C. J. Traviès
Paris, Musée Carnavalet (Inv. G 19008)

Figure 7–7

Henry Bonaventure MONNIER, *Vieille Mendiante* (Old beggar woman). Cat. no. 81.

Nicolas-Toussaint CHARLET, *Invalide* (Invalid). Cat. no. 82.

84. Charles Joseph TRAVIÈS

Winterthur 1804–1859 Paris
Barbès en prison, 1835
Black crayon heightened
50 x 37 cm
Inscribed l.l: 1835 / C. J. Traviès
Paris, Musée Carnavalet (Inv. D2446)
Acquired from M. Proute, 1911

Figure 4–4

As a professional revolutionary active in undermining the powers of the July Monarchy, Barbès received the support of some of the leading members of the agitational press. Traviès, as an artist most strongly linked to realism, has drawn Barbès in prison (he was jailed for his involvement in revolutionary plots) in a work that can function as an allegorical statement of what happened to insurrectionists and as a rendering of the position taken by artists vigorously upholding the code of agitation.

85. Sulpice-Guillaume Chevalier, called Paul GAVARNI

Paris 1804–1866 Paris
Honoré de Balzac, *La Peau de chagrin: Etudes sociales* (The shagreen: Social studies), illustrated by

Gavarni, Paris, H. Delloye, 1838
Book
27 x 18 cm
Chicago, The Newberry Library (Inv. WING ZP 839. B463)
Exhibition in Columbia only

86. *Les Mystères de Paris* (The mysteries of Paris) by **Eugène Sue,** new edition reviewed by the author, ornamented by a great number of wood engravings in the text and 81 plates outside the text (47 on wood, 34 on copper), from drawings by Daumier, E. de Beaumont, Daubigny, Dubouloz, E. Lorsay, E. May, C. Nanteuil, Seigneurgens, Staal, Traviès, Trimolet, etc., Paris, Librairie de Charles Gosselin, & Librairie Garnier frères, 1843–1844, 4 parts grand in 8, imp. Béthune et Plon, 1st, 1843, 315 pages; 2d, 1844, 313 pages; 3d, 1844, 320 pages; 4th, 1844 326 pages; 80 livraisons at 50 centimes
Book
28.5 x 20.5 x 2.5 cm
New Haven, Yale University, The Beinecke Rare Book Library (Inv. HFH Suo 7 M vol I)
Exhibition in Columbia only

Sulpice-Guillaume Chevalier, called Paul GAVARNI, p. 45 from *La Peau de chagrin: Etudes sociales* (The shagreen: Social studies), by Honoré de Balzac. Cat. no. 85.

87. Sulpice-Guillaume Chevalier, called Paul GAVARNI
Paris 1804–1866 Paris
Le Juif errant (The wandering Jew) by Eugène Sue, edition illustrated by Gavarni, Paris, Paulin, 1845–1846
Book
26.6 x 36.5 x 3 cm (open)
Providence, Brown University, John Hay Library, Wandering Jew Collection (Inv. PQ 2446 J8 1845a, Copy 1, Vol. 1)

See also Figure 8–12

VII. Caricature for the Popular Press

88. Jean-Ignace-Isidore GRANDVILLE
Nancy 1803–1847 Vanves
Louis-Philippe et ses ministres dansant autour de la république enchaînée (Louis Philippe and his ministers dancing around the enchained republic)
Pen and ink on paper
25 x 45 cm
Inscribed c.l.: J. I. Grandville
Bordeaux, Musée des Beaux-Arts (Inv. 1971.2.17)
Bequest of J. R. Tauzin, 1971

89. Charles PHILIPON
Lyon 1806–1862 Paris
Promenade bourgeoise (Bourgeois stroll)
Lithograph
46.5 x 32 cm
Inscribed l.l.: Charles
Paris, Musée Carnavalet (Inv. G 17853)

Figure 7–2

90. Honoré DAUMIER
Marseille 1808–1879 Valmondais

Placed by the state at the Musée Municipal before 1861

Plate 30

146. Philippe-Auguste JEANRON

Boulogne-sur-Mer (Pas-de-Calais) 1809–1877 Comborn (Corrèze)
Une Scène de Paris (A scene of Paris), Salon of 1833, no. 1299
Oil on canvas
97.8 x 130 cm
Inscribed l.l.: Jeanron 1833
Chartres, Musée des Beaux-Arts (Inv. 84.8)
Purchased 1984

Plate 29

The early days of the July Monarchy did not bring alleviation of suffering for the lower classes nor the anticipated emergence of the rights of man. In this partially coded image Jeanron calls attention to the plight of a destitute Republican family forced to beg on the quays of Paris for money and food. The sense of urban misery, a major factor at the time, precipitated insurrections in both Paris and Lyon in 1834, one year after this painting was shown at the Salon.

147. Jules Claude ZIEGLER

Langres (Haute-Marne) 1804–1856 Paris
Giotto dans l'atelier de Cimabue (Giotto in the Cimabue's studio), Salon of 1833, no. 2448
Oil on canvas
160 x 130 cm
Inscribed b.c.: Ziegler
Bordeaux, Musée des Beaux-Arts (Inv. anc. 688, Inv. nouv. 6312)
Acquired by the Musée du Luxembourg, 1837; Envoi de l'Etat, 1872

Figure 3–13

Ziegler was one of the major students of J.-A.-D. Ingres, whose classicizing linear style he combined with the colorism of the Venetian tradition in truly eclectic manner. His treatment of this subject is unusual in that he did not depict the normally chosen episode of Giotto's discovery as a natural artist, described by Vasari. Instead Ziegler shows the young shepherd boy in Cimabue's studio, studying medieval manuscript illumination. This image reflects the prevalent interest in medieval and primitive art in Ingres's studio at this time and his own debt to this art.

This painting represents a strong iconographic theme that had its beginnings and proliferated during the July Monarchy, that of episodes from artists' lives.

148. Jean-Baptiste-Camille COROT

Paris 1796–1875 Paris
L'Avant-port de Rouen or *Les Quais marchands de Rouen* (The outer harbor of Rouen, or The commercial quays of Rouen), Salon of 1834, no. 372 (as "Une Marine" [A seascape])
Oil on canvas
110.5 x 176 cm
Inscribed l.l.: Corot / 1834
Rouen, Musée des Beaux-Arts (Inv. D.951.2)
Placed by the state at the Musée des Beaux-Arts, 1951

Plate 31

When Camille Corot was sent to boarding school in Rouen, he spent more time sauntering on the banks of the Seine River than studying for his classes. Like the young Charles Bovary (in Flaubert's *Madame Bovary*), who was sent by his guardian to the riverfront "to look at the boats," Corot must have enjoyed the sight of the traffic on the Seine River, which was particularly busy in Rouen as the town was one of the major river ports of France.

In this painting, exhibited at the 1834 Salon under the title *Une Marine,* Corot had returned to the scene of his boarding-school years. Several carefully studied sailing vessels and rowboats are floating in front of a low horizon lined with farmhouses and trees. On the quay in the foreground, dock workers are engaged in various activities while a woman carries on a conversation with a sailor in one of the nearby boats.

Like other works by Corot from the early 1830s, *L'Avant-Port de Rouen* is clearly influenced by the artist's youthful admiration of Dutch seventeenth-century painting, notably the works of such marine painters as Simon de Vlieger and Willem van de Velde. Indeed, in a letter written to his friend Achille Debray in 1833, Corot had written, with reference to this painting: "I have started a Rouen waterscene. . . . It is composed of small boats, buildings, cottages, and a [wooded] background. If Ruisdael and van de Velde were willing to help me, it would not hurt."

149. Prosper-Georges-Antoine MARILHAT

Vertaizon (Puy-de-Dôme) 1811–1847 Thiers

Dominique Louis
PAPETY, *Mort et
ensevelissement de Sainte
Marie l'Egyptienne* (The
death and burial of
Saint Mary of Egypt).
Cat. no. 142D.

Saint-Merri in Paris. The second image in the
series illustrates a theme that runs through Papety's
entire oeuvre and writings: the voluptuous versus
the denial of the flesh, expressed here in the poses
of the two figures as well as in the narrative as a
whole.

X. Painting for the Salon

143. François-Marius GRANET
Aix-en-Provence 1775–1849 Aix-en-Provence
La Religieuse malade or *Religieuse malade recevant des
soins dans son couvent* (The ailing nun, or Ailing
nun receiving care in her convent), Salon of 1831,
no. 591
Oil on canvas
74.5 x 61.5 cm
Inscribed l.r.: Granet
Paris, Musée du Petit Palais (Inv. 834)
Gift of Dutey-Harispe, 1928

Figure 3–9

144. Philippe-Auguste JEANRON
Boulogne-sur-Mer (Pas-de-Calais) 1809–1877 Com-
born (Corrèze)
Les Petits Patriotes (The little patriots), Salon of 1831,
no. 1121
Oil on canvas

100 x 80 cm
Inscribed b.c.: Jeanron 1830
Caen, Musée des Beaux-Arts (Inv. no. I 87)
Purchased by the state and placed at the Musée des
Beaux-Arts de Caen, 1831

Plate 28

As one of the fervent Republicans during the
revolution of 1830, Jeanron actively participated in
the erection of street barricades; he drew on his
remembrances of these episodes in later drawings
and paintings. This canvas, although partially
romanticized, emphasizes the role of young chil-
dren who actively aped their elders in street
fighting. At the same time the painting is an alle-
gorical reference of the national commitment to the
Enfants de Paris and to the visualization of the days
of the July Revolution in the guise of street fighters.

145. Claude-Félix-Théodore Caruelle D'ALIGNY
Chaume (Nièvre) 1789–1871 Lyon
*Vue prise des carrières de grès du mont Saint-Père, forêt de
Fontainebleau* (View of the sandstone quarries of
mont Saint-Père, forest of Fontainebleau), Salon
of 1833, no. 18
Oil on canvas
163 x 215 cm
Inscribed l.l.: Théodore / Aligny
Clermont-Ferrand, Musée Municipal (Inv. 2252)

Dominique Louis PAPETY, *Saint Mary Is Converted by the Icon of the Virgin.* Cat. no. 142A.

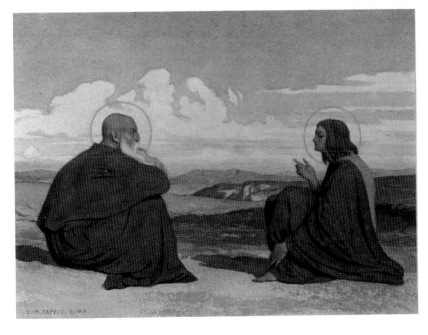

Dominique Louis PAPETY, *Entretien de l'abbé Zosime et de Sainte Marie l'Egyptienne au désert* (Abbot Zosimas and Saint Mary of Egypt in conversation in the desert). Cat. no. 142C.

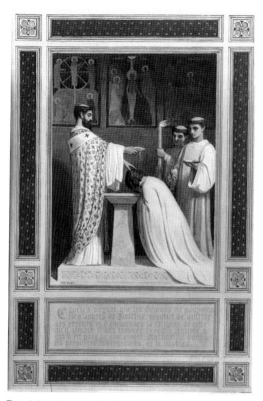

Dominique Louis PAPETY, *Baptême de Cyprien par l'évêque Antime* (Cyprien is baptized by Bishop Antimus). Cat. no. 141D.

Dominique Louis PAPETY, *Les Ames de Cyprien et Justine montant au ciel* (The souls of Cyprien and Justine rise to heaven). Cat. no. 141F.

Mary of Egypt.
Bequest François Sabatier, 1892

A.
Saint Mary Is Converted by the Icon of the Virgin
17 x 12 cm
Inscribed l.r.: Dom. Papety. Roma
(Inv. 892–4–35)

B.
The Abbot Zosimas Hands His Cloak to Saint Mary
12 x 16 cm
Inscribed l.l.: Dom. Papety. Roma
(Inv. 892–4–36)

Plate 25

C.
Entretien de l'abbé Zosime et de Sainte Marie l'Egyptienne au désert (Abbot Zosimas and Saint Mary of Egypt in conversation in the desert)

11.8 x 15.9 cm
Inscribed l.l.: Dom. Papety. Roma
(Inv. 892–4–37)

D.
Mort et ensevelissement de Sainte Marie l'Egyptienne (The death and burial of Saint Mary of Egypt)
12 x 16 cm
Inscribed l.r.: Dom. Papety. Roma
(Inv. 892–4–38)

Saint Mary of Egypt was a prostitute who in a moment of revelation in the Temple of Jerusalem, in front of an icon of the Virgin, was moved to turn her life around and live in the desert where she was found by Zosimas. Various miracles occurred to her, as when a lion helped in her burial and when she was dug up and taken to heaven by angels. This story was later illustrated by Théodore Chassériau in the Chapel of Saint Mary of Egypt in the Church

Dominique Louis PAPETY, *Cyprien promet aux démons d'adorer celui qui lui donnera Justine* (Cyprien promises to worship the demon who will give him Justine). Cat. no. 141B.

Dominique Louis PAPETY, *Sainte Justine en prières* (Saint Justine in prayer). Cat. no. 141C.

D.

Baptême de Cyprien par l'évêque Antime (Cyprien is
 baptized by Bishop Antimus)
Inscribed l.l.: Dom. Papety
(Inv. 892–4–22)

E.

Cyprien et Justine s'exhortant mutuellement (Cyprien and
 Justine exhort each other)
Inscribed l.r.: Dom. Papety
(Inv. 892–4–23)

Figure 2–14

F.

Les Ames de Cyprien et Justine montant au ciel (The souls
 of Cyprien and Justine rise to heaven)
Inscribed l.l.: Dom. Papety
(Inv. 892–4–24)

Of all Ingres's students, Papety showed perhaps the strongest interest in the art of the "Primitives," as is demonstrated by this series of works. Stylistically these works represent a French version of Pre-Raphaelitism; they are based on illustrated manuscript types in their combination of text and image.

This story of two chaste lovers who become saints by denying the flesh can be seen as a retelling of the story of Tristan and Isolde in a Christian context. Papety wrote extensively about Christian art and that it should avoid sensual imagery. In this respect, these watercolors can be said to embody his ideal of Christian painting.

142. Dominique Louis PAPETY

Marseille 1815–1849 Marseille
Four watercolors from the Musée Fabre,
 Montpellier, illustrating the story of Saint

GAVARNI
Paris 1804–1866 Paris
Portrait de Pierre Philippe Thomire, 1838
Graphite and watercolor
30 x 26 cm
Inscribed l.l.: Gavarni / 1838
Paris, Musée des Arts Décoratifs (Inv. 15156)

Figure 6–6

137. Merry-Joseph BLONDEL
Paris 1781–1853 Paris
Portrait of a Man, 1833
Oil on canvas
54 x 44.7 cm
Inscribed l.l.: Blondel / 1833
U.S.A., Private Collection

Plate 22

138. Ferdinand-Victor-Eugène DELACROIX
Charenton-Saint-Maurice 1798–1863 Paris
Un Forgeron (A blacksmith), 1833
Aquatint and drypoint (Delteil 19, state 2)
16.1 x 9.7 cm
New York, S. P. Avery Collection, The Miriam and
 Ira D. Wallach Division of Art, Prints and
 Photographs, The New York Public Library,
 Astor, Lenox and Tilden Foundations
 (Inv. D 19 ii; MEZAC)

139. Eugène Louis LAMI
 Paris 1800–1890 Paris
La Ronde des sorcières, 'Le Sabbat' (The witches'
 round, 'The Sabbath')
Pen and ink wash
16.2 x 12 cm
Rouen, Musée des Beaux-Arts (Inv. 975.4.2606)
Gift of H. and S. Baderou, 1975
Exhibition in Columbia and Santa Barbara only

Not illustrated

140. Théodore CHASSÉRIAU
Santo Domingo 1819–1856 Paris
Le Souvenir (The memory), 1840
Oil on canvas
61 x 49.5 cm
Inscribed l.r.: Th. Chassériau / 1840
U.S.A., Private Collection

Plate 23

141. Dominique Louis PAPETY
Marseille 1815–1849 Marseille

Ferdinand-Victor-Eugène DELACROIX, *Un Forgeron* (A
blacksmith). Cat. no. 138.

Series of six works illustrating the story of saints
 Cyprien and Justine, ca. 1837
Watercolor
26 x 17.4 cm
Montpellier, Musée Fabre
Bequest François Sabatier, 1892

A.
Saint Cyprien et Sainte Justine
Inscribed l.l.: Dom. Papety
(Inv. 892-4-19)

Plate 24

B.
*Cyprien promet aux démons d'adorer celui qui lui donnera
 Justine* (Cyprien promises to worship the demon
 who will give him Justine)
Inscribed l.l.: Dom. Papety. Roma
(Inv. 892-4-20)

C.
Sainte Justine en prières (Saint Justine in prayer)
Inscribed l.r.: Dom. Papety
(Inv. 892-4-21)

Paul HUET, *Inondation dans l'Isle Séguin* (Flood on the Isle Séguin). Cat. no. 133.

Antoine-Louis BARYE, *Sleeping Greyhound.* Cat. no. 134.

Louis-Gabriel-Eugène ISABEY, *Eglise Saint Jean, Thiers* (The church of Saint Jean, Thiers). Cat. no. 132.

University of Missouri–Columbia (Inv. 88.31) Gilbreath-McLorn Museum Fund purchase

133. Paul HUET
Paris 1803–1869 Paris
Inondation dans l'Isle Séguin (Flood on the Isle Séguin), 1833
Etching on mounted china paper (Delteil 8)
22 x 31.5 cm
Columbia, Mo., Museum of Art and Archaeology, University of Missouri–Columbia (Inv. 88.32)
Gilbreath-McLorn Museum Fund purchase

134. Antoine-Louis BARYE
Paris 1796–1875 Paris
Sleeping Greyhound

Bronze with brown varnish patina
6.6 x 27.1 cm
Baltimore, The Walters Art Gallery (Inv. 27.135)

135. Sulpice-Guillaume Chevalier, called Paul GAVARNI
Paris 1804–1866 Paris
Portrait d'Hippolyte Beauvisage Thomire, 1834
Watercolor
47 x 24 cm
Inscribed l.r.: Gavarni 1834
Paris, Musée des Arts Décoratifs (Inv. 15159)

Figure I–11

136. Sulpice-Guillaume Chevalier, called Paul

and below it were various charity scenes. *Pauperi subvenire* is one of those scenes and shows men giving spare clothing and food to the needy.

127. Jean-Auguste-Dominique INGRES
Montauban 1780–1867 Paris
Two cartoons for stained-glass windows in the
 Chapel of Saint-Ferdinand at Neuilly, 1842
Oil on canvas over traces of black crayon
210 x 92 cm
Paris, Musée du Louvre
Transferred from the Musée du Luxembourg, 1874

A.
Saint Raphael, archange (Saint Raphael, archangel),
 1842
(Inv. 20319)

B.
Sainte Amélie, reine de Hongrie (Saint Amélie, queen
 of Hungary), 1842
Inscribed l.l.: J. Ingres fecit 1842
(Inv. 20326)

Figure 3–8

IX. The Private Collector's Study

128. Jean-Jacques, called James PRADIER
Geneva 1792–1852 Rueil
Odalisque Seated, 1841
Bronze
29 cm
New York, Janson Collection

129. Jean-Jacques, called James PRADIER
Geneva 1792–1852 Rueil
Venus and Cupid, 1840
Bronze
30.8 x 20 x 21.6 cm
Cast by Gautier et Cie.
Inscribed front of base: Pradier Scpt.
 left side of base: Gautier & Cie.
New York, Michael Hall Fine Arts, Inc.

Figure 3–1

**130. Karl-Ernest-Rodolphe-Heinrich-Salem,
 called Henri LEHMANN**
Kiel 1814–1882 Paris
Etude d'une femme nue (Study of a nude woman),
 1840
Oil on canvas
35 x 22.2 cm

Jean-Jacques, called James PRADIER, *Odalisque Seated*.
Cat. no. 128.

Inscribed b.c.: Rome 1840, à son ami Chassériau
New York, Private Collection

Figure 3–2

131. Jules Claude ZIEGLER
Langres (Haute-Marne) 1804–1856 Paris
Venise vue de nuit (Venice seen by night), 1830, Salon
 of 1831 no. 2167
Oil on paper mounted on canvas
19.5 x 24 cm
Inscribed l.r.: à Venetia 1830 / Ziegler
Nantes, Musée des Beaux-Arts (Inv. 1237)
Bequest Boulay-Paty, 1861

Plate 26

132. Louis-Gabriel-Eugène ISABEY
Paris 1803–1886 Paris
Eglise Saint Jean, Thiers (The church of Saint Jean,
 Thiers), 1831
Lithograph on mounted china paper (plate 129
 from *Voyages pittoresques et romantiques dans
 l'ancienne France; Auvergne* [Picturesque and
 romantic travels through old France; Auvergne])
34.3 x 28.2 cm
Inscribed l.l.: Eugène Isabey 1831
Columbia, Mo., Museum of Art and Archaeology,

Jean-Auguste-Dominique INGRES,
Saint Raphaël, archange (Saint Raphael,
archangel), 1842. Cat. no. 127A.

Alphonse Henri PÉRIN, *Pauperi subvenire* or *Secourir les pauvres* (To support the poor). Cat. no. 126B.

in one of the pendentives in the chapel, and its subject was explained in the official brochure of the project published after Orsel's death: It shows Christians imploring the Virgin who is crushing the serpent while Heresy and the Islamic religion are taking flight. This representation, as well as the rest of the painting program and symbolism in the chapel, relates to the traditional litany of the Virgin.

126. Alphonse Henri PÉRIN

Paris 1798–1874 Paris
Designs for the Church of Notre-Dame de Lorette,
 ca. 1835–1852
Paris, Galerie Fischer-Kiener
From the collection Alphonse Gosset

A.
Le Christ enseignant (Christ teaching)
Graphite and blue wash on tracing paper
192.5 x 156 cm

B.

Pauperi subvenire or *Secourir les pauvres* (To support
 the poor)
Pencil and red chalk on tracing paper
67 x 64 cm
Inscribed at top: PAUPERI SUBVENIRE

Like his close friend Orsel, Périn was commissioned to contribute to the decoration of Notre-Dame de Lorette. He painted the interior of a chapel dedicated to the Sacrament of the Eucharist, which was located across the nave from Orsel's. His painting program is as symbolical and complex as that of Orsel, and he also worked with the same balance between accuracy in anatomy and abstract symbolical flattened composition (see cat. no. 125).

Le Christ enseignant is a full-scale tracing for the figure of Christ in the tympanum and shows him as the representation of Faith, one of the theological virtues. Below the tympanum were several scenes related to faith.

Another tympanum in the chapel was dedicated to Charity, another virtue related to the Eucharist,

Alphonse Henri PÉRIN, *Le Christ enseignant* (Christ teaching). Cat. no. 126A.

André Jacques Victor ORSEL, *Auxilium christianorum* or *Secours des chrétiens* (Help of Christians). Cat. no. 125.

Eugène-François-Marie-Joseph DEVÉRIA, *Glorification de la vie de Sainte Geneviève* (Glorification of the life of Saint Geneviève). Cat. no. 123.

embodied in the two women on their paths of virtue and vice respectively, is a theme that was often illustrated by the Nazarenes. And the guardian angel watching over the "good" woman is taken almost directly from an Early Renaissance painting at the Campo Santo in Pisa. It shows again Orsel's interest in primitive art, but at the same time reveals his nineteenth-century knowledge of the human body.

Although conceived for a large painting, this composition is related to book illustration. There are many examples of books from the 1830s where illustrators employed a similar format, for example Célestin Nanteuil in his illustrations of Victor Hugo's *Notre-Dame de Paris*.

123. Eugène-François-Marie-Joseph DEVÉRIA
Paris 1805–1865 Pau
Glorification de la vie de Sainte Geneviève (Glorification

of the life of Saint Geneviève) (Study for Notre-Dame de Lorette) 1836
Oil on canvas

73.5 x 44 cm
Paris, Musée du Petit Palais (Inv. 2151)

124. Hippolyte LEBAS
1782–1867
Dessin d'architecture pour l'église Notre-Dame de Lorette (Design for the architecture of the church Notre-Dame de Lorette), ca. 1840
Pen and watercolor
40 x 47.4 cm
Inscribed l.r.: Bon pour exécution M. Lebas
 u.r.: Le Bas (Hte)
 u.c.: Eglise Notre Dame de Lorette
 l.c.: Détail de l'une des chapelles sous les bas-côtés
Paris, Musée Carnavalet (Inv. D1855)

Figure 2–13

 Around 1832–1833 the church Notre-Dame de Lorette, designed and begun during the Restoration by the architect Lebas, was finished so that the extensive decoration program could be begun. Lebas's drawing shows one wall in the chapel immediately left of the entrance and was obviously made after the decoration was in place, probably around 1840. It shows Eugène Devéria's monumental painting of Saint Geneviève, the patron saint of Paris.

125. André Jacques Victor ORSEL
Oullins 1795–1850 Paris
Design for the Church of Notre-Dame de Lorette
Auxilium christianorum or *Secours des chrétiens* (Help of Christians), ca. 1835–1850
Graphite and blue wash on tracing paper
170 cm diameter
Paris, Galerie Fischer-Kiener
From the collection Alphonse Gosset

 Orsel received the commission to decorate the chapel of the Virgin in the church of Notre-Dame de Lorette in 1833 and worked on this project until his death in 1850. (It was completed by his assistants.) It was a small project but of great interest to his contemporaries as it represented an attempt to reinvent a symbolic, religious art. Orsel achieved it in the form of an incredible combination of a naturalistic style based on the live model with an abstract composition and symbolism.

 The drawing is a full-scale cartoon for a roundel

Victor Joseph VIBERT,
Le Bien et le mal (Good
and evil). Cat. no. 122.

56 x 260 cm
Baltimore, The Walters Art Gallery
 (Inv. 93.113 a,b,c)

122. Victor Joseph VIBERT
Paris 1799–1860 Lyon
After the painting of 1832 by André Jacques Victor
 ORSEL
Oullins 1795–1850 Paris
Le Bien et le mal (Good and evil)
Engraving and etching
81 x 55 cm
Lyon, Musée des Beaux-Arts (Inv. unknown)

Bequest of Dangès

 Victor Vibert was one of the finest steel
engravers of the nineteenth century, and he spent
about twenty years on this tour de force of his art.
It shows steel engraving at its best.
 In its subject, arrangement, and style, this work
shows various interests and influences. Thus the
figure of God the father in the roundel at the top is
related to symbolic Byzantine painting in its strict
hieratic frontality and indicates Orsel's interest in
early Christian and primitive art. The polarity of
two opposite principles, here of Good and Bad

Left Center

Right

Louis-Pierre HENRI-QUEL-DUPONT, *The Hemicycle.* Cat. no. 121.

B.
30.5 x 40 cm
(Inv. CD 6195 fol 2)

C.
10 x 63 cm
(Inv. CD 6195 fol 13)

Triqueti made a number of studies for his entry
in the contest held in November 1841 for a tomb
for Napoleon. Drawing A is very close to the one
he finally submitted along with a three-dimensional
model. It shows the emperor surrounded by the
paraphernalia of power and allusions to his career.
Drawing C shows one of the sides of the socle that
was to be sculpted with allegorical representations
of Napoleon's career beginning with the expedi-
tion to Egypt and ending with Napoleon's death on
the island of Saint Helena.

Triqueti's design was greatly admired and rated
highest of the 81 entries by the judging commission
in 1842, but the commission was not awarded at
that time. He was, however, involved in the final
project insofar as he designed the monumental cru-
cifixion scene that is part of the present tomb in
the Dôme des Invalides.

119. Antoine ETEX
Paris 1808–1888 Chaville
Projects for a monument on the place de l'Europe
 in Paris.
Paris, Musée Carnavalet

A.
*Projet de monument destiné à être érigé à la place de
 l'Europe* (Project for a monument to be erected
 on the place de l'Europe), 1839
Graphite
41 x 57 cm
Inscribed l.l.: A. Etex, 1839
 r.: Ce projet était destiné à la place de
 l'Europe en 1839 (This project was
 destined for the place de l'Europe in
 1839)
 l.: La Vapeur domine les éléments qui
 sont vainqueurs par elle (Steam rules
 the elements which conquer through
 her)
(Inv. D7451)

Figure 2–3

B.
Projet de monument à la place de l'Europe (Project for
 the monument on the place de l'Europe), 1839

Graphite
47.1 x 66.8 cm
Inscribed l.l.: A. Etex, 1839
 l.: Projet de monument à ériger sur la
 place de l'Europe en 1839 (Project for
 the monument to be erected on the
 place de l'Europe in 1839)
(Inv. D7450)

Figure 2–4

C.
Projet de Fontaine pour orner la place de l'Europe (Project
 for a fountain to decorate the place de l'Europe),
 1839
Gouache
58 x 43.7 cm
Inscribed l.c.: Projet de Fontaine pour orner la
 place de l'Europe. A. Etex 1839
(Inv. unknown)

Not illustrated

Etex was approached by the Paris–Saint Ger-
main Railroad Company and the City of Paris to
design a monument for the place de l'Europe and
in 1839 consecutively submitted two projects. They
were both rejected, and the place de l'Europe has
remained without a monument. Etex's first design
was an allegorical celebration of the newly dis-
covered powers of steam, whereas the second was
dedicated to the memory of Napoleon. He submit-
ted a variant of this latter project in the 1841 contest
for the tomb of Napoleon.

120. Charles Gavard, *Galeries historiques de Versailles*
 (Historical galleries of Versailles), 1838–1845,
 Volume V
Book
46 x 33 x 3.5 cm
Providence, Anne S. K. Brown Military Collection,
 Brown University Library (Inv. F1838–1845
 France)

Figure 2–10

121. Louis-Pierre HENRIQUEL-DUPONT
Paris 1797–1892 Paris
After the mural by Hippolyte, called Paul
 DELAROCHE
Paris 1797–1856 Paris
The Hemicycle (reproductive engraving in three parts
 of the 1836–1841 mural in the Ecole des Beaux-
 Arts), Salon of 1853, no. 1579
Engraving

Henri Joseph François Baron de TRIQUETI, *Projet pour le tombeau de Napoléon* (Project for the tomb of Napoleon). Cat. no. 118B.

Left

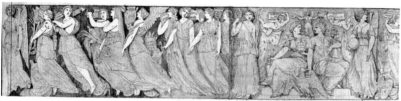

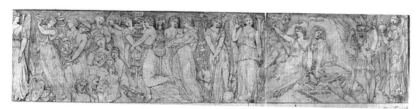

Right

Henri Joseph François Baron de TRIQUETI, *Projet pour le tombeau de Napoléon* (Project for the tomb of Napoleon). Cat. no. 118C.

VIII. Designs for Monumental Projects

Chandler Frost

Figure 2–17

117. François RUDE
Dijon 1784–1855 Paris
Head of the Genius of Liberty, called *La Marseillaise,* ca. 1833–1835 (Central figure of *The Departure of the Volunteers* on the Arc de Triomphe)
Bronze
47 cm
Inscribed l.l. side of neck: F.Rude
 on lower back: cire perdue / Le Blanc
 Barbedienne / Paris
Los Angeles, The Los Angeles County Museum of Art (Inv. 78.8)
Purchased with funds donated by Camilla

118. Henri Joseph François Baron de TRIQUETI
Conflans (Loiret) 1804–1874 Paris
Projets pour le tombeau de Napoléon (Projects for the tomb of Napoleon), 1840
Graphite and wash
Inscribed l.r.: H. de Triqueti 1840
Paris, Musée des Arts Décoratifs

A.
34 x 47 cm
(Inv. CD 6195 fol 1)

Figure 2–25

Nicolas-Toussaint CHARLET, "Le Mendiant" (The beggar), from *Les Français peints par eux-mêmes* (The French painted by themselves), vol. 3, opposite p. 85. Cat. no. 115.

Jean-Ignace-Isidore GRANDVILLE, "Concert à la vapeur" (Steam concert), plate 3 from *Un Autre Monde* (Another world), p. 17. Cat. no. 114.

114. Jean-Ignace-Isidore GRANDVILLE
Nancy 1803–1847 Vanves
Un Autre Monde. Transformations. Visions. Incarnations. Ascensions. Locomotions. Explorations. Pérégrinations. Excursions. Stations. Cosmogonies. Fantasmagories. Rêveries . . . (Another world. Transformations. Visions. Incarnations. Ascensions. Locomotions. Explorations. Meanderings. Excursions. Resorts. Cosmogonies. Fantasmagorias. Reveries . . .), by Grandville, text by Taxile Delord, Paris, H. Fournier, 1844, 1 vol. in 4a, 296 pages, 36 plates, some color, published in 36 livraisons at 50 centimes
Book
(Dimensions unknown)
Baltimore, The Baltimore Museum of Art
(Inv. 1973.53)

See also Plate 21 and Figures 1–12, 1–14, and 8–10

115. *Les Français peints par eux-mêmes. Encyclopédie morale du XIXe siècle* (The French painted by themselves. Moral encyclopedia of the 19th century), Paris, L. Curmer, 1841–1842, volumes III and IV
Books
26 x 35 x 3.6 cm (open)
Providence, Brown University, John Hay Library (Inv. DC 33.6 F8 volume 3 and 4)

See also Figure 8–8

116. Jean-Pierre DANTAN, called DANTAN LE JEUNE
Paris 1800–1869 Baden
Lebas Carrying the Obelisk, 1836
Plaster
33 cm
Inscribed: Dantan, F. 1836
New York, Private Collection

Figure 6–4

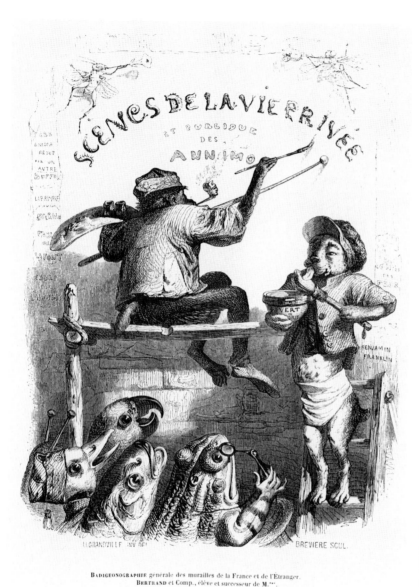

BADIGEONOGRAPHIE générale des murailles de la France et de l'Etranger.
BERTRAND et Comp., élève et successeur de M.***.

Jean-Ignace-Isidore
GRANDVILLE, title
page from *Scènes de la vie
privée et publique des ani-
maux* (Scenes from the
private and public lives
of animals). Cat. no. 113.

113. Jean-Ignace-Isidore GRANDVILLE
Nancy 1803–1847 Vanves
Scènes de la vie privée et publique des animaux (Scenes
from the private and public lives of animals),
vignettes by Grandville, studies of contemporary
morals published under the direction of P. J.
Stahl, in collaboration with Messieurs de Balzac,
L'héritier (de l'Ain), Alfred de Musset, Paul de
Musset, Charles Nodier, Madame Ménessier-
Nodier, Louis Viardot, Paris, J. Hetzel, 1842, 1
volume in 8, 390 pages, 105 plates out of text, 50

livraisons at 30 centimes each (by post), 60 cen-
times
Book
29 x 20.5 x 6 cm
New Haven, Yale University, The Beinecke Rare
Book Library (Inv. HF 71 017 vol. III)
Exhibition in Columbia only

See also Figures 8–9 and 8–14
See Plate 19 for an illustration from a different
copy of this book

36 QUATORZIÈME SATIRE.

Honoré DAUMIER, "Les Charlatans," fourteenth satire from *Némésis médicale illustrée* (Illustrated medical nemesis), 2:36. Cat. no. 111.

çois Fabre, Phocaean, and Doctor, 30 vignettes by Daumier, Paris, 1840, Volume 2, in 8, 278 pages, sold at 12 francs
Book
24 x 16.5 x 2 cm
Boston, Courtesy of the Trustees of the Boston Public Library (Inv. Q.56.57)

112. Jean-Ignace-Isidore GRANDVILLE
Nancy 1803–1847 Vanves
Les Métamorphoses du jour, ou les hommes à têtes de bêtes (Modern metamorphoses, or men with animal

heads) by J. I. Grandville, Editions populaires, Paris, Aubert, Galerie Vero-Dodat, Second edition, hand colored, 1 vol. in 8 oblong, s.d. [1838], 71 plates lithograph, sold for 15 francs colored, 6 francs black and white
Book
21.6 x 26.5 cm
Chicago, The Art Institute of Chicago (Inv. 1981.405 RX13240)
Gift of Nelson E. Smyth, 1981

Plate 20

Déjeunez avec le Classique, et dînez avec le Romantique,
il y a de fort bonnes choses à manger dans les deux écoles

Joseph-Louis-Hippolyte BELLANGÉ, "Déjeunez avec le Classique et dînez avec le Romantique, il y a de fort bonnes choses à manger dans les deux écoles" (Lunch with the Classic and dine with the Romantic, there are very good things to eat in both schools), from *Silhouette*. Cat. no. 110.

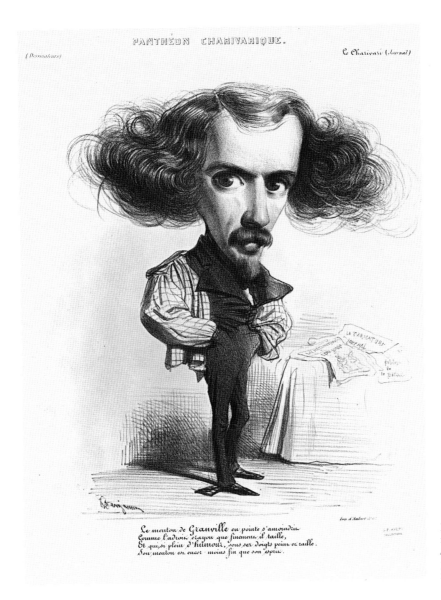

BENJAMIN, *Granville,*
from *Panthéon charivari-
que* (A *Charivari*
pantheon). Cat. no.
109B.

B.
Granville [*sic*]
34 x 26.6 cm
Inscribed l.l.: Benjamin

C.
Ingres
34 x 26.6 cm

Figure 3–15

D.
Vernet
26.3 x 34.4 cm

Figure 3–3

110. *Silhouette,* 1829–1831, 1 bound volume
Book
44.4 x 26.7 cm
Cambridge, Houghton Library, Harvard Univer-
 sity (A. C. Coolidge Fund) (Inv. fFP 8 Si 337 v. 1)

111. Honoré DAUMIER
Marseille 1808–1879 Valmondais
Némésis médicale illustrée, recueil de satires (Illustrated
 medical nemesis, a collection of satires) by Fran-

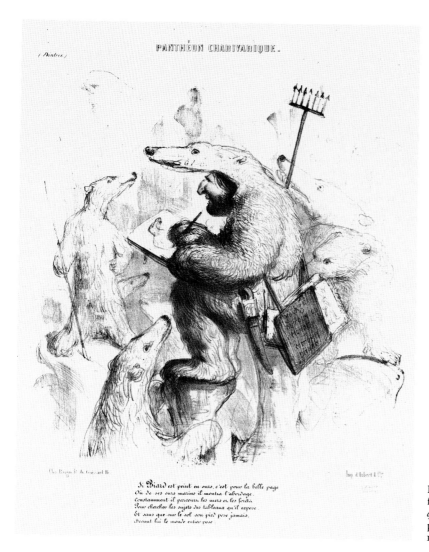

PANTHÉON CHARIVARIQUE.

(Peintres)

Si Biard est peint en ours, c'est pour la belle page
Où de ses ours marins il montra l'abordage.
Constamment il parcourt les mers et les forêts
Pour chercher les sujets des tableaux qu'il expose
Et sans que sur le sol son pied pose jamais,
Devant lui le monde entier pose.

BENJAMIN, *Biard,*
from *Panthéon charivari-*
que (A *Charivari*
pantheon). Cat. no.
109A.

C.
Où peut conduire la lecture du Constitutionnel (Where
reading *Le Constitutionnel* can lead)
(Delteil 1395, no. 8 in the series, published 20 June
1845)
25 x 21.8 cm
Inscribed l.r.: h. D.
(Inv. H and D 2223 ii; D. 1395; MESP)

D.
Désagrément de dîner au trop grand air (The trouble
with eating in the too-open air)
(Delteil 1404, no. 17 in the series, published 7
August 1845)
25.6 x 23.1 cm
Inscribed l.r.: h. D.

(Inv. H and D 2232 ii; D. 1404; MESP)

109. BENJAMIN
(Dates unknown)
Panthéon charivarique (A *Charivari* pantheon)
Series of lithographs, published in *Le Charivari*
New York, S. P. Avery Collection, The Miriam and
Ira D. Wallach Division of Art, Prints and Pho-
tographs, The New York Public Library, Astor,
Lenox and Tilden Foundations (Inv. MEZAD
(Benjamin))

A.
Biard
34 x 26.6 cm

Honoré DAUMIER, *Est-ce que votre mari serait jaloux* (Would your husband be jealous), from *Pastorales* (Pastorals). Cat. no. 108A.

Honoré DAUMIER, *Ma greffe d'un cerisier sur un abricotier n'a pas pris* (My grafting a cherry on an apricot didn't take), from *Pastorales* (Pastorals). Cat. no. 108B.

Honoré DAUMIER, *Où peut conduire la lecture du Constitutionnel* (Where reading *Le Constitutionnel* can lead), from *Pastorales* (Pastorals). Cat. no. 108C.

Honoré DAUMIER, *Désagrément de dîner au trop grand air* (The trouble with eating in the too-open air), from *Pastorales* (Pastorals). Cat. no. 108D.

Honoré DAUMIER, *O Lune! . . . Inspire-moi ce soir quelque petite pensée un peu grandiose!* (O moon! . . . inspire me tonight with some tiny little grandiose thought!), from *Les Bas-Bleus* (The bluestockings). Cat. no. 107D.

Honoré DAUMIER, *Comment! Encore une caricature sur nous, ce matin, dans le Charivari* (What! another caricature of us this morning in *Le Charivari*), from *Les Bas-Bleus* (The bluestockings). Cat. no. 107F.

March 1844)
21.9 x 18.7 cm
(Inv. H and D 701 ii; D. 1237 MESP)
Not illustrated

F.
Comment! Encore une caricature sur nous, ce matin, dans le Charivari (What! another caricature of us this morning in the *Charivari*)
(Delteil 1259, no. 39 in the series, published 3 August 1844)
22 x 19 cm
Inscribed l.l.: h. D.
(Inv. H and D 723 ii; D. 1259; MESP)

108. Honoré DAUMIER
Marseille 1808–1879 Valmondais
Pastorales (Pastorals)
Series of 50 lithographs, published in *Le Charivari*, May 1845 to May 1846.
New York, Print Collection, The Miriam and Ira

D. Wallach Division of Art, Prints and Photographs, The New York Public Library, Astor, Lenox and Tilden Foundations.

A.
Est-ce que votre mari serait jaloux (Would your husband be jealous)
(Delteil 1392, no. 5 in the series, published 11 June 1845)
24.3 x 22.4 cm
Inscribed l.r.: h. D.
(Inv. H and D 2220 ii; D. 1392; MESP)

B.
Ma greffe d'un cerisier sur un abricotier n'a pas pris (My grafting a cherry on an apricot didn't take)
(Delteil 1394, no. 7 in the series, published 22 June 1845)
25.3 x 21.2 cm
(Inv. H and D 2222 ii; D. 1394; MESP)

Honoré DAUMIER, *C'est singulier comme ce miroir m'applatit la taille et me maigrit la poitrine* (It's amazing how this mirror flattens my figure and shrinks my bosom), from *Les Bas-Bleus* (The bluestockings). Cat. no. 107A.

Honoré DAUMIER, *Adieu, mon cher, je vais chez mes éditeurs* (Good-bye, my dear, I'm going to my editors), from *Les Bas-Bleus* (The bluestockings). Cat. no. 107B.

ary 1844)
22.9 x 18 cm
Inscribed l.l.: h. D.
(Inv. H and D 682 ii; D. 1221; MESP)

B.
Adieu, mon cher, je vais chez mes éditeurs (Good-bye, my dear, I'm going to my editors)
(Delteil 1223, no. 3 in the series, published 8 February 1844)
27.8 x 17.9 cm
Inscribed l.r.: h. D.
(Inv. H and D 685 ii; D. 1221; MESP)

C.
La Mère est dans le feu de la composition, l'enfant est dans l'eau de la baignoire! (The mother is in the throes of composition, the child is in the bathwater)
(Delteil 1227, no. 7 in the series, published 26 February 1844)

23.3 x 19 cm
Inscribed l.r.: h.D.
(Inv. H and D 6912; D. 1227; MESP)

Figure 7–22

D.
O Lune! . . . Inspire-moi ce soir quelque petite pensée un peu grandiose! (O Moon! . . . inspire me tonight with some tiny little grandiose thought!)

(Delteil 1228, no. 8 in the series, published 28 February 1844)
23.5 x 18 cm
Inscribed l.r.: h. D.
(Inv. H and D 629 iii; D. 1228; MESP)

E.
Le Parterre de l'Odéon. L'Auteur! (The boxes of the Odéon. Author!)
(Delteil 1237, no. 17 in the series, published 17

Henry Bonaventure MONNIER, *Les Contrastes / Ludicrous Contrasts—On vit de tout / The Nuptials, and Burial Coach-man* (Contrasts—You can live on anything). Cat. no. 102.

Charles Joseph TRAVIÈS, *Dans la position où je me trouve, je crois que je ferai bien de me marier / I think I shall do well to marry now* (The state I am in now, I believe I would do well to get married). Cat. no. 104.

104. Charles Joseph TRAVIÈS
Winterthur 1804–1859 Paris
Dans la position où je me trouve, je crois que je ferai bien de me marier / I think I shall do well to marry now (The state I am in now, I believe I would do well to get married)
Lithograph
35.8 x 27.5 cm
Inscribed r.: C. J. Traviès
Paris, Musée Carnavalet (Inv. G 6909)

105. Charles Joseph TRAVIÈS
Winterthur 1804–1859 Paris
M. Mayeux (Monsieur Mayeux)
Lithograph
36 x 27.1 cm
Inscribed l.l.: C. J. Traviès
Paris, Musée Carnavalet (Inv. G 7875)

Plate 17

106. Charles Joseph TRAVIÈS
Winterthur 1804–1859 Paris

Mayeux et Robert Macaire
Lithograph
36 x 27.4 cm
Inscribed b.c.: C. J. Traviès
Paris, Musée Carnavalet (Inv. G 8027)

Figure 7–20

107. Honoré DAUMIER
Marseille 1808–1879 Valmondais
Les Bas-Bleus (The bluestockings)
Series of 40 lithographs, published in *Le Charivari,* 30 January to 3 August 1844
New York, Print Collection, The Miriam and Ira D. Wallach Division of Art, Prints and Photographs, The New York Public Library, Astor, Lenox and Tilden Foundations.

A.
C'est singulier comme ce miroir m'applatit la taille et me maigrit la poitrine (It's amazing how this mirror flattens my figure and shrinks my bosom)
(Delteil 1221, no. 1 in the series, published 30 Janu-

Honoré DAUMIER, *Ne vous y frottez pas* (Don't meddle with it). Cat. no. 100.

100. Honoré DAUMIER
Marseille 1808–1879 Valmondais
Ne vous y frottez pas (Don't meddle with it), 1834
Lithograph (Delteil 133, published in *L'Association
 Mensuelle,*
March 1834, plate 20)
30.7 x 43.1 cm
Baltimore, The Baltimore Museum of Art
 (Inv. 1929.17.21.28)

101. Honoré DAUMIER
Marseille 1808–1879 Valmondais
Rue Transnonain, le 15 avril, 1834 (Rue Transnonain,
 15 April 1834), 1834
Lithograph (Delteil 135, published in *L'Association
 Mensuelle,* May 1834, plate 24)
29 x 44.5 cm
Inscribed l.l.: H. D.
New York, S. P. Avery Collection, The Miriam and
 Ira D. Wallach Division of Art, Prints and Pho-
 tographs, The New York Public Library, Astor,
 Lenox and Tilden Foundations (Inv. H and D

310; D 135; MEZAD)

Figure 7-13

102. Henry Bonaventure MONNIER
Paris 1805–1877 Paris
*Les Contrastes / Ludicrous Contrasts—On vit de tout / The
 Nuptials, and Burial Coach-man* (Contrasts—You
 can live on anything), ca. 1830
Lithograph
27.1 x 20.4 cm
Paris, Musée Carnavalet (Inv. RG 612)

103. Charles Joseph TRAVIÈS
Winterthur 1804–1859 Paris
Industriel de bas étage / The man who lives by his wits
 (Low-born industrialist)
Lithograph
35.5 x 27.2 cm
Inscribed l.l.: C. J. Traviès
Paris, Musée Carnavalet (Inv. G 6907)

Figure 7-16

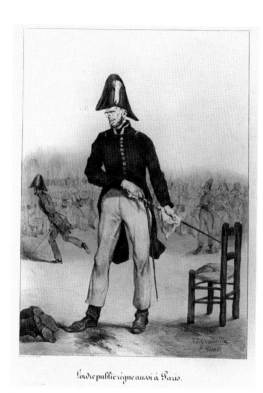

Jean-Ignace-Isidore GRANDVILLE, *L'Ordre publique règne* (Public order reigns). Cat. no. 93.

35.7 x 26.8 cm
Paris, Musée Carnavalet (Inv. G 6681)

93. Jean-Ignace-Isidore GRANDVILLE

Nancy 1803–1847 Vanves
L'Ordre publique règne (Public order reigns)
Lithograph
33.7 x 22.3 cm
Paris, Musée Carnavalet (Inv. G 13002)

94. Jean-Ignace-Isidore GRANDVILLE

Nancy 1803–1847 Vanves
La France livrée aux corbeaux de toute espérance (France, robbed of all hope by the crows), 1831
Lithograph (published in *La Caricature,* 15 October 1831, no. 50, plate 100)
27.5 x 35 cm
Inscribed l.r.: J. I. Grandville / E. Forest / 1831
Paris, Musée Carnavalet (Inv. G 8673)
Plate 16

95. Charles PHILIPON

Lyon 1806–1862 Paris

Le Juste Milieu
Lithograph
35.6 x 26.8 cm
Paris, Musée Carnavalet (Inv. G 17854)

Figure 7–4

96. Jean-Ignace-Isidore GRANDVILLE

Nancy 1803–1847 Vanves
Naissance du juste milieu (Birth of the *juste milieu*), 1832
Lithograph (published in *La Caricature,* 12 February 1832, no. 66, plate 134)
36.4 x 27.5 cm
Inscribed l.r.: J. I. Grandville / E. Forest
Paris, Musée Carnavalet (Inv. G 8684)

Figure 1–2

97. Charles Joseph TRAVIÈS

Winterthur 1804–1859 Paris
Le Juste Milieu se crotte (The *juste milieu* dirties itself)
Lithograph (published in *La Caricature,* 1832, no. 71, plate 144)
36.2 x 27.5 cm
Inscribed b.c.: C. J.Traviès
Paris, Musée Carnavalet (Inv. 19013)

Figure 7–11

98. Honoré DAUMIER

Marseille 1808–1879 Valmondais
Vous avez la parole, expliquez-vous, vous êtes libre! (You have the floor, explain yourself, you are free!), 1835
Lithograph (Delteil 116, published in *La Caricature,* 1835, no. 236, plate 490)
20.6 x 28.1 cm
Minneapolis, The Minneapolis Institute of Arts (Inv. P 8029)
Gift of Mrs. C. C. Bovey

Figure 1–6

99. Honoré DAUMIER

Marseille 1808–1879 Valmondais
Ah! Tu veux te frotter à la presse!! (Ah! you want to meddle with the press!!), 1833
Lithograph (Delteil 71, published in *La Caricature,* 1833, no. 152, plate 319)
22.5 x 20.4 cm
Minneapolis, The Minneapolis Institute of Arts (Inv. P 7986)
Gift of Mrs. C. C. Bovey

Figure 2–21

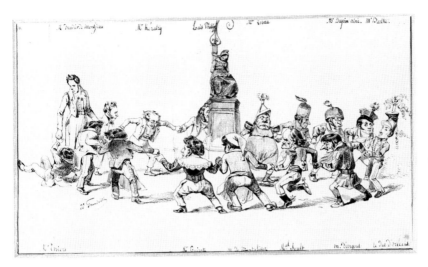

Jean-Ignace-Isidore GRANDVILLE, *Louis-Philippe et ses ministres dansant autour de la ré-publique enchaînée* (Louis Philippe and his ministers dancing around the enchained republic). Cat. no. 88.

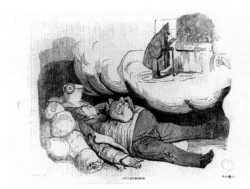

Honoré DAUMIER, *Le Cauchemar* (The nightmare). Cat. no. 91

Pauvres moutons, ah! (Oh! poor lambs!), 1830
Lithograph (Delteil 18)
27.6 x 38.2 cm
Inscribed l.l.: h. Daumier
Paris, Musée Carnavalet (Inv. G 6617)

Figure 7–8

91. Honoré DAUMIER
Marseille 1808–1879 Valmondais
Le Cauchemar (The nightmare), 1832
Lithograph
23.7 x 31.9 cm
Paris, Musée Carnavalet (Inv. G 4209)

92. Jean-Ignace-Isidore GRANDVILLE
Nancy 1803–1847 Vanves
Révolution de 1830
Lithograph

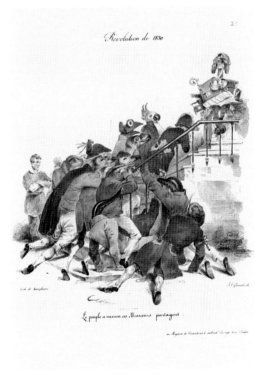

Jean-Ignace-Isidore GRANDVILLE, *Révolution de 1830* (Revolution of 1830). Cat. no. 92.

CHAPITRE II.

L'OGRESSE.

Le cabaret du *Lapin-Blanc* est situé vers le milieu de la rue *aux Fèves*. Cette taverne occupe le rez-de-chaussée d'une haute maison dont la façade se compose de deux fenêtres dites à *guillotine*.

Au-dessus de la porte d'une sombre allée voûtée, se balance une lanterne oblongue dont la vitre fêlée porte ces mots écrits en lettres rouges : *Ici on loge à la nuit*.

Le Chourineur, l'inconnu et la Goualeuse entrèrent dans la taverne.

Qu'on se figure une vaste salle basse, au plafond enfumé, rayé de solives noires, éclairée par la lumière incertaine d'un mauvais quinquet. Les murs lézardés, anciennement récrépis à la chaux, sont couverts çà et là de dessins grossiers ou de sentences en termes d'argot.

Le sol battu, salpêtré, est imprégné de boue ; une brassée de paille est déposée, en guise de tapis, au pied du comptoir de l'ogresse, situé à droite de la porte et au-dessous du quinquet.

De chaque côté de cette salle il y a six tables ; d'un bout elles sont scellées au mur, ainsi que les bancs qui les accompagnent. Au fond une porte donne dans une cuisine ; à droite, près du comptoir, existe une sortie sur l'allée qui conduit aux taudis où l'on couche à trois sous la nuit.

Maintenant quelques mots de l'ogresse et de ses hôtes.

Louis Joseph TRIMOLET, "L'Ogresse" (The ogress), p. 7, chap. 2, from *Les Mystères de Paris* (The Mysteries of Paris) by Eugène Sue. Cat. no. 86.

LE

JUIF ERRANT

PAR

EUGÈNE SÛE.

ÉDITION

ILLUSTRÉE PAR GAVARNI.

TOME PREMIER.

PARIS.
PAULIN, LIBRAIRE-ÉDITEUR.
RUE RICHELIEU, 60.
—
1845.

Sulpice-Guillaume Chevalier, called Paul GAVARNI, frontispiece and title page from *Le Juif errant* (The wandering Jew) by Eugène Sue. Cat. no. 87.

Paysage d'Egypte (Egyptian landscape), ca.
 1834–1844
Oil on canvas
160 x 230 cm
Inscribed l.r.: MARILHAT
Clermont-Ferrand, Musée Municipal (Inv. 74–3–1)

Plate 32

The oeuvre of the short-lived painter Prosper
Marilhat was decidedly influenced by the artist's
trip, in the early 1830s, to Syria, Palestine, and
Egypt. Until his death in 1847 Marilhat painted
oriental landscapes and genre scenes, based on
both memory and on-the-spot sketches. Marilhat's
Paysage d'Egypte is a composite landscape that com-
bines several landscape and architectural motifs.
The painting stands out through its dramatic light
effects, which lend it a mysterious character quite
in keeping with the Romantic conception of Egypt.

150. Alexandre-Jean-Baptiste HESSE
Paris 1806–1879 Paris
Moissonneuse tenant sa faucille (Harvester holding her
 sickle), 1837
Oil on canvas
100 x 82 cm
Inscribed l.l.: A. Hesse, 1837
Nantes, Musée des Beaux-Arts (Inv. 1022)
Gift of Clarke de Feltre, 1852

Plate 33

151. Jean-Claude BONNEFOND
Lyon 1796–1860 Lyon
Une Pèlerine soutenue par un religieux (A pilgrim being
 supported by a monk), ca. 1837
Oil on canvas
101 x 82 cm
Lyon, Musée des Beaux-Arts (Inv. A–2827)
Bequest of Gaspard Dorel, 1850

Plate 34

Bonnefond represents a particular strain of
genre painting in the July Monarchy that is related
to that of Léopold Robert and emphasizes the accu-
rate depiction of Italian costumes and life. This
small-scale genre painting reflects Bonnefond's
interest in religious orders in Italy, a theme he
explored repeatedly around 1837. Although this is
ostensibly a religious theme, his treatment of it
presents a strange mixture of mysticism and erot-
icism insofar as the monk's assistance to the young
pilgrim may be spiritual but there are sexual
undertones.

152. Ary SCHEFFER
Dordrecht 1795–1852 Paris
Faust apercevant Marguerite pour la première fois, (Faust
 seeing Marguerite for the first time), 1838, Salon
 of 1839, no. 1898
Oil on canvas
215.1 x 137.5 cm
Inscribed l.l.: Ary Scheffer 1838
Detroit, The Detroit Institute of Arts (Inv. 80.55)
Founders Society Purchase, Robert H. Tannahill
 Foundation Fund

Plate 35

153. François-Edouard PICOT
Paris 1786–1868 Paris
Episode de la peste de Florence (Episode from the
 plague in Florence), Salon of 1839, no. 1670
Oil on canvas
235 x 180 cm
Inscribed l.r.: Picot 1839
Grenoble, Musée de Peinture et de Sculpture
 (Inv. unknown)
Purchased and presented by the government to the
 Grenoble Museum, 1839

Plate 36

Picot was a very productive academic painter in
many different media, among them mural painting
(he was one of the artists employed in the decora-
tion of the church Notre-Dame de Lorette), and he
worked in an eclectic manner. This work was the
last one he exhibited in the Salon.
 Discussions of this painting in the Salon reviews
and the journal *L'Artiste* indicate that its subject
refers to the great plague of 1348 as it was described
and dramatized in Boccaccio's *Decameron*. In its
own time it evoked memories of the cholera epi-
demic that had ravished Paris in 1832, one of the
great disasters of the early July Monarchy. In gen-
eral, however, the theme of the helplessness of the
innocent against nature, of tragedies wrought by
circumstances beyond human control, was a leit-
motiv of Romantic literature.

154. Ary SCHEFFER
Dordrecht 1795–1858 Argenteuil
*Cornelia Scheffer-Lamme avec ses petites-filles Cornélie et
 Cornelia* (Cornelia Scheffer-Lamme with her
 granddaughters Cornélie and Cornelia), 1839
Oil on canvas
131 x 88 cm
Inscribed l.r.: Ary Scheffer Reuil Août 1839

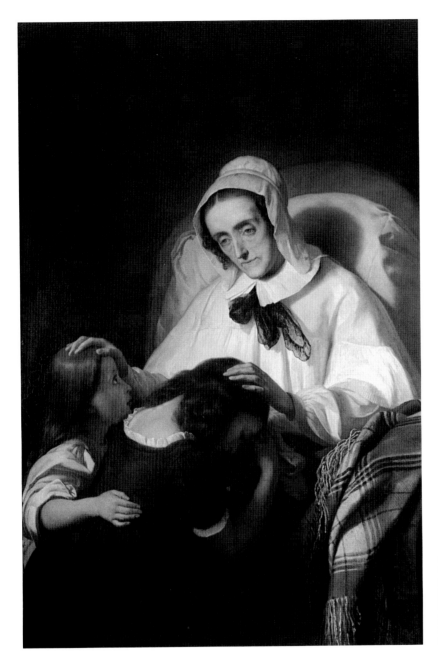

Ary SCHEFFER, *Cornelia Scheffer-Lamme avec ses petites-filles Cornélie et Cornelia* (Cornelia Scheffer-Lamme with her granddaughters Cornélie and Cornelia). Cat. no. 154.

Dordrecht, Dordrechts Museum (Inv. DM/S/64)
Bequest of C. Marjolin-Scheffer, 1899.

155. Louis Joseph TRIMOLET
Paris 1812–1843 Paris
Une Maison de secours (An almshouse), Salon of 1839,
 no. 1985
Oil on canvas
200 x 170 cm
Inscribed l.l.: L. Trimolet
Paris, Musée des Hôpitaux de Paris
 (Inv. A.P. 2199)
Gift of Geoffroy-Dechaume, 1981

Plate 37

Although he was little appreciated at the time,
and submitted few works to the annual Salons,
Trimolet's *Maison* was well regarded when shown at
the 1839 Salon. It reflected the artist's own involve-
ment with misery, his poor upbringing, and the
fact that there were many within the ranks of the
lower classes who needed public assistance. As a
painting long kept from public view and only
recently rescued from neglect, this work is a signifi-
cant harbinger of this type of realist theme painted
in muted tones that attracted such artists as Fran-
çois Bonvin or Théodore Ribot in the 1850s and
1860s.

156. Paul-Jean FLANDRIN
Lyon 1811–1902 Paris
Les Pénitents dans la campagne romaine (The penitents
 in the Roman Campagna), Salon of 1840, no. 591
 (as "Paysage" [Landscape])
Oil on canvas
98 x 132 cm
Inscribed l.l.: Paul Flandrin
Lyon, Musée des Beaux-Arts (Inv. A–2873)
Purchased by the City of Lyon, 1854

Figure 5–2

157. Joseph Nicolas ROBERT-FLEURY
Cologne 1797–1890 Paris
Colloque de Poissy en 1561 (The colloquy of Poissy in
 1561), Salon of 1840, no. 602
Oil on canvas
93 x 132 cm
Paris, Bibliothèque du Protestantisme (Inv. dépôt
 du Louvre 7672)
Placed by the Louvre at the Bibliothèque du Protes-
 tantisme, 1955

Plate 38

Simon SAINT-JEAN, *Emblèmes eucharistiques*
(Eucharistic symbols). Cat. no. 158.

In 1561 leaders of the Protestant and Catholic
churches met to work out a compromise to prevent
the religious war that seemed imminent. Robert-
Fleury's painting of this event portrays many of the
historical figures, such as Catherine de Medici and
the theologian Bezat. It is, however, not only an
illustration of a historic event; at the same time, it
comments on religious conflicts in France during
the July Monarchy. Throughout his life Robert-
Fleury dealt with the issue of religious dichotomy,
in which he juxtaposed Protestant rationalism and
Catholic irrationalism and fanaticism.

This painting is typical of the small-scale history
painting (as opposed to the "grande machine"), a
more modest and more archaeological type of
depiction. Robert-Fleury has been called the finest
representative of this manner in France.

158. Simon SAINT-JEAN
Lyon 1808–1860 Ecully-Lyon
Emblèmes Eucharistiques (Eucharistic symbols), 1841,
 Salon of 1842, no. 1667
Oil on canvas
126 x 106 cm
Inscribed l.l.: Saint Jean 1841
Lyon, Musée des Beaux-Arts (Inv. A.1758)
Purchased by the City of Lyon, 1842

Thomas COUTURE, *Portrait de M. Ohnet, maire adjoint du IXe arrondissement* (Portrait of M. Ohnet, deputy mayor of the 9th district). Cat. no. 160.

159. Jean François MILLET
Gruchy près de Gréville 1814–1875 Barbizon
Portrait de Félix-Bienaimé Feuardent, 1841
Oil on canvas
73.5 x 60.7 cm
Inscribed l.l.: Millet
New York, H. Shickman Gallery

Plate 39

160. Thomas COUTURE
Senlis 1815–1879 Villiers-le-Bel
*Portrait de M. Ohnet, maire adjoint du IXe arrondisse-
ment* (Portrait of M. Ohnet, deputy mayor of the

9th district), Salon of 1841, no. 431
Oil on canvas
117 x 89.5 cm
Inscribed l.l.: Thas Couture
Paris, Musée du Petit Palais (Inv. 2124)
Bequest of Georges Ohnet to the Musée
 Carnavalet, 1920
Placed by the Musée Carnavalet at the Musée du
 Petit Palais, 1927

161. François-Auguste BIARD
Lyon 1798–1882 Plâtreries
Le Duc d'Orléans recevant l'hospitalité sous une tente de

François-Auguste BIARD, *Magdalena Bay* Cat. no. 162.

Lapons août 1795 (The duc d'Orléans receiving hospitality in a Lap tent August 1795), Salon of 1841, no. 140
Oil on canvas
132 x 63 cm
Inscribed l.l.: Biard
Versailles, Musée National du Château de Versailles (Inv. MV 5432)
Commissioned by Louis Philippe for the Musée du Château de Versailles

Figure 5–6

An example of an official commission from Louis Philippe, this one in 1840 brought 2,400 francs to Biard. The painting records the visit of the duc d'Orléans to a so-called primitive culture, the Eskimos. It was destined to be shown in the Musée Historique that Louis Philippe was organiz-

ing for himself and French glory at Versailles. The painting was officially shown at the 1841 Salon.

162. François-Auguste BIARD
Lyon 1798–1882 Plâtreries
Magdalena Bay, vue prise de la presqu-île des Tombeaux au nord du Spitzberg, effet d'aurore boréale (Magdalena Bay, viewed from the presqu-île des Tombeaux to the north of Spitsbergen, during the aurora borealis), Salon of 1841, no. 142
Oil on canvas
130 x 163 cm
Inscribed l.r.: Biard
Paris, Musée du Louvre (Inv. RF 2578)
Purchased by the king at the Salon of 1841

As a young man, François Biard traveled to Egypt and Syria, as well as Lapland and Spitsbergen, and these visits inspired many of his later

Emile SIGNOL, *Jésus-Christ pardonnant à la femme adultère* (Christ pardoning the woman taken in adultery). Cat. no. 163.

works. While the depictions of travel episodes often tend toward the caricatural, his *Magdalena Bay* has a dramatic quality that truly evokes the awe-inspiring greatness of the Arctic circle. To anyone who had been in those northern regions, this landscape must have had a special appeal; it is not surprising, therefore, that Louis Philippe bought this painting for his private collection. Indeed, like Biard, the young duc d'Orléans had, in 1795–1796, traveled from Copenhagen via Oslo and Trondheim to Lapland, and onward, via the Lofoten Islands, to the North Cape. Moving by reindeer sleds and camping out at night, Louis Philippe must have sensed the frailty of man vis-à-vis the raw powers of nature and the forces of the elements—the very feeling Biard has tried to express in this work.

163. Emile SIGNOL

Paris 1804–1892 Paris
Jésus-Christ pardonnant à la femme adultère (Christ pardoning the woman taken in adultery), Salon of 1842, no. 1717
Oil on canvas
141 x 114.5 cm
Detroit, The Detroit Institute of Arts (Inv. 79.6)
Founders Society Purchase

164. Joseph Désiré COURT

Rouen 1797–1865 Rouen
Rigolette cherchant à se distraire pendant l'absence de Germain (Rigolette trying to amuse herself during Germain's absence), Salon of 1844, no. 416
Oil on canvas
132 x 80 cm
Rouen, Musée des Beaux-Arts (Inv. 875.1.2)
Bequest of Admiral Cécille, 1875

Plate 40

Eugène Sue's *Les Mystères de Paris* was perhaps the most popular novel of the July Monarchy and expressed the author's own militant socialist politics. Court's painting illustrates a specific moment in this narrative, showing the *lorette* Rigolette (a woman who is not exactly a prostitute but has numerous lovers) during the time her lover Germain is held in prison for trying to help a poor family against injustice.

165. Jean-Alexis ACHARD

Voreppe (Isère) 1807–1884 Grenoble
Environs de la Grande-Chartreuse (The surroundings of the Grande-Chartreuse), 1844, Salon of 1845, no. 2
Oil on canvas
90 x 130 cm
Inscribed l.r.: J. Achard
Nantes, Musée des Beaux-Arts (Inv. 788)
Acquired 1845

Plate 27

166. Hippolyte-Jean FLANDRIN

Lyon 1809–1864 Rome
Madame Louis Antoine de Cambourg, 1846
Oil on canvas
100 x 76.2 cm
Detroit, The Detroit Institute of Arts (Inv. 73.169)
Founders Society Purchase with funds from Mr. and Mrs. Alvan Macauley, Jr.

Plate 41

167. Dominique Louis PAPETY

Marseille 1815–1849 Marseille
Portrait d'Antoine Vivenel, Salon of 1846, 1377
Oil on canvas
225 x 155 cm
Inscribed l.l.: Dom Papety / A son ami Vivenel Architecte
Compiègne, Musée Vivenel (Inv. B 92)

Plate 42

Vivenel personifies one type of entrepreneur active during the July Monarchy. Involved in the beautification of the central part of the city—in redoing such monuments as the Hôtel de Ville—Vivenel also used his money to advance the arts. His extensive private collection of artifacts was housed in his own cabinet, and he used his finances to commission artists to do portraits of himself that partially immortalized his goals. Papety, as his personal favorite, has shown Vivenel in his own private space with references to his collection of sculpture and the paraphernalia of personal power. Vivenel's collection was ultimately given to his native city of Compiègne, where it helped form a museum that was inaugurated by members of the royal family in the mid–1840s.

168. Dominique Louis PAPETY

Marseille 1815–1849 Marseille
La Vierge consolatrice (The consoling Virgin), Salon of 1846, no. 1375 (as "Consolatrix afflictorum")
Oil on canvas

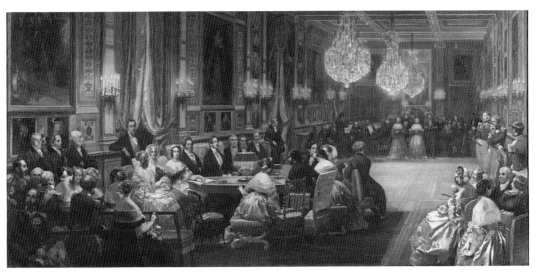

Eugène Louis LAMI, *Concert donné dans la galerie de Guise au Château d'Eu* (Concert given in the Gallery de Guise at the Château d'Eu). Cat. no. 171.

115 x 148 cm
Inscribed l.l.: Dom Papety
Marseille, Musée des Beaux-Arts (Inv. 196)
Purchased by the City of Marseille, 1850

Plate 43

By including Queen Marie Amélie and his own mother and sister among the petitioners, Papety here transformed a rather general subject into a very personal work. In concept it is a companion piece to Scheffer's *Christ Consolateur* (see Figure 2–15) and represents an unusual fusion of early realist imagery (the two homeless children) with the classicizing tradition of the school of Ingres.

169. Ferdinand-Victor-Eugène DELACROIX
Charenton-Saint-Maurice 1798–1863 Paris
Christ on the Cross, Salon of 1847, no. 459
Oil on canvas
80 x 64 cm
Inscribed l.r.: Eug. Delacroix 1846
Baltimore, The Walters Art Gallery (Inv. 37.62)

Plate 44

170. François-Auguste BIARD
Lyon 1798–1882 Plâtreries
Quatre heures au Salon (Four o'clock at the Salon),
 Salon of 1847, no. 142
Oil on canvas
57.5 x 67.5 cm
Inscribed c.l.: Biard

Paris, Musée du Louvre (Inv. RF 2437)
Gift of Mortimer Schiff, 1921

Plate 45

As a painter involved with social mores and historical episodes, Biard also effectively painted scenes reflecting the elevation of genre to a status in the hierarchy of themes appropriate for public exhibition. The fact that this painting also utilizes a theme drawn from the Salon exhibitions themselves—the moment when a guardian walked through the galleries to announce that visiting time was ending—suggests the value of public exhibitions as a means of educating the middle class.

171. Eugène Louis LAMI
Paris 1800–1890 Paris
Concert donné dans la galerie de Guise au Château d'Eu
 (Concert given in the Gallery de Guise at the
 Château d'Eu), 1843
Oil on canvas
83.5 x 172 cm
Versailles, Musée National du Château de
 Versailles (Inv. MV 6119)
Commissioned by Louis Philippe, then Collection
 Vendôme
Purchased 1932

172. Eugène Louis LAMI
Paris 1800–1890 Paris
*La Reine Victoria dans le salon de famille, au Château
 d'Eu, le 3 septembre 1843* (Queen Victoria in the

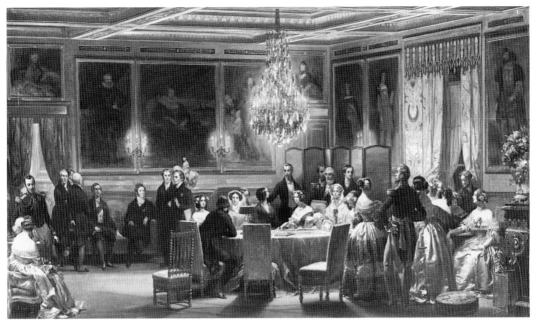

Eugène Louis LAMI, *La Reine Victoria dans le salon de famille, au Château d'Eu, le 3 septembre 1843* (Queen Victoria in the drawing room at the Château d'Eu, 3 September 1843). Cat. no. 172.

François-Auguste BIARD, *La Reine Victoria visitant l'escadre française . . . est reçue à bord du 'Gomer' le 15 octobre* (Queen Victoria visiting the French squadron . . . is received aboard the 'Gomer' on 15 October). Cat. no. 174.

Clock in the Form of a Cathedral. Cat. no. 175.

tant that Lami showed guests dining or listening to concerts in the interior of this château. Each of the guests and ministers can be identified, attesting to Lami's role as a court reporter and suggesting his paintings have validity as official documents. Both the *Salon de Famille* and the *Concert* were official commissions from Louis Philippe, who agreed to pay Lami 5,000 francs for each composition in 1844. The painting of the *Salon de Famille* was formally exhibited at the Salon of 1846.

173. Eugène Louis LAMI
Paris 1800–1890 Paris
and Prosper-Georges-Antoine MARILHAT
Vertaizon 1811–1847 Thiers
Visite de la Reine Victoria et du Prince Albert au Château d'Eu le 3 septembre 1843 (Visit of Queen Victoria and Prince Albert to the Château d'Eu on 3 September 1843), Salon of 1846, no. 1058
Oil on canvas
83 x 174 cm
Versailles, Musée National du Château de Versailles (Inv. MV 6872)
Commissioned by Louis Philippe for the Musée du Château de Versailles

Figure 5–7

174. François-Auguste BIARD
Lyon 1798–1882 Plâtreries
La Reine Victoria visitant l'escadre française . . . est reçue à bord du 'Gomer' le 15 octobre (Queen Victoria visiting the French squadron . . . is received aboard the 'Gomer' on 15 October), 1844
Oil on canvas
150 x 230 cm
Versailles, Musée National du Château de Versailles (Inv. MV 6870)
Commissioned by Louis Philippe for the Musée du Château de Versailles

Addendum

drawing room at the Château d'Eu, 3 September 1843), Salon of 1846, no. 1058
Oil on canvas
83.5 x 145 cm
Inscribed l.l.: E. Lami
Versailles, Musée National du Château de Versailles (Inv. MV 6118)
Commissioned by Louis Philippe, then Collection Vendôme
Purchased 1932

As one of the favorite court painters of the July Monarchy, Lami was frequently called upon to create icons that recorded events linked to the official family and its guests. Since Louis Philippe and his entourage often entertained notables in the Château d'Eu near the northern coast, it is impor-

175. *Clock in the Form of a Cathedral*
ca. 1830
Gilt and silver metal and blue glass
60.4 x 23.5 x 14.7 cm
Inscribed on back of mechanism: Pons. Medaille d'argent 1823
Columbia, Mo., Museum of Art and Archaeology, University of Missouri–Columbia (Inv. 89.64)
Gilbreath-McLorn Museum Fund purchase

BIBLIOGRAPHY

Achille Devéria, témoin du romantisme parisien 1800–1857. Exhibition catalogue. Paris: Musée Renan-Scheffer, 1985.

Adhémar, Jean. *Les Lithographies de paysage en France à l'époque romantique.* Paris: A. Colin, 1937.

Alexandre Hesse (1806–1879): Quelques aspects du portraitiste et du dessinateur. Exhibition catalogue. Paris: Galerie Pierre Gaubert, 1979.

Allen, James Smith. *Popular French Romanticism: Authors, Readers, and Books in the 19th Century.* Syracuse: Syracuse University Press, 1981.

Amprimoz, François-Xavier. *Dominique Papety, peintre d'histoire, Marseille 12 août 1815–20 septembre 1849.* Mémoire de maîtrise d'histoire de l'art, Université de Provence, Centre d'Aix, Institut d'Histoire de l'Art, 1975.

Anon. "Statue équestre du duc d'Orléans dans la cour du Louvre." *Journal des artistes,* 2d ser., 3 August 1845, p. 269.

Ashwin, Clive. "Graphic Imagery 1837–1901: A Victorian Revolution." *Art History* 1, no. 3 (September 1978): 369–70.

Bauche, Henri. *Le Langage populaire: Grammaire, syntaxe et dictionnaire du français tel qu'on le parle dans le peuple de Paris.* Paris: Payot, 1928.

Baudelaire, Charles. *Oeuvres complètes de Charles Baudelaire.* Paris: L. Conard, 1923.

———. "Some French Caricaturists." In *The Painter of Modern Life and Other Essays,* 166–86. Translated and edited by Jonathan Mayne. London: Phaidon, 1964.

Bechtel, Edwin T. *Freedom of the Press and L'Association Mensuelle: Philipon versus Louis Philippe.* New York: Grolier Club, 1952.

Beetem, Robert N. "Horace Vernet's Mural in the Palais Bourbon: Contemporary Imagery, Modern Technology, and Classical Allegory during the July Monarchy." *Art Bulletin* 64, no. 2 (June 1984): 254–69.

Bénichou, Paul. *Le Temps des prophètes: Doctrines de l'âge romantique.* Paris: Gallimard, 1977.

Béraldi, Henri. *Les Graveurs du XIXe siècle.* Paris: L. Conquet, 1885–1892.

Berger, Jacques-Edouard. "Gleyre et l'orient." In *Charles Gleyre, ou les illusions perdues,* 50–69. Exhibition catalogue. Marseilles: Musée de Cantini, 1974.

Bezucha, Robert. *The Lyon Uprising of 1834: Social and Political Conflict in the Early July Monarchy.* Cambridge: Harvard University Press, 1974.

———. "Misery in the July Monarchy." *Harvard Review of French Literature.* Forthcoming, 1989.

Blanc, Charles. *The Grammar of Painting and Engraving.* Translated by Kate Newell Doggett. New York, 1874.

Blu, J. *Musée Vivenel, catalogue illustré des peintures, dessins, sculptures.* With a preface by the Comte de Marsy, Directeur de la Société Française d'Archéologie. Compiègne: Henry Lefebvre, n.d.

Boesche, Roger, ed. *Alexis de Tocqueville: Selected Letters on Politics and Society.* Translated by James Toupin and Roger Boesche. Berkeley: University of California Press, 1985.

Boime, Albert. *The Academy and French Painting in the Nineteenth Century.* London: Phaidon, 1971.

———. *Hollow Icons: The Politics of Sculpture in Nineteenth-Century France.* Kent, Ohio: Kent State University Press, 1987.

———. "Jacques Louis David, Scatological Discourse in the French Revolution and the Art of Caricature." *Arts Magazine* 62, no. 6 (February 1988): 72–81.

———. "The Second Empire's Official Realism." In *The European Realist Tradition,* edited by Gabriel P. Weisberg, 31–123. Bloomington: Indiana University Press, 1982.

———. *Thomas Couture and the Eclectic Vision.* New Haven: Yale University Press, 1980.

Boisson, Jean. *Le Retour des cendres.* Paris: Etudes et Recherches Historiques, 1973.

Botting, Douglas. *Humboldt and the Cosmos.* London: Harper & Row, 1973.

Brivois, Jules. *Bibliographie des ouvrages illustrés du XIXe siècle. Principalement des livres à gravures sur bois.* Paris, 1883. Rpt. Hildesheim & New York: Georg Olms Verlag, 1974.

Brown, Marilyn R. *Gypsies and Other Bohemians: The Myth of the Artist in Nineteenth-Century France.* Ann Arbor: UMI Research Press, 1985.

La Caricature: Bildsatire in Frankreich, 1830–1835, aus der Sammlung von Kritter. Exhibition catalogue. Göttingen: Westfälisches Landesmuseum für Kunst und Kulturgeschichte, Münster, 1980.

Catalogue of a Collection of Early French Books in the

Library of C. Fairfax Murray, Compiled by Hugh Wm. Davies. 2 vols. London: The Holland Press, 1961.

Champfleury, Jules. Histoire de la caricature moderne. Paris: E. Dentu, [1865?].

———. Les Vignettes romantiques. Histoire de la littérature et de l'art: 1825–1840. Paris, 1883.

Chaudonneret, Marie Claude. "Chartres, Musée des Beaux-Arts, Jeanron et 'l'art social': Une Scène de Paris." Revue du Louvre 4/5 (October 1986): 317–19.

Chevalier, Louis. Laboring Classes and Dangerous Classes in Paris during the First Half of the Nineteenth Century. Translated by F. Jellinek. New York: H. Fertig, 1973.

Chu, Petra ten-Doesschate. French Realism and the Dutch Masters. Utrecht: Haentjens Dekker & Gumbert, 1974.

———. "It Took Millions of Years to Compose that Picture." In Courbet Reconsidered, 55–65. Exhibition catalogue. New York: Brooklyn Museum, 1988–1989.

Collingham, Hugh. The July Monarchy: A Political History of France, 1830–1848. London and New York: Longman, 1988.

Collins, Irene. The Government and the Newspaper Press in France, 1814–1881. London: Oxford University Press, 1959.

Courbet Reconsidered. Exhibition catalogue. New York: Brooklyn Museum of Art, 1988.

Courthion, Pierre, ed. Courbet raconté par lui-même et par ses amis. Vol. 2. Paris, 1850.

The Cult of Images: Baudelaire and the Nineteenth-Century Media Explosion. Exhibition catalogue. Santa Barbara: University of California, Santa Barbara, 1977.

Cuno, James. "The Business and Politics of Caricature: Charles Philipon and La Maison Aubert." Gazette des Beaux-Arts 106 (October 1985): 95–112.

———. "Charles Philipon and 'la Poire': Politics and Pornography in Emblematic Satire, 1830–1835." In Proceedings of the Consortium on Revolutionary Europe (1984), edited by Harold T. Parker, 147–56. Athens: University of Georgia Press 1986.

———. "Charles Philipon, La Maison Aubert, and the Business of Caricature in Paris, 1829–41." Art Journal 43, no. 4 (Winter 1983): 347–54.

———. "The Ideology of Types and the Crisis of the City: Paris during the July Monarchy." Unpublished manuscript, 1988.

———. "Review of Musée des Beaux-Arts, Nancy,

Grandville: Dessins originaux." Art Bulletin 70, no. 3 (September 1988): 530–34.

"Les Dantan du Musée Carnavalet: Portraits romantiques." Gazette des Beaux-Arts 107 (January 1986): 1–38.

de Caso, Jacques. David d'Angers: L'avenir de la mémoire. Paris: Flammarion, 1988.

———. "Serial Sculpture in Nineteenth-Century France." In Metamorphoses in Nineteenth-century Sculpture, edited by Jeanne L. Wasserman, 1–27. Exhibition catalogue. Cambridge: Fogg Art Museum and Harvard University, 1975.

Delaborde, Henri. Ingres, sa vie, ses travaux, sa doctrine, d'après les notes manuscrites et les lettres du maître. Paris, 1870.

Delacroix, Eugène. Journal d'Eugène Delacroix. Edited by A. Joubin. Paris: Plon, 1932.

Dessins parisiens de XIXe et XXe siècles (du Musée Carnavalet). Exhibition catalogue. Paris: Musée Carnavalet, 1976.

Dictionnaire de biographie française. Paris: Lotouzey et Ané, 1933–.

Dorbec, Prosper. L'Art du paysage en France. Paris: H. Laurens, 1925.

Driskel, Michael Paul. "By Competition or Administrative Decree?: The Contest for the Tomb of Napoleon in 1841." Art Journal 48, no. 1 (Spring 1989): 46–51.

———. "Eclecticism and Ideology in the July Monarchy: Jules-Claude Ziegler's Vision of Christianity at the Madeleine." Arts Magazine 56 (May 1982): 119–28.

———. "Raphael, Savonarola and the Neo-Catholic Use of 'Decadence' in the 1830s." In Fortschrittsglaube und Dekadenzbewußtsein im Europa des 19. Jahrhunderts: Literatur, Kunst, Kulturgeschichte, edited by Wolfgang Drost, 259–66. Heidelberg: C. Winter Universitätsverlag, 1986.

———. "Singing the Marseillaise in 1840: The Case of Charlet's Censored Prints." Art Bulletin 69, no. 4 (December 1987): 604–25.

———. "'To Be of One's Own Time': Modernization, Secularism and the Art of Two Embattled Academicians." Arts Magazine 6, no. 4 (December 1986): 80–84.

Dubreuil, Marie Martine. "Philippe Auguste Jeanron." Archives de l'art français 29 (1988): 57–61.

DuPays, Baudelaire. Salon de 1846. Paris, 1846.

Eitner, Lorenz. An Outline of Nineteenth-Century European Painting from David through Cézanne. New York: Harper & Row, 1987.

Esquer, G. *Les Commencements d'un empire: La prise d'Alger.* Paris: Larose, 1930.

Etex, Antoine. *Souvenirs d'un artiste.* Paris, 1877.

Exigences de réalisme dans la peinture française entre 1830 et 1870. Exhibition catalogue. Chartres: Musée des Beaux-Arts de Chartres, n.d.

Explication des ouvrages de peinture, sculpture, architecture, gravure et lithographie des artistes vivants. Paris, 1846.

Explication des peintures de la chapelle de la Vierge à l'église de Notre-Dame-de-Lorette. Paris, 1850.

Ferment, Claude. *Charles Joseph Traviès: Catalogue de son oeuvre, lithographie et gravure.* Typed manuscript in the Cabinet des Estampes, Bibliothèque Nationale, Paris, n.d.

————. "Monsieur Mayeux curieux personnage de caricature." *L'Estampille* (July/August 1984): 64–74.

Forestier, Sylvie. "A propos de la création à Compiègne du Musée Vivenel." In *Bulletin de la Société Historique de Compiègne,* 119–35. Compiègne, 1979.

Fourcaud, Louis de. *François Rude, sculpteur: Ses oeuvres et son temps (1784–1855).* Paris: Librairie de l'Art Ancien et Moderne, 1904.

French Caricature and the French Revolution, 1789–1799. Exhibition catalogue. Los Angeles: Grunwald Center for the Graphic Arts, University of California, Los Angeles, 1988.

Gaehtgens, Thomas W. *Versailles: De la résidence royale au musée historique. La Galerie des Batailles dans le musée historique de Louis-Philippe.* Translated by Patrick Poirot. Antwerp: Mercatorfonds, 1984.

Gavard, Charles. *Galeries historiques du Palais de Versailles.* 10 vols. Paris, 1839–1848.

Getty, Clive. *Grandville: Dessins originaux.* Nancy: Musée des Beaux-Arts, 1987.

Gosset, Alphonse. *Notice sur Alphonse Périn, peintre d'histoire: Ses peintures murales de Notre-Dame-de-Lorette.* Paris/Rheims, 1892.

Gowing, Lawrence, and Philip Conisbee. *Painting from Nature: The Tradition of Open-Air Oil Sketching from the 17th to 19th Centuries.* Exhibition catalogue. London: Arts Council of Great Britain, 1981.

Graham, John. "Ut Pictura Poesis." In *Dictionary of the History of Ideas,* edited by Phillip P. Wiener, 4:465–76. New York: Scribner's Sons, 1973.

Grand-Carteret, John. *Les Moeurs et la caricature en France.* Paris: La Librairie Illustre, 1888.

Grandville: Caricatures et illustrations. Exhibition catalogue. Nancy: Musée des Beaux-Arts, 1975.

Grandville: Dessins originaux. Exhibition catalogue. Nancy: Musée des Beaux-Arts, 1986.

Green, Nicholas. "Circuits of Production, Circuits of Consumption: The Case of Mid Nineteenth-Century French Art Dealing." *Art News* 48 (1989): 29–34.

Guignebert, Charles. *A Short History of the French People.* New York: Macmillan Co., 1930.

Guinard, Paul. *Dauzats et Blanchard: Peintres de l'Espagne romantique.* Paris: Presses Universitaires de France, 1967.

Guizot, François. *Histoire parlementaire de France, recueil complet des discours prononcés dans les Chambres de 1819 à 1848 par M. Guizot.* Paris: Michel Lévy frères, 1863–1864.

Gustave Courbet (1819–1877). Exhibition catalogue. Paris: Grand Palais, 1977.

Haskell, Francis. "The Old Masters in Nineteenth-Century French Painting." *Art Quarterly* 34, no. 1 (1971): 55–85.

————. *Rediscoveries in Art: Some Aspects of Taste, Fashion and Collecting in England and France.* Ithaca: Cornell University Press, 1976.

Hippolyte, Auguste et Paul Flandrin: Une fraternité picturale au XIXe siècle. Exhibition catalogue. Paris: Ministère de la Culture, 1984.

Hittorff, Jakob Ignaz. "Mémoire présenté à M. le Préfet de la Seine." *L'Artiste,* 3d ser., 1 (January 1842): 3–22.

Holderbaum, James. "Portrait Sculpture." In *The Romantics to Rodin: French Nineteenth-Century Sculpture from North American Collections,* 36–51. Exhibition catalogue. Los Angeles: Los Angeles County Museum of Art, 1980.

Holt, Elizabeth Gilmore. *The Triumph of Art for the Public 1785–1848: The Emerging Role of Exhibitions and Critics.* Princeton: Princeton University Press, 1979.

Honour, Hugh. *Romanticism.* New York: Harper & Row, 1979.

Horace Vernet, 1789–1863. Exhibition Catalogue. Paris: Ecole des Beaux-Arts, 1980.

Houssaye, Arsène. "La Chambre des Députés et les peintures de M. Eugène Delacroix." *L'Artiste,* ser. 2, 2, no. 27 (1839): 389–92.

Howard, T. E. B. *Citizen King.* London: Eyre and Spottiswoode, 1961.

Humboldt, Alexander von. *Cosmos. Essai d'une description physique du monde.* 4 vols. Paris: Gide et J. Baudry, 1855–1859.

Hunt, Lynn. "The Political Psychology of Revolutionary Caricatures." In *French Caricature and the French Revolution, 1789–1799,* 33–40. Los Angeles: Grunwald Center for the Graphic Arts, University of California, Los Angeles.

Jackson, John, [and W. A. Chatto]. *A Treatise on Wood Engraving*. 1838. 2d ed. London: Bohn, 1861.

Jacobs, Robert L., and Geoffrey Skelton, *Wagner Writes from Paris*. New York: John Day; London: Allen and Unwin, 1973.

Jardin, André. *Tocqueville: A Biography*. Translated by Lydia Davis with Robert Hemenway. New York: Farrar Straus Giroux, 1988.

Jardin, André, and André-Jean Tudesq. *Restoration and Reaction, 1815-1848*. Translated by Elborg Forster. Cambridge and New York: Cambridge University Press, 1983.

Johnson, Christopher H. "The Revolution of 1830 in French Economic History." In *1830 in France*, edited by John M. Merriman, 139-89. New York: Franklin Watts, 1975.

Kaenel, Philippe, "Autour de J.-J. Grandville: Les conditions de production socio-professionnelles du livre illustré 'romantique.'" *Romantisme* 12 (1984): 45-61.

Kolbe, Marthe. *Ary Scheffer et son temps*. Paris: Bolvin, 1937.

Ladoué, Pierre. *Un peintre de l'épopée française: Raffet*. Paris: A. Michel, 1946.

LeMen, Segolene. "'M'Amuse, t'amuse, s'amuse': Philipon et L'Association Mensuelle (1832-1834)." *Cahiers de l'Institut d'Histoire de la Presse et de l'Opinion* 7 (1983): 63-113.

Louis Boulanger: Peintre-graveur de l'époque romantique, 1806-1867. Exhibition catalogue. Dijon: Musée des Beaux-Arts, 1970.

"Louis Trimolet." *Cabinet de l'amateur II* 2 (1843): 544-48.

Loys-Delteil. *H. Daumier, peintre-graveur*. Paris, n.d.

McKendrick, N., J. Brewer, and J. H. Plumb, eds. *The Birth of a Consumer Society: The Commercialization of Eighteenth-Century England*. Bloomington: Indiana University Press, 1982.

McWilliam, Neil. "David D'Angers and the Pantheon Commission: Politics and Public Works under the July Monarchy." *Art History* 5, no. 4 (December 1982): 426-46.

Marrinan, Michael. *Painting Politics for Louis-Philippe: Art and Ideology in Orléanist France, 1830-1848*. New Haven: Yale University Press, 1988.

Martin, Henri-Jean, and Roger Chartier, eds. *Histoire de l'édition française*. Vol. 3. *Le temps des éditeurs: Du romantisme à la belle époque*. Paris: Promodis, 1985.

Mason, Michael. "The Way We Look Now: Millais' Illustrations to Trollope." *Art History* 1, no. 3 (September 1978): 310.

Melcher, Edith. *The Life and Times of Henri Monnier*.

Cambridge: Harvard University Press, 1950.

Melot, Michel. "Caricature and the Revolution: The Situation in France in 1789." In *French Caricature and the French Revolution, 1789-1799*, 25-32. Los Angeles: Grunwald Center for the Graphic Arts, University of California, Los Angeles.

Merson, Olivier. "La Collection Clarke de Feltre (Musée de Nantes)." *Gazette des Beaux-Arts* 8 (15 November 1860): 193-202.

Metamorphoses in Nineteenth-century Sculpture, edited by Jeanne L. Wasserman, 1-27. Exhibition catalogue. Cambridge: Fogg Art Museum and Harvard University, 1975.

Michelet, Jules. *Histoire de France jusqu'au XVIe siècle*. Paris: L. Hachette et cie., 1852-1867.

———. *Journal*. Paris: Gallimard, 1976.

———. *Le Peuple*. Paris: Comptoir des Imprimeurs-unis: Hachette: Paulin, 1846.

Miller, Michael B. *The Bon Marché: Bourgeois Culture and the Department Store, 1869-1920*. Princeton: Princeton University Press, 1981.

Mitchell, W. J. T. *Iconology: Image, Text, Ideology*. Chicago: University of Chicago Press, 1986.

Montalembert, Charles de. "Du vandalisme en France: Lettre à M. Victor Hugo." *Revue des Deux Mondes*, 2d ser., 1 (1 March 1833): 477-524.

Moreau-Nélaton, Etienne. *Daubigny raconté par lui-même*. Paris: H. Laurens, 1925.

Needham, Gerald. *Nineteenth-Century Realist Art*. New York: Harper & Row, 1988.

Nochlin, Linda. *Gustave Courbet: A Study of Style and Society*. New York: Garland Dissertations, 1976.

Nodier, Charles. *Journal de l'expédition des Portes de Fer*. Paris, 1844.

Oeuvres diverses de Victor Orsel. Edited by A. Périn. 2 vols. Paris, 1878.

Pagnerre, Laurent Antoine. *Dictionnaire politique: Encyclopédie du langage et de la science politiques*. Paris: Pagnerre, 1842.

Passeron, Roger. *Daumier*. New York: Rizzoli, 1981.

Peeck, Joan. "The Role of Illustrations in Processing and Remembering Illustrated Text." In Dale M. Willows and Harvey A. Houghton, eds., *The Pyschology of Illustration* 1:116. New York and Berlin: Springer-Verlag, 1987.

Picard, Alfred. *Les Chemins de fer, aperçu historique*. Paris: H. Dunod & E. Pinat, 1918.

Pinkney, David H. *Decisive Years in France, 1840-1847*. Princeton: Princeton University Press, 1986.

Plazaola, R. P. "Le Baron Taylor et le théâtre romantique." Ph.D. dissertation, Université de Paris, 1957.

Procès-verbaux des séances de la Chambre des Députés, session 1832. Paris, 1833.

Ray, Gordon N. *The Art of the French Illustrated Book 1700–1914.* New York: Dover, 1986.

———. *The Illustrator and the Book in England from 1790 to 1914.* New York: Oxford University Press, 1976.

Raymond, Jules. "Une Dette nationale." *L'Art* 5 (1876): 189–91.

Récit de l'inauguration de la Statue de Gutenberg et des fêtes données par la ville de Strasbourg les 24, 24 et 26 Juin 1840. Paris, 1840.

Reddy, William M. *The Rise of Market Culture: The Textile Trade and French Society, 1750–1900.* Cambridge and New York: Cambridge University Press, 1984.

Rémusat, Charles de. *Mémoires de ma vie.* Paris, 1960.

Ribner, Jonathan P. "Henri de Triqueti, Auguste Préault and the Glorification of Law under the July Monarchy." *Art Bulletin* 7, no. 3 (September 1988): 486–501.

Rigaud, Lucien. *Dictionnaire d'argot moderne.* Paris: P. Ollendorff, 1881.

Rosen, Charles, and Henri Zerner. *Romanticism & Realism.* New York: Viking Press, 1984.

Rosenthal, Léon. *Du romantisme au réalisme: La peinture en France de 1830 à 1848.* Paris: Macula, 1987.

Rousseau, Madeleine. "La Vie et l'oeuvre de Philippe Auguste Jeanron, peintre, écrivain, directeur des musées nationaux, 1808–1877." Ph.D. dissertation. Paris: Ecole du Louvre, 1936.

Schoelcher, V. "MM. Delacroix, Léon Cogniet, Decamps." *L'Artiste* 1 (1831): 228.

Seligman, Janet. *Figures of Fun: The Caricature Statuettes of Jean Pierre Dantan.* London: Oxford University Press, 1957.

Sensier, Alfred. *Souvenirs sur Th. Rousseau.* Paris: L. Techener, 1872.

Shapiro, Meyer. *Words and Pictures: On the Literal and the Symbolic in the Illustration of a Text.* The Hague: Mouton, 1973.

Sheon, Aaron. "Parisian Social Statistics: Gavarni, 'Le Diable à Paris,' and Early Realism." *Art Journal* 44, no. 2 (Summer 1984): 139–48.

Stafford, Barbara. *Voyage into Substance.* Cambridge: MIT Press, 1984.

Steele, Valerie. *Paris Fashion: A Cultural History.* New York: Oxford University Press, 1988.

"Tableaux présentés au Salon par Philippe Auguste Jeanron, 1830–1852." *Archives du Louvre.*

Tamisier, François. *Dominique Papety: Sa vie et ses oeuvres.* Marseilles, 1857.

Ténint, Wilhelm. *Album du Salon de 1841–1843: Collection des principaux ouvrages exposés au Louvre, reproduits par les peintres eux-mêmes, ou sous leur direction par MM. Alophe . . . {et al.}.* Paris: Challamel, 1841–1843.

Thore, Théophile. "Le Salon." *Le Constitutionnel,* 29 April 1846.

Tocqueville, Alexis de. *Recollections.* Translated by George Lawrence and edited by J. P. Mayer and A. P. Kerr. Garden City: Doubleday, 1971.

Traugott, Mark. "The Crowd in the French Revolution of February, 1848." *American Historical Review* 93, no. 3 (June 1988): 638–53.

Vigier, Philippe. *La Monarchie de juillet.* 5th ed. Paris: Presses universitaire de France, 1976.

Wechsler, Judith. *A Human Comedy: Physiognomy and Caricature in Nineteenth-Century Paris.* Chicago: University of Chicago Press, 1982.

Weisberg, Gabriel P. "François Bonhommé and Early Realist Images of Industrialization, 1830–1870." *Arts Magazine* 54, no. 8 (April 1980): 132–35.

———. "Hallucinatory Art History: The Bizarre Case of Gustave Courbet." *Journal of Art* 1, no. 1 (December 1988): 10–11.

———. *The Realist Tradition: French Painting and Drawing, 1830–1900.* Cleveland: Cleveland Museum of Art and Indiana University Press, 1980.

Wright, Beth S., and Paul Joannides. "Les Romans historiques de Walter Scott et la peinture française, 1822–1863." *Société de l'Histoire de l'Art Français Bulletin,* 1982, pp. 119–32; 1983, pp. 95–115.

Ziff, Norman D. *Paul Delaroche: A Study in Nineteenth-Century French History Painting.* New York: Garland, 1977.

ABOUT THE CONTRIBUTORS

Robert J. Bezucha, professor of history at Amherst College, was the recipient of a 1987–1988 Guggenheim Fellowship. His research specialty is French social history in the 1830s and 1840s. In addition to numerous articles on history and art history, Professor Bezucha has published *The Lyon Uprising of 1834: Social and Political Conflict in the Early July Monarchy* (Cambridge: Harvard University Press, 1974). Professor Bezucha has served as a consultant for a number of important exhibitions of nineteenth-century French art.

Petra ten-Doesschate Chu is professor and chair of the department of art and music at Seton Hall University. The recipient of several important grants including a Guggenheim Fellowship, she is a specialist in French and Dutch landscape painting of the seventeenth, eighteenth, and nineteenth centuries. Among her books are *French Realism and the Dutch Masters* (Utrecht: Haentjens, Dekker, & Gumbert, 1974) and *Courbet in Perspective* (Englewood Cliffs, N.J.: Prentice Hall, 1977).

Patricia Condon is curator of European and American art at the Museum of Art and Archaeology, University of Missouri–Columbia. Dr. Condon was guest curator for a major exhibition of the works of J.-A.-D. Ingres organized by the J. B. Speed Art Museum and the Kimbell Art Museum in 1983–1984. The exhibition catalog, a study of the artist's pursuit of formal perfection through multiple versions, won the College Art Association's Alfred H. Barr award and the Society of Art Librarians' Wittenborn award.

Michael Paul Driskel is an assistant professor of art history at Brown University. Professor Driskel is the author of numerous articles on French art of the 1830s and 1840s. Among these are "Painting, Piety, and Politics in 1848: Hippolyte Flandrin's Emblem of Equality at Nîmes" and "Singing the *Marseillaise* in 1840: The Case of Charlet's Censored Prints," both published in the *Art Bulletin*. Professor Driskel has received a Kress Fellowship and a John Paul Getty Postdoctoral Fellowship.

Gabriel P. Weisberg is chair of the department of art history at the University of Minnesota. From 1973 to 1981 Professor Weisberg was curator of art history and education at the Cleveland Museum of Art. He has organized and written catalogs for a number of exhibitions including "The Realist Tradition: French Painting and Drawing, 1830–1900" and, most recently, "Art Nouveau Bing: The Paris Style 1900." In addition to many articles, Professor Weisberg has authored *François Bonvin, His Life and Work* (Paris: Editions Geoffroy-Dechaume, 1979) and has edited *The European Realist Tradition* (Bloomington: Indiana University Press, 1982). In 1983–1985 Professor Weisberg was assistant director, Humanities Projects in Museums and Historical Organizations, National Endowment for the Humanities.

INDEX

Page references in bold type refer to illustrations

Abd el-Kader, 56

Achard, Jean-Alexis: *Environs de la Grande-Chartreuse,* 14

Adhémar, Jean, 120

Agassiz, Louis, 129

Alavoine, le Chevalier Jean-Antoine (architect), 70

Albert, Prince, 145, **147**

Algeria, 28, 55, 56, 124, **241, 242, 244**

Aligny, Claude-Félix-Théodore Caruelle d': *Vue prise des carrières de grès . . . ,* 116, **161**

Antommarchi, C. Francesco: *Death Mask of Napoleon on a Cushion,* 58, **58**

Arc de Triomphe de l'Étoile, 69, 71, 77

Arnoux, Albert d.' *See* Bertall

Artiste, L', 52, 82, 96, 104, 194

Ashwin, Clive, 198

Association Mensuelle, L', 26, 179, 180, 181

Aumale, duc d,' 124, 134, **135**

Balzac, Honoré de, 40, 201, **204,** 207, **230;** *Human Comedy,* 37; *Ursule Mirouet,* 118; works of, 21, 33, 206, 210, 213

Banque de France, la, 42

Barbès, Sigmund-Auguste-Armand, 107, 108, **108,** 109

Barre, Jean-Auguste, 134; *La Famille Royale visite la Monnaie le 8 nov. 1833,* 216; *Statuette of Queen Victoria,* 134, **135**

Barye, Antoine-Louis, 70, 85; *Algerian Dromedary,* **242;** *Sleeping Greyhound,* **282**

Bastille, place de la, Paris, 70

Baudelaire, Charles, 51, 108, 208, 209; and Papety, 67; and Salon of 1846, 50; quoted, 37

Beaujolais, duc de, 124

Beethoven, Ludwig van, 128

Bellangé, Joseph-Louis-Hippolyte: "Déjeunez avec le Classique et dinez avec le Romantique . . . ," **267;** *Révolution de 1830,* **234**

Benjamin, *Le Panthéon Charivarique: Biard,* **265;** *Granville,* **266;** *Ingres,* **97;** *Paul Delaroche,* 97, **97;** *Vernet,* **86**

Benoist, Philippe: *View of the Tomb of Napoleon, The Invalides, Paris,* 78, **78**

Béranger, P.-J., 58

Berlioz, Hector, 39, 93, 94; quoted, 25

Bertall (Albert d'Arnoux) caricature, 49, 51, 52, 71; *Le Diable à Paris,* 50

Bertin, Louis Philippe Louis-François, 39, 40

Bewick, Thomas, 198

Biard, François-Auguste, 123–24; caricatured, **265;** *Le Duc d'Orléans recevant l'hospitalité sous une tente de Lapons août 1795,* **123;** *Magdalena Bay . . . ,* **293;** *Quatre heures au Salon,* **176;** *La Reine Victoria . . . ,* **297**

Bibliothèque Nationale, 205

Blanc, Charles, 193, 195

Blois, château de, 98

Blondel, Merry-Joseph: *Portrait of a Man,* **11**

Bodmer, Karl, 129

Boilly, Louis-Léopold, 183

Bonaparte, Louis-Napoleon, 31, 115, 206

Bonheur, Rosa, 35

Bonhommé, Ignace-François (le Forgeron), 54, 101, 112–14; *The Forge at Fourchambault,* 112, **113;** *Interior of the Great Forge at Fourchambault,* **114;** mentioned, 115

Bonnefond, Jean-Claude: *Une Pèlerine soutenue par un religieux,* 91, **165**

Boulanger, Louis, 140–41; *Le Roi Lear et son fou pendant la tempête,* 93, **94**

Boulevard des Capucines massacre, 43

Bourbon, Palais, 52, 63

Bourbons, the, 24, 25; supporters of, 28

Bovy, Antoine: *Medal of Louis Philippe with Allegory of the Establishment of the French Railroad,* 34, **34**

Brivois, Jules, 192, 195, 198

Buss, R. W., 198

Cailleux, Alphonse de, 120

Calamatta, Luigi: *Portrait of Adolphe Thiers (1797–1877),* **223**

Cambis d'Orsan, comte Henri de, 138, **139,** 140, 141, 143–44, 145

Cambis d'Orsan family, 138–41

Cambourg, Madame Louis Antoine de, **172**

Caricature, La, 23, 101–2, 105, 107, 150, 153, 157, 160, 178, 179, 181, 182

Carrel, Armand, 1, 39–40, 41, 73, **228**

Chamber of Deputies, 26, 27, 32, 52, 55, 70; and Louis Philippe, 19, 30; competition to decorate, 22, 81; election to, 20, 42; Guizot and, 21, 42, 44; Tocqueville and, 30, 45, 46, 48

Chamber of Peers, 19, 21, 30, 60, 73; and war in Algeria, 55

Champfleury, Jules, 194; *Les Vignettes romantiques,* 193, **193, 195**

Champs Elysées, 76, **77**

Chapel of Saint Ferdinand, 74–76, **75, 91**

Charivari, Le, 26, 41, 150, 178, 179, 181, 182, 186

Charlemagne: in Ziegler mural, 62

Charles X, 18, 19, 21, 22, 24, 28, 150, 179

Charlet, Nicolas-Toussaint: and Napoleon, 57, 58; *L'Allocution (28 juillet 1830),* **233;** *Les Français peints par eux-mêmes,* **270;** *Invalides,* **255;** *Mémorial de Sainte-Hélène, par le cte. de Las Cases,* **238**

Charter of 1814, 19, 20

Charter of 1830, 19–20, 21, 34, 60, 153; violated, 28

Chassériau, Théodore, 45, 56, 63; *Othello ("La Romance du Saule"),* **247;** *Portrait de Lamartine,* **227;** *Portrait de Tocqueville,* **45;** *La Princesse Belgiojoso,* **228;** *Le Souvenir,* 11, **85**

Chenavard, Claude-Aimé: *Cheminée exécutée pour le Château d'Eu,* **218**

Chevalier, Sulpice-Guillaume. *See* Gavarni, Paul

Church of the Invalides, Paris, 76, 77, 96

Church of the Madeleine, Paris, 44, 60–61

Cicéri, Eugène: *Dumas père,* **227**

Cimabue, Giovanni, 96, **96**

Clauzel, Gen. Bertrand, 55

Clock in the Form of a Cathedral, **298**

Cogniet, Léon, 82, **228**

Commission on Historical Monuments, 63
Compiègne, 142
Concorde, place de la, Paris, 113
Corot, Jean-Pierre: *L'Avant-port de Rouen*, 116, *162*
Cortot: depiction of Napoleon, 70
Courbet, Gustave, 129; *Portrait de l'artiste, dit Courbet au chien noir*, **128**, 130, 143–44
Cour des Comptes, Palais de la, 63
Court, Joseph Désiré: *La Protestation de Mirabeau*, *3*; *Rigolette cherchant à se distraire pendant l'absence de Germain*, 95, **171**
Cousin, Victor, 51, 65
Couture, Thomas, 46; *Portrait de M. Ohnet, maire adjoint du IXe arrondissement*, 143, **292**; *Les Romains de la décadence*, *46*, 48
Cumberworth, Charles, 134; *Le Duc de Montpensier*, **217**
Curmer, Léon (publisher), 196, 200, 201, 205, 206, 207

Dantan le Jeune (Jean-Pierre Dantan), 136, 179; *Lebas Carrying the Obelisk*, **136**
Daubigny, Charles, 110
Daumier, Honoré, 33, 42, 107, 148, 149, 154, 157, 160, 183, 186, 205, 209; *Ah! Tu veux te frotter à la presse!!* 74, **74**, 179; and Macaire, 41; and Philipon, 151; *Les Bas-Bleus*, 190, **262**, 263; caricatures by, 74; *Le Cauchemar*, **258**; *Gargantua*, 158, **159**; *Némésis médicale illustrée*, **268**; *Ne vous y frottez pas*, 179, **260**; *Pastorales*, **264**; *Pauvres moutons, ah!* **156**; *Robert Macaire libraire*, 41; *Rue Transnonain, le 15 avril, 1834*, 27, 180, **180**, 181; *Souvenir de Sainte Pélagie*, 153, **154**; *Le Ventre législatif*, 26, **26**, 179; *Vous avez la parole, expliquez-vous, vous êtes libre!*, **27**, 182; mentioned, 19, 189
Dauzats, Adrien, 56, 120, 124; *Baron Taylor*, **120**; *Campement arabe au pied du Sphinx*, **245**; *Les Français peints par eux-mêmes*, 56; *Les Portes de Fer*, 116, **117**
David, Jacques-Louis, 58, 80
David d'Angers (Pierre-Jean David), 71; *Alfred de Musset*, **71**; and Carrel, 39, 73; *Armand Carrel*, 1, **228**; *Cherubini*, **230**; *Honoré de Balzac*, **229**; *Johann Gensfleisch Gutenberg*, 73; *Léon Cogniet*, **228**; *La Liberté*, **231**; *Monument to Johann Gutenberg*, **72**; *Napoleon as a Revolutionary General*, **236**; *Nicolò Paganini*, **230**; *Victor Hugo*, **230**

Debraux, Emile, 58
Decamps, Alexandre Gabriel, 56, 89, 90, 111, 124; caricatured, 49; *Corps de Garde Turc*, **90**; *Don Quichotte et Sancho*, **247**; *Joseph vendu par ses frères*, 89, **90**; *The Suicide*, **252**
Delacroix, Ferdinand-Victor-Eugène, 24, 56, 63, 80, 89, 93, 94, 124, 210; caricatured, 49; *Christ on the Cross*, 66, **175**; *Cleopatra and the Peasant*, 93, **94**; *Un Forgeron*, **283**; *Un Lion à la source*, **242**; *Un Marocain de la garde de l'empereur*, **243**; Saint-Denis du Saint Sacrement, 66; *Le 28 juillet: La Liberté guidant le peuple*, 23, 24, **24**, 54
Delaroche, Paul (Hippolyte), 58, 62, 84, 98; and Napoleon, 58, 59; and religious subjects, 90; and Salon of 1839, 96, 97; *Assassinat du duc de Guise*, 98, **98**; caricatured, 49, **97**; *Hemicycle*, 85, **97**; Ingres and, 99; *Portrait du peintre Steuben*, 144, **225**; *Portrait of the Actress Marie Dorval (1798–1849)*, *2*; mentioned, 82
Delécluze, Etienne, 81, 82, 83, 85, 86, 95
Delord, Taxile, 37, 40, 213
Demar, Claire, 35, 36
Depaulis, Alexis-Joseph: *Napoleon Lying Dead at Saint Helena*, **239**
Devéria, Achille-Jacques-Jean-Marie, 93, 118, 138, 140–41, 144–45, 146; *Les Dix-huit heures d'une Parisienne*, 118, **119**
Devéria, Eugène-François-Marie-Joseph, 93, 138, 140, 141, 143–44, 144–45, 177; *The Birth of Henry IV*, 23; *Glorification de la vie de Sainte Geneviève*, **275**; Notre-Dame de Lorette, 61, 64; *Portrait de Comte Henri de Cambis d'Orsan*, 138, **139**; *Le Roi Louis-Philippe prêtant serment . . .* , **22**, 22–23, 24, 60, **61**; mentioned, 82
Dieudonné, Jacques-Augustin: *Portrait Bust of Louis Philippe*, **216**; *Portrait Bust of Marie Amélie*, **216**
Dinkel, Joseph, 129
Doré, Gustave, 34
Dorval, Marie, *2*
Duc, Louis, 70
Dumas, Alexandre, 93, 121, 145
Dumas the Elder, **227**
Dumont, Auguste, 70
Duseigneur, Jehan, 132

Ecole de 1830. *See* School of 1830
Ecole des Beaux-Arts, Paris, 62, 97

Éditeurs, 201, 203, 205, 206, 208
Engraving, 144, 145. *See also* Wood engraving
Entr'acte, L', 195
Etex, Antoine, 2, 53; *Projet de monument à la place de l'Europe*, **53**; *Projet de monument destiné à être érigé à la place de l'Europe*, **53**
Eu, château d', 145; fireplace, **218**; galerie de Guise, **296**
Europe, place de l', Paris, 53, **53**
Excursions Daguerriennes: "Mosque at Algiers," **244**

February Revolution, 42, 45
Feltre, Clarke de, collection, 84, 85
Ferdinand, duc d'Orléans, 24, 28, 29, **30**, 42, 47–48, 177; and journal, 124; as patron, 93, 95, 98, 100; memorial chapel at Neuilly, 74–76, **75**, 91
Ferogio, François-Fortuné-Antoine, 76; *Intérieure de l'Eglise des Invalides . . .* , **76**; *Passage du cortège dans les Champs Elysées*, 76
Feuardent, Félix-Bienaimé, 170
Fieschi, Giuseppe Maria, 107
Flandrin, Hippolyte-Jean, 66, 84, 85, 90, **224**; *Madame Louis Antoine de Cambourg*, **172**
Flandrin, Paul-Jean: *Les Pénitents dans la campagne romaine*, 116, **117**, 127; *Portrait d'Hippolyte Flandrin*, **224**
Flandrin, René-Auguste: *Portrait de Georges Hainl*, **227**; *Portrait of a Young Man*, 137, **137**
Flaubert, Gustave: Emma Bovary, 33, 36, 127, 194–95, 197; quoted, 192; recollections of, 39
Fontaine, Pierre, 74
Forgeron, le. *See* Bonhommé, François
Fourchambault ironworks, 54, 113–14
Fournier, Édouard, 205, 207
Français peints par eux-mêmes, Les, 56, 89, 202, 205
Fromentin, Eugène, 56

Gautier, Théophile, 53, 56, 65, 121, 128
Gavard, Charles: *Galeries historiques de Versailles*, 61, **61**
Gavarni, Paul (Sulpice-Guillaume Chevalier), 36, 37, 137, 138, 195, 199, 201, 209–10, 211; *Le Juif errant*, 211, **257**; *La Peau de chagrin: Etudes sociales*, **256**; *Portrait de Pierre Philippe Thomire*, **138**; *Portrait d'Hippolyte Beauvisage Thomire*, **36**; mentioned, 33

Gechter, Jean-François-Théodore: *Louis-Philippe, roi des Français*, 214, 215

Gigoux, Jean-François, 200, 201, 209; *Gil Blas*, 208, 209, 248; *Tony and Alfred Johannot*, 194, 194

Giotto, 96, 96

Girardin, Emile de, 40, 73

Gleyre, Marc-Gabriel-Charles, 56–57; *Turkish Lady, Mrs. Langdon (Smyrna)*, 246

Goethe, 92, 94–95, 210

Gothic, the, 85, 91, 120

Goupil gallery, 68

Goyen, Jan van, 128

Grandville, Jean-Ignace-Isidore, 159, 178, 179, 204, 205; and Balzac, 210, 213; and censorship, 153; and Hetzel, 206; and Philipon, 151; *Un Autre Monde*, 11, 37, 37, 40, 40, 205, 207–8, 213, 270; *Barbe bleue, blanche et rouge*, 177, 178; *Birth of Henry IV*, 23, 177; caricatured, 266; *Digestion du budget*, 157, 157; *Les Fables de La Fontaine*, 8, 199, 199, 250; *La France livrée aux corbeaux de toute espérance*, 7, 160; *La Grippe*, 154, 155, 155; *Louis-Philippe et ses ministres . . .* , 258; *Naissance du juste milieu*, 23, 23, 177; "Nouveau langage musical . . . ," 10; *L'Ordre publique règne*, 259; *Révolution de 1830*, 258; *Scènes de la vie privée et publique des animaux*, 9, 200, 203, 204, 206, 207, 210, 213, 269; mentioned, 19

Granet, François-Marius: *La Religieuse malade*, 92, 92

Green, Nicholas, 118

Grevedon, Henri (Pierre-Louis): *S.A.R. Madame la duchesse d'Orléans, princesse royale*, 221

Gudin, Théodore, 130; *Vue des environs d'Alger, route de Staonelli à Keleif*, 118

Guillemin, Alexandre, 58

Guise, duc de, 98, 98

Guizot, François, 21, 25, 39, 46, 51, 93, 222; Act of 1833, 33, 42; caricatured, 177; in Chamber of Deputies, 20, 26, 42; fall of, 43, 44

Gutenberg, Johann, 72, 73, 197, 200

Hachette, Louis, 42

Hainl, Georges, 227

Haussmann, Baron, 32

Healy, George Peter Alexander: *Portrait de M. Guizot*, 222

Heim, François-Joseph: *Son altesse royale le duc de Nemours*, 1, 29, 29

Heine, Heinrich, 29, 41, 92

Henriquel-Dupont, Louis-Pierre:

The Hemicycle, 273

Hesse, Alexandre-Jean-Baptiste, 84, 134; *Moissonneuse tenant sa faucille*, 85, 164; *Portrait of an Unknown Woman*, 132, 133

Hetzel, Jules (P.-J. Stahl), 200, 203, 205, 207; *Voyage où il vous plaira*, 206

Hittorff, Jakob Ignaz, 64

Hoffmann, E. T. A., 210

Hôtel de Ville, Paris, 25, 141–42, 183

Howard, T. E. B., 123

Huet, Paul, 137; *Inondation dans l'Isle Séguin*, 282; *Paul et Virginie*, 249; *Vue lointaine de Rouen*, 125, 126

Hugo, Victor, 56, 58, 93, 95, 121, 230

Humboldt, Alexander von, 129, 130, 130

Illustration, L', 195

Ingres, Jean-Auguste-Dominique, 56, 85, 89, 90–91, 96–98, 99, 132; *Antiochus and Stratonice*, 99; *L'Apothéose d'Homère*, 62, 63; caricatured, 49, 97; chapel of Saint Ferdinand, 30, 74; *M. Bertin*, 38, 39; *Sainte Amélie, reine de Hongrie*, 91, 91; *Saint Raphael, archange*, 279; students of, 66, 90, 97, 105, 141

Invalides, the, 76, 76, 77

Iodici Badii Ascensii in operis huius compositionem ac finem Epigramma extemporaneu, 197

Isabey, Eugène: *Eglise Saint Jean, Thiers*, 120, 281; mentioned, 130

Italian "primitive" art, 90, 96

Jackson, John, 198, 199; *A Treatise on Wood Engraving*, 198

Jacquand, Claudius, 84; *Un Cardinal vient chercher Ribère dans son atelier à Naples*, 85; *Marie de Médicis visitant l'atelier de Rubens*, 85

Janin, Jules, 82, 92, 206; quoted, 85, 86, 89, 97

Jeanron, Philippe-Auguste, 101–10 passim; *Dying Man*, 104; *Il meurt d'inanition . . .* , 102; *Les Petits Patriotes*, 15, 67–68, 102, 103; portrait of Filippe Buonarotti, 109; *Une Scène de Paris*, 16, 105; *Wounded Man*, 103; mentioned, 112, 114

Johannot, Alfred: *Charles le téméraire*, 93, 93, 194, 194

Johannot, Tony, 193, 194, 194, 195, 199, 201; *Le Coup de fusil*, 4; *Départ de Moïse pour le marché*, 4; *Le Départ pour la prison*, 5; *La Diseuse de bonne aventure*, 4; *Georges prisonnier*, 6; *L'Incendie*, 5; *Mort de Julien d'Avenel*, 93; *Oeuvres de Molière*,

203, 249; *Olivia retrouvée*, 5; *Paul et Virginie*, 196, 196, 197; *Sophie sauvée du torrent*, 4; *Les Vignettes romantiques*, 193, 195; *La Visite dans la prison*, 6; *Vengeance*, 5; *Voyage où il vous plaira*, 206

Journal des Débats, 39, 82

Julien, Bernard Romain, 25, 51; *Louis Philippe Leaving the Palais Royal*, 25

July Column, dedication, 18

July Revolution, 18–27 passim, 39, 42

Kemble, Fanny, 93

Koninck, Philips, 128

Lafayette, General, 18, 25, 235

La Fontaine, Jean de: *Les Fables*, 199, 203, 205, 206, 210

Lamartine, Alphonse de, 56, 121, 227

Lami, Eugène Louis, 124; *Concert donné dans la galerie de Guise au Château d'Eu*, 296; *Projet pour l'appartement du duc de Nemours dans les Tuileries*, 220; *La Reine Victoria . . .* , 297; *Visite de la reine Victoria . . .* , 124

Landon, Charles-Paul, 96

Langdon, Mrs., 246

L'Ardèche, Laurent de, 57

Larivière, Charles, 60

Las Cases, Count de: *Mémorial de Sainte-Hélène*, 57, 59, 238

Lebas, Hippolyte, 63, 64; *Dessin d'architecture pour l'église Notre-Dame de Lorette*, 64; *Notre-Dame de Lorette*, 64

Lebas, Jean Baptiste, 136

Legenda Aurea, 91

Lehmann, Henri (Karl-Ernest-Rodolphe-Heinrich-Salem): *Etude d'une femme nue*, 85, 85; *Liszt*, 145, 145

Lemaître, Frédérick, 41

Lemud, François-Joseph-Aimé de: *Le Retour en France*, 240

Lepaulle, François Gabriel Guillaume: *Eugène Sue*, 144

Leroux, Eugène, 90

Le Sage, Alain René: *Histoire de Gil Blas de Santillane*, 201–3, 208

Le Tourneur, Pierre-Prime-Félicien, 93

Liszt, Franz, 145, 145

Lithograph, 118, 148, 180, 181, 205; albums, 120, 121; caricatures, 155, 157, 158; portraits, 144–45

Lithography, 120, 144–45; in journals, 150–51

Livraison-livre, 203, 205, 210, 213

Louis XIV, 47, 81, 82

Louis XVI, 17–18, 19, 22, 59

Louis XVIII, 19
Louis Philippe, duc de Chartres, 17
Louis Philippe, duc d'Orléans, 17,
 18, 122, 123, 123; travels of, 123, 124
Louis Philippe I, Citizen King, 17,
 18, 19, 20, 24, 25, 43, 47, 71, 150,
 179, 192, 200; and Charter of
 1830, 60, 155; and family, 29, 30,
 47, 48, 51, 134; and Musée Histo-
 rique, 59, 60, 81, 82; and public
 issues, 101, 106, 110, 142; and war
 in Algeria, 28, 55; as patron, 23,
 28, 82, 83, 87, 94, 120, 129; bust
 of, 216; caricatured, 23, 23, 74,
 155, 157, 158, 159, 160, 177, 178,
 258; coronation of, 19, 22, 22–23,
 24, 28, 60, 61; government of, 44,
 52, 58, 113, 120, 159, 179; in paint-
 ing, 25, 60, 62, 146, 147, 215;
 interest in history, 81, 82; medal,
 34, 34; opposition to, 42, 107, 181,
 182; Philipon and, 150, 151–52, 153;
 support for, 34, 39, 45, 140, 143,
 145–46. See also Orleanist
 compromise
Louvre, le, 62, 74, 105; Musée du
 Louvre, 140
Lowell, John, 56
Luxembourg, Palais du, 63
Luxembourg Museum, 24
Lyon, 154, 155, 180

Macaire, Robert, 41, 42, 186, 187,
 188, 188
Magasin Pittoresque, Le, 96, 195
Maison Aubert, 205
Marie Amélie, Queen, 68, 106, 134,
 145, 147, 150, 216
Marie Antoinette, Queen, 196
Marie d'Orléans, Princess, 30, 35
Marilhat, Prosper-Georges-Antoine,
 56, 130; Paysage d'Egypte, 116, 127,
 163
Marochetti, Charles, 74, 78
Maurin, Nicolas-Eustache, 28, 29,
 146, 147; La Famille du prince royal,
 28; Portrait of Louis Philippe, 146;
 Portrait of Louis Philippe, Queen
 Marie Amélie and Queen Victoria of
 England and Her Consort, 147
Maximilian, prince of Wied-Neu-
 wied, 129
Mayeux (Mahieux), Monsieur, 8,
 151, 186, 187, 187, 188
Mecklembourg-Strelitz, Princess
 Hélène de, duchesse d'Orléans,
 29, 30, 42, 221
Melot, Michel, 210
Mennessier, Louis: Statuette du duc
 d'Aumale, 135
Mérimée, Prosper, 63
Michelet, Jules, 18, 19, 43, 65;

quoted, 17, 32, 42
Millais, John Everett, 209
Millet, Jean Françoise: Portrait de
 Félix-Bienaimé Feuardent, 170; men-
 tioned, 130
Mitchell, W. J. T., 207
Mode, La, 195
Moine, Antonin, 132, 134
Molé, Comte, 44
Molière, mentioned, 95, 203
Monnier, Henry Bonaventure, 187,
 188; and Philipon, 151, 179; Les
 Contrastes . . . , 261; Les Ecoliers,
 189; Femme et deux enfants dans une
 chambre, 254; Vieille Mendiante, 255
Montalembert, Charles de, 66, 89;
 Montalembert-Lacordaire-
 Société, 90
Montpensier, duc de (Louis Phi-
 lippe's brother), 124
Montpensier, duc de (Louis Phi-
 lippe's son), 134, 217
Mornay, comte de, 124
Murger, Henry, 40
Musée Carnavalet, Paris, 134
Musée des Beaux-Arts, Nantes, 84
Musée d'Orsay, Paris, 26, 46
Musée du Louvre, Paris, 140
Musée Espagnol, 120
Musée Historique, château de Ver-
 sailles, 55, 59, 81, 82, 86, 124
Musset, Alfred de, 29, 71; Voyage où il
 vous plaira, 206

Napoleon I, 236, 238, 239, 240; con-
 cordat, 63; death mask of, 58;
 legend of, 53, 57–59, 61–62, 70;
 quoted, 21; tomb of, 76, 77, 77,
 78, 78, 79, 271; mentioned, 19
Napoleon III. See Bonaparte, Louis-
 Napoléon
National, Le, 23, 39–40, 73, 74, 111
National Guard, the, 18, 21, 43, 44,
 154
Nemours, duc de, 1, 29, 29, 30, 42,
 48, 86, 124, 220
Nerval, Gérard de, 56, 58, 94
Nodier, Charles, 120, 121, 124, 201;
 La Seine et ses bords, 121
Norvin, Jacques de: Histoire de
 Napoléon, 57, 58
Notre-Dame de Lorette, Paris, 32,
 63, 64, 64, 65
Notre-Dame de Paris, Paris, 24, 30

Ohnet, Monsieur, 292
Orleanist compromise: mentioned,
 17, 20, 22, 23, 28, 39–40, 42, 43
Orléans family, 17. See also Ferdi-
 nand, duc d'Orléans; Louis
 Philippe, duc d'Orléans; Marie

Amélie, Queen; Marie d'Orléans,
 Princess; Mecklembourg-Strelitz,
 Princess Hélène de, duchesse
 d'Orléans; Nemours, duc de;
 Paris, comte de
Orsel, André Jacques Victor, 66, 69,
 90; Auxilium christianorum, 276; Le
 Bien et le mal, 54, 65; quoted, 55

Paganini, Nicolò, 230
Pagnerre (publisher), 71
Panthéon Charivarique, Le. See Ben-
 jamin, Le Panthéon Charivarique
Papety, Dominique Louis, 66, 84,
 85, 141–43; The Abbot Zosimas
 Hands His Cloak to Saint Mary, 13;
 Les Ames de Cyprien et Justine mon-
 tant au ciel, 285; Baptême de Cyprien
 par l'évêque Antime, 285; Cyprien et
 Justine s'exhortant mutuellement, 67;
 Cyprien promet aux démons d'adorer
 celui qui lui donnera Justine, 284;
 Entretien de l'abbé Zosime et de Sainte
 Marie l'Egyptienne au désert, 286;
 Mort et ensevelissement de Sainte
 Marie l'Egyptienne, 287; Portrait
 d'Antoine Vivenel, 141–43, 173; Rêve
 de bonheur, 67; Saint Cyprien et
 Sainte Justine, 12, 91; Sainte Justine en
 prières, 284; Sainte Marie l'Egyp-
 tienne, 91; Saint Mary Is Converted by
 the Icon of the Virgin, 286; La Vierge
 consolatrice, 67, 174;
Papillon, Jean-Baptiste, 198
Paris, comte de, 29, 30, 42
Paris–Saint Germain Railroad Com-
 pany, 53
Paulin, Alexandre, 201, 203, 205,
 206, 210; Gil Blas, 208
Peeck, Joan: quoted, 208, 210
Périer, Casimir, 32, 39
Périn, Alphonse Henri, 65, 90; Le
 Christ enseignant, 277; Pauperi sub-
 venire, 278
Petit, M.: Histoire de la révolution de
 mil cent trente, 235
Philipon, Charles, 26, 107, 145,
 149–54 passim, 157, 159, 177–87
 passim, 205; and journals, 150, 151;
 L'Association Mensuelle, 179; La
 Cuisinière bourgeoise, 149; Le Juste
 Milieu, 152, 153, 153; M. Mahieux,
 187; Promenade bourgeoise, 150, 150;
 La Silhouette, 150. See also Cari-
 cature, La
Physiologies, Les, 33
Picot, François-Edouard: Episode de
 la peste de Florence, 91, 92, 167;
 mentioned, 82
Pils, Isidore, 110
Pius VII, 61
Polignac, Jules Armand, 21

Portes de Fer, les, 116, 117, 124, **244**
Pradier, James (Jean-Jacques), 78,
 84, 85; *Odalisque Seated,* **280;** *Venus
 and Cupid,* **84**
Préault, Antoine Augustin, 132, 134;
 George Sand, **229**
Presse, La, 40, 73
Press Laws of 1835, 40, 148, 178, 181,
 182; quoted, 28
Provost, A.: *Derniers moments du duc
 d'Orléans . . . ,* 30, **30**
Prudhomme, Monsieur, 186–89
Prunelle, Deputy, 26, 27

Quinet, Edgar, 66

Raffet, Denis Auguste Marie, 55,
 124, 151; *A Mort pour la Liberté,* **235;**
 *Combat d'Oued-Alleg (31 décembre
 1839),* **241;** *Journal de l'expédition des
 Portes de Fer,* **244;** *Revue nocturne,* 57,
 57; *Le 2e Léger soutient le choc des
 arabes, 1836,* **241;** *Soldat de l'armée
 républicaine,* **253;** "20 Juin 1792. Le
 peuple aux Tuileries," **232**
Raphael, 54, 97
Ray, Gordon, 196
Réforme, La, 46
Regnault, Elias, 201
Reims, Cathedral of, 18, 22
Rémusat, Charles de, 28, 63, 76, 77;
 quoted, 62
Revolution of 1789, 21, 24, 25, 43
Revolution of 1830, 25, 39, 47, 51,
 54, 69, 70, 107, 109, 121, 148, **258**
Revolution of 1848, 41, 42, 43, 46;
 mentioned, 21
Revue des Deux Mondes, La, 40
Revue des peintres, La, 109
Ribera, José, 85, 96
Ribot, Théodule, 111
Robert, Léopold, 84, 85, 92
Robert-Fleury, Joseph Nicolas, 68,
 69; *Colloque de Poissy en 1561,* **169**
Robespierre: mentioned, 109
Romanticism, 82
Rosen, Charles, 193
Rosenthal, Léon: quoted, 49, 51, 68
Rousseau, Théodore, 128, 130; *Plaine
 de Tartas,* 125, 126–27, **127**
Rubens, Peter Paul, 66, 85
Rude, François: *Departure of the Vol-
 unteers in 1792,* **69,** 70; *Head of the
 Genius of Liberty,* **70**
Rue Transnonain massacre, 27, 107,
 160, 180, **180,** 181
Ruisdael, Jacob van, 128
Ruysdael, Salomon van, 128

Saint-Denis du Saint Sacrement,

Paris, 66
Sainte-Beuve, 40
Saint-Jean, Simon: *Emblèmes
 Eucharistiques,* **291**
Saint-Pierre, J.-H. Bernardin de:
 Paul et Virginie, 196, 197, 200, 205,
 207, 210, **212,** 249
Saint-Vincent de Paul, Paris, 64
Salon of 1824, 92
Salon of 1827, 23, 177
Salon of 1830, 118
Salon of 1831, 22, 23, 24, 89, 92, 93,
 94, 102, 103, 109, 132
Salon of 1833, 25, 54, 132, 134
Salon of 1834, 96, 118, 129, 132
Salon of 1835, 98, 108
Salon of 1836, 93
Salon of 1837, 140–41
Salon of 1839, 55, 85–98 *passim,* 110,
 111
Salon of 1840, 69, 114
Salon of 1841, 58
Salon of 1843, 67
Salon of 1844, 118
Salon of 1845, 67
Salon of 1846, 67, 142; Baudelaire
 and, 37, 50
Salon of 1847, 46, 47, 48
Salon of 1848, 118
Salons de la librairie Curmer, 205
Sand, George, 34, 35, 206, **229;** *Let-
 tres d'un voyageur,* 121
Scheffer, Ary, 39, 68, 73, 74, 76, 93,
 128; and Salon of 1839, 89, 95;
 Armand Carrel sur son lit de mort,
 6, **39;** caricatured, 49; *Christ con-
 solateur,* 68, **68;** *Cornelia Scheffer-
 Lamme avec ses petites-filles Cornélie et
 Cornelia,* **290;** *Faust apercevant Mar-
 guerite pour la première fois,* 95, **166;**
 Mignon aspirant au ciel, 95; *Mignon
 exprimant le regret de pays,* 94–95;
 Le Roi de Thulé, 95
Schnetz, Victor, 82; *La Vœu à la
 Madone,* 92
School of 1830, 121, 127, 128, 129, 130;
 mentioned, 116
Scott, Walter: novels of, 92–93
Sensier, Alfred: quoted, 127
September Laws. *See* Press Laws of
 1835
Shakespeare, 93, **94,** 247
Shapiro, Meyer, 207, 208
Siècle, Le, 43
Signol, Emile: *Jésus-Christ pardonnant
 à la femme adultère,* **294**
Silhouette, La, 150
Simart, Pierre Charles (sculptor), 78
Sixdeniers, Alexandre Vincent:
 Charlotte Corday, **233;** *Mlle. Rachel,
 secrétaire du Théâtre Français,* **226**
Smithson, Harriet, 93
Société de Paris, 100

Société des Amis des Livres, 192
Société Libre des Beaux-Arts, 70, 71
Soult, Marshall Nicolas-Jean de
 Dieu, 177
Stahl, P.-J. *See* Hetzel, Jules
Stapfer, Albert, 94
Stendhal, 96, 121
Steuben, Baron Karl von, 129, 130,
 225; *Esmeralda,* 95; *Portrait of Alex-
 ander von Humboldt,* **130**
Sturm und Drang, 94
Sue, Eugène, **144,** 144, 210; *Le Juif
 errant,* 210, **211,** 257; *Les Mystères de
 Paris,* 39, 95, 257

Talleyrand-Périgord, Charles-
 Maurice de, 18, 22
Taylor, Baron Isidore-Justin-Séverin,
 120; *Voyages pittoresques dans
 l'ancienne France,* 120, 121
Thiers, Adolphe, 20, 27, 39, 51, 61,
 69, 70, 77, **223;** caricatured, 23,
 177; quoted, 26
Thomire, Hippolyte Beauvisage, 36,
 37, 138
Thomire, Pierre Philippe, 137–38,
 138
Tocqueville, Alexis de, 30, 34, **45;**
 quoted, 18, 21, 44, 45, 46, 48
Travelogues, 116, 121, 122, 123
Traviès de Villiers, Charles Joseph,
 101, 183; and Philipon, 107, 151,
 157, 185; *L'Amateur d'huitres,* **182;**
 Barbès en prison, 108, **108,** 109;
 Dans la position où je me trouve . . . ,
 261; *Galerie physionomique,* 184–85;
 Histoire naturelle—le coiffeur, **182;**
 Industriel de bas étage, **184;** *Le Juste
 Milieu se crotte,* 159, **160;** *M. Ma-
 yeux,* **8,** 186; *Mayeux et Robert
 Macaire,* 187, **188;** *Peuple affranchi,*
 156, 157; *Pot de mélasse,* **158,** 159; *Titi
 le talocheur . . . ,* **185;** *Tonnerre de
 D . . . ! . . .* (attr.), 187, **187;** *Types
 français,* 184
Trimolet, Louis Joseph, 101, 110, 111;
 Une Maison de secours, 110, **168;** *Les
 Mystères de Paris,* 257
Triqueti, Henri Joseph François de,
 75, 77, 132; *Funeral Monument for
 the duc d'Orléans, Saint Ferdinand
 Chapel, Neuilly,* 74–76, **75;** *Piédestal
 pour le vase du Palais de Saint Cloud,*
 219; *Projet pour le tombeau de
 Napoléon,* 77, 78, **271**
Tristan, Flora, 35
Trois Glorieuses, 18, 19, 23
Trollope, Anthony, 209
Tuileries Palace, 19, 43

Ultramontanism, 65

Vasari, Giorgio, 96
Vernet, Horace, 25, 84, 88; *Agar chassée par Abraham,* 87, **88**, 89, 91; and his time, 54, 55, 56, 57, 71; and Napoleon, 57, 58; and Salon of 1839, 89, 95; and the Orient, 55, 86, 87; Baudelaire and, 50; caricatured, 49, 51, 52, **86**, 87; group equestrian portrait, 47, 48; *Le Duc d'Orléans {Louis Philippe} demandant l'hospitalité aux religieux du Petit Saint Bernard,* **122**, 123; *Le Génie de la Science,* 52, **52**, 53, 54; *Louis Philippe and His Sons Leaving the Palace of Versailles,* 47, 47–48, 51; *Portrait of a Young Woman,* 35,

35; *La Siège de Constantine,* 86, 87; mentioned, 20, 82
Versailles, château of, 23, 47, 59, 60, 61; Galerie des Batailles, 82; Musée Historique, 55, 59, 81, 82, 86, 124; Salle de Constantine, 55, 87; Salle de 1830, 59, 60, 74
Vibert, Victor Joseph: *Le Bien et le mal,* **274**
Victoria, Queen, 18, **124**, **135**, 145, **147**, **297**
Vignettes, 192–210 *passim*
Vinchon, Auguste Jean-Baptiste, 82
Visconti, Louis, 78
Vivenel, Antoine, 136, 141–43, **173**, 183

Wagner, Richard, 32, 33, 128
Weber, Carl Maria von, 128
Wood engraving, 124, 195, 197, 198, **198**, 199, 200, 201

Zerner, Henri, 193
Ziegler, Jules-Claude, 61, 96; church of the Madeleine, mural, 62; *Giotto dans l'atelier de Cimabue,* 96, **96**; *The History of Christianity,* 61; *Venise vue de nuit,* **14**, 122

PHOTO CREDITS

Most photos were supplied by the owners of the artworks. Other credits are listed below.

EUROPE

Caen, M. Seyve Cristofoli: Plate 28
Dordrecht, Foto Stijns: cat. no. 154
Marseilles, Patrick Box: Plate 43
Nantes, Patrick Jean, Musées des Beaux-Arts: Plates 26, 27, 33
Paris, Jean-Loup Charmet: Plates 37, 42; Figures 4-2, 4-3
Paris, Lauros-Giraudon: Plates 4, 15, 19, 40; Figures 1-3, 1-13, 3-16, 3-17, 4-8, 5-5
Paris, Musée des Arts Décoratifs, Sully-Jaulmes: Figure 6-2; cat. nos. 9, 10, 11, 13, 37
Paris, Photothèque des Musées de la Ville de Paris: Plates 7, 8; Figures 1-8, 1-16, 2-3, 2-4, 2-13, 3-9, 3-12, 4-4, 5-4, 5-10, 7-2, 7-7, 7-8, 7-11, 7-16, 7-20; cat. nos. 24, 25, 27, 28, 81, 82, 91, 92, 93, 94, 95, 96, 102, 104, 105, 123, 160
Paris, Service photographique de la Réunion des musées nationaux: Plate 45; Figures 1-1, 1-17, 1-18, 3-8, 5-6, 5-7; cat. nos. 20, 78, 127A, 162, 171, 172, 174
Paris, H. Roger Viollet: Figure 2-19
Rouen, Photo Ellebé: Plates 5, 6, 7, 8, 9, 10, 11, 12, 13, 14; Figure 5-8

UNITED STATES

Amherst, Robert Bezucha: Figures 8-1, 8-3, 8-6
Columbia, Mo., Jeffrey Wilcox, Museum of Art and Archaeology: cat. nos. 4, 46
New Haven, Regina Monfort, Yale University Art Gallery: cat. nos. 44, 47
New Haven, Joseph Szasfai, Yale University Art Gallery: cat. no. 53
New York, Scott Bowron Photography: cat. nos. 32, 35, 36
New York, James L. Conzo: Figure 2-8; cat. no. 6
Orange, N.J., Petra ten-Doesschate Chu: Figure 5-9, 5-11
Paramus, N.J., Taylor and Dull, Inc.: Figure 2-20; cat. no. 7
Providence, Michael Driskel: Figures 2-11, 2-12
Providence, Brooke Hammerlie: Figures 2-1, 2-2, 2-5, 2-9, 2-15, 2-16, 3-5; cat. nos. 41, 42, 48, 61